Redeeming Art

Critical Reveries

BY

Donald Kuspit

EDITED WITH AN INTRODUCTION BY

Mark Van Proyen

ALLWORTH PRESS
NEW YORK

School of
VISUAL ARTS

© 2000 Donald Kuspit

04 03 02 01 00 5 4 3 2 1

Published by Allworth Press
An imprint of Allworth Communications
10 East 23rd Street, New York NY 10010

Copublished with the School of Visual Arts

Cover and book design by James Victore, Beacon, NY

Page composition by Sharp Des!gns, Lansing, MI

ISBN: 1-58115-055-5

LIBRARY OF CONGRESS CATALOGING-IN-PUBLICATION DATA
Kuspit, Donald B. (Donald Burton) 1935–
Redeeming art: critical reveries / Donald Kuspit.
 p. cm. — (Aesthetics today)
Includes bibliographical references and index.
ISBN 1-58115-055-5
1. Art, Modern—20th century—themes, motives. 2. Aesthetics, Modern—20th century.
3. Postmodernism. I. Title. II. Series.
N6490 .K876 2000
709'.04—dc21
00-024398

AESTHETICS TODAY
Editorial Director: Bill Beckley

Dialectic of Decadence by Donald Kuspit
Beauty and the Contemporary Sublime by Jeremy Gilbert-Rolfe
Sculpture in the Age of Doubt by Thomas McEviley
The End of the Art World by Robert C. Morgon
Uncontrollable Beauty edited by Bill Beckley with David Shapiro
The Laws of Fésole by John Ruskin
Lectures on Art by John Ruskin
Imaginary Portraits by Walter Pater

Printed in Canada

Contents

Acknowledgments

I'd like to express my gratitude—my very profound gratitude—to Mark Van Proyen, for the interest that he has shown in my work, and for his brilliant essay about it, which is also a remarkable analysis of the situation of art criticism during the last few decades. I am also very grateful to Bill Beckley and Tad Crawford for their interest in publishing this collection of essays and interviews. I admire their effort to bring art criticism to the attention of the educated public beyond the art world. Without their seriousness, art discourse would be greatly impoverished. I am also grateful to Elizabeth Baker, Jack Bankowsky, Kathryn Hixson, Ida Panicelli, Ingrid Sischy, and Miles Unger for their editorial support and understanding. And I want to thank my wife Judith Clements Kuspit, whose emotional support and intellect are essential to my existence.

DONALD KUSPIT

New York, June 1, 1999

I would like to express my deep gratitude to several individuals who have made important contributions to the development and presentation of this book. For their support of and enthusiasm for this project, I would like to thank Tad Crawford and Bill Beckley, respectively the publisher and the series editor of the School of Visual Arts/Allworth Press Aesthetics Today series. Jeff Gunderson and his able staff at the library of the San Francisco Art Institute were superb in assisting with a number of research details, as were Susan Barron and Crystal Green, who also did a remarkable job in typing much of the material included here. Most importantly, I would like to extend special thanks to Donald Kuspit for being supremely generous with his time, encouragement, and enthusiasm. The critical spirit will be forever indebted to him.

MARK VAN PROYEN

Bolinas, June 4, 1999

Donald Kuspit: Dialogical Art Criticism
in the Era of Administered Art

BY MARK VAN PROYEN

I do not believe that the academically oriented article, claiming to be definitive, is superior to the supposedly transient journalistic article as a vehicle for serious critical analysis, or that self-styled systematic thinking is inherently more rigorous and insightful than an informal quick-witted argument which is responsive to immediate issues. Neither guarantees a more genuine understanding than the other. Neither has a monopoly on the truth. Neither offers a more long-term perspective . . . there is no exclusive way of communicating today, none that is automatically more successful than any other.

—Donald Kuspit, Preface to *The New Subjectivism,* 1988[1]

I have elsewhere maintained that so-called aesthetic pleasure is an umbrella term covering a complex variety of psychic satisfactions, specifically, the satisfaction of one or more of what Erich Fromm called "psychic needs" or "existential needs": "the need for relatedness, for transcendence, for rootedness, for a sense of identity, and for a frame of orientation and an object of devotion [and] for effectiveness." I would argue that one of the reasons figural art in general and so-called realistic art in particular are regarded as being inferior to abstract art is that they nakedly reveal these needs, debunking the myth of pure aesthetic pleasure. They are overtly and honestly psychological, and as such, anathema to abstraction.

—Donald Kuspit, *A Freudian Note on Abstract Art,* 1989[2]

Journalism is unreadable and literature is not read.

—Oscar Wilde, *The Critic as Artist,* 1890[3]

In an uncharacteristically blunt utterance, Donald Kuspit once wrote, "Narcissism to overcome nihilism: that is the formula for the best art."[4] It is a statement that speaks volumes about his unique position as a postmodern art critic, especially if we see how closely it is shadowed by the recognition of how narcissism in the service of techno-bureaucratic nihilism will lead to the disaster of calculated gamesmanship triumphing over defiant subjectivity. And there's the rub, for we are again reminded that art needs to have some kind of psychomoral consequence if its claim on our time and attention will be a deserved one. It is a reminder that Kuspit repeatedly presents with a stunning degree of sophistication and subtlety, even as it is also a reminder which has not had much circulation as of late, owing to the fact that the linked worlds of contemporary art and art criticism have been too preoccupied with the business of hastily refashioning an identity that is appropriate to the emerging circumstances of the post–Cold War period. This is the period of the post-Warholian nightmare[5], as Robert C. Morgan has called it—and its chief characteristic seems to be an adamant view of itself as being somehow above the experiential pragmatics and psychological politics that inhere in an aesthetic experience rooted in the dramas of the lifeworld. It is just such a reminder that this book seeks to put into the foreground, and in so doing it hopes to invigorate a debate that has gone sterile in recent years, a debate that has collapsed into a quagmire of dead rhetorical ritual that seems ever more complacent in its making a spectacle of its irrelevance to the present as well as its lack of sincere concern for any viable future.

This collection of Donald Kuspit's writings and interview statements reflects other concerns as well. One of these is to provide a synoptic survey of the evolution of Kuspit's multifaceted thought from all phases of his twenty-five-year career as an art critic and public intellectual. To accomplish this, I have sought to include examples of his work which represent the widest possible spectrum of his interests and approaches, giving special emphasis to how they might be taken as waypoints upon which a larger intellectual trajectory might be mapped. My secondary hope is to further flesh out and clarify a body of reflective thought which already casts an imposing and controversial shadow upon the history of contemporary art and its critical record. To that end, I have taken pains to select essays

which have not yet appeared in any previously published book or anthology. In keeping with that ambition, I have also sought to give special emphasis to the disparate modes of address which Kuspit has employed. These have run the gamut from the academically formal to the journalistically topical, and their representation in this volume is intended to provide a multiplicity of useful points of entry and comparison for a wide spectrum of otherwise uninitiated readers, allowing them to gain substantial acquaintance with Kuspit's complicated projects of psychoaesthetic inquiry and rigorous intellectual challenge.

The material in this volume also reflects an additional overarching concern. Its keynote is to encourage and facilitate a larger discussion and evaluation of the import and significance of Kuspit's contribution to the linked histories of art, art criticism, and postmodern thought. To this end, I have penned a rather lengthy introductory remark that will provide the reader with a sensitizing framework through which the issues raised by Kuspit's writings might be better understood. Here, my own interpretative agenda comes to the fore. In my view, the debate between modernist notions of essential autonomy and postmodernist notions of an all-determining context is not only well past the point of being passé, but is in fact subtly pernicious. Its perniciousness lies in the confused motives that lie behind its adamant fetishization of a false dichotomy, that being the dichotomy which casts identity as being either a self-objectified manqué of some formalist provenance, or an institutionally identified (and objectified) symptom whose existence owes and concedes too much to the suspect mandates of ideological groupthink as it might be determined by administrative mandate. Either way, subjectivist interiority (and the intersubjective conviviality that issues from it) is programmatically trivialized, usually in the name of outmoded political categories that are but disingenuous masks for competing theories of exonymic manipulation, none of which are at all adequate to the task of helping people live better in any meaningful sense of the word.

In my view of Kuspit's view, art does indeed contain the capacity to help people live better via its abilities to invite, establish, and encourage a subjectivist conviviality. It does this by crystallizing experience and desire into a coherent and dramatic form which functions as both a sense-making and sense-breaking entity for kindred spirits, and as such it semipublicly poses a "way" of seeing that, by virtue of its multiple connections to the actual psychogeographies of lived experience, is intrinsically other and more timely than "the way"

as it might be determined by any superordinate entity. This much said, we can also follow Kuspit's lead in realistically noting that such artistic "ways of seeing" also run (and frequently capitulate to) the risk of being co-opted into programs of totalization not-of-its-own-making, be they the commodifications that are determined by the market or official instructions as they are determined by bureaucratic mandate. It is in relation to the encouragements leading to such co-optation that Kuspit reveals art criticism as having an important (albeit often neglected) potential as being a countervailing force. For Kuspit, the rightful position of art criticism is that of being the voice of art's noblest self-conscious-ness, one that always strives to see the optimal potential for an immediate con-viviality as it exists both amid and beyond a clearly understood reality, even and perhaps especially when the relations between the two operate on a predomi-nantly unconscious level. The question that Kuspit has devoted his professional life to is how might art criticism most honorably actualize this potential with-out succumbing to the temptation of demagoguery, that is, of lazily becoming just another one of administration-culture's exploitative, superordinating agen-cies, "a self-serving institution in its own write."

In short, this book seeks to highlight the picture of Donald Kuspit as an important psychomoral thinker who works in the literary medium of art crit-icism, and as such it will reveal a model of art critical practice that courageously diverges from the quagmire of tired assumptions that undergird other postmod-ern critical orientations. In so doing, this book also hopes to honor a remarkable career that is still a long way from its conclusion.

I

If we were to look at the practice of art criticism that has taken place during the past three decades, we would find it easy to see how its differing ori-entations gather into a plethora of distinct but nonetheless identifiable camps. These might range from those of smug autobiographers and pompous pro-nouncers to ideological sanctimones of every conceivable stamp, and they might also include cadres of paleotraditionalists, nostalgic formalists or silver-tongued panegyrists, as well as many other groups and subgroups of heretofore undiffer-

entiated literatuers. What they all have in common is an unconscious reliance upon two unexamined assumptions, both of which are rooted in an honorable past even as their relevance to the present lives in a state of dramatic decrease. The first of these is that art criticism is essentially an exercise in valorizing and promoting specific artistic careers, implying that from the standpoint of the reader, a critic may be sufficiently known merely by the work that he or she deigns to endorse and promote. From this pragmatic perspective, the reasoning behind such endorsements matters little, and oftentimes doesn't even exist, except perhaps as the very distant rhetorical backdrop for the artistic names that are to go up in momentary lights. The second of the aforementioned assumptions seems at cursory glance to devote more attention to such critical reasoning, but it too echoes a pigeonholer's imperative. It stems from the desire to gain a quick professional identity via an unconsidered embrace of some prepackaged form of intellectual solipsism loudly raised as a rhetorical talisman against an increasingly indifferent and chaosmorphic world. Of course, such solipsisms are also inevitably doomed to be articles of passing intellectual fashion, just as much so as any artistic style that a given critic might choose to promote, for once they conclude their heralding of-the-next-big-thing-that-will-change-everything-for-the-next-five-minutes, they too are inevitably doomed to be of only a momentary and easily managed relevance amid the quickly shifting sands of the postmodern turn.

What is missing from both of these assumptions is a sense of criticism's more honorable mission of thoughtful public examination and interrogation, which is not so much an omission of convenience (although it is that) as it is one bred from the now unavoidable confusion of values surrounding and undergirding the world of contemporary art. Without a coherent and persuasive value system, criticism has no Archimedean ground upon which to stand, and hence, can neither picture nor question any meaningful relationship between its subject and the larger world. A shortsighted skepticism might opportunistically see something resembling liberation in the elimination of questions of value from the equation of art (art equals fact, response equals simple opinion—end of simple equation), but that would be folly, for parochial interests are always lying in wait to fill and corrupt any void that remains after questions of value have been withdrawn from the field. Thus, the fundamental problem of how to go about questioning the given in the name of relevant values grows ever more pressing, even if there is no consen-

sual certitude regarding what those values might be, whose interests they should serve, or from what process might they be legitimately derived.

From the standpoint of the serious art critic, addressing the problem of relevant values is crucial if he wants to invoke and sustain an evolving point of view that can meaningfully address, redress and inform the changing vicissitudes of the contemporary moment. Only through an understanding of and an appeal to values as they are actually lived in the lifeworld can a critic gain the necessary perspective to question the imperatives of fashion. And only through an understanding of and an appeal to lifeworld values can a critic avoid hiding behind the comforting walls of an ossifying ideological dogma. Such dogmas might seduce one into thinking that they solve the problem of values insofar as they appear to offer the critic a "method" in lieu of a stable and coherent vantage point, but with that offer comes the hidden peril of said method becoming a confining cell, which is to say that when the dogma inevitably dies—that is, when the dogma no longer bears any relation to values as they are actually lived in the lifeworld—the ideologically incarcerated critic must of necessity die with it. In recent years, the rapid growth in the scale of the world of contemporary art has tempted far too many critics into such confining cells of rote scholastic methodology so that they might position themselves at the center of some easily identified ideological territory, implicitly taking to heart William Blake's anxious maxim stating, "I must Create a System or be enslav'd by another Man's."[6] Only in the proliferating case of postmodern scholasticism, such a system almost always arrives as prepackaged ideology, and is thusly earmarked by an iconophobe's faith (usually of Marxist provenance) in the necessary authority of sociolinguistic determinism.

Other critics, (or "artwriters," as they so often call themselves) have recoiled at the specter of this kind of intellectual self-imprisonment, but in so doing, they have shown themselves to be impulsively prone to writing fashion-conscious panegyric, or, at the other extreme, peppering their work with an excess of empty (albeit pompous) pronouncement, reveling in a narcissistic fascination with the sound of their own literary voices. Either way, they are tacitly (and, I think, naively) appealing to Oscar Wilde's notion of "criticism as the highest form of autobiography," here cast as the legitimizing banner for the broadcast of self-important confessions which almost always fail to attain the status of meaningful revelation. As is most often the case, they do so only

because the call for a more considered and systematically precise exposition seems to threaten a kind of elemental narcissism, one that is irrationally invested in an emotivist notion of writing that turns out to be the simplistic siren song that is the undoing of any good critic. This is so because the confessional mode of criticism is too trapped in its own delusion of self-importance to bother linking its pronouncements to a generally recognized "metaphysics of art," and these artwriters tend to opportunistically assume that their own unformed intuitions supply all of the metaphysics that any art might happen to need. What needs to be emphasized in the case of this group of pseudocritical "art writers" is the fact that their common path of impressionistic utterance is also fraught with peril, as it will inevitably lead them either into the boo-and-hooray whirlpool of market-oriented influence-peddling or hard upon the all-too-visible rocks of self-important puffery—and the beach of unintended comedy that lies beyond.

The fact that panegyric and scholastic circularity will both flourish like kudzu in the rhetorical space vacated by untenable values is not really at issue here. It is simply the given, albeit insufficiently remarked-upon, underbelly of the postmodern climate, which has programmatically sought to collapse certitude, knowability and coherent purpose into a thousand articles of parochial "perspective," each crying out to the world of social administration for a momentary salvation while receiving a dose of exploitative manipulation in the bargain. What is very much at issue is the remaining dignity, usefulness, and resurgent necessity of the production and circulation of a rigorously self-conscious and intellectually independent analysis, one which can negotiate the institutional contours of the post–Cold War art world with a high level of sophistication and intellectual subtlety. It is becoming increasingly clear that the chief characteristic of this art world is its programmatic encouragement of a passive-aggressive sycophancy which has now become highly skilled at co-opting potentially destabilizing gestures of rebellion and deviance, subtly transforming them by administrative fiat into harmless articles of nugatory spectacle. Concomitant to these encouragements is a subtle kind of denial that either seeks to subsume serious examinations of artistic meaning and value under a rug of marketing and promotion, or cordon it off into a sanitized island of scholastic hyperspecialization. Either way, the serious discussion of any artwork's psychomoral consequence is deferred, and the transformative charge of art is blunt-

ed and nullified, lest it otherwise represent an untoward instance of an authoritarian will-to-power. The serious ambitions that undergird both artistic and critical aspiration may well be that, but I would say that we may have come to a pass where circumstances force us to recognize that they are honorably so, given the scholastic's Pecksniffian co-optation of criticality as a cynical vehicle for administrative "positionality," as well as in the other light of the panegyrist's own peripatetic will-to-administrative favor as it passive-aggressively reveals itself to be a particularly pathetic and subtly dangerous form of will-to-power.

What needs to be stressed here is how Kuspit's work represents and exemplifies the long overdue arrival of a persuasive and necessary third alternative to these moribund approaches. Because his work is intellectually rigorous, one might expect him to prize so-called conceptual art, yet conceptual art often fails his critical test because it facilely predigests its own facile conceptuality, thereby failing to configure itself as a knot of consciousness that can only be unraveled by an external critical consciousness. Because he is steeped in the critical theories of the Frankfurt School, one might expect him to see art as an exercise in oppositional politics or "negative dialectics," yet he was among the first to see that the art world's prizing of so-called "opposition aesthetics" had long ago become a hollow shell game devoid of necessary critical purpose. And in his prizing of the artwork's tangible and dramatic embodiment of meaning, he might be said to side with the formalists, but he is vigorous in denying the physical particularity of art as a be-all and end-all, insisting instead that the "insistent particularity" of art be viewed as a spontaneous condensation of its metaphysical generality rather than as a truistic assertion of its own dubious facticity. And most significantly from the standpoint of the history of art criticism, his emphasis on the artwork's particularized knotting of metaphysical generality might seem to place him on the side of the Postmodernists, except that for Kuspit, such generalities are in no way limited to the mechanisms and politics of sociolinguistic designation. On the contrary, his view of the metaphysical generality that saturates aesthetic experience is perhaps the most learnedly expansive one that the history of art criticism has ever seen. It stems from an unparalleled command of what can be called "the phenomenology of aesthetic reading," and in the past fifteen years this has been further buttressed and elaborated upon by Kuspit's equally unparalleled command of post-Freudian psychoanalytic theory. Of this unique theoretical orientation, more will be said, but

suffice it to say here that it allows Kuspit to simultaneously rebuke the self-serving naiveté of aesthetic fetishists on one side and iconophobic ideologues on the other. In so doing, Kuspit's criticism carves out a space where the work of art as a catalyst of consciousness can be emphasized via a focusing on its ability to condense, channel, and overcome the experiential schism that separates the rare and condensed world of embodied symbols from the accelerating and all-pervasive world of disembodied information pictures—the schism to which T. S. Eliot ascribed the term "dissociation of sensibility," that being both the curse and earmark of modern self-consciousness.

To accomplish this feat, Kuspit has devised a method of interrogation which he has termed "dialectical criticism."[7] With it, he is able to deploy a mighty rhetorical arc that can surround, bind, and then finally suspend Eliot's curse, taking us to the cognitive threshold where art's subjects and objects become fused into a singular distillation of reflective consciousness. This arc has two distinct phases that in themselves seem as different as night and day, yet both are needed if the completed critical circuit is to generate the appropriate rhetorical charge. The first of these I would call "discursive sophistry" for its grasping of the expansive vantage made available by the highest crest of worldly erudition, a vantage that can put perspectivalism itself into an even greater historical and intellectual perspective. This is achieved in the following fashion: it starts with the recognition that there can be no mono-paradigmatic outlook that can legitimately ascertain the total field of artistic production without placing that production into a kind of procrustean bed—an unacceptably arbitrary (not to mention lazy) solution to the problems of criticism. From this recognition evolves what might be called a "poly-paradigmatic" understanding of art— not a promiscuous assertion that "anything goes," but the recognition that the postmodern condition provides us with a plethora of available theoretical models which all have their own situational usefulness as changing circumstances might warrant. Here, we see the critic taking responsibility for becoming expertly conversant in the articulation of many different generative perspectives out of recognition that actual circumstances will of necessity effect principles of analysis just as surely as those principles will effect circumstances. This is a fact of recent intellectual history which cannot be ignored.

Despite the bad and undeserved reputation that sophistry has for an alleged lack of ethical consistency (after all, we should note that Plato was a

sophist), it should be recognized that it holds the key for a sustained critical relevance insofar as it allows for a fluid approach to art's fluid approach to life (it should be remembered that the name Kuspit is derived from the Hebrew word for quicksilver). The value of this lies in how it allows the critic to maintain a viable perspective on the fluctuating character of his subject matter, thereby distancing him from the numbingly obvious clown show of successive solipsisms which comprise common critical practice. But it should also be recognized that the full circuit of critical operation would be incomplete if it stopped at this sophistic phase, and it is at this juncture that we see Kuspit turning hard away from the high crest of sophistic erudition and toward the deep understanding of the psychoaesthetic substrate that undergirds the creative impulse.

I call this second phase "psychoaesthetic grounding," and in it I see a deep appreciation and respect for the nonverbal imperatives which lead us to understand our experiences through the generation and circulation of what Edmund Husserl called "the picture contents of fiction," those being the mimetic constructs that link facts, ideas, and concepts to a chain of purpose.[8] Here, we see a foregrounding of the notion of image as it lives in the word "image-ination," and it is always linked to the important reparative task of symbol-formation, perhaps most eloquently described by Melanie Klein:

> . . . the development of the ego and the relation to reality depend on the degree
> of the ego's capacity at a very early period to tolerate the pressure of the earliest
> anxiety situations . . . a sufficient quantity of anxiety is the necessary basis for an
> abundance of symbol formation and of fantasy; an adequate capacity on the part
> of the ego to tolerate anxiety is necessary if . . . the development of the ego is to
> be successful.[9]

Following from this by way of reasonable extrapolation, we can assert that real encounters with real works of art provide the beholder with an opportunity to vicariously reengage and reactivate our own latent capacities for active symbol formation (as opposed to passive symbol digestion), thereby facilitating an ability to integrate and contain otherwise intolerable moments of anxiety. Society can and in fact does give us predigested symbols—in fact, a great many of them—and it certainly provides endless amounts of anxiety, but only art can reveal in its own being the sense-making and sense-breaking activity of symbol

formation which actively registers, integrates, and responds to new anxiety situations as they emerge. This is the point where Kuspit's art criticism becomes actively facilitative by imaginatively reading the self-crystallizing symbol formation process that latently operates below the apparent surface of an artwork's putative symbolic display. In so doing, he reveals how the engagement with a work of art can reenergize the viewer's own aptitude for the active forming and shaping of symbolic meaning as it is revealed and occasioned in his or her own dynamic experience of the lifeworld. Thus, by way of presenting analytical narratives that simultaneously go above the ideological ceiling and under the experiential subconscious of any given work of art, Kuspit leads us on a path that, in Alfred North Whitehead's words "unloosens the depths of feeling where the precision of consciousness fails."[10]

At different junctures, the path has different names, but it has a few unvarying purposes, presented here as linked succession of rhetorical operations and projects:

1. To disengage the work of art from the circumstances that render it "topical" from an instrumental point of view;

2. To surround the work of art in a sensitizing framework of historical consideration, seeking out its complex contextual lineages;

3. Seeing in its relationship to those lineages a symptomology that sets it apart from them, thereby re-rendering it as the article of a contemporary crystallization of lived experience;

4. To see how the work of art might be viewed as standing apart from the prevailing postmodern notion of the sociolinguistic construction (and replication) of the psychological so as to replace the implicit "administration envy" of that notion with a set of psychologically astute priorities that might help all concerned live better—or at least live with a degree of psychological intelligence—via the insight gained from criticism's interpretative intervention;

5. To explicitly account for the intertransferential dynamics that occur between artwork and its critical analysis, that is, to show that works of art and articulations of critical perception both have their own complementary ontological grounds which mutually mirror and construct each other as fictive representations of the struggle to regain an authentic selfhood;

6. And finally, to read artistic performance as being exactly that—the

putting into play of performatives that seek to transfigure and invigorate the pro forma constitutive etiquettes of reception so as to realize and fulfill a larger therapeutic purpose, which when successful, becomes the larger ontological purpose as well.

All of which is to say that (again, in my view of Kuspit's view) art can and should do something to diagnose, bridge, and mend the common conditions of disassociation and narcissistic injury that celebrates and breeds psychic deadness at every postmodernist turn.

II

Kuspit's critical position and methods have thus far never been the subject of any serious analysis, but it has been subjected to a good deal of stereotypical thinking casting him as the arch sophist of postmodern art criticism. Because of this, we can note that his work has garnered much in the way of misguided condemnation and even demonization from a wide range of ideological voices that one would otherwise assume to be at extreme odds. For example, Theodore Prescott has written in the neoconservative *New Criterion* that "Professor Kuspit's point of view is that misery is the only genuine human condition . . . he implied that the measure of any real artist is his ability to confront a viewer with the relentless nastiness of reality,"[11] while an imperious Rosalind Krauss was sufficiently distracted from her editorship of the neo-Marxist journal *OCTOBER* to be quoted by Janet Malcolm as saying that Kuspit was even worse than Thomas McEvilley, who was "a very stupid writer . . . pretentious and awful."[12] Not to be outdone, Adrian Piper went so far as to publish drawings of Kuspit portrayed as an insect to be gassed, an odd lapse in sensitivity from an artist and writer known for her attempts to "deconstruct" racial stereotypes.[13] Other commentators have gone to rather extreme lengths to argue against straw facsimiles of Kuspit's ideas, as was the case in David Carrier's short survey of contemporary art criticism titled "Artwriting." Carrier's literal-minded summary of Kuspit's book-length treatment of the work of Leon Golub was worse than facile when it reduced Kuspit's psycho-

logically sophisticated notion of Golub as an "existentialist/ activist painter" to one of an illustrator of simplistic political agitprop, all-the-while ignoring Kuspit's detailing of the complex psychological identifications represented in Golub's mercenary paintings from the early 1980s.[14]

When Richard Kostelanetz reviewed Kuspit's 1988 collection of essays titled *The New Subjectivism,* he called attention to what he alleged to be Kuspit's "riots of duplicity," only to support this allegation by citing two fragmentary remarks that seemed to contradict each other in tone, but in fact both supported the actual thesis in question, i.e., the point that the undeniable pluralism of the postmodern art world forces critics to rethink the very meaning of criticality as a third alternative between irrelevant dogmatism and automatic novelty celebration. Of course, such a cynically selective grasping for contradictions only served to reveal Kostelantz's own loyalist agenda, which was to anxiously reconfirm the monarchical authority that he himself had projected onto the work of Clement Greenberg and Harold Rosenberg, the two "kings" of American art criticism who, "in their thrones, . . . hand in hand, are safe for now."[15] Nothing could have been further from the art-historical truth at the end of the deconstructive 1980s.

Kostelanetz went to considerable lengths to attack the polyglossic style of the essays in that book, implicitly revealing his own inability to seriously engage or debate the ideas contained within them. This was made apparent when he rhetorically asked his readers, "Zowie, aren't you impressed?" followed by a second question, "Don't you wonder who is?" But let us look closely at the actual statement that he denigrates as being a particularly egregious example of Kuspit's "rhetoric of oneupsmanship."

> The prototaxic mode of experience is infantile. It is paradoxical that to establish an infantile mode of experience of the art object—immediate experience of it—requires such a heroic effort. But this is because only an infantile experience of the art object can disclose its extra-ordinary significance for us. Only the experience of it as "mothering" us with its "sensational" immediate givenness discloses the infantile character of our attachment to it.[16]

If we replace the Sullivanian technical term "prototaxic" with the over-general and commonplace "primary process," the four sentences in question

reveal themselves to be clear, succinct, and jargon-free in conveying Kuspit's own sense of how the aesthetic unconscious operates in its quest for the symbolic opportunity to intropsychically reenact the initial discovery of a "miraculous" moment of intrapsychic facilitation. When we experience and re-cognize the echoes of that moment, we respond with a heightened anticipation and aware-ness, which is to say that we are having what is more conventionally understood to be an "aesthetic experience." We might also want to remember that the quote in question was taken from an essay that was originally published in a specialized journal directed at a readership that could reasonably be assumed to know tech-nical psychoanalytic terms, so no sense of occasion can be said to have been vio-lated via the cited instance of specialized parlance. Sounding a particularly igno-rant note, Kostelanetz also compared Kuspit's critical position "to that other great hater of contemporary art, Hilton Kramer," a flippant assertion that can hardly be justified by any side-by-side reading of the two critics' work.

On the other hand, Kuspit's work has also gained significant recogni-tion and praise. Thus far, he has received three Honorary Doctorates in addition to the two that he has earned (not counting his more recent completion of psy-choanalytic training at the New York University Medical Center). Most recent-ly, he was honored with a lifetime achievement award presented by the National Association of Schools of Art and Design.

Perhaps the most noteworthy recognition of his accomplishments came in 1983, when he was awarded the College Art Association's prestigious Frank Jewett Mather Award for excellence in the field of contemporary art crit-icism. Upon announcing the award, the judging committee pointed out that Kuspit's approach represented a bold and provocative direction for postformalist art criticism:

> Since the demise of Formalism, art critics have been under particular stress to find a new type of criticism that is suited to the rapidly changing and pluralis-tic nature of contemporary art.
>
> Suddenly, in the midst of the search, there appeared a mighty presence—a man with unbelievable energy, passion, conviction, and an erudite approach which he brought from another discipline—philosophy—where he was already a scholar. His dialectical discourse was less absolute, more open, and seemed particularly suited to postmodernist art.

The sheer quantity of his writing is stunning. Not a month has gone by that articles, reviews or catalog essays have not appeared. Although the choice of this critic is in part for an earlier body of work, it is in 1981–82 that he has reached a high point with his special understanding of the New (and Old) Expressionism and with his Lucas Samaras catalog essay which reveals his remarkable ability to confront the artist and snap back to an empirical kind of writing.

However, it is perhaps more for his spirit of commitment to the field, his unremitting search, that we have chosen to honor Donald Kuspit. In the very process which his methodology dictates, we are made aware of a struggle of the mind to surround and infiltrate the truth as he sees it, which lends art criticism a credibility and dignity so needed at this time.[17]

Many artists have also responded with enthusiasm to Kuspit's work because it so frequently revealed a willingness to rethink received opinion while simultaneously recognizing the complex ontological particulars of a wide variety of differing kinds of art, regardless of whether or not such works advertised themselves as having "conceptual" ambitions. This was particularly evident in his energetic advocacy of the so-called neo-Expressionist figurative painting that was practiced in Germany and America during the 1970s and 1980s. Perhaps the most notable aspect of this advocacy was Kuspit's counter-critique directed at some of the "ideological" criticisms that were leveled against that work by academic Marxists, brilliantly detailing how their objections stemmed from an overconventionalized form of neoscholastic criticality that implicitly defended an institutional and psychological politics of privilege and control.[18] Such a willingness to stand apart from and challenge the sanctimonies that so often inhere in institutionally determined groupthink, has been a consistent hallmark of Kuspit's work, and its programmatic willingness to question and challenge conventional assumptions stands in stark contrast to the now solidifying character of the post–Cold War art world, where the imperatives of institutional self-congratulation have programmatically operated behind the frozen mask of a presumed (albeit conventionally conceived) criticality. Reviewing Kuspit's first anthology of essays, Rudolf Baranik (an artist) summarized an initial rift in art world opinion which has lingered into the present: "Readers quickly divided, saying two things: (1) He is unreadable; (2) He is worth read-

ing because embedded in his uncompromising language are some of the most worthwhile thoughts ever written on art."[19]

This leads us, as well, to recognize that Kuspit's approach, based as it is on the search for signs of authentic, "autonymic" selfhood, has been out of step with the larger drift of postmodern art criticism, which has shown an overwhelming tendency to make an issue out of the ways that identity is constructed by the mechanisms of "exonymic" designation which are derived from the contexts that surround it. This situation was made clear as early as 1964 in Lawrence Alloway's prophetic maxim: "The anthropological definition of culture is likely to appear under other titles. By it I mean to refer to the impulse toward open-ended as opposed to formal description of events and to a speculative rather than contemplative aesthetics, the main enemy of which is at present in the United States is academic formal art criticism."[20] A host of seemingly different theoretical orientations have since come to the fore, advancing themselves under the banners of "Visual Studies," the "New Historicism," and the "Institutional Theory of Art," the latter serving to some extent as an authorizing argument for the approaches of the former. In brief, the Institutional Theory of Art (hereafter the ITA), as it is explained by George Dickie, holds that "a work of art in the descriptive sense is (1) an artifact (2) upon which some society or some group of society has conferred the status of appreciation." As a point of telling clarification, Dickie also offered this qualification regarding his view of the social property of art: "It all depends on the institutional setting."[21]

Here, it needs to be stressed that the ITA seeks to arrive at a definition of art in the descriptive (rather than the evaluative) sense of the word, and it presents itself as the only workable answer to the epistemological question pertaining to the necessary and sufficient conditions of anything being namable as a work of art. Supporters of the theory claimed that it provided the only answer to that question which could withstand serious scrutiny, thus it was held up as the necessary starting point for any subsequent inquiry into "evaluative" aesthetic values. But, notwithstanding this caveat, it must be recognized that the ITA's razor cuts two ways. Any logically enforced agreement on description will of necessity foreclose and/or emphasize certain possibilities of evaluation, and in the ITA's case it will do so in the direction of privileging both the aforementioned "institutional setting" as well as the administrators who are its day-to-day stage managers. Despite its legitimate claim to satisfy the requirements of both a logical

and historical point of view, it is a profoundly anticritical doctrine with distressing political implications. One of these speaks to the authoritarian motives of those who would insist on using formal logic in the place of everyday logic: the former might assert that "all meaningful statements can be proven to be true or false," while the latter would contend that the meaningfulness of a given statement depends on its operation in a dialogical stream of shared communication. Another is its encouragement of a phenomena that I would call "administrator envy" as a way of suggesting the rationale for a manipulative and even exploitative mindset, one that lets its servants do its living for it even as it is all too eager to subcontract the "revolution" which it claims to support. Defenders of the ITA have pointed to the ready-mades of Marcel Duchamp as being the generative works that subsequently initiated the theory's necessary prizing of acts of designated meaning at the expense of works of embodied and/or described meaning, with Andy Warhol, Minimalism, and then later a large group of "Neo-Geo" artists all forcing the issue of separating artistic authorship from actual production, by way of using underpaid assistants and subcontractors to "administer" their works into physical and social being. For his own part, Kuspit has addressed this phenomena by writing:

> The argument usually made in support of the post-Duchampian ready-made is that it finesses consumerism. In fact, it only confirms that consumerism is the presiding ethos of our culture. The post-Duchampian ready-made asserts not only that art is a more princely commodity than other commodities, but that it cannot be anything but a commodity, can have no meaning other than its exchange value.
>
> It is the explicit consumerism of the post-Duchampian object that reduces it to ordinariness, to the pre-lapserian state of banality—to the state before Duchamp got an intellectual hold on it.[22]

The work of some theory-identified artists notwithstanding, it nonetheless has to be admitted that the real beneficiaries of the ITA were and are the burgeoning ranks of institutional art administrators whose importance in the postmodern scheme of things is to make censorious decisions about artistic visibility on a day-to-day basis, leading the art market by the nose in the bargain. For this reason, they themselves become highly visible as central players

in and central beneficiaries of the art game, with announcements of their job appointments now routinely accompanied by the kind of generic "big brother" portrait photographs that are usually reserved for representing the heads of large corporations. These are the programmers, rainmakers, and masterminds who govern our brave new world, and what they say goes(!): so much so that at this writing, several museum exhibitions have taken the ITA one short step further by allowing curators to select mass-produced objects as "candidates of appreciation" even though these objects have no documentable tie to any individual claiming to be an artist, thereby fulfilling the Orwellian promise that was only implicit in the early articulations of the ITA. Following from this, we can see that in the mid-1990s, the art world as an institutional mechanism designating itself as its own subject of self-designation seemed to be moving away from the realms of rhetorical tautology and philosophical thought-experiment, and into the world of practical and even desirable possibility. It is a system in the truest sense of the word, a system that reveals itself to be the systemic unconscious of a facile if not outrightly blind faith in the value of systemic thinking.

And it is the selective blindness of systemic thinking that criticism contends with, lest that blindness invite disaster upon itself. I refer here to recent history, first by taking note of the resurgent ascendancy of 1970s style "art writing" in the post–Cold War art world, and then by pointing to what I think are its implications. Hindsight reveals that this model returned to the forefront of the art world in the early 1990s, emerging simultaneously with the sudden and unexpected centrality of the visual arts in the national political debate. A decade later, the picture of that moment is strikingly clear: Soon after Senator Jesse Helms castigated the National Endowment for the Arts in May of 1989 for its support of allegedly obscene art, there was a belated recognition of a political crisis in the arts, leading to a renewed questioning of the role and efficacy of art criticism in a democratic society. Various interest groups within the art world made their cases, and in so doing managed to make art criticism a convenient scapegoat for a wide range of long-standing political miscalculations. To add sycophant's insult to the scapegoat's injury, art criticism was also asked to compensate for these miscalculations by actively re-addressing itself to (read: persuade) a general as opposed to specialized audience, because that general audience was presumed to be the same polity that had been willingly led to

demonize the arts for an alleged "Taunting the American people with indecency"[23] in the first place.

In point of previously unremarked-upon fact, arts policy thinkers recognized that there was a great disparity between the polity that followed the lead of such organizations as the American Family Association and the "other" polity that was allegedly attending art museums in record numbers while (supposedly) being interested in an art criticism addressing itself to the cultural tourist pretending to be the general reader. From the vantage of the institutional art world, the hope was that the latter could in some way be motivated to stand against the former in a contest of values that was much less a culture war over the fate of civil society than it was a contest over competing product loyalties, with "government supported art" already having been relegated to the status of just another logo alongside the many other corporate donor plaques decorating museum lobbies, another desirable brass ring with its own set of protocols and requirements to be factored into a complex marketing equation of institutional constituency building. But here, I digress, for even though that other polity of cultural tourists was indeed waiting in the political wings to save the arts from budget-slashing Christian fundamentalists, the unfolding circumstances of this controversy proved that that's all that they did, for they too were alienated (in fact, self-alienated) from the issues and debates surrounding contemporary art, even though there were at that time many excellent critics writing in daily newspapers and weekly newsmagazines.

In any event, as of the early months of 1990, the so-called Culture Wars were well underway, and there was a mounting and pervasive pressure directed at critics to work toward countering the perception that the Arts were antidemocratic and elitist. Actually, these politically driven questions had been in play at least as far back as 1984, when the Endowment suspended a small fellowship program for art critics on the supposed grounds that the critics supported by it were producing work that was, in John Beardsley's words "clumsy, awkward, and incoherent."[24] Hilton Kramer seized on Beardsley's report when he aggressively demonized the program as being a boondoggle for people "who were publicly opposed to just about every policy of the Federal Government except the one that put money in their pocket."[25] At that time, Kuspit was one of the very few prominent art world voices to explicitly challenge this decision as well as Kramer's gross characterization of the collective self-servitude of art

critics—reminding readers of the dangers of scapegoating a group who could "be pushed around easily."[26] Kuspit was also among the very first to draw parallels between political attacks on the NEA and the kind of treatment accorded to modern art by the Nazis. In a 1984 Artforum editorial (in this volume), he pointed out that a year before the Nazis' 1937 demonization of modern art as a form of *entartre kunst* (degenerate art), Joseph Goebbels announced that he was "forbidding . . . art criticism, as it has been practiced to date," which was to be replaced by something called "the art report . . . less an evaluation than a description and appreciation."[27]

It is just this kind of "art report" that has become the favored mode of art criticism in the 1990s, and its close resemblance to the "art writing" of the 1970s should lead us to some serious reflection. It is worth remembering that the development of the discursive style that was characteristic of the art criticism of the 1980s took place soon after 1976, when art's political and economic relationship to society also went through a significant change.[28] At that time there was palpable anxiety over the sudden financial enthusiasm that was bestowed on art by corporate art consultants—an anxiety stemming from the realization that such an enthusiasm could actually shape what would and could be exhibited along "corporately acceptable" lines, even as funds for so-called "alternative" art suddenly became scarce. This anxiety led critics to (mistakenly) view the academy as a safe haven from the corrupted market, in turn giving impetus to the characteristically discursive style of 1980s art criticism which openly paraded its ideological predilections. This proved to be the last scholastic gasp of *épater les bourgeosie,* and it seems remarkable that when the post–Cold War era consolidated itself into what is euphemistically referred to as "The New Globalism," scholastic postmodernists had little trouble insinuating themselves (but not their values) into the emerging realm of the techno-bureaucratic institution, seeming remarkably at home in an art world determined by cultural tourism and marketing imperatives. And it is this world of marketing and cultural tourism that now so dearly prizes the kind of "art report" that Goebbels so emphatically insisted upon.

Of course, what is missing from this new scenario is a clear expectation for what art might accomplish apart from its strategic staging of itself as a fashion prototype developed by the research-and-development wing of the military-entertainment complex (i.e., the art world), and it is on this score that Kuspit's

work most significantly distinguishes itself. It does this by reminding us that works of art should provide symbolic rather than (merely) spectacular satisfactions, with the idea of "the symbolic" treated with a unique and expansive comprehension. On this score, we can look toward D. W. Winnicott's 1953 essay titled "Transitional Objects and Transitional Phenomena" as being a particularly cogent theoretical stimulus, perhaps even a touchstone in its presentation of what is psychologically at stake when we make nominal reference to the experience of aesthetic (re)-cognition and gratification:

> I have introduced the terms "transitional object" and "transitional phenomena" for designation of the intermediate area of experience, between the thumb and the teddy bear, between oral eroticism and true object relationship, between primary creative activity and projection of what has already been introduced, between primary unawareness of indebtedness and the acknowledgment of indebtedness.[28]

The indebtedness that Winnicott refers to is the (recognition of) extrapsychic dependence on an elaborate albeit coherent continuum linking inner subjectivity and outer reality, with the aforementioned coherence in turn being dependent on an informed respect for "illusory experience," the "substance" of which is made available to adults through the "intermediary" forms of art and religion. From the vantage of this recognition, we can do one of two things. We can side with the reality principle, and make an "epistemological" distinction between the falseness of symbolic aesthetic gratification, only to find that it is then incumbent on us to articulate in epistemological terms what a "non-false" aesthetic gratification might be (and how it is in fact "non-symbolic" and still legitimately gratifying).

This route has been embraced by formalists and semioticians, and has proven itself to be the path to an icy institutional perdition. On the other hand, we can side with the dialogical notion that aesthetic gratification's claim on our attention is, if not completely a matter of common sense, then surely a matter of fulfilling an intersubjective contract with what is presumed to be a shared sensibility. This path makes a case for the essentially social and convivial dimensions of aesthetic communication, and it allows us to make distinctions between artistic propositions that are psychologically intelligent and/or psychologically

stupid to the degree that they succeed or fail in imagistically facilitating a workable rapprochement between and synthesis of a "true" subjectivity and a "false" externally determined self.

Of course, nothing could fly more offensively in the epistemology-worshiping faces of formalist modernism or semioticized Postmodernism, because they both stem from a claim to objectivist precepts, one predicated on an alleged autonomy of the art object and the other on its self-conscious reflection of the external context governing its construction. Either way, the reality principal is invoked and held in excessive esteem for suspect reasons. In the case of the formalist's argument-to-autonomy, there remains a hidden albeit significant dimension of wish fulfillment in the way that it projects onto the work one kind of particularly pathological narcissistic fantasy—the fantasy of idealized self-objectification as a preemption of the adult demand for mastery. This is the view that holds art in a frozen state of arrested adolescence, the overdressed state of cosmetic compensation where looking good is everything because it camouflages the valueless nothing that the true self feels itself to be—owing to the lack of will, tools, and patience that its weak ego would find necessary for performing its vision of goodness against the murky resistance offered by the world. In fact, for all of formalism's advocacy of the artistic posture of autonomy, its excessive investment in looking good actually "protests too much" and betrays its own worst fear, the fear that the world will withdraw the conditions of privilege that it has momentarily endowed upon the autonomous work. In the practical psychological terms of art criticism, this narcissistic overinvestment in "the aesthetic" is most tellingly revealed by the tantrum-like rage that formalist critics express when the art world's fleeting limelight turns in a direction that differs from the assumptions of adolescent autonomy worship, which are held to be eternal as a matter of moral fact. For paleoformalists like Hilton Kramer, intimations that the self-objectified talisman of art might somehow fail to sustain the loving adoration of the world-parent are anxiety-producing in the extreme, and must be energetically resisted, lest the protracted condition of inflated narcissism collapse into the deep and immobilizing depression reflecting the suppressed trauma of infantile helplessness.

But when that limelight turns away from illuminating the reality of art's autonomy and toward the other reflective reality of the way it displays an aware-

ness of (and fealty toward) its determining context, another pervasive form of psychological stupidity ensues, that being the stupidity of the schizoid character's paranoid investment in a kind of administration envy, here cynically laboring under the oh-so-euphemistic banner of semiological realism. Whereas the narcissist is driven to a self-objectifying reaction-formation by subconscious fears of abandonment, the schizoid is motivated by another fear (also related to the introjected image of the mother who devalues through giving and withholding), the fear of being engulfed and imprisoned by a hostile omnipresence. To ward off that fear, the schizoid constructs elaborate systems of coded and frozen stand-ins for real experience which can be held in a kind of schematized fantasy that can, and indeed must be a safe substitute for a fearful reality, the reality of affective embodiment and its unpredictable world of potentially murderous images and appetites. But is anything truly accomplished when the schizoid seeks to murder imagistic murderousness by means of slow passive-aggressive starvation? Again, the specter of psychological stupidity comes to the fore, for we again realize that images are the very thing that allows a world to be, and as disquieting as the murderousness of any given image might be, it is none so disturbing as the schizoid's compulsive revenge indiscriminately taken against all images.

Even in their most disturbingly malformed state, images carry with them a kind of generosity-of-confession, for every time we look at one we can look into some part of ourselves, including those parts that are often not able to give voice to their own motives and particularized conditions. Art criticism can and should focus on the voices that images convey (for art exists to be heard as a reflective statement as much as it exists to be seen as presentational spectacle), in part to help them come into more eloquent being and in greater part to guide them back to a fuller consciousness of their own motivations, which also become the phantasmagoric echoes of our own motivations as well as those of others; potential tests of how honest and knowing we can be with them. In this way, we can learn to better reckon with the monster of psychological stupidity wherever we may find it.

For Kuspit, two important recognitions lead us to this pass: one is that of substitute gratification which stems from the idea that art should enchant the viewer because quotidian life is no longer able to. The second is a therapeutic mission that allows art to claim an ability to restore and enhance the viewer's potential for gratification through an extended acquaintance with its offering of substi-

tute gratification. This is art's therapeutic mission, which is at the core of Kuspit's "basic thesis":

> avant-garde art is therapeutic in intention, which is part of what gives it its
> authenticity, and motivates its stylistic innovations, while neo–avant-garde art
> has lost or rather forfeited that intention, which is part of why it is inauthentic.
> It derives from the avant-garde artist's recurrent, stated fear of decadence and
> disintegration in the modern world, which is what leads him or her to search
> for self-renewal and rejuvenation through the innovations of avant-garde art,
> and from the neo–avant-garde artist's explicit acceptance of the decadence and
> disintegration of avant-garde art.[30]

This is where we see the crux of the matter, and are led to Kuspit's sense of his own continuation of the *geistesgeschichte* tradition of art-historical analysis. It stems from the ambition to understand "the emotional values of art" to use Wölfflin's words, himself a great "psychologist of style." It also stems from a faith that an understanding of those values is an important social necessity, for without them we simply become a population, rather than a collection of reflective subjectivities set in an omni-relational equilibrium. The search for manifestations of those values may take the critic near and far and high and low, for the visual world has many mansions, and a great many more pretenders to its mercurial and treacherous throne. Analysis is where the search begins in a field where diamonds-in-the-rough and fool's gold diverge and converge like water into water at almost random intervals in the space between first and second glances, and it is a search that simultaneously runs and undermines the risk of its own potential reification into exploitable history while taking careful and in some ways paradoxical note of the sources and goals of its own history. It is a search that also directly begs perhaps the most important Janus-faced question that now confronts all of the disciplines that comprise the humanities: If not fashion, what? And if fashion, why bother? For Kuspit, the provisional answer is an elegiacally pronounced "Yes" (it is), followed by the vigorous caveat that it needn't always be so. Rigorous and sophisticated analysis seeks and becomes the fulcrum point that might lead to a desirable change in the world's priorities, keynoted by the imperative that we take stock and stop pretending.

Notes

1. Donald Kuspit, Preface to *The New Subjectivism* (Ann Arbor: UMI Research Press, 1988), xxiii.
2. Donald Kuspit, "A Freudian Note on Abstract Art," in *Signs of Psyche in Modern and Post-Modern Art* (Cambridge UK and New York: Cambridge University Press, 1993), 112.
3. Oscar Wilde, "The Critic as Artist," (1890) in *Intentions: Three Plays by Oscar Wilde* (London and New York: A. R. Keller, 1907), 122.
4. Donald Kuspit, "Deadministering Art," *Art Criticism 2*, no. 1 (1985): 58 (contained herein).
5. Robert C. Morgan, Introduction to *The End of the Art World* (New York: Allworth Press, 1998), xvii.
6. William Blake, "Jerusalem," ([1804–1820] part 1, plate 10, p. 20) in *Blake: Complete Writings*, ed. Geoffrey Keynes (Oxford and New York: Oxford University Press, 1966), 629.
7. Donald Kuspit, "The Necessary Dialectical Critic," (1979) in *The Critic as Artist: The Intentionality of Art* (Ann Arbor, UMI Research Press, 1984), 109–125. My own admittedly fanciful re-reading of Kuspit's point in Husserl's program of "locating the work of art against its own grain" (p. 111) tries to take into account the way that psychoanalytic theory amplifies this process. See also "A Phenomenological Approach to Artistic Intention,"(1974, pp. 3–24) and "The Dialectic of Taste" (1973, pp. 25–46) for early accounts of Kuspit's dialectical method.
8. For a detailed account of the role of fancy in Edmund Husserl's notion of epoche (i.e., the cognitive bracketing that both pre-cedes and is subsequently necessitated by phenomenological reduction), see Donald Kuspit, "Fiction and Phenomenology." *Philosophy and Phenomenological Research 29*, no. 1. (September 1968): 18–29. Formulated well before Kuspit shifted his intel-lectual focus toward the visual arts, this long philosophical essay was devoted to examining a technical difficulty in Husserl's theory of "adequate insight into pure essences" by seeking out the fanciful fulcrum point in Husserl's notion of epoche where mutability strikes a perfect balance between the worlds of determinate will and extra-determinate representation. It is a point of curious slippage in the larger context of Husserl's philosophy, for it seems to invite and indeed galvanize contradictory readings vis-à-vis how one might rightly prioritize the proper relations between mimetic and exegetical modes of experience consideration. Kuspit's account of the role of "fancy" in perception's fictioning of its world seems very much like a harbinger of things to come, both for Kuspit and for the practice of postformalist criticism in general:

 > In a sense, the process of fancy is a limbo between naive experience and essential knowledge. But it is limbo only from the standpoints of experience and knowledge, which are self-seeking and would like to use images for their own ends. Yet the process of fancy conveys something more than either experience or knowledge. It conveys the constant involvement of con-sciousness to make things clear to itself. The process of fancy is essentially the effort of consciousness to make clear to itself whatever crosses its path. As such, the process of fancy is the archetype of consciousness. (*Fiction and Phenomenology,* p. 22)

 It almost goes without saying that Husserl's notion of epoche is a slice of philosophic territory that has remained ripe for contesting definitions. Perhaps the most widely cited of these is Jacques Derrida's early examination of Edmund Husserl's theory of signs, taking issue with the oscillating spatial metaphors which Husserl repeatedly employs. Everything has, no doubt, begun in the following way:

 > "A name on being mentioned, reminds us of the Dresden gallery. . . . We wander through the rooms. . . . A painting by Teniers . . . represents a gallery of paintings. . . . The paintings of this gallery would represent in their turn paintings, which on their part exhibited readable inscriptions and so forth. (Husserl, *Ideas*, part 1, p. 293)"

 Certainly, nothing has preceded this situation. Assuredly, nothing will suspend it. It is not comprehended as Husserl would want it, by intuitions or presentations. Of the broad daylight of presence, outside the gallery, no perception is given us or assuredly promised us. The gallery is the labyrinth which includes in itself its own exits: we will never come upon it as upon a particular case of experience—that which Husserl believes he is describing.

 > It remains for us to speak, to make our voices resonate throughout the corridors in order to make up for the break-up of presence. The phoneme, the akoumenon, is the phenomenon of the labyrinth. . . .
 >
 > And contrary to what phenomenology—which is always a phenomenology of perception—has tried to make us believe, contrary to what our desire cannot fail to be tempted into believing, the thing itself always escapes.
 >
 > Contrary to the assurance that Husserl gives us a little further on, the "look" cannot "abide." (Jacques Derrida, *Speech and Phenomena: Introduction to the Problem of Signs in Husserl's Phenomonology* [1967], translated by David B. Allison [Chicago: Northwestern University Press, 1973], 104.)

 In a revealing elaboration on this point, Derrida crystallizes his critique of Husserl's implicitly mimetic notion of epoche as a "stage upon which experience is staged" by stating

 > While it cannot be doubted that, for Husserl, writing is indicative, in its own sphere, it poses a formidable problem, which probably here explains his prudent silence. For in supposing that writing is indicative in the sense that he gives to the term, it has a strange privilege which endangers all of the essential distinctions: in phonetic writing . . . what it would "indicate" would be an "expression," where as in non-phonetic writing it would take the place of expressive discourse and immediately connect with the "meaning." (pp. 27–28)

 What is articulated here is the germinal basis of Derrida's famous claim that "nothing exists beyond the text except more text," that is, that linguistic designation is the real and only ground for "bracketing" the secondary brackets which render experience intelligible. Of course, by uttering this statement in a philosophical paper, he is preaching to the previously con-verted, and only contends (rather than proves) that the fictioning process is exegetical prior to being image-atively mimetic. It

remains just as easy and just as fruitful to argue that the reverse is the case. For his own part, Kuspit contends in Fiction and Phenomenology that that consciousness remains as an active mechanism of choice-making, and as such seeks out the best imaginative "light" in which to display its sense of its own alternatives—and fancy (or desire, which Derrida rather tellingly casts in the role of demon of consciousness), appears in Kuspit's work as a precategorical source of that light's illumination, rather than as the obscuring cloud which others have cast it.

In its de-determinate guise as a philosophic changeling, fancy (and the interior monologue of self-consciousness which it authorizes) also allows for the seizing of a core predicate that holds strategic importance for Kuspit's subsequent campaigns. Since Ludwig Wittgenstein originated the concept of ordinary language philosophy in his *Tractatus Logico Philosophicus* of 1922, the large majority of philosophical theorists inquiring into the problem of consciousness have taken his maxim "what we cannot speak about we must pass over in silence" as a credo, thus casting consciousness as a closed and essentially passive system of category acquisition and reflection. What is "passed over" and left untouched here is how consciousness can be prompted to actively determine and transform the taxonomies of its own experience, how "image-anation" forwards this notion of consciousness-as-agent into being.

An ironic illustration of this lies in Ferdinand de Saussure's famous description of the dichotomous nature of the structure of language (langue /parole; synchrony/diachrony, etc.) as being a set of potential "linguistic habits" made coherent via the "chessboard" of available linguistic opportunities, a description that Wittgenstein also resorted to in *Philosophical Investigations*. Here, we see the key to our "proper" understanding of language as a system of rules which govern the thresholds of intelligibility revealed as an image (of a chessboard), thereby grounding the "concept" of interpenetrating dichotomies as a vision of likely gestures acted out upon a systemic grid or amid the warp-and-woof of a fabric. At least in this particular instance, the image abides rather well, and we are reminded that the relative priorities that we might accord to mimetic and/or exegetic bracketing of phenomena are of equal philosophic weight—meaning that neither can claim an exclusive and authoritative ownership of consciousness on the basis of a demonstrable reality principle. Thus, the criteria governing the discussion defaults to the grounds of psychomoral efficacy, and it is here again that the image abides fairly well, owing to the rhetorical efficiency that inheres in the mimetic's ability to condense layers of meaning.

9. Melanie Klein, "Symbol Formation in Ego Development" (1930), in *The Selected Melanie Klein,* ed. Juliet Mitchell (New York: Macmillan/Free Press, 1987), 98.

10. Quoted in Donald Kuspit, "Art is Dead, Long Live Esthetic Management," *New Art Examiner,* April 1999, 30. (included herein)

11. Theodore Prescott, "Professor Kuspit comes to Rural Pennsylvania," in *New Criterion,* June 1987, 84–85. Rich in presumptuous hyperbole and unbuttressed by any actual examination of Kuspit's texts, Prescott's remarks play fast and loose with Kuspit's spoken remarks about the status of self in contemporary art, particularly in their indication of how they might intimate how "vast tracks of human hope, experience and pleasure have been bulldozed and paved over with uniform ideological concrete." (p. 85). In point of fact, Kuspit has consistently been critical of efforts to enforce any ideological uniformity in the world of contemporary art, and has offered a substantial analysis of the subtextual motivations undergirding claims for a "moral imperative" in art. See, Donald Kuspit, "Art and the Moral Imperative," in *Signs of Psyche,* op. cit., 136–148.

12. Quoted in Janet Malcolm, "A Girl of the Zeitgeist" (1986), in *The Purloined Clinic* (New York: Alfred A. Knopf, 1992), 234.

13. Adrian Piper, "An Open Letter to Donald Kuspit," *Real Life Magazine,* no. 17–18, (Winter 1987–88): 3–11. One of these drawings was used to illustrate the cover of the magazine, while a detail of same was included on page 3. Piper's article was in response to an essay that Kuspit wrote about her work which was published in *Art Criticism,* Fall 1987, 9-16.

14. David Carrier, *Artwriting* (Amherst: University of Massachusetts Press, 1987), 93–95.

15. See Richard Kostelanetz, "Review of The New Subjectivism," *New Art Examiner,* November, 1989, 61.

16. Ibid. (from "The Narcissistic Justification of Art Criticism," in *The New Subjectivism,* 544.)

17. Jeanne Siegal, et al., "Statement for the Award of the Frank Jewett Mather Award for Excellence in *Art Criticism,"* 71st Annual Conference of the College Art Association, Philadelphia, PA. February, 1983.

18. Since the early 1980s, Kuspit has written several essays that mined this particular theme. One that has seen more circulation that most is "Flak from the Radicals: the Case Against the New German Painting" in Brian Wallis (ed.) *Art After Modernism: Rethinking Representation* (New York: New Museum/David Godine, 1985), 137–151. The following passage summarizes Kuspit's difference with his ideological interlocutors:

Marxist critics assume that the 'natural attitude' to things is the enemy, for it implies a refusal to suspend our relations with them for the sake of an analysis of our attitude toward them. Such a disengagement presumably leads to an abstract understanding of their meaning. But in a world overdetermined by analytic abstractions—artificial understandings of all kinds— which seem to have an "expressivity" of their own, the natural attitude toward things becomes a desirable if elusive goal, a critical factor for survival, and the only method for the recovery of concreteness and engagement. The natural attitude implies the creation of a new kind of concreteness, resistant to abstraction, even questioning the abstractness of its own expression. In the new German painting, concreteness through the skeptical gesture—the disintegrative and self-destructive mark—is the proposed mode of operation of the new natural attitude. (p. 139)

19. Rudolf Baranik, review of "The Critic Is Artist: The Intentionality of Art," in *Artforum,* Summer 1984, 81.

20. Lawrence Alloway, "Pop Art: The Words" (1964) in *Topics in American Art* (New York: W. W. Norton & Co., 1975), 122.

21. George Dickie, "Defining Art," *American Philosophical Quarterly* 6 (1969): 254–255. It is worth noting that Dickie cites an essay written by Arthur Danto in 1964 as an impetus to his own views on what is describable as art. As Danto has famously written, "To see something as art requires something that the eye cannot descry—an atmosphere of artistic theory, a knowledge of the history of art: an art world." (in Arthur Danto, "The Art World," *Journal of Philosophy,* 18 October 1964, 580.) For an instructive example of how the ITA has insinuated itself into contemporary art criticism, see Hal Foster, *The Return of the Real* (Cambridge: MIT Press, October Books, 1996). Foster's valorization of minimalist and conceptualist art is based on how it "mimes the degraded world of capitalist modernity in order not to embrace it, but to mock it." (pp. 15–16). Allegedly,

this is accomplished through "the preservation (in an administered, affirmative culture), of spaces for critical debate and alternative vision," so long as the alternatives fall with "specific genealogies of art and theory" (p. xiv) that are themselves informed by Foster's intuition that "since the middle 1970s, critical theory has served as a secret continuation of modernism by other means: after the decline of late-modernist painting and sculpture, it occupied the position of high art." (p. xvii). Foster clarifies his own view of the contemporary place of the institution when he writes "Obviously convention and institution cannot be separated, but neither are they identical. On the one hand, the institution of art does not totally govern aesthetic conventions (this is too determinist); on the other hand, these conventions do not totally comprise the institution of art (this is too formalist). In other words, the institution of art may enframe aesthetic conventions, but it does not constitute them. This heuristic difference may help us distinguish the emphases of historical and neo-avant-gardes: if the historical avant-garde focus on the conventional, the neo-avant-garde concentrates on the institutional" (p. 17). Of course, Foster's appeal to the value-free character of the enframing institution is disingenuous, for it only suceeds in making a spectacle of its alleged refusal of spectacle, and in no way continues the "debate" about the real criticality of the modernist project. In point of fact, it forecloses that debate.

22. Donald Kuspit, "Breakfast of Duchampians," *Contemporanea*, May 1989, 69 (contained herein). This is not necessarily to be read as a blanket dismissal of the artistic use of found objects per se, only of a certain hyperconscious and hyperdesigned "way" of using them. For an account of how Kuspit views an artistic deployment of found objects in a different, more psychologically astute light, see the catalog essay "Donald Lipski" (1985), Germans Van Ekk Gallery (contained herein).

23. Jesse Helms, Alfonse D'Amato et al., "Debate in Senate over the NEA," in Richard Bolton (ed.) *Culture Wars* (New York: New York Press, 1992), 28–30. For an account of the rhetorical and political implications of the fight to save the budget of the National Endowment for the Arts, see Mark Van Proyen, "Diary of a Disaster," in *ARTWEEK*, September 1995, 16–18.

24. John Beardsley, "The Art Critics Fellowship Program: Analysis and Recommendations" Report prepared for the National Endowment for the Arts, Washington, D.C. 1983, 1.

25. Hilton Kramer, "Criticism Endowed: Reflections on a Debacle," *New Criterion*, November 1983, 5.

26. Donald Kuspit, "Forum: Art Critics Grants," *Artforum*, May 1984, 78–79 (contained herein).

27. Ibid., p. 79.

28. During most of the late 1960s and early 1970s, the budget of the National Endowment for the Arts grew by a annual factor of about 100 percent. In FY 1976–77, however, it suddenly leveled off and enjoyed only modest annual increases until the time of the Mapplethorpe/Serrano controversies in 1989. It is interesting to note that in 1976, tax codes were amended to give corporations incentives to develop "corporate" art collections.

29. D. W. Winnicott, "Transitional Objects and Transitional Phenomena" in *International Journal of Psychoanalysis 23* (1953): 7.

30. Donald Kuspit, "Author's Comments on 'The Cult of the Avant-Garde Artist,'" *Art Criticism*, Spring 1996, 91.

REFLECTIONS AND AGENDAS

FORUM: Art Critic's Grants

This is a peculiar moment in history.

On November 11, 1936, Joseph Goebbels, the German Minister of Propaganda, issued a "Decree Concerning Art Criticism." The decree stated:

I granted German critics four years after our assumption of power to adapt themselves to National Socialist principles. . . . Since the year 1936 has passed without any satisfactory improvement in art criticism, I am herewith forbidding, from this day on, the conduct of art criticism as it has been practiced to date. From today on, the art report will replace art criticism, which, during the period of Jewish domination of art, totally violated the meaning of the concept of "criticism" and assumed the role of judging art. The art critic will be replaced by the art editor. . . . The art report will be less an evaluation than a description and appreciation. . . . The art report of the future presupposes reverence for artistic activity and creative achievement. It requires an informed sensibility, tact, purity of mind, and respect for the artist's intentions. In the future, only those art editors will be allowed to report on art who approach the task with an undefiled heart and National Socialist convictions. . . . I therefore decree that in the future every art report will be signed with the author's full name. The professional regulations of the German press will require a special

approval for the position of art editor, and this approval will depend in turn on proof of truly adequate training in the art field in which the editor in question will work.[1]

In an article in the November 1983 issue of the *New Criterion*, Hilton Kramer states that one of the reasons he thought the Criticism Seminar of the National Endowment for the Arts (September 1983) was a "debacle" was that he felt two of the papers presented at the seminar—those by Adrian Piper and Douglas Davis—were "unalloyed politics" and "more politics," critical politics not to his liking.[2] Another reason was that two other papers presented at the seminar—those presented by Rosalind Krauss and myself—were "in opposition to clarity," that is, they advocated a theoretical, evaluative art criticism rather than the descriptive art report. Yet another important reason Kramer gives for his contempt for the art critics fellowship program is that it had since 1972 given "a great many" fellowships "as a matter of course to people who were pub-licly opposed to just about every policy of the United States government."[3] Kramer offers no proof of his charges, and wraps himself in the flag to repress some of the things it stands for.

In a letter to Catherine A. Fox, an art critic of the *Atlanta Journal* who was present at the Criticism Seminar, Frank Hodsoll, Chairman of the NEA, wrote (March 7, 1984):

> We have decided not to include Fellowships for Critical Writing in the FY 85/86 Visual Arts fellowships guidelines which will soon be published. Our rationale is not based on Hilton Kramer's article, but rather on our judgement that the criticisms raised by John Beardsley (in his September 1983 report to the Visual Arts Criticism Seminar) have not been adequately answered. Our decision was also influenced by doubts expressed by the National Council on the Arts about this area of funding.

John Beardsley, who offered the seminar his NEA-commissioned analysis of the art critics fellowship program as it existed in the past, and who became the hero of the seminar in Kramer's editorial, began his report by assuming "the generally lamentable quality of recent visual arts criticism."[4] This unexamined assumption is not justified by analysis of individual art critics, and

in fact insidiously dissuades one from looking too closely at actual critical positions or methods. Style is what counts for Beardsley—"stylistic self-awareness," the presumed lack of which leads critics to produce writing that, to quote an anonymous panelist Beardsley quotes, is "clumsy, awkward, and incoherent."[5] And where is he going to find style? Among "newspaper critics," he says, and he recommends that the revived NEA critics fellowships favor them because they have "the potential to reach a broader group" and to be "intelligible to the layman." Moreover, "because they pay regular salaries and exercise less editorial control than art magazines, daily newspapers and mass market periodicals offer the best hope of an independent criticism."[6] This seems absurd, for it is unlikely that a newspaper would hire a critic whose position does not conform to ideological expectations. In any case, the difference between newspaper criticism and specialized magazine criticism is not the issue; free criticism is at stake, wherever it might appear. Beardsley set up a dichotomy that is beside the point of the larger issue of the critics fellowships—to encourage critical thought in whatever medium of communication it might appear.

Unfortunately, it first has to be said that Kramer's editorializing report of the discussion at the Criticism Seminar does not correspond to the way I and most of my colleagues remember it. In fact, twenty of the twenty-three professional critics and editors—representing a wide variety of critical positions—who attended the seminar signed a letter to Hodsoll, protesting Kramer's published report of the seminar.

In general, Kramer and Beardsley, who seem not to comprehend that critical theorizing is sensibility at its most refined and intense, prefer to pick on clarity because it makes those who object seem ludicrous. The problem is that their kind of "clarity" not only neutralizes criticism, but undoes the whole Modernist understanding of it—enunciated perhaps most clearly by Oscar Wilde and T. S. Eliot, and the cornerstone of the contemporary belief in the continuity between creative art and its criticism (the creativity/criticality continuum). Modernism, in Geoffrey H. Hartman's words, "reinvents criticism with creative potential."[7] Kramer implicitly understands "art" to mean "aesthetic object," which means to deprive it of the critical power that Modernism has recognized and cultivated in it. However unwittingly, Kramer's decree of clarity in art criticism unexpectedly resembles Goebbels' command that it be reverent description; in Berthold Hinz's words, this forbade art as a means of public dis-

Weegee, *The Critic*, 1943. Gelatin silver print, 11" × 13⁷/₈". Collection of the Whitney Museum of American Art, New York. Gift of Denise Rich. Photograph copyright © 1996: Whitney Museum of American Art, New York. Photograph by Geoffrey Clements, New York.

cussion and communication; art was made instead into an aid to contemplation, empathy, and spiritual edification. The decree not only affected the reception of art but also had a continuing influence on its production. If it was the art editor's task only to "appreciate" and not to "evaluate," then the artworks he examined from this point of view had to be free of problematic elements that might provoke criticism and debate.[8]

In other words, the artworks had to be aesthetic rather than insubordinate, conformist rather than contradictory, polite rather than "fresh," "Frechheit . . . auf die Spitze getrieben" (impertinence . . . carried to an extreme), in the banner headline words of one page in the guide to the 1937 "Degenerate art" exhibition in Munich.[9]

Kramer is not only after art criticism, he is after art, and he is not only after art, he is after society. He attacks art under the cover of attacking art criti-

cism, and he attacks the social challenge of critical opposition under the cover of demanding clarity and good writing, where both mean "correct," obedient thinking. Clarity in fact is relative, as much the burden of the reader as the writer, for it has as much to do with the reader's understanding of the concepts the writer uses as with the style the writer uses to articulate them. Clear thinking is the issue, not clear writing. Kramer's clear writing is writing meant for minds that are not very clear about what clear thinking means. It is inevitable that Kramer's authoritarian anti-intellectualism and his suppressive opposition to critical thinking would lead him to dismiss Krauss's seminar paper as "an exercise in feminist nihilism feebly attempting to disguise itself as critical theory."[10] For feminism provides not a reverent description of woman as aesthetic object—an idealizing report on her nature—but an irrelevant evaluation of woman's condition. It is inherently critical rather than conformist. Beardsley's assertion that fellowships have not helped "raise the standards of art criticism more generally" because they serve a narrow group of intellectuals rather than the broad public is also inevitable, on similar antitheoretical grounds.

The attack on intellectual and critical freedom implicit in the arguments put forth by Kramer and Beardsley, with their implicit insistence on the art report, was continued by Samuel Lipman in his article entitled "Government Money, Government Art?" in the December 6, 1983, issue of the *Washington Times,* an explicitly right-wing newspaper (see *Newsweek,* December 19, 1983). Lipman is the publisher of the *New Criterion,* which Kramer edits. The yahooism of Lipman's article was made explicit by the cartoon that accompanied it, which indicated that the article was as much a diatribe against unclear (Modern) art as against government support of art criticism. In the cartoon Groucho Marx is shown as an "NEA Board Member," Chico Marx as an "NEA Critic," and Harpo Marx as an "NEA Artist" making a Modern sculpture entitled *Ode to Butey.* Chico says "Otsa some nice-a-piece-a art, eh, boss?" suggesting the dumbness and inarticulateness and "foreignness" (what kind of paranoia lies behind this implication that critics are un-American?) of art critics. Groucho, turning to a plump figure wearing an armband with a dollar-sign insignia, representing the dumb American government, says: "For an investment of a million or so, this boy could be to art what Phillips is to screwdrivers!" From this cartoon it follows that in his article Lipman would dismiss "a brand of trendy exhibitionism going under the title of 'The New Wave'" as an example

of the kind of degenerate art the dumb government supports because the NEA is controlled by the "arts advocacy lobby."

Kramer dwells a good deal on the supposed collusion between the panelists awarding the critics fellowships and the critics receiving the awards. The panelists of one year are the critics of the next year, and vice versa. In this point Kramer is partially justified. The fact of the matter is that—for a variety of reasons, from economics to education—the field is regrettably small, and like any highly particularized inquiry can tend to respect those with demonstrated commitment. But Kramer's exaggerated attempt to depict NEA art critics as a cozy, self-serving, small in-group is belied by the fact that from the start the critics fellowships went to a variety of critics, representing positions often at odds with one another. No cohesive group of critics ever controlled the decision-making process in the awarding of fellowships, because there is simply no such group. The panelists transcend their prejudices, practicing a typically American pluralism. Kramer attacks art critics in part because they are a small, vulnerable group, with no spirit of solidarity. Anyway, everyone attacks them. They can be pushed around easily, and they are the best scapegoat available on which to take out one's discontent with contemporary art.

This essay is reprinted with kind permission from Artforum, *May 1984.*

Notes
1. Quoted in Bertold Hinz, *Art in the Third Reich* (New York: Pantheon Books, 1979), 37.
2. Hilton Kramer, "Criticism Endowed: Reflections on a Debacle," *The New Criterion,* November 1983, 5.
3. Ibid., 4.
4. John Beardsley, "The Art Critics Fellowship Program: Analysis and Recommendations," report prepared for the National Endowment for the Arts, Washington, D.C. August, 1983, 1.
5. Ibid., 8.
6. Ibid., 12.
7. Geoffrey H. Hartman, *Criticism in the Wilderness* (New Haven: Yale University Press, 1980), 8.
8. Hinz, 37–38.
9. Illustrated in Hinz, 41.
10. Kramer, 5.

FORUM: Art Students

Art students tend to see themselves as exceptions to the social rule: they don't have to conform, they can avoid, as one said to me, "the constraints and responsibilities of the nine-to-five world." They see themselves as the amoral minority in the moral majority, the free spirits among the inferior slaves. They aspire to the tired Nietzschean myth of elitist nonconformity—of avoiding a dreary fate worse than death, the living death of everyday life; at the same time, they are unconsciously—as well as not so unconsciously—conformist. Their different drummer marches a well-traveled route to a familiar tourist attraction. They want success, on their own, unique terms—as everyone does. They want the rewards, tangible and intangible. As one wrote, they want "money, glamour/fame, parties/openings"—in that order; that is, from the commonplace to the exclusive. They have no more self than other people concerned with "making their mark."

Indeed, many students do nothing but make, in a great hurry, "original" marks. Others, equally impatient to "find themselves," make little manipulations of big media images—star images, a parasitism they expect will make them stars. For all their idealism, they are searching for a marketable identity, something the capitalist public will find of intense and immediate interest—will experience as "genuine," as genuine as its maker. They innocently market

their sincerity, thinking that the system and their belief in themselves can come together. It is this that gives them, as one said, the "confidence" that they are "extraordinary." They are the willing victims of their self-contradiction, which they expect the world to heal. Why shouldn't it? For it teaches that to be appropriated is to be individualized—to be rewarded is to be recognized for one's difference, the most consumable of commodities.

How these expectations affect art students' art is not as unclear as might be supposed. One student put it well: he was "perfecting" his "signature." Clearly his identity was not yet, and not likely to be, in crisis. To perfect a premature signature: this is a common desire in the mature art world. It is the reason that world prematurely wizens so many would-be artists, and arrests the development of many more. Yet there is a heroic streak to it: the desire to be a "genius," to so change the order of things that it will never again be the same. This radicalization of difference into transcendence is the psychic place where the myths of conformity and nonconformity come together seamlessly. The transcendent role accorded difference in immature artists never quite dissipates in mature ones, for it is tied to the correlate myths of self-generation and of the radical independence and freedom of art. But older artists know that the castle in the air may be Kafkaesque, that their self-esteem may not be appreciated by others. It is only when they experience and survive this realization that they can begin to develop.

The excessive self-love of the immature is necessary in a crowd. John Bernard Myers writes that "more than 200,000 'artists' compete with one another in New York;" in that situation, they really shouldn't love their neighbors as themselves. To be art students in the face of such odds requires a surplus of idealism—an exaggerated idealism, which, when it dawns on them that glory may be out of reach (even now, when glory is a bankrupt idea, available at a discount), permits them to fall back on the glory of the "artist's lifestyle," with its mythical freedom. Idealism, then, is a virtue in art students, for it helps them through the pitfalls of a career, and above all, over the inevitable isolation that one feels in the art world, for all its (superficial) other-directedness. But the idealism of today's art students seems to carry with it no sense of painful sacrifice, no sense of Goethean renunciation. It is simply a way of maintaining a holding pattern until they get "the breaks." It is an announcement of their availability rather than of their transcendental commitment, with all of the isolation that

brings. If the world identifies art students as idealistic, their idealism then implies no renunciation, only the fine-tuning of the self to the world's own ambitiousness. Theirs is a realistic idealism, with no hint of suffering for a "higher purpose." It is beyond cynicism; it is finally the willingness to play the game, on whatever terms. Student idealism signals the channeling of social rebelliousness into artistic conformity. These days that may indeed make one into art royalty, with both property and critical reputation. To conform artistically—to create a signature as rapidly as possible—may be to invest in a future with concrete benefits and spiritual fringe benefits.

All this is still a sign of art-student innocence, for it is politically naive, politically unconcrete. Both the expectation of radical individuality and that of conservative success are romantic superstitions. The idealism of students, which preaches eventual dominance, is tempered by the realism of their instructors, which preaches finding one's own niche. The pursuit of power gives way to holding one's own. The best part of student expectation is the expectation of hard work and concrete, usable knowledge. Art is not presupposed as an answer, but becomes a question. When it becomes the question that creates a self, true apprenticeship begins; the future is conceived, even if never to be delivered in an expected form. The most touching aspect of the art student's horizon is belief in the absolute value of art—the excitement of faith in a god that has not yet disappointed. Art has been connected with the promise of happiness, an indirectly eudaemonic activity, and art students show this promise fulfilled in their happiness at the elementary givenness of art. But this unquestioning happiness, this sense of the inevitable value of art, makes art students no more than *Luftmenschen*, living on air, even at their most determined and hard-working. For they understand neither the incompleteness and inexactness of their project to be artists, nor the significance of the codes by which they are trying to realize themselves.

There are two shadow sides to an art student's existence: the dubious practicality of being an artist, for all the willingness to inwardly serve society; and their theoretical inadequacy about the nature of art, for all their idealism about its special necessity. At the moment, the latter seems more pressing than the former, for insecurity has increasingly become a general condition of bourgeois existence. The more "speculative" capitalism becomes, the more bourgeois life as a whole approximates the artist's condition as it is generally conceived—

one reason the artist is readily assimilable in the bourgeois world today (and perhaps even at his or her most serious, can do no more than remind it of its inadequacy which it itself experiences in the form of insecurity, anxiety, overlaid by an ideology of seductiveness). Before giving themselves to art, art students should study Plato's argument against it as a socially disruptive appeal to all that is irrational in the soul, fostering ignorance and immorality—disintegration of the self. To ask themselves, "Why make art?," and to try to answer this question without myth-making, is to begin to achieve the self-consciousness necessary to sustain development as an artist. Only by trying to be autonomous with respect to art will they experience the real possibility of making art.

Art schools take art for granted, but art students shouldn't. They should understand that being an artist is about being a certain kind of subject, not just about making certain kinds of objects. Part of the art student's self-education is to test art against reality; the acceptance that it is important in itself may be a beginning position but is hardly a demonstration of its possible significance in the lifeworld. Today, that must be reconceived, in ever more uncertain terms. Harold Rosenberg's sense of the anxiety of the art object seems more important then ever. The art school's first responsibility is to the selfhood of art students, not to the art they might make. The proliferating self-help courses in how to market oneself do not generate the kind of self at stake. It may be that the best thing an art school can do is teach the zealous, idealistic art student to have no expectations of art, not even the expectation that creating art objects will automatically create a critically conscious self. This is not a mechanically stoic strategy, but the purest form of self-preservation, a principle art students tend to forget despite their idealistic manipulations of and accommodations to the system.

This essay is reprinted with kind permission from Artforum, *March, 1984.*

Philosophy and Art: Elective Affinities
in an Arranged Marriage

Art and philosophy have converged in our times, beginning with the reaching out of art to philosophy in the conceptual period, and ending (perhaps) with philosophy's current aggressive appropriation of art through sociosemiotics. The affinity of the two is that both are obsolete value-conferring contexts. It is a case of the bringing together of a pair of weak planks in an attempt to make a strong one—to achieve the durable value that was traditionally the stock-in-trade of both fields. Such value now is a barely desirable fiction, for it interferes with today's rapid flow of events and requirement of perpetual innovative change. In a revolutionary, truly modern world, a world without essence, philosophy and art obstruct the independent momentum of forward-looking science and politics rather than posit their utopian goals. Science and politics do not need such a resolution invented for them; it falsifies them. Philosophy and art, thus forced back on themselves in uselessness, are revealed for what they always secretly have been: awkward reflections of reality, impotent to dominate it.

Philosophy has always pretended to the authority of theoretical adequacy. Art has never had meaning without the blessing of world-historical authority. These days, when "the arts have . . . continued to gravitate, if not towards entertainment, then certainly towards commodity and . . . pure tech-

nique or pure scenography" (Kenneth Frampton); when art gains a new sense of adequacy from its far-from-reluctant, finally complete socialization, philosophy appears with its belief in art's profundity as the privileged realm of reflection of ideas. Posthermetic, art still remains prereflective, the innermost mirror of the mind. Ever since Husserl wrote that art was the "royal road" to essences, philosophers have been determined to make it the exclusive realm of the exemplification of truth. Just when art demythologizes itself into a self-evidently populist practice, philosophy reprivileges it. Just when art reveals that it has no secret value, a Heidegger tells us it is the privileged place where Being can be remembered.

The irony of the philosophical resurrection of art is that it occurs at a time when art is pragmatically desublimating itself to become just another obsessive form of capitalist production. (Its obsessiveness is to maintain its self-belief.) Philosophy's attention to art may be its way of looking for art's social success, although it is unlikely ever to get its fair share of the consumer dollar. What artists think about the esotericism offered them by philosophers is not clear; certainly they must have some self-doubt as they see themselves heroically elevated by elaborate ideas—or are they that narcissistic? Perhaps they value any accretion of halo.

It is important to note that the strategy philosophy uses to reconcile itself to art generalizes "art" and "artist" and ignores actual practice. Art is reprivileged by being treated at the level of "sublime" generality. (This intellectual politeness is necessary to restore art to a state of grace; it may also help to blind philosophy to its own fallen state—to its need to reach low for an object to make worthy of its ambition. As Plato implied, for philosophy to deal with art is a kind of slumming.) Philosophy exaggerates the artwork into an epistemological problem, into the problem of epistemology itself (Michel Foucault on *Las Meninas*, Louis Marin on Poussin), thereby positing it as completely submissive to intellectual discipline. Imprisoned by intellectual consciousness, the artwork takes on its power of command. Thus Julia Kristeva can say, with philosophical hyperbole, that "freedom does not seem to exist outside of what we agree to call an 'artist.'" Giotto's color and form are not only supposedly independent of the theological norm signified by his work, but pit themselves against it. It is worth noting that here philosophy reinforces the familiar formalist prejudice or fallacy about art, a tendency confirmed by Kristeva's assertion

that the "sociological aspect" of Giotto's paintings—the fact that his "mythical characters resemble the peasants" of his time—is secondary to his "disruption of space and color." Might it be the other way around, the formal disruption following from the sociological/ideological one? Which is more "real" in Giotto's art, the peasants or the space and color? Kristeva's simplification here is a typical result of the pursuit of philosophical adequacy, which tends—ultimately naively—to reduce the artwork to a single variable which becomes its "fundamental principle." Similarly, Kristeva fetishizes the term "artist" as the exception to her rule about the difficulty of freedom. In what is really aristocratic haste to maintain status, she shuts out everyone else from even knowing they are subject to the rule.

What philosophy ignores is the concreteness that is the source of the artwork's intense particularity. This concreteness declares its independence of theory in the very act of seeming to submit to it, asserting its strange otherness just by forcing philosophers to overtheorize about it. They are compelled to realize that the artwork can never be completely subsumed within theory, that it is not necessarily the most exemplary exemplification of thought. Philosophy avoids this recognition exactly through its reinforcement of stifling clichés about art. Not only Kristeva but Heidegger does this, when he argues, with that exaggeration always signaled by announcement of "the fundamental," that "the conquest of the world as picture" is "the fundamental event of the modern age." All this does is claim ontological status for a conventional notion of the picture as a direct correspondence with the world pushing art toward the opposite cliché to that advocated by Kristeva.

The philosopher rarely experiences the artwork as a knot of consciousness, an intransigent texture not easily shaped to intellectual order. To do so would be to become a critic, one of whose tasks is to restore the concreteness of the artwork by recognizing its resistance to thought—its "poetic" character. Until the philosopher experiences the work's untranslatability, he or she will neither experience it critically nor experience its critical condition. Roland Barthes, in *Empire of Signs* (1970), is not far from this point when he remarks on the experience of descending into "the untranslatable" when confronted with a foreign language (in this case Japanese)—of descending until his own language no longer seemed "natural." There comes a point in the critical relationship to an artwork when the work is experienced as an essentially untranslat-

able, absurdly foreign language. It is thus experienced as completely at odds with one's own existence; it becomes sufficiently alien to throw back one's own untranslatable particularity. Paradoxically, this experience of recovery of one's innocence, and of the work's—this peculiarly sublime naiveté—comes only at the end of a protracted theoretical appropriation of the work. At the start of analysis, the work is simply fuel for intellectual lift-off; only in the final throes of dialectical fatigue can the critic escape to concreteness and "enjoy" the art's particularity.

Philosophy completes "the murder of poetic language" that Roman Jakobson implicitly regarded as the crime of society. In a kind of intellectual Stalinism, it hardens the understanding of art "along narrow and rigid models." For Kristeva, this murder takes the form of "the inability to hear and understand the signifier as such—as ciphering, as rhythm, as a presence that precedes the signification of object or emotion." But it may be that philosophy is attracted so strongly to art these days because art no longer "wants . . . to make language perceive what it doesn't want to say." It no longer wants to be untranslatable. It may be that art's desire to denote ideas is another form of its desire to be popular. For philosophy invariably translates art into popular generalities; it is the subtle logic with which it makes the translation that philosophy prides itself on, not the final results. What this does for art is secretly justify its pursuit of commonality, its desire to be ordinary. It now has a reason for being accessible.

Only through criticism, perhaps, can art once again be restored to untranslatability, despite itself, against its public will and better modern judgment. A criticism that uses philosophical theories poetically might recover the "something that is more-than-speech" in art. But of course it no longer is in art; to be untranslatable is no longer art's prerogative, no longer its immanence. Untranslatability today lies only in the complex, dialectical resistance of the critic to art. This resistance, which alone can know art intimately, reminds us of our own being's resistance to the nothingness of everything—a nothingness embodied in the way the artwork eagerly seeks popularity and communicability, but is still inevitably concerned with the untranslatability of being. It is this that is repressed by philosophy, that art itself increasingly seeks to repress, but that criticism shows to be the artwork's undesirable essence.

This essay is reprinted with kind permission from Artforum, November, 1984.

Deadministering Art

Like Christ in the temple with the moneylenders of art, or like Hercules cleaning the Augean stables of art criticism itself, I have always tried to write in the spirit of T. W. Adorno's strictures "Against administered art."[1] My images may suffer from hyperbole, but to be a critic is to suffer the scorn of both artist and society. Like Tristram and Iseult, they are so eager to fall into one another's arms, they cannot suffer the critical sword between them. Adorno writes: "As the organization of culture expands, the desire to assign art its place in society, theoretically as well as practically, becomes more intense." For Adorno, the wish "to control art . . . to enforce the primacy of the administered world over art," is countered by art's wish "to be left alone," correlate with its ability to act "against total socialization." By reason of "the dialectic between aesthetic quality and social function" innate to authentic art, it is able to withstand the culture industry's insistence upon its consumability (which is what standard art-historical education unconsciously emphasizes) and the ideological use to which it is put as an instrument of society's self-validation.

The culture industry has the important task of mediating society's meaning to itself—justifying it to itself, making it narcissistically content. Society's sense of its own profound value—its sense of the "justice" or absolute rightness of its existence—hinges upon the success with which the culture

industry superficializes such dialectically integrated reflections as art by dismembering them into reified essences. This makes them universally available as tokens of society's "advance." (Art flashily crystallizes, in mock redemption—the way a crystal ball, by reason of its concentrated space, appears to bring under control the future it predicts or the way an elegant watch gives the illusion of total command of time—the complex contradictions the society may keep from itself through its delusions of grandeur.) With a kind of dubious Solomon's wisdom, the culture industry bifurcates art into consumable and creative parts, that is, into pure matter and pure spirit (equally rapidly digestible, equally likable goods). In other words, the culture industry treats art with absolute vulgarity and absolute purism—astonishingly explicit managerial appropriation and spontaneously cynical delicacy—simultaneously. The culture industry takes the already dialectically elevated host of art and elevates it still higher, into the seventh heaven of significance that comes with the unconditional popularity of complete consumability, in which not a trace is left for thought. Or what is left for thought has the status of a trophy, affording a necrophiliac delight. Consumed open-eyed in a standard operation of recognition, art becomes socially successful; the culture industry apotheosizes art by cannibalizing it. Society is enriched by the experience, and thinks itself blessed with taste. The bones of art become relics that thinkers ponder, wondering whether they can, like the bones Ezekial saw, live again through divine intervention.

I am not as hopeful as Adorno about art's power of recuperation from the culture industry—of which criticism, in one of its lesser incarnations, is not a significant part. I do not believe art even speculates about resisting it; art's will to resist, its general power of opposition, which is associated with its avant-garde character and authenticity (in whatever historical period) has been drained from it by society, which has appropriated that power and with it art's authenticity and adventurousness. It is society that now, however ironically, has the possibility of genuine authenticity and vanguard risk, which is why art is far from finding its rape by the culture industry a violation of its integrity, for that integrity no longer really exists, or exists only coyly. (It does not even exist as an ironical metaphysical substratum, hidden from view except to the initiates—to connoisseurs and other cognoscenti). Avant-garde art's power of opposition exists only as a token power—exists paradoxically and perversely as its own opposite: as a token of society's power to oppose art by administering it, of

Kiefer, Anselm, *The Red Sea*, 1984–85. Oil, lead, woodcut, photograph, and shellac on canvas, 9'1³/₄" × 13'11¹/₈". Collection of the Museum of Modern Art, Enid A. Haput Fund. Photograph © 1999 the Museum of Modern Art, New York.

which the act of appropriation may be the least aspect, and even look like a naive gesture of possessive love.

The difference between Adorno and myself may be the difference between a German philosopher who grew up within the reach of the heyday of the European development of avant-garde art and an American art critic who, however philosophical, matured during the decadence of American avant-garde art and witnessed at first hand its submission to the pressure of the market, to the extent that it began to take its identity from the market, "grew" only in response to the market. The market became avant-garde, as art was no longer able to. In my case, philosophy afforded no consolation and little insulation from this experience. Even less than art itself, philosophy was unable to shield me from reality, at least for longer than it took to dispel the momentary illusion that it did. Like art and the ostrich hole, philosophy for me was only a safe place for pride. I could not accept the contrary claim of philosophical aesthetes as different as Oscar Wilde and T. S. Eliot that art was able to mediate as direct an experience of eternity—detachment—as was possible here on earth, creating a space for philosophical meditation. In Adorno's case, there was greater belief in philosophy and art (if not belief in their eternally detached character),

undoubtedly because he had to believe there was some defense—and his use of them as points of view from which to aggressively analyze society is a kind of defense—against a Fascist society. He had experienced one at first hand; Nazi Germany was his implicit model for the totally administered society, with its bogus unity based on forced interdependence.

Whatever the social and historical differences between us, it seems to me generally the case today that art wants to copulate passionately with the culture industry, wants the success of being appropriated (as if that at last gave it the consensus to believe in itself—was the right mirror, correctly compensating for its flaws, to confirm its narcissism, to make it feel sufficient unto itself). Adorno himself once thought as much, recognizing the effect of the social investment in art as a commodity on the character of art itself—on its autonomy, its sense of adequacy:

> With the cheapness of mass-produced luxury goods and its complement, the universal swindle, a change in the character of the art commodity itself is coming about. What is new is not that it is a commodity, but that today it deliberately admits it is one; that art renounces its autonomy and proudly takes its place among consumption goods constitutes the charm of novelty.[2]

For me, then, the problem of criticism is now to make it function to deadminister art. How can it reappropriate the power of opposition and resistance from society, and thus itself become avant-garde and authentic (as art can no longer be and as society can only playfully—deceitfully—be)? What critical techniques can it use to combat administrative techniques that reduce art to a cultural asset and adornment of polite society (but also make it indiscriminately available to the masses as a proof of their authenticity) as well as to an investment property? What techniques can criticism use to combat art itself, for art welcomes this reduction as its salvation from the taboo of social isolation (not to speak of inherent aloneness—the taboo of being autonomous), even from the threat of extinction by censorship through radical neglect or outright suppression?

The real problem of art criticism today is to reconstitute the critical spirit as such. Then that spirit can be used to reconstruct authenticity in art—to reconceive art in terms of its deepest intentions, forgotten even by art itself. The

depth of art's transformative intention toward the world has become obscured—to the extent that art seems to have lost all subliminal force—by its commodity identity and its broad culture industry use as a ratification of the status quo of social appearances as well as principles, that is, its use as another administrative technique of control. (Once controlled, art controls in turn, whether as a harmless escapist outlet for disturbingly real sensations—temporary exception to the rule of no exit that proves it—or as a more charming way to insist upon it, to rule.)

Criticism's job is to save art from itself by going against the grain of conventional categorizations of it, perversely setting it in a defiantly deviant context. (An example of what I mean is available in my article on "Comic Modern," where, following the lead of certain modern artists, I argue that modern art as a whole is essentially comic in effect.) But this is done in the name of revealing the dialectical intention that makes it truly radical in its relationship to social reality and experience in general. Stripping art down to its subtly irreverent intention by grossly irreverent treatment of its conventional administrative conceptualizations—indifferently dismissing them or replacing them, seemingly arbitrarily, with their opposites, yet showing how these opposites grow directly from the art itself—uncovers the meaning of its peculiar kind of dialectical integration of contradictory materials. (An example of what I mean is available in my article "The Status of Style," where I attempted to show how modern art's aim at the impossible ideal of stylelessness is not only essential to its self-respect but responsible for its restless development and abandonment of styles, and its constant invention and reinvention of the meaning of style.)

We can begin to approach this inner dialectical meaning through three quotations from the preface to Charles Baudelaire's "Salon of 1846," addressed "To the bourgeois." The bourgeois has power, but he needs "poetry." Baudelaire attempts to tell the bourgeois what poetry and beauty are, and what they can do for his life. Baudelaire writes:

> Art is an infinitely precious good, a draught both refreshing and cheering which restores the stomach and the mind to the natural equilibrium of the ideal.
>
> And yet it is just that if two thirds of your time are devoted to knowledge, then the remaining third should be occupied by feeling—and it is by feeling

alone that art is to be understood; and it is in this way that the equilibrium of your soul's forces will be established.

If you recover the amount of enjoyment which is needed to establish the equilibrium of all parts of your being, then you are happy, satisfied and well-disposed, as society will be satisfied, happy and well-disposed when it has found its own general and absolute equilibrium.[3]

Art is conveniently understood as an escape from reality. Adorno notes that "any deviation from the reality principle is immediately branded as an escape," and responds: "The experience of reality is such that it provides all kinds of legitimate grounds for wanting to escape."[4] For him, art at its best attempts "to keep a hold on the negativity of the real and to enter into a definite relation to it."[5] In other words, only when reality is "insane," is it truly sane to make art—to dialectically engage the negativity or insanity of real experience. Such engagement is also rebellion, a struggle against reality which uncovers and plunges into the full depth of its insane negativity—in order to expose it, to assimilate it, but also to come up with something positive, namely, the autonomy that can resist it. The fiction of autonomy motivates art—is the mainspring of its struggle with and rebellion against reality. Autonomy is the shape rebellion takes—but autonomy remains a myth, an ideal statement of a seemingly impossible goal, receding the closer one comes to it, and all the more consequential for that. The autonomy of art is always limited and tenuous, more of an unreality, an illusion, than a positive reality: for reality is insane, negative.

Yet it is just this illusion—this illusion of equilibrium, as Baudelaire calls it, involving the return of repressed feeling, of neglected "intimacy, spirituality, colour, aspiration towards the infinite" (all that is "romantic")[6]—that is art's gift. Adorno insists that art is simultaneously autonomous and heteronomous, that "art's essence is twofold: on the one hand, it dissociates itself from empirical reality and from the functional complex that is society and on the other, it belongs to that reality and to that social complex."[7] But he never sufficiently explicates aesthetic autonomy—he seems perpetually unhappy with the terms customarily used to conceive it—never even acknowledges its nature decisively, although he broadly hints at it, as when he asserts "It is as if art works were reenacting the process through which the subject comes painfully into being."[8] It may be that his dialectical method, which involves thinking in

Helmut Federle, *Panthera Nigra*, 1997. Acrylic on canvas, 11' × 17'. Courtesy Peter Blum Gallery, New York.

terms of the mutual qualification of opposites and thus refuses to allow any member of the pair dominance or exclusivity, precludes allowing aesthetic autonomy any self- or unequivocal identity. Any straightforward definition would be simplistic, a betrayal and falsification of the complexity of art. Yet Adorno is also afraid of the ideality of autonomy, which seems to make it self-negating.

But understood through Baudelaire's conception of aesthetic autonomy as the abstract form of equilibrium, art's inner intention, its ulterior motive, as it were, becomes clear. The "natural equilibrium of the ideal" is not so much another forced integration of reified life fragments as a spontaneous reemergence within the revived (and revivified) totality of the self of the infinite horizon of feeling for life that survived its reductive/repressive integration into the pursuit of power and knowledge, that is, that survived the attempt to dominate it—a part of life making the feeling for the whole of it submissive. Art is reparative, its intention is to restore psychic health, and its proposal—anticipation—of autonomy is not an idealistic, self-defeating illusion, but a means of articulating just what health means: the ability, through a determined however incom-

plete and flawed integration of all the powers in the self, to withstand negative reality, insane experience. The very fact of the resurrection through art of the power of feeling that was negated—declared insane—by reality and truly real experience, that of power and knowledge, already shows the power—healing effect—of the myth of aesthetic autonomy. Adorno writes that "To experience the truth or untruth of art is more than a subjective 'lived experience': it signals the breaking-through of objectivity into subjective consciousness."[9] The objectivity that breaks through under the auspices of aesthetic autonomy is that of the real possibility of the autonomous self—the truth of the self that can resist and oppose the negativity of experience with its own "insane" reality. Such a self seems "insane" because from the point of view of normally insane experience it seems impossible, abnormal, hopelessly ideal and illusory.

But today only critical autonomy is really possible, not artistic autonomy, which has been co-opted as a sign of the presupposed material and spiritual ideality of a society. In *The Birth of Tragedy from the Spirit of Music*, Nietzsche writes: "The truth once seen, man is aware everywhere of the ghastly absurdity of existence, comprehends the symbolism of Ophelia's fate and the wisdom of the wood sprite Silenus: nausea invades him. Then, in this supreme jeopardy of the will, art, that sorceress expert in healing, approaches him; only she can turn his fit of nausea into imaginations with which it is possible to live." But art can no longer do this; most of it is nauseating, because it bespeaks the administered society—eagerly presents itself as commodity and the token of a code—with its nihilistic human consequences, summarized for Baudelaire in the notion of its attempted extermination of feeling, with the resulting loss of equilibrium, of integrated selfhood. Adorno at one point speaks of art as "a fragile balance, attained now and then, quite similar to the psychological equilibrium between id and ego."[10] It is when such a balance, such a "dynamic equilibrium" (Mondrian) is attained, that art seems autonomous, and transmits to the self the ideal of autonomy in the form of a feeling for integration. This ideal gives it the determination to survive, to preserve itself in the face of the disintegrative negativity of reality, to persist in its complex project of integrity: to withstand the insane world, by whatever means are necessary. "Without a heterogeneous moment," Adorno writes, "art cannot achieve autonomy."[11] This heterogeneous moment is not simply the acknowledgment of the negativity of reality, but the assimilation of it, in a kind of mithridatism: effective autonomy implies dynam-

ically integrated selfhood, a self sustained by that sense of wholeness that comes from having all its resources at its command, from being simultaneously "instinctive" and "egoistic."

Today criticism is art's heterogeneous moment, lending it the autonomy that comes of critical dissociation from reality—critical intervention in the social functioning of art. Criticism creates storms which interfere with art's desire for smooth sailing in well-administered waters, in the shallow lakes of cultural understanding and communal property. Above all, what criticism does is romanticize art, romanticization being the way, as Novalis says, to "original meaning. Romanticizing means nothing but raising to a higher level of quality . . . In giving a noble meaning to the vulgar, a mysterious appearance to the commonplace, the dignity of the unknown to the known, the semblance of infinity to the finite, I romanticize it."[12] And in so romanticizing it the critic makes it a fictional "second self," reinvents it as "a form that integrates" selfhood so that it functions with new stamina and power of confrontation in the face of the negativity of real experience.[13] The autonomy art creates may have all along been escapist—which is why it welcomes its cultural/capitalist administration (its totalization as cultural capital)—rather than critical. But the autonomy criticism gives art through criticism's own struggle for autonomy gives art a sublime integration that is the analogue for the healthy ego, all too rarely encountered in the real world, because of the negativity of experience.

It is criticism, then, that does the real "work" of art, and that is responsible for the creation of successful artworks, that is, objects that seem to possess the integrity of authentic selfhood, that radiate ego-strength once feared lost forever—that seem the very model of secured selfhood. (But not the formalist criticism that misinterprets aesthetic integration as a matter of syntactic subtlety with "formal facts," a neutralization, reduction, and a total materialization of the process of aesthetic integration that is equivalent to the culture industry's administration of art as cultural capital, with a sharply reduced sense of the power and meaning of both culture and capital. Indeed, formalism is the preferred mode of aesthetic administration in the totally administered society.) If the work of art is not critically recreated as the second self, then it becomes the "happy prison" the formalist thinks it is, that is, "a place of safety, a retreat from the unpredictable and traumatic causality of civilization, and a withdrawal from apparently hopeless relationships into onanistic solitude, aloof self-sufficiency,

and omnipotent self-possession"—into an infantilistic condition.[14] The artwork as happy prison—what false, positivistic (and falsely positive) criticism turns it into—also signifies "potential revolt and escape," as indeed it did for the late nineteenth–early twentieth-century aesthete who endorsed it for its power of transcendence. What the true critic does—the critic who recognizes the psychosocial implications of aesthetic integration—is return "the abstract idea of aesthetic autonomy," as it is developed by formalists and art administrators of all kinds—formalist art administrators—to its "likely origin" in "tragedy,"[15] that is, in the tragic sense of self Heinz Kohut speaks of.[16]

This self, the self that has not been empathized with, finds succor in the happy prison of the artwork, but is made to realize, by criticism which explores the psychosocial effects of art, that the consoling artwork is in fact a distorted mirror image of the integrated self it would like to be—the untragic self that is not the victim of an indifferent reality, a social reality that couldn't care less whether the self lives or dies, or has any particular reason for doing one or the other. (The feeling of the lifeworld's nihilistic indifference is a general effect of experience in the totally administered society.) That is, the fabulously integrated artwork, by virtue of the mythical absoluteness of its integrity understandable as an abstract analogue of the ideally integrated self—the self equal to the negativity of reality—is a perversely narcissistic reflection of the tragic self, in a sense, the image which with it empathizes with or comforts itself. The perversely ideal self—the autonomous self—represented by the subtly, complexly integrated artwork, has a tragically narcissistic function; it is rooted in a tragic experience of social reality as nihilistically indifferent. Narcissism to overcome nihilism—that is the formula of the best art. This is why Baudelaire insists that the critic be "partial, passionate and political"—have "temperament" and feeling, express "love or hate"—rather than, using "the pretext of explaining everything" about the artwork, practice "a cold, mathematical [formalist] criticism."[17] For critical recognition of the profound meaning of the feeling of the artwork, the critic's need to cure his own tragic sense of life, to heal his own sense of the world's nihilation of him through its indifference. At times this is converted into indifference to the artwork, on the grounds of its naiveté and absurdity ("unreality") in daring to attempt to create and project absolute integrity (rather than accept the flawed, relative integration of selves and artworks in this imperfect world). This equally essential indifference must also be overcome; otherwise

the critic leaves the artwork in the tragic limbo of its own dumb material and innocently social identity, that is, its well-administered role as superior object and sign of superior subjectivity. This also shows it to have an uncompromised integrity, but one without autonomy.

My attempt to debunk abstract art—to depose it from its throne of self-importance—in my article "Authoritarian Abstraction" goes hand in hand with my attempt, in an article on Van Gogh, to understand his art in terms of his problematic selfhood, all the more tragic by reason of his implicit recognition that he could not have a more than momentary, unsteady integrity until society did. He would then reflect its cohesion, and it would seem to mirror him warmly, positively. This brings us back to Baudelaire's comparison of the bourgeois's search for "the equilibrium of all parts of (his) being" with society's attempt to find "its own general and absolute equilibrium." Both efforts are implicitly hopeless; for all the encouragement Baudelaire gives the bourgeois, Baudelaire is not so certain that he will find his happiness in art, trust the feeling it awakens in him. Nor is he convinced that society will ever find "the equilibrium of the ideal." The bourgeois is in Van Gogh's situation, and Van Gogh speaks for the bourgeois—gives voice to the rage he must secretly feel at the indifference—the thinly disguised negative response—of society to his existence, shown by it refusing him happiness, always making it hard.

Most of my criticism reflects in one way or another my sense of the tragic situation of art and criticism in the modern period. My article on collage examines the difficulty of integration in the authentically modern work of art. My article "The Unhappy Consciousness of Modernism" examines one inadequate, forced kind of integration in dubiously authentic modern art. Much of my criticism examines the difficulties modern art has achieving any kind of equilibrium. All in all, what I have tried to do is remind the reader of the truth of what Oscar Wilde said at the beginning of this century, namely, that the critic is an artist—that the very root of art is criticality—and is thus subject to the same disintegrative forces of the negativity of modern reality as the artist. These forces include the media which shape the voices of both art and criticism; the audience which listens to them, uncertain of its own seriousness, and so implicitly indifferent, interested only in the developing novelty of both; and the ideologies which preempt them, making a mockery of the criticality in which their autonomy is rooted.

Indeed, the critic is the only authentic artist left, for the typical artist comes to rest in an integrated style, which he takes as the emblem of his narcissistically completed selfhood, while the critic remains restless, disbelieving in the absolute integrity of any style (or artwork), free of the need for steady narcissistic succor. This is why the critic remains more authentic than the artist in the administered society, for it insists that everyone be satisfied.

The critic is neither art's John the Baptist, Grand Inquisitor, or crucifier, but himself crucified, the victim of a Passion of his own. This is not only because he is the victim of the contempt of artists—such as Gauguin, who said the critic was always comparing art to something that had nothing to do with it,[18] or Olga Rozanova, a Suprematist artist who thought that criticism was a "cautious," "pseudo-artistic path" taken by "the person without talent,"[19] or the contemporary English activist artist Conrad Atkinson, who thinks critics "dip their pens in pig's urine."[20] It is also because he refuses to give the artist the satisfaction of telling him that his art has overcome the negativity of the real, triumphed over an insane world by mediating a sense of absolutely integrated selfhood—an eternal equilibrium of selfhood achieved through art. How can the critic tell the artist this when the critic knows the autonomy art proposes is only a fiction, and must remain one if it is to have any value. It is because the critic is so distrustful of art's claims to autonomy that he gets no satisfaction from criticism, which argues for art's privileged integrity—which is exactly why the critic continues to be critical. Criticism is the only enterprise with no narcissistic satisfaction, which is why there is so little of it, compared to art.

This paper was originally given at the Fifth Mountain Lake Symposium titled Directions in Post-Modern Art and Architecture, *Mountain Lake, Virginia, October 25–27, 1984. It was published in* Art Criticism 2, *no. 1. Spring, 1985.*

Notes

1. T. W. Adorno, *Aesthetic Theory* (London: Routledge & Kegan Paul, 1984), 355.
2. Max Horkheimer and Theodore W. Adorno, *Dialectic of Enlightenment* (New York: Seabury Press, Continuum Books, 1972), 157
3. Charles Baudelaire, "The Salon of 1846," *The Mirror of Art* (Garden City, NY: Doubleday & Co., Doubleday Anchor Books, 1956), 38–40.
4. Adorno, 13.
5. Ibid., 17.
6. Baudelaire, 44.
7. Adorno, 358.
8. Ibid., 165.
9. Ibid., 347.
10. Ibid., 9.
11. Ibid., 9.
12. Quoted in Kurt H. Wolff, ed., *From Karl Mannheim* (New York: Oxford University Press, 1971), xliv.
13. Roy Schafer, *The Analytic Attitude* (New York: Basic Books, 1983), 291.

14. Ibid., 264–65.
15. Adorno, 9.
16. Heinz Kohut, *The Restoration of the Self* (New York: International Universities Press, 1977), 206.
17. Adorno, 41.
18. Paul Gauguin, "Letter to Andre Fontainas, March 1899," in Herschel B. Chipp, ed., *Theories of Modern Art* (Berkeley, University of California Press, 1968), 76.
19. Olga Rozanova, "The Bases of the New Creation and the Reasons Why It is Misunderstood" (1913) in *Russian Art of the Avant-Garde: Theory and Criticism, 1902–1934,* ed. John E. Bowlt (New York: Thames and Hudson, 1988), 109.
20. Conrad Atkinson, *Picturing the System* (London: Pluto Press, 1981; Institute of Contemporary Art exhibition catalogue), 78.

Authoritarian Abstraction

Abstract art today defines itself exclusively in terms of its objecthood; it means to have a purely physical presence. For example, Richard Serra says that "the only way to understand" *Delineator* (1974–76), is to experience the place physically, and you can't have an experience of space outside of the place that you're in.

In *Sight Point* (1971–75), the volume of the piece is experienced as a physical characteristic, and it's controlled not only by the enclosure but primarily by the light that comes in from any one of the four openings.

Finally, *Circuit* (1972) generates "physical sensation" which is "almost didactic."[1] But of course it is not Serra's sculpture that teaches us what space, light, and physical sensation are—as though we had never experienced them until we encountered a Serra sculpture. Rather, it is the sculpture that depends for its effect on our previous, generalized physical experience. Indeed, that generalized experience makes itself strongly felt, for under its pressure every one of Serra's works loses its integrity and reduces to its general conditions. It becomes simply its location and material, its topography and the vista on it. The space of the work is carried by space in general, in volume by volume in general. Its physicality universalizes, and Serra's control of the work, however minimal—a matter of measurement and placement, and choice of material—comes to seem

superficial in contrast to the way the work reduces to its surroundings. Our consciousness of the work's physicality camouflages our awareness of the work that actually went into its creation, and assimilates it into its ambiance. Even geometry does not resist this "naturalization" of it, for as its materiality becomes increasingly vivid, its geometry seems increasingly dumb, the least telling part of the work, a superficial frame for the material. This comes to seem even more naively asserted, but it is just this illusion of naiveté that is prized, as the sign of the purity of physical sensation.

But to reduce a work of art to the truism that it is physical is to be scholastically narrow. Recognition of this scholasticism, and the way it makes current abstract art circular and pedantic, mechanically self-referential, and affectedly formal, is the first step in my attempt to show its authoritarian style, which I take to be a symptom of the decadence of abstraction, its decline into a mannerism. My last step will be to show that what current abstraction thinks it renders extraneous by reason of that style—reference to the lifeworld, to what it regards as "theater"[2]—returns to haunt and eventually undermine it from within, put it in a state of contradiction with itself. As Habermas says, formalist art, in carrying autonomy to the extreme, prevents art from preserving "emphatic experiences"—from emphasizing experience, from giving, in Walter Benjamin's words, "secular illuminations"—but extra-art experience returns to haunt formalism and lead it to self-dissolution.[3]

Initially, however, authoritarian style seems invulnerable and impenetrable—self-validating, or, as Adorno says, tautologous, decreeing its own existence. This is true of any abstraction, and in art as in thought abstraction is achieved by reduction, a deliberate strategy of detachment from all but the essential which seems to make the abstract result itself essential. But the advance of current over traditional abstraction is the purge of the metaphysical by the physical, the obscurely connoted by the obviously denoted, the illusion of the essential by the really essential. This advance, sweeping away with it all wayward associations that might be pinned on the work of art, makes abstraction more ultimate and essential in itself, but at the same time makes it more immutable and mute. Thus the increasing delicacy or "poetry" with which the physical is asserted in current abstraction, and the increasing threat of the meaninglessness of the assertion. Formalist art means to be an epiphany of the physical, an ecstatic acknowledgment of what is essential in all experience. But

what it means to be and what it is are not necessarily the same, for it can easily be seen as a sterile rendering of the self-evident, as a fruitful vision of the fundamental. Purity, in other words, can just as easily be read as emptiness, especially when it seems obsessed with the trivial, and redundantly emphatic. In other words, the vulnerability of abstraction increases as its reductionism intensifies, until a point is reached when more seems lost than was gained, when it becomes clear that to make the physical obvious is unenlightening. The formalist must constantly be on his toes, demonstrating that reductionism is an illumination, not a deprivation, of reality—an assertion of its essence rather than a dwindling away to the dregs of a convention about its character, to the ordinary way of defining the real as the physical. He tries to keep the flame of art alive by Talmudic attention to physical detail, but after a while even this traditional fuel no longer burns brightly. The mode of presentation of the physical becomes crucial, but even the subtlest mode follows old tracks and becomes academic. The work as a whole is in perpetual danger of losing whatever spirit it might have and reducing to the letter of its details, which are magnified out of all proportion. The work is talked of in terms of the details of its "surface" and "tectonic density,"[4] "insistent crispness of form" and whatever does "something to material" to create an "affirmative object."[5] These come to be absolutes desirable in themselves, but also redundant and unevocative, signs of the same sheer physicality, the same irreducible literal minimum, which they merely accent. Thus, as the works become more and more exclusively physical, they lose significant differentiation. The terms in which they can be talked about are general enough to be used for any reductionist work. The above terms were meant for Robert Grosvenor's sculpture and Robert Mangold's painting, but they can be used to describe the abstraction of any number of artists.

But the trick is not to use them to describe the art but to use their presence to confirm that we are in the presence of art. Thus gravity is said to be the "operational force" in the sculpture of Charles Ginnever and Richard Nonas.[6] But it is of course an innate physical characteristic of every object, so that to say that it is the operational force in a sculpture is not to say anything about the character of the sculpture as a sculpture. Yet, from the reductionist point of view, to call attention to its objecthood by calling attention to its gravity is calling attention to it as sculpture. It is not necessary to spell out how the sculpture makes gravity more self-evident than it is in any other object. It is in

fact impossible to do so. One need only to be reminded that the sculpture is only physical—noting its subjection to gravity is a current sophisticated way of doing so—to prove that it is art. Art and objecthood are totally confused—lose all differentiation—in the self-identity of the physical.

The reduction of the work of art to its physical identity reduces it to the identity of its medium. This, the theoretical ideal of reductionism, not only precludes figurative use of the physical, but presents it as its most matter-of-fact. Whether it be a matter of arguing that "the physical identity of the pictorial object" is entirely a matter of its "surface and support," as has been said about the pictures of Brice Marden,[7] or of arguing that "the very features that affirm the (mature) sculpture (of David Smith) as a physical object—shape, surface, structure—simultaneously establish the peculiar elusiveness of the work,"[8] the key point is the inescapable literalness with which the work asserts itself. Whatever pictorial and elusive character—imagistic potential, psychic charge—abstract art might have is secondary to its physical order, and the perceptions this order generates. Perhaps the clearest statement of the ideals of abstract physicalism has been made by Carl Andre, who describes his metal floor pieces as, "a kind of drone or 'great bass' on which the primary qualities (mass, color, hardness, conductivity, reactivity, texture, etc.) of matter are played."[9]

This idea becomes absolute in Annette Michaelson's analysis of Robert Morris's sculpture:

> Developing, sustaining a focus upon the irreducibly concrete qualities of sensory experience, they renew the terms in which we understand and reflect upon the modalities of making and perceiving.[10]

This idea, which is usually regarded as the essence of modern art, has been with us since Baudelaire and Manet expresses contempt, as Valéry put it, for "any effects not arrived at by conscious clarity, and the full possession of the resources of their craft." It is this that defines "purity":

> They have no mind to speculate on "sentiment" or introduce "ideas," until the "sensation" has been skillfully and subtly organized.[11]

Early in this century it was called "physical transcendentalism" by

Boccioni, who held that the whole aim of art was to uncover "the mysterious sympathies and affinities" in "plastic form," particularly "the reciprocal formal influences" of "planes."[12] Another moving idea of physical transcendentalism is Braque's view that "limitation of means determines style, engenders new forms, and gives impulse to creation." He admires "primitive painting" because "limited means often constitute (its) charm and force," and in general he believes that "extension . . . leads the arts to decadence."[13] Thus physical transcendentalism marks the beginning of absorption, as Braque put it, in "the material because there is as much sensibility in the technique as in the rest of the painting."[14] It is this absorption that characterizes what Apollinaire called "pure painting,"[15] and that was made doctrinaire and codified in Clement Greenberg's conception of modernism. Greenberg traces it back to Cézanne's, and even Courbet's, respect for the "rawness of matter," and believes that modern art developed "on the crest of a mood of 'materialistic' optimism."[16] It asserts materialism "in principle," as expressed by its belief in the superiority of the medium over whatever it figures; thus the invincible flatness of the picture plane; the ineluctable shapedness of the canvas, panel, or paper; the palpability of oil pigment, the fluidity of water and ink—this expresses our society's growing impotence to organize experience in any other terms than those of the concrete sensation, immediate return, tangible datum.[17]

As we see, these terms are still in force in current abstract art. Indeed, in greater force than they once were, for there is no longer the sense of having to escape, as Baudelaire and Manet, and even Boccioni felt they had to, from arbitrary sentiment and speculative ideas. These have been fully purged, so that the reductionist impulse can pursue its way indirectly, with seeming spontaneity.

The perceptual goal of physical transcendentalism is a kind of ecstasy of vision: certain features of the physical seem to stand out from and transcend—exist independently of—their origin, and yet at the same time are clearly an articulation of its essence. This sensation of standing out is the essence of the aesthetic of abstraction, and while what stands out is the irreducible concreteness of the physically given, what matters for the art is the way the standing out is arrived at. But there is abstract art in both the visionary standing out of the irreducible and in its formal attainment, in the transcendental aesthetic sensation and in its artistic means. In abstract art the aesthetics of consciousness and of creation fuse. It is perhaps in recognition of this that led Valéry, in his

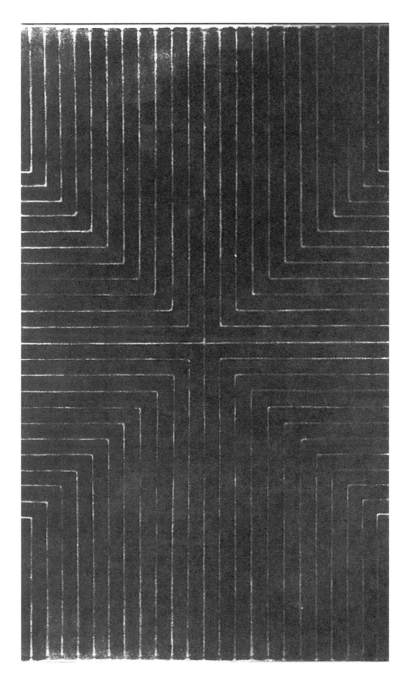

Frank Stella, *Die Fahne Hoch* (1959). Black enamel on canvas, 121¹/₂" × 73". Collection of the Whitney Museum of American Art, New York. Photograph © 1999: Whitney Museum of American Art, New York. Image Copyright © 2000 Frank Stella / Artists Rights Society (ARS), New York. Photograph by Geoffrey Clements, New York.

famous reverie on his bust, to ask: "Why, after all, should the making of a work of art not be considered a work of art in itself?"[18]

The goal is noble: physical transcendentalism means to put us in possession of our consciousness as it creates its world by abstracting from the given world, put us in possession of our sensibility as it creates its sensations. It is an analogue for the general process of consciousness: the standing out of certain features of reality, the reduction of reality to their terms, the exclusive concentration on and organization of them in the name of an inner logic—in the name of what both Schiller and Kandinsky called inner necessity. However, physical transcendentalism, and inner necessity itself, are no longer evangelical ideas. They have become typecast; even the esoteric, and sensation, can become clichés. We know what to expect from them, and so they depreciate. They make us suspect that abstraction is a matter of diminishing returns—that, after all, less is less and not a matter of more. They make us suspect that the fundamental is the trivial, except at moments of crisis, when one needs to get one's bearings, and imagines the bedrock necessary to do so. Otherwise it is not in constant use, and even an interference with exploration of what is more obviously given in experience. To fight this depreciation, artistic abstraction to the fundamental adopts an authoritarian style. At the same time, seemingly in contradiction with this style yet also crucial to it, abstract art doubles back to its origins in the lifeworld, searching for a new vitality—an energy beyond that of its own physical forms, which confuses their meaning. They no longer seem, in Whitehead's words, to have the aura of eternal objects—they no longer have the stability of the truth. This renewed conflict between pure form and the theater of life—now one in which life, not form, is trying to assert itself, in which extension, not limitation of means, is at stake—is a sign of authoritarian style, for such style comes into existence to repress what no longer seems repressible, to control what no longer seems controllable by conscious form, which loses authority as the repressed arises. The authority of artistic form derives from the belief that, in Oscar Wilde's words, words echoed almost intact in Greenberg,

> It is through Art, and through Art only, that we can realize our perfection; through Art, and through Art only, that we can shield ourselves from the sordid perils of actual existence.[19]

But when art has made us so perfect and so charged with superior significance that our actual existence seems so imperfect that it seems meaning-less—as Wilde said, let our servants do our living for us, i.e., life is for artless others—then it becomes a peril which, whether sordid or not, threatens art. It is this sense of life in the raw, almost undefined—an indefinite, unfocused life whose only quality is its extravagance, and which because it is self-contradictory in appearance seems arbitrary—which we will later explore in some of the work of Robert Morris, which perhaps best exemplifies the authoritarian style. Now it is sufficient to note that such style, which seems an attempt to hold fast and validate whatever perfection pure form can convey, is in fact self-indulgent—permits itself theatrical asides of life, such as, we will see, Morris's 1974 self-portrait poster and in the same vein, but a more common phenomenon, Andre's Marxism. The artist, in other words, tries to assert a vital self while at the same time asserting pure forms. The two are incommensurate, although they can be juxtaposed, and it is out of their irreconcilability that the artist's authoritarian style is formed. This conflict is a sign of self-doubt. Physical transcendentalism becomes uncertain of the purity of its effect, the artist's own life uncontrollably however archly pushes its way into his art, in an informal appearance—as an impure expression of his sordid existence. The larger art of life surrounds the life of art, at once showing up its forms and giving them greater significance than expected. The forms which shielded us from life seem too insignificant to do so, and yet become symbolic of life—of certain attitudes to it, and certain assumptions about it. They bespeak a world of art which now clearly locates in the lifeworld, and cannot be conceived as a perfect world, for a perfect world is not inhabitable. In the name of the perfection and purity of art, artists decided, in Malevich's words, "to have nothing further to do" with nature, to suspend relations with the "time-tested wellspring of life," to abstract itself from the objective world and "exist in and for itself" "in the feeling of nonobjectivity" or abstraction, to free itself from "utility," service to "the state and religion," and illustration of "the history of manners."[20] But in so completely removing itself from the lifeworld, it has itself become a manner, a religion, a commodity with surplus if not use value. To escape the inertia of its own autonomy it has begun to return, however hesitantly, to nature and history other than its own. This is minimally evident in Serra's open sculpture, the landscape context of other quasi-minimalist sculpture, and even in such trivia as Brice Marden's allusion to

the Seasons in the title of one of his works. Nature has here been met, if not penetrated, and if the state and religion, and the manners and morals of men, have not been. Clearly, abstract art feels the need for release from an abstraction whose rigor seems increasingly flaccid, reduced as it has been to what has been called a "few sickly formal devices."[21] Its subtlety no longer spontaneously generates ecstatic sensation, and seems more the result of the manipulation of matter than a cunning re-cognition of it. To escape the sickliness of such abstraction, and the absurd attitudes underlying it, many physical transcendentalists become theatrical, locating their work perilously in imperfect worlds, or making the work itself, as in Serra's case—where steel plates precariously and presumptuously balance each other—perilous. This does not ground a new art, but it does upset the values of the old formalism, at least by introducing, however indirectly, new values.

Before examining the authoritarian aspect of this theatrical turn to life, I would like to demonstrate concretely the absurdity of the materialist perfectionism of physical transcendentalism—the absurdity of the modernist belief in the superiority of the medium over anything it figures. It is epitomized in remarks by Stella and Andre. No medium has a monopoly on it. Stella says:

> I wanted to get the paint out of the can and onto the canvas . . . I tried to keep the paint as good as it was in the can.

And Andre:

> I realized the wood was better before I cut it than after. I did not improve it in any way.[22]

In both cases the material medium is assumed to be so perfect that any artistic work with it causes a fall from its state of grace. Art not only tries to leave undisturbed this primary perfection, but to make it self-evident: the work of art is a revelation of the innate goodness of matter. Matter narcissistically mirrors itself in art, with the artist's hidden hand that holds the mirror up, the impersonal mechanism by means of which matter makes its perfection manifest. The impersonal has been commonplace in art since Abstract Expressionism. It is as though matter—whether it be the physical transcendentalist's raw matter

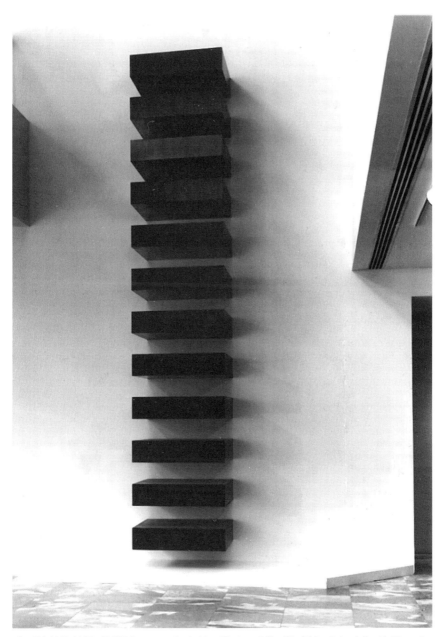

Donald Judd, *Untitled (stack)*, 1967. Lacquer on galvanized iron, 12 units, each 9" × 40" × 31", installed vertically with 9" intervals. Collection of the Museum of Modern Art, New York, Helen Achen Bequest (by exchange) and gift of Joseph Helman. Photograph © 1999 The Museum of Modern Art, New York.

or the Pop artist's visual clichés—was self-acting, with the artist merely its handmaiden, the midwife of its self-reproduction, seemingly infinite self-extension. Rebellion against this illusion in part inspires the theatricalism of latter-day physical transcendentalists. But the belief in self-acting perfection has a long heritage, both to validate a hermetic system of effects and to articulate the felt magic of matter. The idea of perfection confirms the sense of the inevitability, and so seeming self-sufficiency, of the given order of reality—in the case of art, the unavoidability of matter in its making. Thomas Aquinas wrote:

> An effect is most perfect when it returns to its source; thus, the circle is the
> most perfect of all figures, and circular motion the most perfect of all motions,
> because in their case a return is made to the starting point. It is therefore nec-
> essary that creatures return to their principle in order that the universe of crea-
> tures may attain its ultimate perfection. Now, each and every creature returns
> to its source so far as it bears a likeness to its source, according to its being and
> its nature, wherein it enjoys a certain perfection.[23]

The modernist work of art, insofar as it does nothing but return to its principle or source—its material medium—enjoys a certain perfection. But the question is why it should do nothing but circle back to its source, as though, if it did not do so, it would, like Antaeus, lose strength. Its principle may be inescapable, but insofar as it does nothing to get beyond its origin—does nothing but articulate and refine its source—it has no end. Thomas's creatures return to their principle after existing as creatures in their own right. Do modernist works exist in their own right—exist apart from their materialist principle? It seems not, which makes them extraordinarily perfect, perhaps ultimately perfect, but curiously inadequate and inconsequential. Nonas's logs, Andre's metal plates, are curiously innocent, rudimentary, and not with any flair. They are knowingly naive in their realization of the by now traditional modern aesthetic of truth to material, but the self-limiting physical identity they achieve by this honesty denies this material its full use value, its constructive potential. Paradoxically, what seems an honest assertion, in the name of a logic of perfection, of the given, inhibits our sense of what we can do with it. Our intention toward it becomes an accessory of its self-assertion. Our consciousness of it is passive, for all its recognitions. Art no longer becomes an acting upon material

to make it show human cause as it were, but an almost entirely mental demonstration of the aesthetic transcendence of its medium, which can be anything that is given. There is no difference in principle behind Duchamp's display of found objects and Stella's display of paint or Andre's display of wood or metal or whatever. The consciousness that locates the material in the lifeworld not only infringes on its aesthetic display, but it is not the kind of consciousness that goes into the creation of art, which works just the other way—abstraction from the lifeworld to a realm of autonomous existence. Art is autonomous exhibition or it is nothing, and the physical transcendentalists would rather that it be nothing than that it be "transcendence" towards life, which for them is the essence of the theatrical. That they themselves unexpectedly become theatrical shows the inevitable circling back of art to life, material to what it can figure, for the lifeworld, not the material out of which it superficially seems made—to reduce it to that material is to dissolve it—is the source of art.

Modernism's reaction to the material medium is already authoritarian, and the recognition that the reduction is a form of repression—a denial of the lifeworld, of the art's impulsive, theatrical emphasis of some of its features, an emphasis which is as complex as its subject matter—increases our awareness of the absoluteness of its authoritarianism. It is not simply a style—a convention or pattern of operations—but what Adorno calls a "syndrome," i.e., a constellation of signs and symptoms which characterize a mentality. In modernism what is achieved, by the insistence that art cannot transcend its physical identity—its sheer givenness—is acceptance of the given order of the world, internalization of it as an elementary form of being. This simplification of its reality not only rids it of the conflicts which characterize its history, but precludes any questioning of its order. Artistic radicality—the radicality of reductionism—replaces political radicality. It is no accident that its origins, as in Malevich and Mondrian, are in frustration with the social order. Reductionism is in a sense a utopian response to a felt need for, yet a recognition of the impossibility of, social revolution. Even after reductionism has been domesticated into a safe style, the hidden political impulse behind its simplifications reappears, as in Andre's Marxism, and becomes a part of its theatricality, its impulsiveness. The best reductionists retain an oblique lifeworld affiliation. While their forms do not always show an affinity for it, their behavior about their forms does. But in general, reductionist art does not suggest a historically fluid, tense lifeworld, but

a world of fixed forms with inherent authority, forms which cannot be expressively reconstituted by art but simply exhibited as such. Reductionist art does not expressively explore the lifeworld but completely objectifies it, signals only its reification in time and space, but these become natural time and natural space, not historically conditioned in their fundamentality.

However, in naturalizing time and space, in fundamentalizing form, modernist reductionism goes against consciousness itself, falsifies perception. In demanding that consciousness, like art, be neutral towards matter, simply asserting its perfection but doing nothing with its actual existence in the world—not sharing in the worldly use, the attempted mastery of matter—it ignores the fact that perception is never pure, but always motivated by lifeworld intention, however obscure, and gives meaning to what it senses, otherwise it would not trouble to sense it. By denying that the process of signification is inherently one of showing the significance of what is given rather than simply displaying it neutrally, reductionism denies the symbolic process inherent in consciousness. For reductionism the issue is not simply a matter of denying, as Stella put it, "humanism," by which he meant whatever seemed to have been meant by the art but could not be perceived in it, but a matter of direct appeal to pure perception, of trusting sensations, not the speculations they might lead to. Thus Stella's assertion that you see only what you see. But sensation has long since been shown to be a myth, and more has been shown to be at stake in seeing than Stella dares to acknowledge. Seeing is theatrical, it creates drama, dialectic, contradiction. It represses more than it asserts, and what it represses comes back to haunt it—moves from its exile on the periphery of perception to its center. Malevich once wrote: "Our life is a theater piece, in which nonobjective feeling is portrayed by objective imagery."[24] But objective imagery, even in Malevich's sense of the term, also portrays objective feeling, i.e., feeling about the theater piece of life. As we have noted, it begins to portray such feeling explicitly, but such feeling is already implicit in the abstractions it offers to perception. The abstract imagery, like the pure perception it means to appeal to, is the tip of an iceberg of consciousness. The refusal to recognize this hidden consciousness is also part of the authoritarian style, which prefers to deal with surfaces but is in the end overtaken by its own depths.

The separation of the objective and the nonobjective, the contradiction between the theatrical and the abstract, the opposition of art to the lifeworld,

the elimination of expressive association in the name of autonomous exhibition, is characteristic of authoritarian style. For Adorno, the key to it is ambivalence: its rigid adherence to the obvious, yet its secret feeling of oppression by the obvious. It must relieve this feeling on a scapegoat—a symbol of the authority it identifies with, and from which it takes its own authority—if it is to survive, if it is not to self-destruct, to be torn apart by its own tension. The authoritarian style is posited on irrational respect for authority—in reductionism, for the authority of matter and geometrical form. "Irrational" respect, because identification with the authority leads to resentment of it, because at the same time it gives one its authority, it robs one of one's own. One is a puppet in its theater piece, rather than creative of a life which is a play of its own. As Adorno puts it, the internalization of authority, while giving one its power—in physical transcendentalism, the power of eternal form and "enduring" material—repress-es one's instinct for life. They are committed to and possessed by the power of the internalized forms, the authority one has given them over oneself. One eventually tries to break away from them and their authority, but initially one accepts the authoritarian style they impose, and "takes pleasure in obedience and subordination" to them. The break away, when it comes, formulates itself as prejudice. Life becomes a theater in which a scapegoat takes upon himself both the desired authority and the rebellious instincts. The scapegoat acquires the burdensome authority and is victimized for it. The authoritarian acts out on his scapegoat his vengeance on the authority he must bear; his instincts find their lifeworld release in this vengeance. The drama of the scapegoat is repeated in art. The physical transcendentalist turns against his work, victimizes it, treats it as a scapegoat. He becomes prejudiced against the forms whose authority he originally endorsed, to give himself authority as an artist. In different ways, Stella's recent theatricalization of his work, and Andre's Marxist condemnation of the artworld in which he himself is a major commodity, are examples of this, to which we will return. The interesting thing about the authoritarianism of current abstract art is that it turns on itself, victimizing itself so thoroughly per-haps because it believed in its authority and autonomy so absolutely. It ends deliberately misunderstanding the meaning and violating the integrity of its forms, as it originated in a misunderstanding of the meaning of the standing out of abstraction, viewing it not as a symbolic process but as a precipitation of the inherent values of perception from its process, as though those values could

be finally fixed independently of their human use. But the misunderstanding by which reductionism self-destructs undoes the misunderstanding by which it constructively began, restoring abstract forms to a flux which makes them seem to belong to the lifeworld (as in Stella's recent work), or emphasizing that world anew by calling attention to the situation and life of the artist who made the forms (as in Morris and Andre).

Adorno views prejudice as Oedipal in origin. The prejudiced person is caught in conflict between father and mother figures—in abstract art between fathering, purposive form, and mothering, instinctive life. The one forbids the other. The two seem incommensurate, and apparently cannot be possessed at the same time. Prejudice against the scapegoat permits for the satisfaction of both sides, for the scapegoat is ambivalently both. It symbolizes transcendence and repression of instinct—superiority to and control of life—and, in the mistreatment of it, expressive release from repression, the violent return of instinct. The paradox of prejudice is complicated by the fact that the "very same qualities" the prejudiced person attacks in the father—the qualities that give him his authority—are stereotyped in the scapegoat, giving them an extra authority, i.e., making them not simply authoritative but authoritarian. The forms of abstract art have not only the authority of their purpose in art, but because they have this purpose they can be completely codified, and appear as absolutely autonomous, i.e., as having no other purpose. Stereotyping is the basis of autonomy; to call something autonomous is to describe it as a stereotype. At the same time, such authoritarian autonomy is an easy target: the forms are clearly in focus as alien to life, and so more easily made a scapegoat. As Adorno says, stereotyping serves an "economic function": "it helps to canalize . . . libidinous energy according to the demands of . . . overstrict superego."[25]

Economy of means has the same function in abstract art. The reduction which creates physical transcendental forms—which makes forms formalistic—canalizes the artist's libidinous energy according to the demands of the overstrict conscience of his art. This consciousness originates in his sensibility of the superiority of material to any artistic use it might be put, in his awareness of its inherent perfection. In his reluctance to touch it, he transcendentalizes it—hypostatizes it in transparent forms, formalizes it in a fixed appearance. The material is thus preserved intact, as an autonomous absolute, as though it was unworked—reductionist art has about it a special sense of *facilità*, which seems to reduce stylistic con-

siderations to a minimum, to render the material stylelessly because the forms which do the rendering are so simple, perceived so painlessly. There is complete capitulation to the material in recognition of its perfection, a stifling of any impulse to work with it in more than a minimal way—this restraint is also part of minimalism. This instinct for work breaks out in prejudice against the materialistic work of art—the artist begins to play hard and fast, almost scornfully, with his material, unwittingly denying its sanctity and wittingly complicating the simple forms which made it manifest, in effect undermining the art's formalistic purity. Thus Andre, upset with the way the Whitney Museum exhibited one of his metal plate pieces, facilely devalues it by declaring it to be worth only the price of its materials—uses materialism and economic determinism to negate the work as art—and makes the work anew, exhibiting it according to his intention. His intention catalytically converts sculpture to scrap metal and vice versa. The perfection of the material is no longer respected; it is subject to the artist's intention, and thus becomes ironical, rather than transcendental—in appearance. It is no longer safely beyond the reach of art, even if it is only the art of intention.

In Stella's recent work this art makes itself forcefully felt in his dismemberment of his transcendental decoration—a deliberate violation of its formalist control by ostentatiously manipulating its elements. Thus surface, frame, and color separate—deformalize—and as it were, whirl like so many dervishes, and the work as a whole deritualizes. These works—and the work of the art is now obvious and intense—seem to show the decorative in a final, decadent phase, but the key point is that it has been brought down to earth. It is no longer transcendentally intact but vulgarly vivid—indiscreetly projects—in all its parts, and the fact that the new work is a sum of parts rather than a whole like the old work shows that Stella's conception of its physical identity has changed. The physical is no longer perfect matter, but imperfect body. It no longer completely fits into pictorial space, but incompletely projects into actual space, and so is experienced as much in an extra-art as art way. The German distinction between Körper and Leib is at stake; the objecthood or body of the work of art is no longer mechanically physical but organically lived. But by making decorative works in this new vein, by making the parts more assertive than the whole so that the whole cannot settle into didactic form, by denying any ready or at least predictable harmony, Stella works against, undoes his own earlier art— shows himself prejudiced against the authority of his own formalism. It is not

simply that it has become a well-known style, and so an embarrassment, but that it has become authoritative, and so blindly binding. Working with it is no longer "instinctive" but ritualistic; its forms are so stereotyped they can be vitalized only if they are performed. But in his new theatrical abstraction Stella makes a scapegoat of his old decorative abstraction.

Andre is also theatrical in his Marxism, his critique of the assimilation of living art into dead culture by giving it at once critical and commodity value, making it a pawn in a game of consciousness and commerce. Much as Stella turns against the art which brought him into prominence, so Andre turns against the art world which gives him significance. The split in his authoritarian style is more obvious than that in Stella's, for Stella remains hermetic, directly converting his desire for instinct into art, while Andre's critical impulsiveness does nothing to upset the known structure of his art—it is not reflected in any playfully violent contradiction of his familiar forms. His work remains physically transcendent; it is only his outlook which toys with it, giving it perhaps an ironic expressivity, but not changing its look radically. His prejudice against his own work is put to less creative use than the prejudice which compels Stella to show up the terms of his art.

In general, the unexpectedly ambivalent attitude of the artist to his material—the collapse of its perfection under the pressure of its authoritarian stylization—leads to a recognition of its uncontrollable expressive implications, an expressivity which was previously denied although implicitly acknowledged. The contradiction now comes out into the open. Thus, there is a whole species of apologetics for the "charm" of color, designed to repress it. Yet the apologetics itself bespeak the charm. For example, Robert Mangold's painting is said to have "an almost unnecessarily pleasing, muted color."[26] The point is to rationalize the "sensational" character of color—the expressive dimension that makes it more than a sensation, and compromises its pure materiality, i.e., that makes it qualitative as well as quantitative. While color is supposed to be without gravity in the painting of Brice Marden,[27] the difficulty with which its effects are controlled—made expected—shows that it retains subjective expressive import, however indefinite. That is, it remains theatrical and libidinous, and insidious, insinuating expression of repressed instinct—an outburst of energy—and so in contradiction with its transcendental deployment in authoritarian abstraction.

Suddenly matter no longer seems perfect in itself, but tainted with vul-

gar expressitivity—theatrically self-transcending. This becomes increasingly clear as the artist makes his own authoritarian style a scapegoat, in confirmation of its authoritarianism. Abstract physical identity seems a springboard for obscure yet concrete subjective implications; the work concretizes in a new way, contradicting its aloof abstraction. It begins to seem impulsive rather than predictable, giving rise to impure perceptions—perceptions which do not codify the facts about matter but imply intangible and uncodified "spirituality." The work's material becomes unexpectedly enigmatic. Thus the "opulence and play of materials" in Andre's metal floor pieces does not simply articulate the logic of the physical, but becomes symbolically suggestive. The sculpture becomes part of a process which may originate with its physical identity but does not end with it, a process of self-transcendence epitomized by the view that the metal sculpture "radiates an extraordinary play of light that is almost Byzantine in its splendor." The "very real presence" of the sculpture is a matter of its subjective location as well as objective properties. Because we respond to

> the physical reality of the metal plates; the very real differences of surface, textures, and colors of the materials of such elementary substances as lead and zinc; the possibility of walking on the pieces; time—the natural process of allowing his materials to weather, decay, rust,[28]

instinctively, they acquire expressive value. The "good tone" of the work is denied by the vulgar life implications aroused by its own authoritarian pretensions, its own physical transcendentalism. The work becomes unintentionally expressive; the physical way it is intended is contradicted by the way the viewer works it over with his intention. He of necessity contradicts its givenness—by reason of the way consciousness necessarily works, and by reason of the way the work is unconsciously anchored in and so suggestive of a natural process in which its immediate appearance is only a detail. We respond to this process rather than to the work, which is merely its cue. In a sense, it does not matter—except for convention, which creates convenience—what state the sculpture exists in. What matters is how it makes us aware of the process which encompasses all its possible states, convertible into one another under certain conditions. It is this convertibility which matters; it makes the physical identity of the work ambivalent, and leads to recognition of its expressivity.

Conscious exploitation of this situation—in which a stereotyped physical identity becomes "unintentionally" expressive—seems to me epitomized in Robert Morris's work in general, and in his so-called sadomasochistic self-portrait poster (made for his April 1974 Castelli-Sonnabend show) in particular. In its exhibition of a quasi-authentic self, the poster makes explicit authoritarian style's self-contradiction in its "expressive" use of clichés, i.e., of seemingly unconditioned, universal forms and forms of meaning. The apparent sincerity of the self-portrait is belied by its self-advertising character, which makes clear that it is propaganda for Morris's art-self. Like all propaganda, it exists, as Ellul says, to "arouse an active and mythical belief" about its subject, not to give us accurate information about it.[29] That is, it exists to give the artist a mythical—transcendental—identity, much as authoritarian abstractionists make the physical identity of the work of art mythical and transcendental. Morris uses an authoritarian style to make himself abstractly significant, as though he had an identity which, like pure matter, was so perfect it had no need of activity to realize itself, any exemplification to complete itself. "I am who I am" says Morris, in the oldest cliché, that of self-identity. A cliché is a minimalist form; Morris's World War II German helmet, chains, and stony stare—all surplus, vintage stock—are the theatrically abstract materials of the cliché. Morris, a master of objectivist minimalist forms in the sixties, shows himself a master of subjectivist minimalist forms in the seventies. He brings the two together, under the auspices of the seemingly inescapable cliché—maybe their juxtaposition is meant to be the springboard of escape—in the article in which he declares his subjectivist intentions.[30] There the photograph of an ithyphallic water pot, with priapic spout and skull-shaped vessel, confronts geometricizing earth markings. Phallus and skull on the one hand, elementary geometry on the other, are minimalist in intention and form. The one gives us the cliché of life and death in connection, the other gives us the cliché of physical and transcendental form in connection. The two have never been clearly separated in Morris. For example, the predictable expressive effect of their juxtaposition is exploited in the *I Box* (1962) , a visual and intellectual pun in which the form of the capital letter *I* becomes a frame for a naked, grimacing Morris. In both cases we have the seemingly unadorned *I*, abstract form and expressive symbol confirmed and united by the concrete photograph. As with water pot and earthwork the juxtaposition is multi-leveled; it is both internal and external. Internally between life

and death, the physical and transcendental; externally between their pairing. The internal pairing prepares us for the external one, and perhaps controls it in the sense of reducing it to a cliché. We focus the juxtaposition of water pot and earthwork not dialectically but as a cliché, not as a process but as a finished, fixed meaning, because the pairing of life and death, the physical and transcendental is given to us as a cliché beforehand. Similarly, the capital letter *I* and the photograph of the naked artist juxtapose in a conventional, matter-of-fact manner. The irony achieved by the juxtaposition is predictable and tedious; it bears no fresh fruit, because it begins no new process of thought.

Morris holds that in "one energetic part" of seventies art "the private replaces the public impulse" of sixties art. Seventies space is subjective rather than objective, "centripetal and intimate" rather than "centrifugal and tough," a container for the lived body rather than a frame for the material body. Yet, as shown, the subjective and private is as much minimalist in form and a cliché in character as the objective and public. This view is confirmed by Morris's own demonstration of the subjective and private in the tape on which he recites an excerpt from Kraepelin's writing on schizophrenia. Kraepelin, who invented the term (which is now a slogan), was a nineteenth-century psychiatrist, and his sense of the self and its pathology are now obsolete. The obsolete hides in the cliché, which is the formalist dregs of living thought, the remains of a process which has moved elsewhere. The cliché is in effect a kind of embalmed corpse of consciousness, and its use is atavistic. The constant use of clichés, as in Morris, is authoritarian—an appropriation of their authority. They produce an art of instant readability and so seeming "command"—of materials and consciousness. The artist is credited with mythical power of control; all he has done is appropriated the over-controlled, the well-worn, and exploited its psychic patina. Authoritarian style finally becomes historicist, as in Morris or in the recent realism of Al Leslie. Morris's sixties sculpture communicates a nineteenth-century sense of the subjective—the cliché, as in Kraepelin, that it is readily reducible to types. The cliché inevitable leads to reductionism—historicism is one of its variants; and reductionism inevitably produces clichés—the two are reciprocal. The use of clichés satisfies the desire for economy of means, and economy of means creates clichés.

It is only when a great deal of energy is invested in the cliché that it seems to become more than itself. It is not clear that Morris invests such ener-

gy; his work, on face-value, seems cool. Nonetheless, in the self-portrait, a certain energy is generated by Morris's propagandizing, myth-making intention. The energy Morris spends making himself ironically heroic—theatrically grandstanding—is energy heaped on a scapegoat, the passion of vain instincts—vain in both senses of the term—expressing themselves in a self-destructive authority figure. In his vanity—and perhaps only by reason of it—Morris is an authority figure, exhibited for our acclaim. But he appears to us in chains, which, however theatrical they may appear in the context of an art exhibition, suggest a troubled, self-flagellating, imprisoned—at least in the role of artist—authority figure.

In this contradiction we seem to have something fresh. And yet the idea of the artist as scapegoat is a cliché with romantic and symbolist origins. It is at least as old as Van Gogh—Morris again shows his nineteenth-century sources, his reliance on the grandeur of clichés, on old intellectual and visual capital. Like all clichés, it is recycled, no longer for truth-telling but for myth-making purposes. Perhaps the most powerful recent statement of the scapegoat cliché is Rauschenberg's *Monogram* (1958). The artist, symbolized by an actual (stuffed) goat—paint-dabbed but still reminiscent of Hunt's more tidy *Pre-Raphaelite Scapegoat* (1854)—is both society's emblem and victim. He is driven into the American wilderness—the rubble of images the goat stands on. Fancifully yet necessarily wearing a tire—symbol of the American way of life always on the move—to show he is an American goat, he is both buoyed and burdened by his social role as symbol. He has riding on him, in the cliché form of a tire, social energies which at once raise him in importance yet weigh him down. The artist sees himself mythically both ways: at sea in society's bewildering wilderness of appearances, signs of its Protean energy; and safely afloat in it. He is both victim of its complex, contradictory life forces, and the epitome of its power and authority. This is the artist's use to society: he plays its goat.

In general, for Morris the work of art is a scapegoat surplus product, a dispensable cliché of form and meaning, having only the value the spectator—the symbol of society at large—gives it as he encounters it in the no man's land of the gallery or museum. He victimizes it and is victimized by it; he is ambivalent about it as it is in itself. It has a certain amount of authority, yet no more than he gives it by channeling his life-energy in its form. In other words, it forces him to recognize his own authoritarian style, i.e., his tendency to treat

his own identity as a finished form, but at the same time possessed of an energy that contradicts that form by reaching for other identities. The work of art teaches the spectator that he too is communal cliché and unfinished expression. Morris's self-portrait means to make clear that authoritarian style is archetypal, as Adorno means to do by rooting it in the Oedipal complex. That is, it is the primordial style of consciousness, always naively identifying with its object yet in the end negating the object by investing it with consciousness' own identity and energy. Stella and Andre also mean their authoritarian art to mediate the primordial style of consciousness, but their works fail to do so because they are unequivocally what they are, so the spectator cannot deeply invest in them. Morris's juxtaposition of clichés creates equivocation, evoking the spectator's own ambivalence, and so gains entry into the depths of his consciousness.

Morris's self-portrait thus summarizes the paradox of authoritarian style, especially because it shows Morris as both master and slave.[31] It is well-known that the core of Hegel's treatment of consciousness in the *Phenomenology of Mind,* and of Marx's treatment of the relationship of bourgeois and proletariat, is the master-slave dialectic. The point of these references is to make clear its universality and circularity, coinciding with its primordiality. Taken together as the opposite sides of a closed narcissistic circuit, master and slave relentlessly reflect one another. Neither can have a consciousness that transcends awareness of the other. Both thereby come to exhaust and absolutize the other's meaning—to finalize it is to exhaust it. Morris both exhausts and absolutizes his narcissism by presenting himself as simultaneously master and slave. He has thereby solved the problem of the relationship of art's physical identity to its expressive meaning, and so has exhausted the potential of art. Paradoxically, in authoritarian abstraction this potential is not exhausted because physical identity is made master, expressive energy is made slave—the discrepancy between them is upheld. At the same time, because each has the other as its exclusive horizon, the significance of both becomes bankrupt. Authoritarian abstraction creates a transcendence which becomes artistically as well as humanly crippling.

Much as the master cripples society as a whole by oppressing the slave, and the bourgeois cripples society as a whole by oppressing the proletariat, so in authoritarian abstraction pure form cripples art as a whole by repressing expressive meaning. All three suppress in the name of economy of means, material

welfare—in art the welfare of the material. The suppression paralyzes the entire order in a tension which eventually wears it down. In Morris's self-portrait, and also in Lynda Benglis's self-portrait posters, we witness such worn-out art, art reduced to a last stand—to a final minimum of form and meaning which, ironically, lacks all resistance to, any tension with larger social meaning, which floods it, and wipes it away as art. This is exactly what it means for art to wear out: it no longer seems like art, at once resistance to and significant codification of reality. In Morris and Benglis's self-portraits the codification is not significant because it is society's own. It is not the result of a resistance to society which transforms its surfaces into physiognomies indicative of depths of meaning. In fact, Morris and Benglis are resisting the art world—which is one way to get a significant identity in it, as Pop artists also knew—by introducing into it socially conventional, habitual at least in one area of society, images of themselves, which are unconventional only in an art-world context.

In the self-portraits the sheer material display of the artist's flesh reminds us that he/she is both master of his/her medium and slave to his/her instinctive compulsion to exhibit it. The theatricality of the exhibition is contradicted by the stereotype followed to make it possible, i.e., the cliché character of what is exhibited. In the end neither artist nor spectator know the point to the exhibition. There is a certain blasé dimension to it. It presents an identity which claims to have authority simply because it is exhibited—the same reason, in the last analysis, that the physical has authority for the physical transcendentalists. But the body has authority because we cannot exist without it, and the body as exhibited has authority because of its pose, which has the form of a cliché—the softcore porno pinup—despite its appearance to the contrary by reason of the rawness of its nakedness. But nakedness, raw or refined, is not new in art; Morris and Benglis indeed show themselves not only cliché-ridden, but traditional. Thus it is the underlying convention which counts, which has substance for them, and makes clear that we are witnessing a display of vanity—of the self-evident—rather than an exhibition of art, which always suggests that it reveals hidden evidence, hitherto unknown facts about the case of the world. Art returns to the vanity with which it began, the vanity of its prehistory. It ends making the sign of vanity indicating the loss of all dialectical tension, all challenging resistance to the conventions which create and control what we mean by a world. Vanity is the luxury of the artist who gains his reason for

being by commitment to and imitation of what, because it is obviously given, seems to need no reason for existing, and so seems to exist with self-evident authority—transcendentally. Similarly, in authoritarian abstraction forms are given vanity, i.e., assumed to have their own reason for being—to be transcendental. When the artist begins to substitute vanity—false self-reconciliation, with its false identity and false consciousness—for creativity, and presents himself as an idol—and his forms as idols—to be worshipped (Morris as self-destructive war-god, Benglis as rancid Venus and Harpy hermaphrodite) rather than a dialectician trapped in a struggle, then art has truly become a decadent luxury.

This essay is reprinted with kind permission from the Journal of Aesthetics and Art Criticism 36. *Fall, 1977.*

Notes

1. Liza Bear, "Richard Serra: Sight Point '71–75/ Delineator '74–76," (interview), *Art in America 64* (May–June 1976): 84–85.
2. For an analysis of objecthood and the view that "the success, even the survival, of the arts has come increasingly to depend on their ability to defeat theater," see Michael Fried, "Art and Objecthood," *Minimal Art: A Critical Anthology,* ed. Gregory Battcock (New York: Dutton, 1968), 116–47. Originally appeared in *Artforum,* June 1967.
3. Jürgen Habermas, *Legitimation Crisis* (Boston: Beacon, 1975), 85–86.
4. Joseph Masheck, "Robert Grosvenor's Fractured Beams," *Artforum 12* (May 1974): 40.
5. Joseph Masheck, "Robert Mangold: A Humanist Geometry," *Artforum 12* (March 1974): 40.
6. Nancy Foote, "Three Sculptors: Mark di Suvero, Richard Nonas, Charles Ginnever," *Artforum 14* (Feb. 1976): 34.
7. Jeremy Gilbert-Rolfe, "Brice Marden's Painting," *Artforum 13* (Oct. 1974): 34.
8. Rosalind E. Krauss, *Terminal Iron Works: The Sculpture of David Smith* (Cambridge, Mass.: MIT Press, 1971), 12.
9. Carl Andre, Letter to the Editor, *Art in America 64* (Sept.–Oct. 1976): 5.
10. Annette Michelson, "Robert Morris: An Aesthetics of Transgression," *Robert Morris* (exhibition catalogue), Washington, D.C., Corcoran Gallery of Art, 1969, 7.
11. Paul Valéry, "The Triumph of Manet," *Degas Manet Morisot* (New York: Pantheon, 1960), 108.
12. Umberto Boccioni, "The Technical Manifesto of Futurist Sculpture" (1912), *Theories of Modern Art,* ed. Herschel B. Chipp (Berkeley: University of California Press, 1968), 300.
13. Georges Braque, "Thoughts and Reflections on Art" (1917), Chipp, 260.
14. Georges Braque, "Observations on His Method" (1954), Chipp, 262.
15. Guillaume Apollinaire, *The Cubist Painters* (1913), Chipp, 222.
16. Clement Greenberg, "Master Léger," *Partisan Review* 21 (Jan.–Feb. 1964): 91.
17. Clement Greenberg, "Art," *The Nation 63* (27 July 1946): 109.
18. Valéy, "My Bust," 180.
19. Oscar Wilde, "The Critic as Artist," *Intentions* (New York: Brentano, 1912), 168.
20. Kasimir Malevich, "Suprematism" (1927), Chipp, 344.
21. Lawrence Alloway, "Isabel Bishop, The Grand Manner and The Working Girl," *Art in America 63* (Sept.–Oct. 1975): 62.
22. Dianne Waldman, *Carl Andre* (exhibition catalogue), New York, Solomon R. Guggenheim Museum, 1970, 8.
23. Thomas Aquinas, *Summa Contra Gentiles, Book Two* "Creation" (Garden City, N.Y.: Doubleday, 1956), 139.
24. Malevich, Chipp, 344.
25. T. W. Adorno, Else Frankel-Brunswick, Daniel J. Levinson, R. Nevitt Sanford, *The Authoritarian Personality* (New York: Harper, 1950), 759.
26. Masheck, "Robert Mangold: A Humanist Geometry," 40.
27. Gilbert-Rolfe, 38.
28. Waldman, 21.
29. Jacques Ellul, *Propaganda* (New York: Knopf, 1965), 25.
30. Robert Morris, "Aligned with Nazca," *Artforum 14* (Oct. 1975): 26–39.
31. Robert Pincus-Witten, "Scott Burton: Conceptual Performance as Sculpture," *Arts Magazine 51* (Sept. 1976): 115.

Authoritarian Aesthetics and the Elusive Alternative

I

A crisis in critical method has been in the making since the advent of modernist ideas about art. When the views of Clement Greenberg came together into something that, however loosely, could be called a doctrine, and were focused into the even sharper clarity of a code by Michael Fried—a process begun in the late 1940s and ending in the late 1960s[1]—they brought apparent order and inevitability to the practice of criticism. For one thing, the direction of criticism became as clear as the direction of art. Both emphasized its formal constitution, recognized its autonomy or purity. Criticism and art converged on the apparent essence of art; and the certainty with which the one grasped that essence and the other manifested it made both secure. But something happened since then which in fact was in the making long before the advent of modernism. Explicit doubts about the character of art's essence arose, almost violently, in the late 1960s, and quickly spilled over into the larger epistemological issue as to whether art had or needed an essence. Above all, the question was raised as to whether manifest form was this essence, thereby raising the question implying a resistance to manifest form—an indifference to art as display. Conceptual art focused both doubts, using them to generate a new

view of art as a realm of thought in which an idea was treated as a particular, and a rule was regarded as self-justifying. The nihilism implicit in such doubts shook the foundations of modernism, which began to seem more of a rigid scholastic dogma than a flexible approach to the necessities of art, and revealed its provincialism, i.e., its isolation and hypostatization of particular aspects of the practice of abstraction and their exaggeration into general principles. The critic was compelled to join the debate started by these doubts, or else, in an unwitting capitulation to another kind of nihilism, become no more than a passive reporter of art events, naively grateful for the bounty of works but still essentially in a passive relation to them, for they are not seen in terms of issues.

Before continuing, I should note that I am acutely aware that the outcry "Crisis!" like crying wolf, has occurred too often in contemporary thinking, and in general is an all too "typical symptom of our time"[2]—too typical to be heeded. And of course it need not be heeded by those who think that art, like a child, should be seen but not heard. To satisfy them there is an abundance of art that exists only to be seen, that does not want to be heard from because it has nothing to say. However, for those who practice criticism, which can be defined as the effort to listen to as well as look at art—to tune into it the way, putting one's ear to the earth, one tunes into distant yet impinging forces—the crisis is real if typical. In fact, its typicality confirms that it involves long-standing, unresolved issues indicating an enduring problematic of abstract art—embarrassing perhaps to those who take its practice for granted, yet the sign of genuine vitality. In this sense, awareness of crisis indicates renewal of the ground of critical understanding, the reassertion of criticality itself as the theme of art and criticism, the spirit that is at stake in both. Insistence upon crisis means the refusal to see either the artistic or the critical task as self-evident, as modernism thought they were—a refusal based on the recognition of the impossibility of a clear reading of the "essence" of both, indeed the recognition that to uncover essence is to obscure critical spirit. It is no longer possible to regard criticism as the visual equivalent of the *exposition du texte*, a "reading" of form in terms of its professed appeal to the senses. Such exposure of form no longer articulates the totality of the work: sensibility is no longer an adequate or exclusive accent to art, even sensibility "theoretically" refined by a consciousness of the supposed language of art. The alternative is perhaps not yet clear, but criti-

cism has become unexpectedly fresh with new if vague possibilities, new if obscure challenges, and art with a potential import that manifest form alone does not sustain or originate.

The drift toward an entirely positivist or purely descriptive "criticism" and resistance to it in the form of a criticism that sees the being of art emerging from and articulating a larger-than-art meaning, have been with abstract art from the start. Indeed, abstract art sharpened the contrast between these two approaches, for on the one hand its increasingly nonobjective surface seemed to function like an independent, free-floating erogenous zone, and on the other hand it seemed to promise a greater, more sublime significance, by reason of its apparent detachment from—even indifference to—society, than past art. Indeed, abstract art seemed genuinely classless, protecting no vested interests, and accessible to anyone willing to be "sensitive." The problem of choice between the approaches seemed solved with the socialization of abstract art, making it a convention there for the asking and a respectable source of sensation. It became enough to describe that sensation and the art that was its source. The ideologies that were used to justify it in its infancy—that claimed special import for it—became dispensable, beside the sensuous point of art. Indeed, they seemed all too abstract in contrast to the concreteness of the art, which sensibility had learned to bring into focus. The theories that were used to give abstract art depth of meaning were regarded as trivial in comparison to its sensuously manifest being, i.e., in Whitehead's expression, to its "insistent particularity." It was never imagined that without its "theoretical" background it would lose its sensuous insistence, and would be left only with a banal manifestness. It was assumed that particularity was immediate—in no need of mediation to make itself fully manifest—and that direct sense experience was the inviolable witness of particularity, a confirmation of the insistence of sheer givenness. Modernism absolutized abstract art's manifestness to prevent it from becoming banal, emphasizing its semantics and syntactics at the expense of its pragmatics, which were collapsed entirely into sensuous appeal. Modernism, with its descriptive assertion of the subtleties of formal achievement within the medium—achievement which always recognized the conventions of the medium as the touchstone for illuminating production—rescued abstraction from its own innocence. But the sophistication of modernism only seemed to empty abstraction of all meaning for those who thought there had to be something "behind"

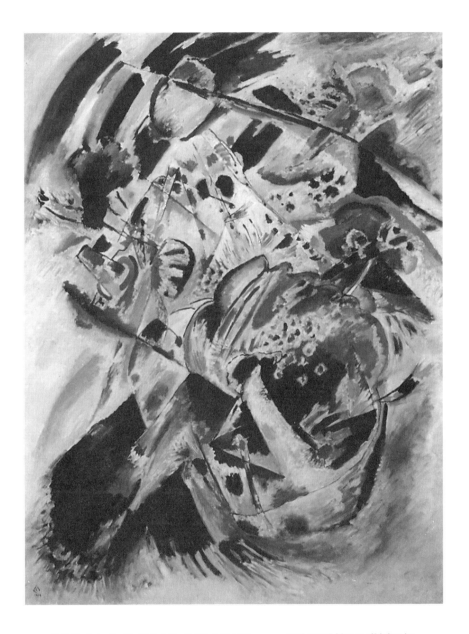

Vasily Kandinsky, *Panel for Edwin R. Campbell No. 4*, 1914. Oil on canvas, 64¹/₄" × 48¹/₄". Museum of Modern Art, New York, Nelson A. Rockefeller Fund. Photograph © 1999 The Museum of Modern Art, New York.

its surface—who thought there could be no particularity that was not mediated by a generality, that the effect of immediacy was the illusion at the end of a process of generalization and could even be regarded as the sign of overgeneralization. The generality behind the particularity was perhaps obscure—"behind" is undoubtedly a shorthand for what was irreducibly complex—but there was no way a particularity could be experienced as insistent without it. Thus modernism, despite its best intentions—the assumption that it had ended speculative obfuscation about art and revealed its reality as a matter of living appearance—only succeeded in aggravating the crisis it meant to end.

The nature of the crisis of critical method is clear in Michael Butor's comment on Will Grohmann's understanding of Kandinsky's late work, an understanding based on a preliminary, if admittedly inadequate, descriptive formalist approach.

> It is certain that for the most part those who talk about the painting they call abstract do not know how to look at it. I have a great deal of respect for Will Grohmann, and I am grateful to him for the work he has done, but when I read lines such as these:
>
>> "The last five years, from 1940 to December 1944 were nothing if not difficult ones, but the restlessness and tragedy of the period are not manifest in the paintings of these years. Similarly, during the First World War and during the Russian Revolution, Kandinsky's works did not reflect what was going on outside the studio."
>
> and when I look at his pictures, either those of the revolutionary period where everything is violence and deflagration, or those of the last war, where all the colors have grown darker, where the feeling is meditative, and whose repertory of forms has been utterly transformed, those paintings which are called (and we know what exemplary care Kandinsky took over his titles): *Fragments, Shadows, Twilight, Anxiety, Isolation,* I think I am justified in saying that Grohmann doesn't know what he is talking about. A few pages further on, moreover, describing *Fragments,* Grohmann himself makes the following comment:

"In *Fragments* a very similar form lies on a blue-black ground as in a grave, around which is set a mosaic of brightly colored stones. This mosaic has three small hollows in it with hieroglyphic-like offerings to the dead, and the whole is surrounded by a violet-brown border . . . Perhaps forebodings."

In 1935 Kandinsky wrote:

"I'd like people to understand at last what there is behind my painting . . . and not to be satisfied to notice that I use triangles and circles."[3]

It is worth noting that Butor's comment occurs in the context of a discussion of "Pollock: The Repopulation of Painting," which concludes with the following statement:

This problem of the "habitation" of the canvas is the central problem of painting today.

The study "from nature" is no longer enough for us, and abstract painting as it is prized today makes us sick to our stomachs; we are interested only when something in the concept of a composition tells us about nature and ourselves, speaks to us of the world and its workings.

The age of stupid painting is past.[4]

This was written in the early 1960s, but it is not yet clear that the age of stupid painting is past, or, for that matter, that the age of stupid criticism is past, i.e., formalist criticism that would prefer to attend to the triangles and circles of Kandinsky's late paintings rather than to what is behind them. There is a painting that caters to such criticism—a painting, indeed, which has nothing behind its forms. Grohmann himself, as Butor points out, cannot remain a strict formalist for long, but equivocally offers an uncertain metaphoric analysis of Kandinsky's *Fragments,* based on just what he insisted must be suppressed in the analysis of the late paintings, viz., reference to "what was going on outside the studio." Criticism always finds itself in the situation of the return of the repressed, undermining the methodology which insists on staying with manifest form rather than latent content. Here the repressed—"what was going on outside

the studio"—at first seems vague, and so hardly worth the trouble of serious attention, and yet—a world war—it was blatant enough during the last five years of Kandinsky's life, and during the formative years of his abstraction. Yet from the point of view of what can be called a generalized studio attitude it is impossible to find a precise connection between actual production in the studio and even the most blatant facts of social life. Such repressed facts can be recognized, but not utilized in analysis, because they contradict the basic assumption of formalist analysis, viz., that the studio world and the lifeworld outside it are not simply distinct but separate, not simply different but alien. Indeed, the formalists implicitly believe that their separateness protects the one from the other, allows the studio to become a higher world in which integrity can be achieved as it never can in the world outside the studio. The world of art becomes the alternative to the world of life, whose sordidness and horrors—"restlessness and tragedy," in Grohmann's words—seem to exist just to remind us of the necessity of transcendence, simply for self-preservation. There is always something wrong with the world, which the rightness of good art cannot correct, but escape from.

And yet Butor, and the Grohmann who wrote about Kandinsky's *Fragments,* assume that there was no way Kandinsky, hiding out in the studio, could mentally escape from the world outside it, for that world is the necessary if not sufficient condition for the existence of the studio. The studio rests on its foundation, and when that foundation is threatened, as in a world war—a war disrupting and altering the world which includes the studio—the studio itself is threatened, and the works that issue from it altered, indicating a disruption in the history of the artist. The question for criticism is not only why the altered art should take and eventually become normative, as in the case of Kandinsky's abstraction, but how the world-historical event manifests itself in the what—the form—of the art. Form is assumed to mediate the world historical, and even if that amounts to no more than what is historically important in the world of art—and that is often what it seems to amount to in trouble-free times—form is never assumed to exist on its own or without a latent source which it disguises as well as reflects. But Butor implies more: that there is not only no separateness between the studio world and the lifeworld, but that the boundary between them is arbitrary and nominal, a matter of convenience. Like a movable partition, this boundary exists as the need for it arises. The question is why the formalists should need such a strict boundary, a Berlin Wall of a boundary. Is it to

keep the pressures of the lifeworld out, behind a dam, or is it to keep the inhabitants of the art world in their zoo? Why is it that the formalists do not even acknowledge that the energies of the lifeworld may be harnessed, and converted into the electrical force that lights up the studio? Or is it that to work in a studio that has electrical power is already to betray its principle and purity, its primitive meaning? For Butor, we spontaneously "read" the lifeworld in the productions of the studio world, which is no more than another kind of workshop rather than a realm unto itself. It may have its own rules and conventions, like other specialties, but it is not different in kind from them, and the material it makes into useful products is supplied by the lifeworld. The lifeworld profoundly contains the studio world from this point of view. It makes possible the very idea of the studio, and changes in it are reflected in changes in studio production.

And yet so often in practice, after the initial readings of the lifeworld in the studio work, both seem to fade into insignificance, and the connection cannot be made to stick. The marriage seems forced, a house of cards that crumbles once one notes the matter-of-fact existence of the partners, which in the same breath seems to restore their individuality, or radical independence from one another. They are indeed different, and struggling to be separate, stretching the umbilical cord between them to the limit. One of them is sure to use it to strangle the other. The world historical, it seems, cannot be shown to be actively at work in the studio production, however much it may be acknowledged as the passive horizon of the studio itself. Every effort to show the world historical as immanent in the studio production only emphasizes the transcendence of the studio production. To deny the separation of the studio world and the lifeworld seems methodologically unsound: an openness to influences that amounts to chaos results, diminishing the identity of the studio production until it seems nothing more than the sum of its own susceptibilities. At best, the studio production is reduced to a symptom of the world historical, but that too hardly leaves it with a will of its own.

All of these caveats are well-taken but hardly seem true, especially in view of the fact that, in practice, analysis of abstract art has never reached so far as to view it exclusively in world-historical terms. In fact, it is harder to establish an exclusively world-historical approach than it is to establish an exclusively formalist approach, for the world-historical approach is inherently more respectful of formal values than the formalist approach of world-historical fac-

tors, and so is inherently less totalitarian. Simply to read a formal factor as a world-historical symptom is already to trust it—not only to allow it its integrity, but to take that integrity as indicative of what is integral to an understanding of world history. In contrast, the formalist approach dismisses any sense of the world historical as unreliable as well as inimical to the studio ideal—to the kind of integrity possible in the studio. Such dismissal amounts to repression, and as Butor suggests, it will come back to haunt formalist analysis. However much formalist analysis claims to deal with pure visibility, the world historical it has dismissed as hardly even an invisible influence in the studio will return to make that visibility seem impure, to poison the springs of pure seeing. That return may be hesitant and awkward, and the world-historical "inhabitant" whose traces are found in the studio production may be ill-defined and hideous with the horror of insurmountable obscurity, but its lurking presence will be undeniable, and undermine the apparent unity of the studio production. From the point of view of the studio mentality, the world historical is a monster haunting the purity of the work, destroying its integrity from within, corrupting it to the point where it loses sight of the studio and blindly searches for another frame of reference as a sanctuary. From the perspective of the lifeworld, it is the world historical that effects that disorder of the senses Rimbaud swore by—as the only salvation from the world historical.

But I reiterate, the world historical has not been established as the unequivocal basis of abstract art, and, apart from the inherent but not insurmountable difficulties of doing so, can never be in the face of an authoritarian studio aesthetics. The dominance of the studio approach is shown in the fact that the gallery is conventionally understood as no more than a stand-in for the studio which incorporates the spectator, who is regarded as an extension of the artist and whose criticality is regarded as no more than a submissive objectification of the artist's intention. The spectator is thus no longer a threat, no longer truly critical—no longer a representative of the historical world outside the studio. The studio approach neutralizes the critic, incorporating him in the studio as the factotum and alter ego of the artist. Similarly, the museum is regarded as the place that makes the world safe for art, the world in which the studio and the lifeworld are reconciled through aesthetic means—through a contemplation so absorbed in the studio production that it almost believes the production was self-generated. Thus we find Fried asking us to believe that

"Morris Louis's paintings, more than those of any previous painter, give the impression of having come into existence as if of their own accord, without the intervention of the artist."[5] For Fried Louis's paintings more than any other belong in a museum, which is ideally the apotheosis of the studio. Also, contemplation in the context of a museum seems so successful because in a museum the work has become completely at home in the world. It has, at last, achieved the security of representing the world—a cleaned up, ahistorical version of the world as petrified life, life frozen in whatever track it happens to find itself at the moment of contemplation. In the museum the studio production no longer resists the world while reflecting it—reflection is no longer a subtle form of resistance to what is reflected—so that a controlled experience of it is possible, and it acquires an essence, i.e., becomes "Art." And thus the notion of contemplation of essence through art develops, contemplation being the epitome of a controlled experience which leads to the illusion of essence. Indeed, for Husserl, the method of contemplation, based on a museum experience of art, is the privileged method of access to essence. It is not only in modernism that the studio convention has been absolutized, but in the world of art at large—the world of art considered not only as a privileged location in the lifeworld, but one that can bend the lifeworld to its will.

II

Modernist aesthetics has its most authoritarian formulation in Michael Fried. For Fried, modernism offers both a logic for the attainment of pictorial integrity and an analysis of the sensation of presentness—an aesthetics of presentness—that is its sign and effect. The analysis of presentness is Fried's unique contribution to modernism; his version of its logic is a refinement of Clement Greenberg's understanding of pictorial integrity in abstraction. As Fried writes in his essay on Morris Louis, "integrity is not only a moral condition but a pictorial task," as if to "evince integrity in pictorially significant terms"[6] was also to achieve a morally significant position. This is worth noting, especially in view of Grohmann's separation of the studio world and the lifeworld—the art historical and the world historical—and Butor's demonstration

of its hypocrisy, in view of the fact that the lifeworld completely contains and thus radically conditions the art world. Fried expects the successful realization of integrity within the studio to count for something in the lifeworld, as if the dignity of art was inherently a moral dignity. He assumes that artistic solutions are moral solutions, and that artistic determinations are determinations of being-in-the-world—resolutions of the problem of how to be in the world authentically. This is the dregs of the familiar idea that to the artist is to be more authentic than anyone else—to be a kind of god in conscious command of existence rather than its unwitting victim. It is to assume that the artist escapes the everyday and confronts the critical variables of life in a more fundamental way than everyone else. These implicit assumptions strike me as self-evidently false and arrogant—show a pretentious and self-righteous pursuit of dominance. More directly to the point, they indicate how the studio mentality appropriates and misuses categories of understanding appropriate to existential issues, as if being-in-the-studio was a superior way of being-in-the-world.

It should be noted that Louis, the exemplary hero of modernism for Fried, is described by him as a person who "lived for painting," who was never able "to reconcile himself to the inevitable circumstance that his students were often less passionately devoted to painting than he," and who "above all" was "profoundly serious," for he realized that "the ambition to make good painting has always entailed a stringent artistic morality."[7] Fried clearly identifies with this attitude, never doubting that to live entirely for painting was not necessarily a superior moral position, but may indicate exactly the opposite, viz., a refusal to face up to the facts of the lifeworld. However unconsciously the lifeworld was reconciled to the studio world—and I hope it is clear that by "studio" I mean a state of mind not a physical space—in what might be called the "unconscious" of Louis's paintings, it is clear that Fried does not believe there is hard evidence for such "reconciliation," or that there is something that might be called an "unconscious" to a painting, i.e., a realm in which the world historical might lurk. The relation between the studio world and the lifeworld is as "problematic" as Fried regards the relation of the modernist painter's "personal integrity" to the integrity "actually manifest in his paintings."[8] In Fried, so-called "art for art's sake" has become an ethical position making claims for itself in the world outside the studio. It almost seems to offer itself as a St. Sebastian to the arrows of the ordinary, vulgar world. Indeed, it even seems to regard itself as a vital

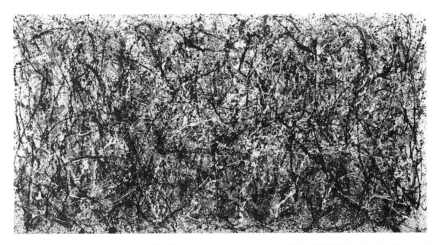

Jackson Pollock, *One (Number 31, 1950)*, 1950. Oil and enamel on unprimed canvas, 8'10" × 17'5⁵/₈". Collection of the Museum of Modern Art, Sidney and Harriet Janis Collecton Fund (by exchange). Photograph © 1999 The Museum of Modern Art, New York.

alternative to conventional moral complacency. Fried does not realize there is a sad confusion of categories—of the aesthetic and the moral—in his position.

The integrity of the modernist work is not and in no way can ever be a model for moral integrity, not even metaphorically. The modernist work rises above those it claims to lead. There is nothing remotely humanitarian about it, and the authenticity it offers tends to cast aspersions on those whom it expects to admire it. In world historical and moral terms, it is a hollow integrity that the modernist work offers. To demonstrate to its audience their philistinism— and a good deal of Fried is premised on the philistinism of nonmodernist artists as well as the public for art at large—is one thing, but to assume that this also demonstrates to them their moral inadequacy is another. The "truth" of the studio may ultimately be articulated in the sensation of timelessness that Fried calls "presentness," and that he regards it an impertinence to question, but such presentness makes little sense and has little to say to the world outside the studio, a world not simply stuck in time but which tries to make each step in time timely. Fried tries to tell us that the studio world has something to say about our condition—tries to convince us that, in the last words of his well-known essay *Art and Objecthood*, "presentness is grace."[9] But he succeeds only in convincing us of his and above all the studio mentality's presumptuousness, its lack of capacity for what it claims to achieve. The studio mentality tries to spread its wings as far as possible—encompass the lifeworld, as if to assure itself of its

own world-historical significance—but, like a haughty penguin, it cannot fly, and can survive only in the cold cage of the studio.

Fried gives away the inner meaning of his claim for the moral superiority of the modernist integrity by identifying it with "the illusion of a sovereign impersonality, that Mallarmé called for in poetry."[10] Extending his analysis of the "extraordinarily impersonal" character of Louis's painting, Fried asserts, quoting Hart Crane, that it signifies "certain aesthetic experience" that "can be called absolute," a form of "spiritual illumination."[11] Fried then makes a leap of faith to his own conception of presentness, based on the familiar view that the best art—the sign that is the best—establishes an illusion of eternal presence or eternal nowness. It is art that transcends history through its presentness, acquiring contemporaneity—consistent givenness—through its ahistoricity. Such art frees us from the sense of time by embedding us in the absolute moment—an ideal immediacy.

In fact, Crane's vision of the "absolute" poem as present to consciousness and memory not as something which has duration but as a single, new, unsayable "word" is, I suggest, a vision of it as somehow attaining to the non-temporal, and as it were instantaneous, presentness of paintings: as though it were the condition of painting, rather than to that of music, that Symbolist and Post-Symbolist poetry has been aspiring all along.[12]

There is a presumptuous reversal of traditional ideas in this statement—the assertion that poetry, and presumably the arts in general, aspire to the condition of painting rather than that of music—that is hardly worth dwelling on. Fried's challenge to Pater's conception of Symbolist aspirations is a byproduct of his conception of painting's extraordinary presentness. The question is why painting should have this presentness and make it more apparent than any of the arts—than music or poetry. Presumably each medium achieves its own presentness in particular works; the hierarchical emphasis on one medium at the expense of the others contradicts the integrity of each. Fried's assertion of the privileged position of painting seems like a concession to it rather than a demonstration of privilege. Fried is simply following his eyes, as presumably the most superior of the senses. This old idea, implicit in Fried's predication of the greater possibility of presentness of painting than of other art, is nothing more than extension of a traditional prejudice in favor of seeing. It is as if he is updating Plotinus's assertion that "beauty addresses itself chiefly to

sight"; for Fried it is presentness that manifests itself chiefly through sight. The prejudice has not gone unchallenged in the history of thought, and it should not be allowed to slip by unnoticed in Fried, for much in his thought depends on it. Belief in the primacy of seeing, and that modernist painting caters to pure seeing—offers an object which can be analytically reduced to "out-standing" elements yet loses nothing of its stability, thus satisfying seeing's ability to deal with diversity and unity together—are the presuppositions which give Fried's idea of presentness substance.

More immediately to the point is Fried's way of making presentness an issue. For by understanding the strategy he uses to articulate presentness the whole mentality of the modernist is revealed. Moreover, we will be able to see presentness for what it is, viz., another misconception of the infinite—of the eternal. The customary error is to regard the infinite as the endless finite; Fried errs on the other side, making it the finite limited to the immediate. Since presentness is inseparable from particularity of painting for Fried, the infinity presentness embodies by reason of what Fried calls its "atemporality" amounts to no more than an overdetermination of the finiteness of painting. To speak of presentness is no more than to speak of the finite particular at the moment the spectator becomes aware of its sheer givenness, emphasizing what Fried calls its apparent "instantaneousness." To settle on the instantaneousness of its appearance is to seriously reduce the terms available for our understanding of it while increasing our appreciation of it. For all the "positiveness" of appearance this gives it, it remains curiously blank—for all the painting's presentness it remains ironically empty, for it is all too finitely itself. Known exclusively through sensibility it is affirmed nondialectically—when, as Hegel asserts, the infinite, conceived even as the empty Absolute of the present, is the very embodiment of the idea of dialectic.

For Fried, the present becomes emptier and emptier because it refuses to give up its absoluteness. It does not renew itself, but remains tautologically banal: the modernist painting dwindles into a trivial, all too particular, self-identity. Whatever material dialectical structure constitutes it seems beside the point of its apotheosis in presentness. Indeed, the tension between the medium and its pictorial manifestation that modernism demands is less the immanent, inevitable dialectic of studio art, than the doubling—of the medium, the truly "positive" element of the work, altogether responsible for its integrity. The medium is aug-

mented, as it were, by its own manifestation in the particular work—it is that tautological demonstration of the medium which in the last analysis is responsible for the illusion of the work's superficially daring presentness.

Fried's presentness comes to us in two ways, which correlate: as under siege—embattled, threatened—and as carrying the burden of the being of art. He offers us an all-or-nothing situation: Either we win through presentness, securing art, or with the loss of presentness art is defeated. Thus, as Fried asserts, in a paranoid argument—as though only the desperation of paranoia could give credibility and urgency to his ideas of presentness, which otherwise loses all authority—"presentness has for the first time become an issue for painting," and unless "the ambitious painter" "secures" presentness—"for example, through the medium of shape"—his paintings will lack "conviction as paintings" and "be experienced as a kind of object, and as having, rather weakly at that, the essential theatrical kind of presence that exhibited objects have."[13] Fried invents a situation of painting haunted by theatricality, desperate to disinfect itself of the taint of theatricality, in a kind of paranoid aestheticism: "What is nakedly and explicitly at stake in the work of the most ambitious painters today is nothing less than the continued existence of painting as a high art."[14] The presumed crisis in painting is tied directly to the persistence of theatricality in high art, or rather, because of this persistence, pseudo-high art.

Thus, reciting the modernist credo, Fried offers the following catechism: "The success, even the survival of the arts has come increasingly to depend on their ability to defeat theater;"[15] "art degenerates as it approaches the condition of theater;"[16] and "the concepts of quality and value—and to the extent that these are central to art, the concept of art itself—are meaningful, or wholly meaningful, only within the individual arts."[17] These dogmatic assertions are noteworthy for their moralistic tone: theater is the moral sin of art, the cancer that corrupts and rots it from within, destroying it in the name of a false conception of art. The opposite of modernism's martyrdom complex is its crusader mentality, which Fried also gives abundant evidence of: "It is the overcoming of theater that modernist sensibility finds most exalting and that it experiences as the hallmark of high art in our time."[18] Both the complex and the mentality are strategies of dominance: one is either the martyred victim of the dragon of theater or its slayer. In either case one has fought the good fight on the right side.

In a final statement of the modernist aesthetic, Fried makes the manifestness of modernist art itself the condition of its dominance or superiority, generalizing Greenberg's conception of all-overness into a conception of manifestness, in which total manifestness implies timelessness.

The literalist preoccupation with time—more precisely, with the duration of the experience—is, I suggest, paradigmatically theatrical: as though theater confronts the beholder, and thereby isolates him, with the endlessness not just of objecthood but of time; or as though the sense which, at bottom, theater addresses is a sense of temporality, of time both passing and to come, simultaneously approaching and receding, as if apprehended in an infinite perspective. . . . This preoccupation marks a profound difference between literalist work and modernist painting and sculpture. It is as though one's experience of the latter has no duration—not because one in fact experiences a picture by Noland or Olitski or a sculpture by David Smith or Caro in no time at all, but because at every moment the work itself is wholly manifest. . . . It is this continuous and entire presentness, amounting, as it were, to the perpetual creation of itself, that one experiences as a kind of instantaneousness; as though if only one were infinitely more acute, a single infinitely brief instant would be long enough to see everything, to experience the work in all its depth and fullness, to be forever convinced by it. . . . I want to claim that it is by virtue of their presentness and instantaneousness that modernist painting and sculpture defeat theater. In fact, I am tempted far beyond my knowledge to suggest that, faced with the need to defeat theater, it is above all to the condition of painting and sculpture—the condition, that is, of existing in, indeed of secreting or constituting, a continuous and perpetual present—that the other contemporary modernist arts, most notably poetry and music, aspire.[19]

Part of my objection to Fried's formulation of presentness is the godlikeness it not simply asks of but gives to the spectator, as an extension of the "divine" manifestness of the work—a manifestness in abstraction not unlike the kind of manifestness or presentness established in Jan Van Eyck's *Adoration of the Lamb*. But there is one crucial difference. In Van Eyck divinity or divine presence imbued the lifeworld and was carried over into the pictorial world, giving it its sense of presence. In the modernist art Fried mentions, art as such establishes the divine aesthetic experience of presentness, which does not carry over into the literal lifeworld; the studio world/lifeworld separation remains

intact. This difference—modernism's denial of even the possibility of continuity of experience between the studio world and the lifeworld—is another indication of the authoritarian character of presentness. The literalists suffer at Fried's hands because they insist on, indeed never doubt, the continuity of the studio world and the lifeworld. They bring time into the supposedly timeless world of the studio, interfering with its attempts to demonstrate timelessness and thereby to make its own ideality manifest. Thus Fried sheds crocodile tears for the literalists; while acknowledging their "dedication, passion, and intelligence," he dismisses them as not producing "the authentic art of our time." They cannot even begin to do so because they are committed to "the concepts of literalism and theater," which for Fried are endemic to—and he would probably say epidemic in—the lifeworld. These concepts are alien to and subversive of the studio world.[20]

There are other, somewhat subtler, signs of authoritarianism in Fried. When, in the last extended quotation, Fried writes that "I am tempted far beyond my knowledge to suggest," or when, near the end of his essay on Louis, he states that his "remarks are perhaps impenetrably obscure"[21]—the remarks about illusory sovereign impersonality and absolute art—he takes a stance which broaches no argument. Hiding one's head in the ostrich hole of obscurity has always been a sign of yearning for dominance. Indeed, the sensation of presentness itself, conceived as an absolute—as sovereign and impersonal— indicates a fascistic centralization of the art experience. It implies that the aesthetic is exhaustive of—totalizes—the art experience. Such presentness is more than an expression of what T. S. Eliot calls "the full surprise and elevation of a new experience of poetry" and other kinds of art.[22] Similarly, sovereign impersonality is more than the impersonality Eliot spoke of when he noted that a work of art "is no longer purely personal, because it is a work of art itself,"[23] or when he remarked that "the poet has, not a 'personality' to express, but a particular medium, which is only a medium and not a personality"[24] and again that poetry "is not the expression of personality, but an escape from personality."[25] Eliot concludes his essay *Tradition and Individual Talent* with the following statement:

> But very few know when there is an experience of significant emotion, emotion which has its life in the poem and not in the history of the poet. The

emotion of art is impersonal. And the poet cannot reach this impersonality without surrendering himself wholly to the work to be done. And he is not likely to know what is to be done unless he lives in what is not merely the present, but the present moment of the past, unless he is conscious, not of what is dead, but of what is already living.[26]

Fried's sense of art's impersonality or disinterestedness—it should be noted that he has written that "the concept of interest implies temporality in the form of continuing attention directed at the object" in contrast to "the concept of conviction"[27]—is much more than a fresh formulation of Eliot's sense of art as an *Aufhebung* of personality by those with strong personality: "But, of course, only those who have personality and emotions know what it means to want to escape from these things."[28] (Note, incidentally, Eliot's distancing if not dismissal of them by regarding them, at arm's length, as "these things.") Rather, Fried is upholding a sense of impersonality as absolute—hardly denied by the alibi of calling it "illusory" since it is pursued vigorously—in the sense that, to use a key concept of his latest book, it implies the "absorption" of the person in the work to the extent that he can no longer properly be called a person. He seems to have transcended his life-history, to have hardly any existence outside the studio world implied by the work, as indeed seems to have been the case for Morris Louis. The idea of being totally absorbed in art is a way of absolutizing it, giving it an authority it does not normally have in the lifeworld—indeed, making it seem to triumph over the historical lifeworld. What Eliot wanted from the artist—an impersonality achieved by an aesthetic experience that would "engross the total faculties of the spectator"—Fried wants with a vengeance, a completeness that amounts to a nihilistic denial of the world beyond the studio. (It should be noted that I am not equating such denial with renunciation of the world for a higher commitment, even though there is a strong hint of the ideology of art as religion in Fried.) The absoluteness of absorption he calls for is not another version of otherworldliness or yearning for the beyond, but rather the elimination of the world and of being-in-the-world as a problem. Traditional religious otherworldliness offers itself as a solution to this problem, but absolute absorption in absolute aesthetic experience denies that there is such a problem.

That presentness represents a triumph of the aesthetic over the exis-

tential for Fried is made transparently clear in his most recent reaffirmation of his modernism, in which he asserts that much seemingly difficult and advanced but actually ingratiating and mediocre work of those years (the 1960s) sought to establish what I call a theatrical relation to the beholder, whereas the very best recent work—the paintings of Louis, Noland, Olitski, and Stella and the sculptures of Smith and Caro—were in essence anti-theatrical, which is to say that they treated the beholder as if he was not there.[29]

That is, they treated the beholder with ruthless impersonality. One cannot say that this is a matter of contempt for him, but rather based on the assumption that he will realize his "thereness" in all its fullness only when he absorbs himself in the modernist work's presentness, i.e., its thereness. As Fried has written, "For theater has an audience—it exists for one—in a way the other arts do not; in fact, this more than anything else is what modernist sensibility finds intolerable in theater generally."[30] It is as though existing for an audience detracts from—altogether precludes—the experience of presentness or absolute aesthetic sensation, because it reminds us of a basic condition of being in the world, viz., that we are there for others.

Further and more crucial difficulties arise from Fried's assumptions. He regards art as entirely a matter of sensibility. Imagination, for example, in Baudelaire's sense of the term, is precluded. For Baudelaire, imagination "decomposes all creation, and disposed in accordance with rules whose origins one cannot find save in the furthest depths of the soul, it creates a new world, it produces the sensation of newness."[31] But for Fried art is neither the re-creation of the old world or, what amounts to the same thing, the creation of a new world. It neither originates in nor is it destined for the world, as a kind of profound comment on it. Nor is it concerned to produce the sensation of newness—a category of history and the lifeworld—but of presentness, which is a category of the timeless studio world. Studio art is a way of producing the sensation of presentness, whereas imaginative art—theatrical, for Fried—is a way of producing the sensation of newness. Thus Fried begins his study of Louis with a quotation from Marx: "The forming of the five senses is a labor of the entire history of the world down to the present."[32] Fried praises Louis because in the very act of clarifying or purifying the medium of painting he affords us a superior or purer sensation of sight. Fried assumes that each medium appeals to a different sense—in part the justification for keeping it separate from the other

mediums, not blurring the distinction between them in a theatrical art designed to appeal to more than one sense, and not dulling its distinctive "edge" on experience—and that the purer the medium the more acute the experience of the sense it appeals to. This finally amounts to the sense becoming conscious of its own experience. Thus the drive toward purity or the insistence on the autonomy of each art exists in the name of the education of the senses, forming them so that each can finally experience its own presentness through the experience of the medium's presentness. Thus, when Fried asserts that "the opticality of the 1947–50 paintings, founded on the negation not only of traditional tactile illusionism but of drawing as well, . . . lies at the heart of Louis's relation to Pollock,"[33] he is urging that we view both Pollock and Louis in terms of purity, i.e., their purification of the medium of painting in the name of pure seeing. Only such sense purity can give the charge of presentness, the illusion of sovereign impersonality, central to Fried's aesthetics.

Taking Fried at face value, one cannot help thinking that the sensation of ineffable presentness—strictly bound by pure sense experience—is simply the effect achieved by insisting that a particular work directly reflect its general medium, thus reducing the work to a kind of absurdity. Ineffable presentness simply acknowledges that the work has nothing to say that is not already said by the medium. Carrying this further, one recalls Gombrich's remark that "the scholastics who were impressed by the fact that the individual eludes language coined the famous phrase that *individuum est ineffabile.* I think it follows from this that *individuum est inexplicable.*"[34] Presentness is simply a way of asserting the nonlinguistic character of painting, i.e., that because language is not part of its particularity experience of it is ineffable, indeed, finally inexplicable—not translatable into language. Presentness announces that no perspective on the particularity of painting is possible; one is silently absorbed in seeing it, one's necessary silence enhancing, indeed, constituent of, its effect of instantaneousness.

If this is true, Fried commits what Whitehead calls the fallacy of misplaced concreteness, i.e., Fried overstates the concreteness of particular paintings as well as the medium of painting. By treating them strictly in terms of a studio version of seeing he precludes their world-historical meaning. Whitehead writes that the "fallacy consists in neglecting the degree of abstraction involved when an actual entity is considered merely so far as it exemplifies certain categories of thought. There are aspects of actualities which are simply ignored so long as we

restrict thought to these categories."[35] In Fried's usage, presentness is an abstraction, a category of thought, to which painting must conform if it is to be truly actual. And yet by viewing painting exclusively in terms of presentness there are aspects of it which are undoubtedly overlooked, aspects which are not strictly aesthetic and yet which have everything to do with its existence as art— the seriousness with which we take it as art. Superficially these have to do with *Weltanschauung,* including the understanding of the studio mentality as a *Weltanschauung.* More pointedly, what is missing from the studio aesthetic of presentness Fried articulates in a sense of the presentness of painting, and art in general, as a response to being-in-the-world, one solution to the problem of how to be in the world. This gives painting a more than "simple location,"[36] to use the language with which Whitehead describes the results of misplaced concreteness. And it makes clear that what Whitehead calls "insistent particularity,"[37] whether in art or in life, is never simply a matter of simple location— which is all that presentness gives art and life.

To speak of painting entirely in terms of presentness, or to boil down the difference between authentic and inauthentic painting to the distinction between purity and theater, is to do violence to painting—to simplify it to the extent that it seems simplistic, and so hardly relevant even in itself, which is the only way Fried wants it to be relevant. More pointedly, it is to make a certain kind of pure painting seems simplistic, an effect which no amount of talk about its "sovereign impersonality" can eliminate, for such impersonality is a characteristic form of unconsciousness. The tautological reaffirmation of the pure as the impersonal, or, for that matter, the festishistic treatment of presentness, avoids recognition of the lifeworld implications of purity, above all, recognition of it as an ineffective way of being-in-the-world. It is more a form of aggressive negativity toward the lifeworld than an affirmation of the possible power of abstract painting. To see it this way—as a kind of perverse attachment rather than heroic detachment—is at least to see it less simplistically than automatic ratification and exaggerated embellishment of its purity does.

Lacking, then, a "large, adequate generality"[38] in which to locate abstract painting, Fried reduces it to a temporary erogenous zone of static sensation. Certainly the distinction between purity and theater is hardly such a generality, since it is another version of the distinction between the studio world and the historical world outside the studio. The preference for purity over the-

ater is not more than a preference for the studio, with its promise of escape from world history and the presumed happiness of aesthetic experience that it brings, to the world outside, in which there can never be even the illusion of escape, at least not any durable or incontrovertible illusion. Indeed, preference for the studio, backed up by the belief that it is the high road to purity, ignores the fact that being in the studio is a way of being-in-the-world—a highly personal way, in the sense that it becomes an avenue of approach to becoming a certain kind of person, which I would define as one all too trusting of the transcendence supposedly offered by aesthetic experience, all too believing in aesthetic experience as a source of transcendence.

Whitehead writes: "One characteristic of the primary mode of conscious experience is the fusion of a large generality with an insistent particularity."[39] Fried's aesthetics offers no such fusion, and so cannot be regarded as a kind of criticism; true criticism attempts to effect such a fusion. Fried is obsessed with art's particularity, whose insistence he exaggerates, as if in compensation for the absence of a large, adequate generality in his "criticism." The medium is not this generality, for it is hardly able to adequately account for the work of art's insistence. It is obviously a necessary condition for the particular work, but hardly the source of its full effect, even when the work seems to use its medium effectively. For an adequate account of the work's presence one must go beyond the sense of its self-identity that Fried's notion of its presentness articulates. As Hegel writes,

> the pure Law of Identity is met only too frequently in experience, where it is seen clearly enough what respect is paid to the truth which it contains. When the question, "What is a plant?" (for example) is met by the answer "A plant is—a plant," the truth of this proposition is straightaway admitted by the entire company upon which it is tested; and it will be said with equal unanimity that this answer says nothing.[40]

Thus presentness says nothing; to say that a painting is its manifestness and that it makes its medium manifest is only to say it is a painting. To insist that that is all there is to it is to give it an absolute identity. But as Hegel writes, "Identity is not truth and absolute truth in itself, but quite the opposite; it is not a rigid simplicity, but a passing beyond self into self-dissolution."[41] But

Fried establishes the painting as a rigid simplicity; it has no "further determination," it does not pass beyond itself. It has only the identity of a limited product of the hermetic studio, which is hardly enough to make it insistent in the world.

III

What is the alternative to modernist aesthetics, and why do I think this alternative is elusive? Despite my sense that Fried has turned a method for describing a certain kind of abstract painting and sculpture into an authoritarian assertion of what is ideal and unconditionally at stake in painting and sculpture as such, I cannot help but share his skepticism "in advance of any attempt to represent that relationship (between the painting and the beholder) and that ('internal') development (of the art of painting and the wider social and cultural reality) as essentially the products of social, economic, and political forces defined from the outset as fundamental in ways that the exigencies of painting are not," thereby putting on guard "any thoroughgoing social-historical (e.g., Marxist) interpretation of that material."[42] I say this even though I do not believe there is such a thing as a strictly "internal"—even put between quotation marks which leave its meaning open, if not so porous as to end up totally in doubt—development of art. I also do not believe there is a ready-made social-historical interpretation of the development of art that can do it justice. Every attempt at thoroughness—whether from the side of aesthetics, such as Fried's, or from the side of social history, such as the Marxists offer—eventually erodes the art which is its object, misplaces its concreteness, reduces it to the special irrelevance and simple location of a symptom or example. However much existence through a system—finding its place in a more comprehensive reality than its own—raises the status of art and affirms its significance, the location of it within a system of thought radically reduces our sense of its concreteness. Above all, what is lost is our sense of its critical thrust—the criticality of its existence, of its relations with itself and with the world. Systems in general are useful to a point and in fact inescapable, but absolute systems lose their usefulness by demanding accommodation as the price of admission—by demanding submission to their categories as the price of elevation to their kind of

significance. In modern art's case such accommodation is particularly pernicious and self-defeating of the art eager for elevation to some form of self-styled universal significance, since modern art is an enlightened approach to art which views it as an escape from and criticism of absolute systems, with so-called divine rights to rule life and thought. Not that they don't rule, only that their rule is not inevitable, and thus that they are not absolute. This may be a naive assumption on my part—although I think it is a demonstrable idea—but the best modern art strikes me as self-consciously critical in spirit, and a reminder to our own critical spirit, a call for it to rouse and renew itself. Modern art is not simply critical of the means of art, but of the world in which it locates—of the very meaning of location in the world, which a critical conception of the means of art cannot help contributing to. This has been said before—the special emphasis on the critical spirit of modern art has been remarked by artist-thinkers as diverse as Baudelaire and Wilde and T. S. Eliot—but it must be remarked again, for modernism makes us forget it, or at least blurs it into a limited truism, one that applies only to art's consciousness of its conventions. In modernism, to say that art has a critical relationship to its own conventions is to affirm rather than deny art as a closed system—to do just the opposite of what the critical spirit, with its search for an opening in the inevitable, attempts to do.

In general, the application of a comprehensive, seemingly irrefutable logic, whether modernist or Marxist, to art—a logic which, as Karl Mannheim says, we can only show to be ineffective, not incorrect—leaves us with what might be called the disappearing work of art. Indeed, it is to transform the active work of art into the passive object of art. It may be that every attempt, in Whitehead's words, "to infuse into the insistent particularity . . . that non-temporal generality which primarily belongs to conceptual thought alone"—to reconcile experience and "conceptual justification"[43]—is doomed to subtly fail. But the attempt to absolutize insistent particularity by absolutizing conceptual thought is doomed to fail in a particularly miserable way, for it desensitizes us to the insistence of the particularity, and finally makes it seem not only less compelling but a fraudulent aspect of the particularity. While particularity needs generality to be insistent, fusion with absolute generality suppresses insistence—destroys intensity of experience. Unintense art is more easily seen as symptom or example, i.e., as representative of a system. As Hans Sedlmayr writes,

To evaluate works of art that are genuine creations exclusively as symptoms of mental disorder would be doing them a great injustice, yet hardly greater than taking them exclusively as examples and transitory points in the development of a style, as the criterion of art on purely stylistic grounds—levelling all differences of quality and worth no less than symptomatic criticism does—has been doing for some time.[44]

But my last reason for speaking of an elusive alternative to modernist aesthetics is based on my sense that the world-historical generalities that are customarily brought to bear on art have been ill-defined and ineptly applied, leading at once to an overgeneralization and underdetermination of art. They have not been used precisely—which does not mean that the sense of precision modernist aesthetics gives us is adequate to the art it advocates. The vagueness with which world-historical generalities have been brought to bear on modern art is due to the difficulty of formulating them in critical terms— the difficulty of showing how they concretely influence the work of art, critically affecting its choice of terms and method of operation. This difficulty is inherent, due to the fact that art seems to be an unstable dialectical structure with no easily formulated or even assumed unity because it is partially grounded—in its immanent structure as well as "transcendental" appearance— on the changing perspective of a time-bound beholder. (The modernist assumption of the work of art's unity is a hypostatization of it based on an undeclared assumption of its essential timeliness. Only out of time is stable unity possible.) Because the work of art offers itself as something that can to an extent be reconstituted by its beholder in terms of his lifeworld—and I think this fact of the experience of art, rather than deference to the idiosyncratic power of the senses, is the message behind the common assertion that taste cannot be disputed—the work is only temporarily in a situation of stable unity or simple location. And, in a time when the lifeworld itself has been secularized—which means denied any central tendency—the determination of the world historical, which is the only satisfactory basis for a large, adequate generality, is far from easy. It is doubtful that the world historical has ever been self-evident—anything more than a construct of archeological retrospection—but its lack of self-evidence is itself self-evident and troubling these days.

Despite these problems, one finds oneself propelled towards world-historical generality in the effort to escape the authoritarianism all aesthetics tends toward, limited as it is by its appeal to sense-certainty. The bottom line of any argument from sensation is a further qualification of sensation, a circling back of sensation on itself in an infinite regress. This is a situation of diminishing returns, for all the "ideality" it achieves—for the way it makes sensing a self-conscious process. The only escape from this circle of sensation, which seems to reduce the work of art to a trigger of sensing, is by recognition of world-historical generality, which substantiates the work anew as a relational process, and, paradoxically, thereby intensifies the sensation of it. The work is no longer reduced to a source of pure sensation, but becomes a sensation of the lifeworld, a more or less articulate way of registering its presence and effect. The absorption the work of art promises is disclosed to be a measure of the binding, indeed coercive power of the lifeworld rather than of one's capacity for sensation. The work becomes emblematic of dialectical intensity rather than pseudo–self-absorption. What it loses in catalytic power, it gains in psychosocial import, but that in turn makes it all the more "stimulating."

One comes to recognize that aesthetic sensation as such reflects the beholder's sense of what "inhabits" the work of art—the beholder's general sense of the world, which in the final analysis is what determines his sensibility. Butor's problem of habitation of art is inescapable, even in aesthetics—in the aesthetics of presentness, which asserts that what inhabits the work of art is neither more nor less than the work of art. Modernist aesthetics gives the work of art an easy identity, a self-identity which results from its aesthetic doubling, more precisely, the doubling of it in aesthetic sensation. This does not so much generalize it— give us a perspective on it which tells us why it is important (i.e., it can only be important from a point of view that is outside it—from a beholder's point of view)—as insist on its particular givenness. Aesthetic sensation—recognition of the work's presentness—isolates and abstracts the work's insistence, returning it to the work's particularity as a kind of grace, the seemingly gratuitous gift of the gods. All this does is confirm the results of the aesthetic "operation" which bifurcates the work into its particularity and its insistence. The aesthetic operation seems to succeed in taking its pound of aesthetic flesh from the work without shedding any artistic blood. The operation performed is clearly a success, even though the patient—the work of art—is left dead.

Rather than attempt to offer my own determination of what might be crucially world historical in the development of abstract art—at once beside the point in a paper on critical method, and methodologically mad to the extent it assumes a dominating rather than persistent factor—I would like to examine one comprehensive yet self-critical attempt to characterize modern art as a whole in terms of world history. In general, such an attempt assumes distance from as well as closeness to art, a perspective on it which regards its presentness as a source of possible if unfocused generality rather than as a symptom of assumed ideality. Such an attempt assumes that art itself is an attempt to articulate significant and adequate generality, and thus can be said to refer back to the world-historical conditions of its origin. I am speaking of Hans Sedlmayr's interpretation of modern art as the reflection of a spiritual crisis in Western culture, sign of a fundamental reorientation in the spirit with which man creates and inhabits his world. Such an interpretation is somewhat declassé in art-historical circles, if not entirely passé in other circles. However, I am not interested in questioning the validity or invalidity of Sedlmayr's approach, but rather calling attention to the perceptive, even brilliant analyses Sedlmayr makes of particular works and particular artists, under the auspices of his general theory of modern art. It is the general theory that is the condition for the specific analysis but it is the specific analysis rather than the general theory that is adequate or inadequate. The general theory is a numinous limit to analysis, the heuristic gambit that makes it possible, but adequacy depends on the dialectical fit between art and the concepts—intermediate between the art and the general theory—the general theory makes possible. The general theory is the light giving life to the concepts, which in turn give life to the art; the general theory occupies the place of the "good" in Plato's epistemology. The general theory is at once the origin and end of all else, the final cause of creation in the sense that the general theory gives it overall intelligibility, the condition which makes it articulate in itself and allows us to articulate it analytically.

What initially counts, then, is not the correctness or incorrectness of Sedlmayr's vision of the "good" of modern art, but the working hypotheses by which he makes his vision more than contemplative, by which he activates it so that it becomes analytically trenchant. It is his sense of modern "tendencies" that matter, each one like a bit to be used in an analytic drill.

1. The establishment of "pure" spheres in art (purism, isolation).
2. The progressive driving asunder of opposites (polarization).
3. A progressive hankering after the inorganic.
4. Detachment from the solid earth.
5. A tendency to be attracted by the lower rather than the higher.
6. A tendency to give an inferior status to man.
7. The abolition of the distinction between top and bottom.[45]

The way, e.g., Sedlmayr brings his notions of detachment from the solid earth and the abolition of the distinction between top and bottom to bear on Ledoux's proposed spherical house (1773),[46] illuminates it as no merely formalist description, however aesthetically responsive, could. Sedlmayr shows us how the being and the meaning of the work interpenetrate in an apotheosis of it—something quite different from taking it as a symptom or example—that makes the precision of formalist description beside the point. As Klaus Riegel observes, "as the precision (of formalist description) increases, so does the rigidity of the structure it provides."[47] In Sedlmayr's dialectical description structural rigidity is precluded because the insistence of the particular work is not aesthetically codified. General concepts, grounded in observation of function and relation rather than in deductive presentness, comprehensively articulate the workability of the art, rather than seduce us into a sense of its inevitability. Sedlmayr's concepts function descriptively rather than, like the sensation of presentness, prescriptively. They give us the categories which open the work to the beholder rather than the ideal way it is closed in upon itself, and imposes itself on the beholder.

One can regard Sedlmayr's largest generality as "unfitting," and finally as altogether inappropriate, but this is because the concept of the spiritual health of a culture has not been clearly developed, undermining its value if perhaps allowing an increase in its circulation. Sedlmayr's use of it is self-critical, i.e., he tells us not only where he is coming from, but exactly why he is coming from there. He exposes the roots of his methodology, in a kind of self-analysis, something Fried, and the modernists in general, hardly seem capable of, so obsessed they are with getting their point of view across, to obtain ideological power. Sedlmayr is nowhere near as dogmatic; the virtue of his position, by reason of his self-critical presentation—by reason of the fact that he offers it to us

as a perspective rather than a dogma—is its tentativeness and thus revisability, its cautiousness and thus its self-consciousness about its consequences. It is presented not as a primordial truth about art and culture, such as modernism thinks it offers, but as a proposed way of thinking which makes certain things intelligible, or rather, gives them a certain kind of intelligibility which makes no claim to exhaust their significance.

Sedlmayr does what must be done with every determination of the world historical, and which by its nature modernism is incapable of doing, viz., show how the terms of the work are operational in terms of the determination—how the world historical constitutes the work without codifying it. Such an analysis tries to operate as far as possible without falling back on studio conventions of constitution, or rather, by subsuming them in the world historical. They become a dialectical product of the process of world constitution; every modernist attempt to awaken from the nightmare of history, such as Fried's, is such a product. Specious presentness is replaced by the true transcendence of dialectical location, aesthetic integrity by internalization of the work as a possible identity in the world. The world historical becomes responsible for the internal development and external effect of the work of art, without thereby becoming prescriptive of excellence in art.

Sedlmayr, it seems to me, is most illuminating in his discussion of the relationship of technology—understood as an insistent, if not absolutely dominating, world-historical factor partially definitive of modernity—to art. His discussion, in some of the essays collected in *Der Tod des Lichtes*, almost reaches the heights of Ellul's discussion of art's role in *The Technological Society*. What is important for my purposes here is what Sedlmayr has to say, speaking generally, about the way one determines the world-historically significant. "Art," he writes, "is only art when it remains related to the totality of the human."[48] Quoting Adelbert Stifter's assertion that the work of art has effect only to the extent that it elevates (*aufhebt*) every other voice and thereby finds its own, Sedlmayr remarks that the decisive social effect of art lies in its ability to objectify the horizon that already gives lives their openness and direction.[49] The world historical is what can be taken as universal in the lifeworld, i.e., what seems to impinge on the mode of being in a particular world, finally what seems constitutive—if not exclusively—of it. There is an aura of coercion around the world historical that signals it, and that signals also a characteristic sociality. It

is undoubtedly the case that the studio world is the universal that constitutively determines the art world. But it is also undoubtedly the case that this was not always so, and that in fact the studio world has been losing its compelling universality for some time now, and that modernism in general, and Fried's modernism in particular, is an attempt to prop it up. It is a sagging, even crumbling ideal, that no amount of good abstraction can restore to absolute dominance. The point is that to absolutize one universal—to assume that there is any variable that exclusively determines the nature of a world and significance in that world—is not only to fall into the fallacy of misplaced concreteness, overdetermining the particularity of the products of that world, but to overestimate the logic of that world's history, giving it an inner necessity it hardly has as a whole. Indeed, when a world so absolutizes itself it is in the process of committing suicide.

In Fried's hands, Mallarmé's purity and Hart Crane's absoluteness have become the single instrument of the art world's suicide. Giving voice to the studio world that seems to totally objectify the art world—the horizon that seems its inner core, as if the inner necessity behind the making of all art was to preserve intact the integrity and independence of the studio—Fried's modernism in fact reduces the horizons of the art world, closing it in upon itself until it knows no other voice but its own, and finally must forget that, since it is, when it is not an elevation of other voices, a whisper. The art Fried endorses—the art of Louis, Noland, Olitski, Stella, Caro, and David Smith (and one wonders how much Greenberg is responsible for that last endorsement, which I imagine to be partial and reluctant)—is nothing but a kind of whisper in the studio, a ghost that haunts the studio, and that evaporates in the world outside the studio. With Fried's modernism, and the art it supports, we see the idea of the purity and absoluteness, the autonomy and integrity of art, armoring itself in the very act of dying. But the alternative to it—the idea of the world historical as responsible for the development of abstract art—will remain elusive until modernist aesthetics is analyzed in world-historical terms. Until we see how modernism in general was a retreat from—whether by subverting or obscuring, which are in part the same—predetermined messages, from a world of bourgeois speech which knew in advance what was to be seen because seeing was a decorous, common way of making the world intelligible and confirming the status quo—we will never understand modernism, and abstraction in general, as no

more than the tip of the iceberg of modern art's self-consciousness in the world, and about being-in-the-world as such. Modernist art was an attempt to reoriginate art, as it were, bracketing it—but not suspending its practice—to find its meaning in itself, as if in defiance of all the meanings that claimed to constitute not simply art but the world. But it became another justification for the studio as the exclusive scene of art, rather than a mode of expectation of an art that could reoriginate the world, at least for consciousness—an art that could help consciousness free itself from its own conformity, and become critical spirit. Modernism, as Fried unwittingly tells us, reduced its revolutionary demands, becoming no more than institutionalized resistance to everyday sensing—an alternative institution of sensing. It became as everyday as what it criticized—and the danger of criticism is to become everyday, or, what is effectively the same thing, a Cassandra-like voice crying in the wilderness—and so lost its dialectical role, its negativity, which alone made it world historical.

This essay is reprinted with kind permission from the Journal of Aesthetics and Art Criticism, *Spring, 1983.*

Notes

1. One might limit the process on the one side with Greenberg's essay "On the Role of Nature in Modernist Painting" (1949) and on the other side with Fried's essay "Art and Objecthood" (1968), although these are by no means hard and fast boundaries.
2. Hans Sedlmayr, *Art in Crisis: The Lost Centre* (London: Hollis and Carter, 1957), 207. The title is an altogether inadequate translation of *Verlust der Mitte—Die bildende Kunst des 19. und 20 Jahrhunderts also Symptom und Symbol der Zeit.*
3. Michael Butor, "Pollock: The Repopulation of Painting," *Inventory* (New York: Simon and Schuster, 1968), 257.
4. Ibid., 259.
5. Michael Fried, Morris Louis (New York: Abrams, 1971), 40.
6. Ibid., 10.
7. Ibid., 9–10.
8. Ibid., 10.
9. Michael Fried, "Art and Objecthood," *Minimal Art: A Critical Anthology,* ed. Gregory Battcock (New York, E.P. Dutton, 1968), 147.
10. Fried, *Morris Louis,* 40.
11. Ibid., 40–41.
12. Ibid., 41. It is worth noting that Paul Gauguin stated a similar point of view: "Painting is the most beautiful of all arts. In it, all sensations are condensed; contemplating it, everyone can create a story at the will of his imagination and—with a single glance—have his soul invaded by the most profound recollections; no effort of memory, everything is summed up in one instant.—A complete art which sums up all the others and completes them.—Like music, it acts on the soul through the intermediary of the senses: harmonious colors correspond to the harmonies of sounds. But in painting a unity is obtained which is not possible in music, where the accords follow one another, so that the judgment experiences a continuous fatigue if it wants to reunite the end with the beginning. The ear is actually a sense inferior to the eye. The hearing can only grasp a single sound at a time, whereas the sight takes in everything and simultaneously simplifies it at will." "Notes Synthetiques," ca. 1888. Quoted from Herschel B. Chipp, *Theories of Modern Art* (Berkeley: University of California Press, 1968), 61.
13. Ibid.
14. Fried, *Morris Louis,* 42.
15. Fried, "Art and Objecthood," 139.
16. Ibid., 141.
17. Ibid., 142.
18. Ibid., 140.
19. Ibid., 145–46.
20. Ibid., 147.
21. Fried, *Morris Louis,* 41.

22. T. S. Eliot, "Preface to the 1928 Edition," *The Sacred Wood* (London: Faber and Faber, 1950), ix.
23. T. S. Eliot, "The Perfect Critic," *The Sacred Wood,* 7.
24. T. S. Eliot, "Tradition and Individual Talent," *The Sacred Wood,* 56.
25. Ibid., 58.
26. Ibid., 59.
27. Fried, "Art and Objecthood," 146.
28. Eliot, "Tradition and Individual Talent," 58.
29. Michael Fried, *Absorption and Theatricality: Painting and Beholder in the Age of Diderot* (Berkeley: University of California Press, 1980), 5.
30. Fried, "Art and Objecthood," 140.
31. Charles Baudelaire, "The Salon of 1859," *The Mirror of Art* (New York: Doubleday and Co., 1956), 234–35.
32. Fried, *Morris Louis,* 9.
33. Ibid., 18.
34. Ernest Gombrich, "Art History and the Social Sciences," *Ideals and Idols: Essays on Value in History and in Art* (Oxford: Phaidon, 1979), 136.
35. Alfred North Whitehead, *Process and Reality* (New York: Humanities Press, 1959), 11.
36. Alfred North Whitehead, *Science and the Modern World* (New York: Mentor, 1948), 59.
37. Alfred North Whitehead, *Modes of Thought* (Cambridge: Cambridge University Press, 1956), 5.
38. Ibid., 4.
39. Ibid., 5.
40. W. F. Hegel, *Science of Logic* (London: Allen Urwin 1951), vol. 2, 41.
41. Ibid., 41.
42. Fried, *Absorption and Theatricality,* 5.
43. Whitehead, *Process and Reality,* 25.
44. Sedlmayr, 257.
45. Sedlmayr, 147.
46. Sedlmayr, 98–100.
47. Klaus F. Riegel, *Psychology of Development and History* (New York: Oxford University Press, 1976), 15–16.
48. Hans Sedlmayr, "Normen der Bildenden Kunst," *Der Tod des Lichtes* (Salzburg: Ritter, 1964), 146.
49. Ibid., 147.

Vicissitudes of the German Antaeus Complex: Ego Strength through Mother Nature

. . . and when Nature has instructed you, the strength of your own soul will be revealed. . . .
Eternal nature, where shall I grasp you?
Where are you, breasts, you springs of life
on which hang heaven and earth,
toward which the parched heart presses?
Spirit of the Earth, you are nearer to me; already I feel my powers increasing,
already I glow as if I'd drunk new wine,
I have the courage to venture into the world

—Johann Wolfgang von Goethe, *Faust,* Part I[1]

Here, in the midst of the mountains, high above the wooded, gloomy earth, which seemed still darker against the sparkling skyline of a summer night, and a vault of stars flaming above me, I sat all by myself in this desolate place for a long time, feeling that I had never known such solitude before.

—Johann Wolfgang von Goethe, *Truth and Fantasy from My Life*[2]

. . . only black rain out of the bruised and swollen clouds . . . is fit atmosphere in such a land. The rain drives on, the stinking mud becomes more evilly yellow, the shell holes fill up with green-white water, the roads and tracks are covered in inches of slime, the black dying trees ooze and sweat and the shells never cease . . . they plunge into the grave which is this land It is unspeakable, godless, helpless.

—Paul Nash, *War Artist*[3]

Ever since Albrecht Dürer's studies of a *Wire-Drawing Mill* and the *Cemetery of St. John* (both 1494), the first autonomous landscapes in German art, and especially with "the magnificent drawing entitled *Wehlsch Pirg,* that is: *South-Tyrolian Mountains* (1495), in which "Dürer achieved a panoramic or even cosmic interpretation of scenery,"[4] the Germans have claimed a special rapport with nature. This privileged relationship reached an early climax in the pictures of the Danube School artists, particularly in Albrecht Altdorfer's remarkable *Forest with St. George and the Dragon* (1511), in which man and nature are intimate to the point of merger. Indeed, nature dominates and dwarfs—virtually encompasses and almost extinguishes—the human. As Otto Benesch writes, "It is difficult to distinguish the figure of the saint in his plumed helmet from the thicket of the high forest . . . the holy legend is reduced to a sparkling colour spot."[5] The saint is immersed in the "unlimited" forest as though he was a male Daphne about to become another tree; his plumage is easily mistaken for another bright branch. His elegance is to no avail: he is swallowed up by "the overwhelming richness of uncouth nature" the way Jonah was by the whale.

Does he, alone in the depths of the forest, find the courage to face and slay the dragon—they are about to do battle—the way Jonah, alone in the belly of the whale, found the courage to carry out God's mission? I think so: the ability to be alone, in D. W. Winnicott's sense, is a basic sign of ego strength. Of course, Winnicott's point is that one is not alone: the mother of one's being is inside one, secretly caring for one, her goodness invisibly surrounding and supporting one. She is the emotional atmosphere that makes it possible to be alone and act in the world without succumbing to it. Similarly, the forest forms a protective motherly atmosphere—a strong, sustaining, vitalizing presence, amounting to an extended aura—around the saint. He seems unaware of it, but this suggests how completely a part of him it is. He seems to be an extension of it, as Benesch says; it lends him its energy, vivid in the play of light on the leaves, and strength, evident in the sturdy trunks of its trees. Yet he is separate enough—man enough—to face the dragon alone, and find the strength and steadiness of purpose to slay it. The dragon, of course, represents evil—the devil—and the saint rids the forest of it. Can one say that it represents the

inherent evil of the world? Mother Nature, in comparison, seems inherently good, which, in a sense, makes the dragon the saint's threatening Oedipal father. Or does Altdorfer depict, however unwittingly, a split in the saint's psyche, with the good, lively forest on the one side, and the bad, deadly dragon on the other side? There is, as always, a monstrous snake in primitive paradise—just because it is primitive. Indeed, the snake belongs in paradise; the good and bad mothers coexist.

However facile such interpretations—theological as well as psychoanalytic—may or may not be, the forest seems to express both the excitement and poise of the saint as he fights the dragon. Self-possessed and buoyant, he is able to triumph over any adversity.[6] For the German hero, solitude in the forest—apparent isolation in it that, in psychological reality, is unconscious communion with it—is an absolute emotional necessity for success. When Dürer suffered he identified with Christ; when he felt self-assured he identified with the confident figures of classical mythology; but when he needed emotional fuel, he turned to nature. When he wanted real succor and support, he nursed at the *Great Piece of Turf* (1422), a fullsome breast of Earth. It was, even more than Christianity and humanism, a necessary context of selfhood. The enemy can only be defeated with the help of Mother Nature or the Earth Spirit.

I call this necessity of nature the Antaeus complex. It is of course not unique to German culture, but it seems most self-evident there, and it is officially endorsed by it. The rise of the Green Party, and the fact that almost a third of Germany is cultivated forest—a kind of tranquilized wilderness—suggest the depth of Germany's devotion to nature. The forest is a good part of its substance, and the mainstay of its emotional existence. Nature is consciously regarded as a therapeutic landscape in Germany, that is, a facilitative, transmuting environment—a redemptive or restorative space, in which mental health and bodily vigor can be renewed. Attuned to nature, one cannot help but be healed and happy. It is, as it were, the ideal transitional space, in that one can remain completely adult in it yet be in touch with what is most primitive in oneself: the most elementary subjective reality and the most sophisticated understanding of the world are marvelously equilibrated. Virgin forest is presumably more therapeutic than a cultivated garden: raw, primitive, or unspoiled nature is healthier, and thus able to make one healthier, than nature that has been reduced to decorative background, and thus become a decadent symbol

and ironical trophy of reason. But in whatever form—if more slowly in domesticated form—nature is assumed to work directly and benignly on the psyche, neutralizing the power of the punitive superego, suspending reality-testing, and throwing the caution of reason to the fickle winds. Primordial nature is always emotionally surprising, and even traumatic, but this acknowledges its radical difference from social space and everyday experience, a welcome awareness that begins the healing process. Thus, in whatever state, nature remains self-identical, which is why it can be a reliable source of security and identity.

Antaeus, we may recall, was "the son of Terra, the Earth." He was "a mighty giant and wrestler, whose strength was invincible so long as he remained in contact with his mother Earth. He compelled all strangers who came to his country to wrestle with him, on the condition that if conquered (as they all were) they should be put to death. Hercules encountered him, and finding that it was of no avail to throw him, for he always rose with renewed strength from every fall, he lifted him up from the earth and strangled him in the air."[7] Antaeus was a Titan, and Hercules represented the Olympian order—the rule of the father—that replaced the rule of the Titans, that is, the order of the mother. Hercules was ingenious, resourceful, and quick-witted, Antaeus rough and ready—a raw, primitive character, empowered by the mother. Indeed, he embodied her power: she supported him without fail, so long as he remained in contact with—dependent on—her. Held in the sky—the realm of the Olympians—he lost his strength, even his reason for being: he could no longer express and represent the omnipotence of the mother. Antaeus's death was a narcissistic wound to Earth, suggesting an unsuspected weakness. It was in effect the beginning of the end of Mother Nature's reign. If the Olympian order represents civilization with all its sublime cunning and complexity, and the Titanic order represents nature in all its simple strength and spontaneous life-giving power, and if the victory of Hercules over Antaeus represents the triumph of higher civilization over lower nature—the conquest, enslavement, and finally destruction of nature by civilization—then one can say that the Germans represent a last-ditch defense of the Titanic order against the Olympian order. They are the forest people who refuse to found cities. Indeed, that is the way the Romans conceived them—the ultimate reason they were regarded as "barbaric." They worshipped the Earth, not heaven. The latter hid the enigma of mind, but the former hid something more fundamental: the enigma of life.

Now what I want to deal with is the hard times the Antaeus complex has fallen on in neo-Expressionist—I think it should be called neo-Primitivist—German art. It is about how the Earth Spirit failed Germany, which is offered as an emotional explanation of Germany's defeat in World War II. The traditional German obsession with nature remains alive and well in neo-Expressionist art; it reflects a compulsive effort to restore a living connection with her. But it has become fatalistic, for the connection cannot be made, since she is dead, her generative power lost forever. Thus she can no longer magically mother Germany. Neo-Expressionist art tries to revive her, to miraculously bring her to life, but all it can do is futilely copulate with her corpse, in a desperate act of mourning.

Or is it depression? It does something else: it acknowledges that she was raped and murdered by the Nazis. They betrayed Germany by destroying the Earth Spirit. They were not genuine sons of the earth, but false Titans—dragon seeds. They turned what had once been a sanctuary and reprieve into a killing field, what had once been teeming with life into a sterile desert.

Perversely, the Nazis were prophetic: they were ahead of the world in their indifference, even contempt for nature. What they did deliberately, with their scorched-earth policy, the world now does everyday, casually. What once seemed so horrible has become a matter of course. Thus the neo-Expressionists enlarge the issue: for them the biggest battle the Nazis fought was against nature. They all but destroyed it, preparing the way for a completely artificial world. In fact, the Nazis developed artificial gasoline, sugar, and coffee. And artificial life has also become a matter of course: ironically, the Nazis were leaders in more ways than one. They showed us that nature could not only be mastered, but dispensed with. (We ghettoize—"thematize"—its residue.) In a sense, the Holocaust was a last sacrifice of human victims to Mother Nature—the Jews, like the gypsies, homosexuals, and Slavs the Germans persecuted and exterminated, were in effect the strangers Antaeus wrestled and put to death—in an effort to appease her, add to her strength, and assure her support for Germany.[8] But when it did not help Germany win the war, she was spitefully destroyed, in a suicidal act of revenge. The neo-Expressionists deal with the dregs of nature: nature Nazified, a symbol of death rather than life.

For Georg Baselitz and Anselm Kiefer nature is a monumental ruin. For Baselitz, it is not simply a paradise lost, but a paradise murdered, as *The*

Anselm Kiefer, *Nigredo*, 1984. Oil on photosensitized fabric, acrylic emulsion, straw, shellac, relief paint on paper pulled from painted wood, 11' × 18'. Collection of the Philadelphia Museum of Art: Gift of the Friends of the Philadelphia Museum of Art. Photograph by Eric Mitchell, 1986.

Tree I (1965–66) makes succinctly clear: the work shows a tree with its branches cut off, blood dripping from them, with the bloody knife that did the deed stuck in the ground next to it. That the fallen German hero identifies with this murdered tree—feels that his limbs have also been chopped off—is transparently clear in the equally allegorical *Trap* (1966), which shows a castrated, earth-colored, charred soldier seated beneath and between two ruined trees, blood from their broken limbs pouring on his head, as though to anoint him with death—blood and soil indeed. *The Red Flag* (1965)—another soldier, holding a flag of blood, abandoned in the forest, something resembling his penis hanging from a tree—makes the same point. When nature and natural man are not castrated and bleeding to death, then they are broken into fragments and turned on their sides or heads, as disoriented as a Humpty Dumpty that has had a bad fall and cannot be put back together again, as in *Woodsman* (1968) and *Man Near a Tree* (1969). (Baselitz claims this distortion or dislocation is an abstract device, but this is disarming, although he may be unconscious of its meaning. It develops directly out of his images of fallen heroes.) For Kiefer the earth is permanently soiled by the Nazi shadow—blackened beyond repair, as Painting of the *Scorched Earth*, *Nero Paints*, *Painting = Burning*, and *Cockchafer Fly* (all 1974)

indicate. Altdorfer's lush forest has burnt down in *Varus* (1976), *Ways of Worldly Wisdom* (1976–77), and *Ways of Worldly Wisdom—Armenius' Battle* (1978–80). Again and again one sees the blackened ruins of German civilization, as in *Interior* (1981) and *The Stairs* (1982–83), as well as of nature in Kiefer's pictures. His scenes of redemption, such as *Reclining Man with a Branch* and *Man in the Forest* (both 1971), as well as *Father, Son, Holy Ghost,* and *Faith, Hope, Love* (both 1973), with their barbaric wooden temples, and *Resumptio* (1974), with its limp Christian symbolism (certainly in comparison to Dürer's), seem less convincing—perhaps necessarily more ironical and ethereal (literally less down to earth)—in comparison to his scenes of desolation. Kiefer seems more authentic when he is bleak: when he shows the dead straw that grows in the black earth, as in *Your Golden Hair, Margarete—Midsummer Night* (1981), *The Meistersingers* (1981–82), and *Nuremberg* (1982).

The Berlin Neue Wilden Karl-Heinz Hödicke, Bernd Koberling, and Bernd Zimmer seem to recommend a return to nature, however castrated—no longer the titanic phallic mother. It may be a place of *No Sun,* as the title of a 1969 painting by Koberling says, but it is still full of sinister, dark life, as his *Bud Bloom Pod I* (1976), Zimmer's *Big Waterfall II* (1980), and Hödicke's *Nocturne* (1983) show. For all their differences, all these artists agree that the Nazis turned against Mother Nature when they saw that their cause was lost. As Paul-Armand Gette makes clear, in his documentary photographs of the trees he encountered while walking in Berlin—they are all relics, like the war-ruined buildings they grow next to—the Nazis reduced nature to an ironic residue, another kind of exotic rubble and banality, as Gette says. Joseph Beuys sentimentally presented pressed flowers as drawings as early as 1941 and as late as 1985, as though in nostalgia for a dead nature, and Dieter Appelt went to the extreme of repeatedly caking his naked body with earth and laying himself out in the forest as though dead, as if to empathize, even identify with a helpless nature, but these returns to nature seem abortive and futile. Nature must be consoled, but it is inconsolable: its sons turned against it.

In short, for the neo-Expressionists, the Nazis —acting in the name of Germany, but in a very un-German way—committed a crime against nature as well as humanity in World War II. While they tend to rationalize this second holocaust by viewing it in terms of the contemporary, worldwide despoilment of nature, it nonetheless remains a profoundly personal matter between them and

the Nazis. All of them were too young to have participated in World War II—or for that matter to have been Nazis—but they are part of its fallout. Their art is part of the ash that is left of Germany. In trying to come to terms with the Nazi past, and the emotional environment it left in its wake, they turn to a neglected aspect of it. For them, however unconsciously, the natural holocaust is more emotionally important than the human holocaust, for the former destroyed the special German relationship with nature, while the latter only undermined—temporarily—Germany's place in the world. The human holocaust was a minor setback. It was a social crisis that sharply reduced the regard with which Germany was held in the world, but the natural holocaust was an existential crisis that destroyed Germany's self-regard. It was thus more fundamental, and caused greater despair. The human holocaust caused the Germans neurotic guilt, but the natural holocaust made them psychotic, for it seemed to deprive them of a raison d'être, a birthright, indeed, the right to exist. The neo-Expressionists have been understood to be contrite about the human holocaust, but that seems to be a cover for their violent outrage—their profound sense of narcissistic injury—at the natural holocaust, which suggests the ethical failing—dare one say pseudo-ethicality? (ethical incompleteness?)—of their art. (Or do they displace their feelings about the human holocaust—feelings that are difficult to face let alone master, and thus threaten to drive them mad—onto the natural holocaust, which simultaneously denies the feelings and the devastating significance of the human holocaust?)

Nature is no longer the spiritual, healing resource it was for Dürer, the Danube School artists, Caspar David Friedrich, and the original German Expressionists, most notably perhaps in Erich Heckel's *To the Convalescent Woman* (1913): the Nazis destroyed a tradition of salvation that reached back to antiquity, indeed, to prehistoric times. Nature worship existed long before the Christian tradition, which the Nazis destroyed with the human holocaust: after the Nazis, there was nothing that could save Germany from itself. Indeed, the German neo-Expressionists depict its exhausted, fallen, futureless state of being—the limbo in which it is stuck. Its thinkers are as dumb and dead as the earth, as *Landscape with Head* (1973), as well as the *Ways of Worldly Wisdom* pictures, make clear. Like Heidegger in Kiefer's portrayal, their brains have become tumors, as though to suggest how misguided they have been—misguided enough to have been blind to the disaster the Nazis were for Germany as well

as the world, for nature as well as humanity. All the thinkers in Germany cannot restore nature to its holy place in the German psyche. The artist may try to do so, but art is wishful thinking. Yet art can mourn—feel, suffer—as philosophy cannot. Indeed, it denies feeling and suffering, tries to extricate itself from them with logic, or else metaphysicalizes them, as though to transcend them. Nor can philosophy, or for that matter art, bring the human beings the Nazis murdered back to life. Thus Kiefer and Baselitz, as well as the Berlin Neue Wilden, have more reasons than one to be depressed: German philosophy, the great German achievement, is as anti-life—necrophiliac—as the Nazis, if not as conspicuously so. The artists know that without nature to depend on Germany will lose its strength; it is certainly not the Titan it once seemed to be. All its culture and philosophy cannot save it; only nature can, and nature is dead. Death and nature were always competitors in Germany, and now death has triumphed over nature. German neo-Expressionist art is convincing—it achieved widespread recognition—because its pessimistic message about the futility of culture as well as the destruction of the environment seems addressed to everyone. It renders the apocalyptic convergence of internal and external reality—emotional, cultural, and natural disaster—in our lifeworld, a union of irreconcilables which seems to predict our doom.

There are virtually no images of dead nature in German art before the neo-Expressionists, apart from Grunewald's *Isenheim Altarpiece* (ca. 1510–15), and there dead nature is a convention associated with the death of Christ on the cross. The collapse of the symbiotic relationship with Mother Nature that Germany had as a result of World War II results in what has been termed "the abandonment depression, in which the individual experiences extreme difficulty in self-activation, panic, an empty terrifying loneliness, and fragmentation of the self."[9] More fully, it results in an "annihilation-abandonment crisis," involving "activated fears of annihilation on the one hand and abandonment of individuation on the other."[10] It no doubt also involves the loss of the feeling of being alive and real, in Winnicott's sense. Is the swashbuckling painterliness—the seeming excess, however stylized—of neo-Expressionism an attempt to overcome the sense of being dead and unreal—the deadness and eerie unreality of the idea of being-German—as well as a defense obscuring it? Do the neo-Expressionists wish to be something else, but are stuck with this unwholesome thing called being-German, which they try to make the artistic best of?

Baselitz's ironic "New type" heroes are hardly self-activating and seem terrifyingly alone and emotionally empty—hollow, sullen Titans—and are conspicuously fractured. They fragment into crude body parts, completing their annihilation. Indeed, Baselitz's paintings are full of panic, or "pandemonium," as he called it, and when not panic, the futile retaliatory rage of narcissistic injury, as though he was acting out nature's wounds as well as Germany's, and his own as a German. Nature was Germany's body ego, and the German hero lost his body ego—Baselitz shows him disemboweled —when nature was destroyed.

Similarly, Kiefer's earth symbolizes annihilation anxiety, and all the self-destructiveness implicit in that. The absence of human beings in his landscapes, however much human presence is implied by roads and buildings, suggests how profoundly abandoned Germany feels. The loss of self is complete; no individuation is possible. Indeed, its futility is suggested in the dedifferentiating effect of the painterliness, which seems to embody catastrophe. The few human beings that appear in Hödicke's pictures are blanks, and almost none appear in those of Koberling and Zimmer. Those that do are obscure, their faces hidden in deep shadows, their bodies often sealed in heavy, black, rather stark contours. The human beings that appear in the pictures of other Neue Wilden painters, such as Rainer Fetting and Helmut Mittdendorf, are blindly driven and lack any particular identity. They are all but grotesque. All of this suggests the lament of the sons, who have fallen from the grace of Mother Nature—the price they must pay for the sins of the fathers, who first broke the covenant with the Earth Spirit.

This essay first appeared in American Imago no. 53, *Summer, 1996.*

Notes

1. Johann Wolfgang von Goethe, Part I, from the opening speech by Faust.
2. Johann Wolfgang von Goethe, "Truth and Fantasy" from *My Life* (London: George Weidenfelt & Nicolson, 1949), 119.
3. Quoted in Modris Ecksteins, *Rites of Spring* (Garden City, NY: Doubleday Anchor, 1989), 146–47.
4. Erwin Panofsky, *The Life and Art of Albrecht Dürer* (Princeton: Princeton University Press, 1955), 38.
5. Otto Benesch, *The Art of the Renaissance in Northern Europe* (London, Phaidon, 1965), 44.
6. I am referring to Jean-Michel Quinodoz's notion of buoyancy, a feeling that comes from "flying with one's own wings." See *The Taming of Solitude* (London and New York: Routledge, 1993), 172. The "sensation of buoyancy is perceived . . . as a gain in autonomy relative to dependence, and as an affirmation of . . . identity." Thus, buoyancy is a signal of "becoming, truly" oneself. St. George truly becomes himself relative to his dependence on Mother Nature, whose own buoyancy gives him the strength to act on and hold his own against the evil in and of the world.
7. Thomas Bulfinch, *The Age of Fable or the Beauties of Mythology* (New York: Heritage Press, 1942), 149–50.
8. Just as the Nazis led the way in denaturalization, so they led the way in dehumanization, its correlative. Just as they wanted to eradicate nature, they wanted to eradicate the human—not so much natural phenomena, as the principle of nature; not so much human beings, as the principle of the human. Both are obstacles to efficient, routine functioning, and as such unmodern. Implicit in this is the idealization of the machine as the modern model for creativity, replacing traditional nature and humanity, which are hardly as "self-controlled." The Nazis' robot rockets, programmed to perform untouched by human hands, and their extermination camps, which optimally functioned with an equally automatic efficiency and "inhumanity,"

were experiments in dehumanization. Both attempted to prove that it was possible to function without reference to human nature. Thus, it can be argued that the point of the camps was to teach the soldiers who ran them to function like unfeeling machines, rather than simply to destroy human beings. Indeed, the people who had to be destroyed were those who insisted they were human, that is, who refused to have a machine "attitude" and behave like machines, which is what made them, from a modern perspective, *Untermenschen*. They simply had no place in the modern world. No doubt from a human point of view the Nazis were evil murderers, but from their own they were simply as indifferent and perfect as properly functioning machines. The machine, indeed, was their model for being—and continues to be for many people who do not think of themselves as Nazis. In short, in attempting to totalize the world in machine terms, they carried the hegemony of the machine in modernity to its logical conclusion. Thus they cannot be faulted for having no conscience—not feeling guilt, shame, the wish to make amends—because machines have no conscience. In fact, their conscienceless, feelingless war machines were their greatest achievement. (The Nazis would probably regard the unconscious as an anachronistic residue of humanness, a kind of unnecessary psychic tail hanging on for dear life to the backbone of machine man, the genuine *Übermensch*.)

One of the failings of the post-Nazi neo-Expressionists is that they do not address the central role of the machine in the natural and human holocausts, although Kiefer makes nominal mention of it in his works, e.g., in his oblique reference, by way of railroad tracks, to the trains that brought Jews to Auschwitz. The Nazis castrated the spontaneously fertilizing phallus of Mother Nature (the *Mutterland*), replacing it with the sterile artificial phallus of the machine (the basic *Führerprinzip* of the *Vaterland*). In other words, they replaced one principle of omnipotence with another—organic grandiosity with mechanical grandiosity.

9. Stephen M. Johnson, *Character Styles* (New York and London: Norton, 1994), 140.
10. Ibid., 176.

The Psychoanalytic Construction of the Artist

I

The psychoanalytic literature on the artist is marked by a blind spot, a peculiar failure of criticality: understood in contrast to the neurotic, the psychotic, the imposter, and the psychoanalyst himself, the artist is not only elevated over all four, but privileged as a kind of ideal person—the consummate human being, as it were. It seems psychoanalysis has to propose a numinous model of health to counterbalance the psychopathology that is its usual preoccupation, and it chose the artist, as though creativity guaranteed mental health, or at least precluded serious mental illness. The artist, with his creativity, which seems to conquer all emotional hardships or at least prevents them from becoming chronic, is the healthy exception that proves the pathological rule, the *Übermensch* that proves the rest of us are defective *Untermenschen*.

Nietzsche had a similar idea,[1] but not to the extent of declaring, as Julia Kristeva does, that "freedom does not seem to exist outside of what we agree to call an artist."[2] Daniel Bell writes that "in the phenomenology of time . . . freedom is the end of necessity and of history, the beginning of man's unbounded ambition as a singular self."[3] The artist is supposedly the most singular of selves, and as such the embodiment of "the end of constraint," as well

as the relentless ambition, seemingly able to overcome all obstacles, that follows from it. The rest of us can only dream of the inner freedom, and freedom from the immediate environment, that he presumably has. The rest of us have learned to confine our ambition to what is socially possible. This notion of the artist is, of course, too good to be true, as Kristeva's hyperbole suggests. I will argue that psychoanalysis endorses the conventional idea of the artist as "beyond compliance"—the heroic exception to the rule of social compliance that confirms everyone else's unheroic compliance—and as such shows its own conventionality and uncritical compliance.

There is no essential difference between the psychoanalytic construction of the artist and the standard social construction of the artist, however more psychologically subtle and sophisticated the former is. Since the Renaissance, the artist has been regarded, in a rather extravagant example of magical, wishful thinking, as "divine," that is, more than human—indeed, as far from ordinary mortals as they are from animals. His creativity has been hyped and reified to make him seem a different order of being. While our creativity is subsumed in the world's work, he works for himself, which makes him all the more superior. He creates his uniqueness, seemingly at will, while we struggle to create a workable world. Psychoanalysis implicitly accepts this cliché of the artist's radical difference—the idealizing stereotype of the artist's miraculous creativity—rather than questions it, as it might be expected to do, by reason of its psychological realism. It eloquently refines the cliché of the artist's privileged position and person until it seems like a fresh insight, rather than brings it into the disrepute it deserves.

Society no doubt needs to posit a dangerous exception to its own rule in order to confirm the benefits of its rule: society needs to posit a marvelous yet peculiarly mad and unprincipled ("divinely inspired") outsider to underscore its own sanity, safety, and sobriety. But there is no reason to accept society's understanding of the artist's peculiarly absurd place in it (by reason of his being a pseudo-god), however much that understanding may be a metaphoric overstatement of the often tense dialectic between the individual and the social environment. It subtly serves society rather than helps us understand creativity. Similarly, psychoanalysis stays on the social surface when it comes to the artist, in effect deferring to the conventional rationalization of creativity as a transcendental rather than psychological—all too human—phenomenon, effectively

removing it from critical examination and comprehension. In short, with respect to the artist, psychoanalysis fails as a "depth psychology," that is, a psychology which "criticizes" the surface from the perspective of the unconscious.

If every act of interpretation is a critical act, in the sense that it disillusions us about social appearances—shows that they are something other than they seem to be, even as they are what they are—then the psychoanalytic interpretation of the artist is peculiarly cowardly. Perhaps this is because psychoanalysis, like society, has to posit a completely authentic, autonomous, creative individual, whose existence is disturbingly extraordinary and beyond the control of the status quo—an unrealistic individual, which it names the artist—to justify its own practice, in its case a therapeutic practice. That is, psychoanalysis needs the myth of the artist—the exceptional individual, healthily transcending his surroundings and superior to all determinisms[4]—as the numinous goal of therapy.

When Freud takes Oskar Pfister to task "for being 'overdecent' and insufficiently ruthless to his patient," and advises him "to behave like the artist who steals his wife's household money to buy paint and burns the furniture to warm the room for his model,"[5] and when Winnicott remarks, similarly, that the artist's "ruthlessness" often "achieve[s] more than guilt-driven labor,"[6] they are enviously emulating the artist. This is especially the case in Freud's poignant recognition that the artist "had an astonishingly intuitive grasp of what he could only painstakingly and laboriously discover through research."[7] Not that the envy is unconditional. It is counterbalanced by a certain theoretical realism, and sometimes observational evidence. When Freud writes that "in only a single field in our civilization has the omnipotence of thoughts been retained, and that is in the field of art,"[8] and when he asserts that art is "almost always harmless and beneficent, [for] it does not seek to be anything but an illusion,"[9] he presents both psychological and social reasons for regarding art as not particularly relevant in the larger scheme of things, however relevant for this or that "obsessional" individual, as he says.

These remarks point to the psychoanalyst's profound ambivalence toward the artist. It is evident, as I have suggested, in the ironic difference psychoanalytic theory establishes between the artist and the neurotic, the psychotic, the imposter, and the psychoanalyst himself. The artist is differentiated from them, but never sharply enough to separate him completely, so that it

Sigmund Freud's study at 20 Maresfield Gardens, London. Photograph by Nick Bagguley, courtesy Freud Museum.

becomes unclear whether they are the artist's foils or the artist is their foil, that is, whether he is a heuristic gambit for understanding them or they are springboards for understanding him. In the end one is forced to ask whether the artist is a closet neurotic, psychotic, imposter, and psychoanalyst—a neurotic, psychotic, imposter, and psychoanalyst in disguise. For psychoanalysis, the artist is implicitly neurotic, even psychotic, and an insightful imposter—a perversely protean character indeed. His creative achievements indicate that he is not always conflicted, crazy, and a fake, even though they make it clear that his psychological insight is deceptive and piecemeal, just as Plato thought Homer's medical knowledge was only a matter of appearance and incidental observation.

In other words, psychoanalysis constructs an artist that is an all-in-one self-contradictory monster, suggesting how fragmented its view of the artist is,

and how unable it is to put all the fragments together into a coherent picture. This suggests that the psychoanalytic construction of the artist is a sweeping if discombobulated mythology rather than a considered, systematically elaborated theory with a clear point to make and evidence to support it. Thus it adds to the confusion about the artist, which confirms the conventional belief that he is a mystery, in effect overestimating him—expecting wonders from him, as though his art was the saving grace of life. Psychoanalysis, then, like society, is baffled by the artist, which is why it praises him excessively by treating him from every perspective it knows, in effect compensating for the fact that it cannot pin him down. It aims its entire arsenal of ideas at the artist, but it never seems to score a clear, direct hit. In a sense, the tower of theoretical babble psychoanalysis builds to reach the artist reflects a universal difficulty: reluctance to recognize the everydayness of creativity. Like society, psychoanalysis privileges the person who obviously possesses it, ignoring the numerous, less conspicuous manifestations of creativity—a creativity that changes reality rather than expresses fantasy, and as such keeps the self and the world going, indeed, indicates that they are more dynamic than art, which sometimes seems like their parasitic residue. But the artist may be necessary to psychoanalysis as a screen on which it can project its theoretical dreams. Or, to put this another way, the artist may be the whetstone on which psychoanalysis sharpens and toughens its own ideas, more particularly, the paradox condensing its counterintuitive paradoxes into a singular form, which can be easily intuited.

II

Psychoanalysis's reinforcement of the elitist myth of the artist as a superior type of human being starts with its wish to communicate as effectively—seductively—as art. One cannot help thinking, when one reads Freud's statement, in a letter to a literary artist, that "my words and ideas strike people as alien, whereas to you all hearts are open,"[10] of Freud's own suave language. His skillful use of metaphor to make his ideas persuasive, and the fact that his case histories read like novellas rather than scientific reports, have been much noted. They are attempts to make his ideas less alien, and open all hearts to

them—supposedly the way they are opened by art. In short, Freud appropriated literary modes of expression to communicate his ideas convincingly. That is, he tried to write artistically as well as scientifically—sugarcoat his bitter scientific medicine with art. I think that in his desperation to communicate his initially unacceptable scientific ideas, he overestimated art's power of persuasion—of seductive communication, that is, its power to make the unacceptable acceptable, indeed, the unthinkable thinkable. And with that, Freud overestimated the artist, even as he attempted to demythologize the artist by showing that he was not immune to the unconscious.

Ernest Jones notes Freud's belief in the artist's ability to please—in effect seduce—the ladies, and quotes Freud's remark: "I think there is a general enmity between artists and those engaged in the details of scientific work. We know that they possess in their art a master key to open with ease all female hearts."[11] This assumes that scientific work is men's work while making art is women's work, for it works on women—so the artist must be a kind of woman. The irony of Freud's attempt to mediate his scientific ideas through artistic language—in effect an attempt to reconcile the masculine and feminine, indeed, his masculine and feminine sides—is that such language works only on women or appeals only to the woman in man. It is thus not truly effective, for it does not get real men to accept his ideas, and more crucially, to think scientifically, that is, "heartlessly." Real men are immune to seduction—appeals to the heart rather than the mind—and the irrational artistic language that is its instrument. Real men want the truth, and are convinced only by rational argument and empirical evidence. To make scientific ideas artistically seductive is thus ironically self-defeating.

Freud sets up a rather conventional contrast between seductive artistic language, which is supple, soft, devious, and subjective, all traditional feminine traits, and straightforward scientific language, which is rigorous, systematic, logical, and objective, all traditional masculine traits. Artistic language aims to deceive us (like women), so that even when art tells the truth it seems like a lie, while scientific language aims to clarify and instruct (like men), so that even when what it tells us is wrong it seems right. Female artistic language shows us reality through a dark glass, whose darkness rubs off on or contaminates reality, as it were, while male scientific language holds up a clear mirror to what it represents as reality, so that it seems self-evident and transparently the case. Feminine

artistic language detracts from the scientific content of what it communicates and undermines the masculine effort necessary to work and think with scientific detachment. Its very seductiveness makes it scientifically worthless—a stumbling block on the way to scientific knowledge. Freud did not realize that art was a Delilah that seduces science and destroys its strength.

The artist, then, lacks detachment from his subject matter because he is feminine at heart. He is determined to attach his audience to it the same way he is attached to it and to attach his audience to the feminine language he uses to transform it into art, which cements his original attachment to his subject matter. Indeed, he encourages his audience to invest in his artistic language and subject matter simultaneously, so that they are experienced as inseparable. In a final step, he tries to convince his audience that his artistic language is more important than his mundane subject matter—that the real point of the work of art is its subjectively charged language—language charged with his own subjectivity—rather than its objective subject matter. The artist triumphs when the audience experiences the subject matter as the vehicle for his artistic language—and thus himself—rather than vice versa, thus overturning the conventional assumption with which the audience initially approached the work of art. This is the ultimate seduction of art—the final proof of its wily feminineness. It parasitically attaches itself to its audience the way a woman attaches herself to her lover in order to narcissistically gratify herself—to see herself uncritically reflected in his admiring, worshipful eyes.

But all this goes against the grain of the masculine scientific spirit: the scientist must disinvest in a subject matter to gain an objective perspective on it, thus positioning himself to analyze it in a disinterested way. He is not trying to seduce or charm an audience, only understand what can be understood. His language is a critical means, not an aesthetic end. Scientific language should be as clear and distinct—forthright and public—as possible, which is the bracing masculine way of communicating, rather than call undue attention to itself, which is the artistic feminine way of communicating, for it is at bottom a way of manipulating the audience for private narcissistic gain.

However skeptical he may have been about art's truth value, Freud nonetheless felt he had to make an artistic case for psychoanalysis, that is, had to use artistic language to make psychoanalysis seductive for a skeptical, unreceptive audience, more familiar with art than science. Perhaps this was neces-

sary in the early days of psychoanalysis, but ever since people have not been certain whether psychoanalysis is a science or an art. Freud has been acclaimed as a great literary artist more often than psychoanalysis has been regarded as genuinely scientific. He was awarded the Goethe Prize for literature, not the Nobel Prize for scientific work. Thus his artistry proved ironically counterproductive in the long run.

But my point is that Freud's emulation of the artist led him to elevate the artist, out of his narcissistic need to communicate and justify himself. And this led him, and later psychoanalysts, to fill out his portrait of the artist as a great, magical communicator by attributing to the artist a special ability that made him different from all other human beings: spontaneous and intuitive understanding of the unconscious. As Freud wrote to Arthur Schnitzler, "Whenever I get deeply absorbed in your beautiful creations I invariably seem to find beneath their poetic surface the very presuppositions, interests, and conclusions which I know to be my own."[12] This implies that the artist has enormous ego strength, for he is able to dive into the depths of the unconscious without being crushed by the pressure, and bring back a pearl of insight every time he does so. But this is absurd: it is impossible to have an unmediated relationship with the unconscious, let alone escape ego-crippling unconscious conflict. The unconscious is not at one's beck and call, however strong one's ego seems to be. The notion that the artist has an invulnerable ego—rooted in absolute integrity—is spurious. Psychoanalysis has in fact created a kind of Dorian Gray portrait of the artist: he keeps his monstrousness hidden behind a magnificent facade of ego and integrity. No doubt we are all monsters on the inside, but we never claimed to have a privileged relationship with the unconscious, nor to always have integrity, nor an ego that can face the unconscious truth without flinching. Unlike the artist, we do not claim to be superhuman.

III

I want to focus on the psychoanalytic distinction between the artist and the imposter, for it seems to be the most socially relevant of all psychoanalytic approaches to the artist. It speaks directly to our postmodern situation, in

which the artist increasingly looks like an imposter—another social personality out for a fast buck and celebrity, another manufacturer of spectacle and glamour. The artist has been called the rock star of the eighties, as though his goal was to be a popular entertainer. In a sense, the moment the avant-garde artist claims to address the collective rather than the individual—seeks uncritical applause from the masses rather than attempts to deepen the individual's sense of self—he becomes postmodern.

To understand the artist through the imposter exemplifies the shift from a drive to an object-relational approach in psychoanalytic theory. The artist's special sense of himself and his particular way of relating to the world have come to seem more important psychologically than the wishes he shares with everyone else. Not that Freud's characterization of the artist as a glorified neurotic in rabid pursuit of instinctual gratification doesn't do a certain justice to the artist, but it does not sufficiently emphasize the object-relational and narcissistic reasons for making art. When Freud writes that "the artist, like the neurotic, had withdrawn from an unsatisfying reality into [the] world of the imagination [but] unlike the neurotic, he knew how to find a way back from it and once more to get a firm foothold in reality,"[13] Freud seems to ignore the fact that the artist is attempting to get a firm foothold in his own reality—to establish a firm sense of self—by making art, and that he is attempting to do so by relating to an audience.

Works of art, Freud writes, "differed from the asocial, narcissistic products of dreaming in that they were calculated to arouse interest in other people and were able to evoke and to gratify the same unconscious wishes in them [as in the artist] too,"[14] but he ignores the psychological fact that they make unconventional relational demands on other people and change their sense of themselves as well as gratify their conventional wish for instinctual gratification. Jones thought that the sentence "artists are endowed with a powerful capacity for sublimation and with a certain flexibility [Lockerheit] of repression" contained "the essence of what [Freud] had to say" about the psychology of the artist.[15] But if this is so, then it is seriously incomplete, for Freud ignores the artist's basic need for an audience, indeed, his perpetual search for the right audience and the effect of his unconscious expectations from his imagined audience on his sense of self. The artist makes the work of art for an imaginary ideal audience, as though trying to live up to its impossible expectations, or at least

trying to appease it by not disappointing it too much. To attend to the work of art's gratifying effect on its audience's unconscious is not to attend to the audience's not always gratifying effect on the artist's unconscious.

Freud, who viewed art as a form of dream-work, misses what W. R. D. Fairbairn calls "art-work." Without it, there is no guarantee that a powerful capacity for sublimation and a certain flexibility of repression will produce a socially credible work of art that will appeal to—seduce—an actual audience. While art-work is as "essentially unconscious" as dream-work, and "provides the means of reducing psychical tension in the artist's mind by enabling his repressed urges to obtain some outlet and satisfaction without unduly disturbing his equanimity,"[16] it also produces a socially meaningful symbol rather than an asocial hallucination important and engaging only for the individual who experiences it.[17] Artwork turns the private dream into a public work of art, so that it not only makes cognitive and emotional sense for other people than the dreamer—indeed, the work of art makes cognitive sense before the emotions it arouses can be sorted out, while the dream has an emotional impact before its meaning becomes intelligible—but it addresses social values. The unconsciously produced dream is in fact only one ingredient in the socially conscious work of art. The dream is a personal anomaly and social curiosity, as it were, while the work of art is informed by social concern—even if some works of art seem to push the limits of respectability, thus challenging society—and, however strange, is peculiarly impersonal. No doubt the artist also manipulates the public, in that he uses artistic form to implant his very personal dreams in his audience, so that they become social property—even though their content was common psychic property in the first place. If art is ultimately about unconscious suggestion, then art-work makes it ironically clear that such suggestion is most effective when it is disguised by sophisticated means. If I want to make my suffering your suffering, I must make it seem to be "fun," as Fairbairn says, rather than suffering. There is enough suffering in life, and we do not want any more from art. Paradoxically, art must seem to be a superficial game played for its own pleasurable sake to have unconscious effect, that is, to remind us of our own deep, unpleasant conflicts. Art seems inviting because it promises to help us forget them, but it slyly gives them memorable form that makes them more tolerable, which is the next best thing to resolving them.

For Freud the artist is at bottom as conventional—not to say banal—as

everyone else: he "has won—through his fantasy—what before he could only win in fantasy: honor, power, and the love of women."[18] Presumably these are the real reasons he makes art. But however instinctively gratifying, they are all external, socially defined goals—tokens of a conventional success—and suggest the artist's reconciliation with society, indeed, his completion of his socialization through art. Freud expects the artist to be a good citizen, integrated into society the way everyone else supposedly is. He wants to be reassured that the artist is like everyone else—not as antisocial as he has come to be regarded in modernity. But the artist/imposter dialectic strongly suggests that the artist's goal is primarily internal and secondarily external, and that the reconciliation of internal and external is not a necessary and foregone conclusion, and in fact may not occur in many artists. Honor, power, and the love of women are secondary to them, and finally obstacles to making art. Winnicott has famously said that "it is the self that must precede the self's use of instinct."[19] Similarly, gaining a sense of self—a feeling of integrity or wholeness of being—through art-work must precede gaining instinctive gratification, which includes the world's reward, by making works of art. As Winnicott writes,

> In a search for the self the person concerned may have produced something valuable in terms of art, but a successful artist may be universally acclaimed and yet have failed to find the self that he or she is looking for. The self is not really to be found in what is made out of products of body or mind, however valuable these constructs may be in terms of beauty, skill, and impact. If the artist (in whatever medium) is searching for the self, then it can be said that in all probability there is already some failure for that artist in the field of general creative living. The finished creation never heals the underlying lack of sense of self.[20]

The imposter wants worldly success without going through the trouble of artwork—it is part of general creative living, for it involves what Winnicott calls the "creative apperception" in which the split between subject and object is healed—that can alone provide a firm sense of self. Indeed, a self strong and sure enough to realize that worldly success is emotionally unsatisfying in the long and often short run.

IV

Phyllis Greenacre has written at great length on the difference yet resemblance—one is tempted to say competition—between the artist and the imposter. Her 1958 papers on "The Imposter" and "The Relation of the Imposter to the Artist" are seminal. In the first paper she states: "An imposter is not only a liar, but a very special type of liar who imposes on others fabrications of his attainments, position, or worldly possessions."[21] In other words, the imposter misrepresents his identity, sometimes borrowing another person's identity, sometimes inventing one. There may be "plagiarizing on a grand scale" or "claims which are grossly implausible." Most crucially, "imposture appears to contain the hope of getting something material, or some other worldly advantage," although there are cases in which "distinguished, wealthy, and competent persons . . . lose themselves in cloaks of obscurity and assumed mediocrity." In the second paper Greenacre writes that the artist, like the imposter, "is at least two people, the personal self and the collectively stimulated and responsively creative self," and that "these two selves are sometimes nearly as separate as they are in the imposter."[22] She observes as well that "the character of the imposter seems especially to intrigue the artist," as she demonstrates in her analysis of Thomas Mann's numerous stories about imposters. (She could also have pointed to Herman Melville's *The Confidence Man*.)

How, then, does the artist differ from the imposter, even though, implicitly, as Greenacre suggests, he recognizes an imposter dimension to himself, and may even unconsciously regard himself as an imposter? Without going into all the details of Greenacre's psychodynamic interpretation of the imposter, the difference between the artist and the imposter boils down to the fact that the imposter is, in Greenacre's words, "his own work of art," while the artist produces works of art that are separate from himself. In a sense, he has successfully dealt with separation anxiety, while the imposter has not. In separating works of art from himself, the artist in effect separates himself from his primary object, while in some way the imposter remains dependent on it. The artist has put something between himself and others—creatively filled the space between, as Joyce McDougall suggests—while there is nothing between the imposter and his audience—except, of course, his alter ego, which is also a creation, indeed, a

"self"-creation. The artist may be tempted by imposture, whether out of paranoid tendencies or to protectively disguise his creative gift, but he produces something that can be understood apart from himself, however much it may reflect himself. And there's the rub, the devious point of intersection and dialectical tension and affinity, for as Greenacre writes in her 1959 paper "Play in Relation to Creative Imagination," "each artistic product is the delivery into an externalized and communicable form of an economically organized piece of the artist's interaction with the world around him."[23] This amounts to a certain assertion of ego and declaration of individuality, as Greenacre says. The imposter does the same, but in the form of the artistic product of his make-believe or illusory person.

For Greenacre, the difference is that "the imposter seems to be repeatedly seeking confirmation of his assumed identity to overcome his sense of helplessness or incompleteness," which is "the secret of his appeal to others"— even the most "conscientious people are 'taken in' . . . because of the longing for that happy state of omnipotence which adults have had to relinquish"[24]—while the artist does not assume any identity, but wants confirmation of the identity he already has, by reason of his creative gift. Indeed, he wants recognition, approval, and acceptance for his creative gift and creative difference: he wants to be universally loved for his True Self, as it were—an incredibly unrealistic wish. But the imposter also shows a certain creative gift and difference by inventing a convincing alter ego that the world acknowledges and respects—at least as long as the fraud is not discovered—and the artist wants the same material and worldly advantage—the same concrete vote of confidence—that the imposter does. And, if a choice had to be made, the imposter would probably take the world's loving recognition of his created self—imaginatively assumed identity— rather than its material gifts, just as the artist would take the world's love for his creative self rather than all the honor, power, and women in the world. Or at least the genuine artist and the genuine imposter would. (This leaves the postmodern imposter artist out.)

The artist and the imposter are entangled in each other, if not inextricably then significantly, for all Greenacre's efforts to disentangle them. It is incidentally worth noting that Freud calls the dream an "imposter" in the course of his analysis, in *The Interpretation of Dreams*, of Hans Christian Andersen's fairy tale "The Emperor's New Clothes." He also calls the two tailors who wove the

Emperor's invisible clothes "imposters."[25] Freud states that the dreamer is the Emperor, and that he is lying to himself about a forbidden infantile wish to exhibit himself without shame. My own interpretation is that the Emperor symbolizes the self, which regards itself as sovereign, but knows that it is an imposter—just another ordinary person underneath its feeling of being superior to everyone else—and would like to be seen and accepted for what it is. But nobody does: even though people see the Emperor in all his nakedness, they still accept him as a king superior to them. For there are terrible consequences for not doing so: they would be executed if they told the plain truth they see with their own eyes. Their silence preserves the social peace as well as the Emperor's dignity. For the moral of the story is that a mature person wisely lets other people present themselves as who they think they are—save face socially—for he would pay a high price if he told them that they are just like everyone else underneath their immature grandiose self-presentation. This would disabuse them of the fantastic sense of superiority—the heir to infantile omnipotence—they need to survive psychically, and, for that matter, to function socially. Undermining their sense of self, one would also wreak social havoc. Disillusionment invariably causes revolution, if also depression. The mature person is an imposter like everyone else, but he hides the truth that would destroy society rather than pretends to be someone he is not.

The dream is an imposter, but it also tells the truth: that's the point of the imposter/artist dialectic. The imposter's truth is that he is of consummate importance to himself; he wants to become socially important to affirm this. The artist's works tell the same narcissistic truth: both imposter and artist want interpersonal recognition at any cost. Who is to say the creative cost is not as great for the one as for the other? The cost of working for material and social advantages—symbols of recognition, bringing with them the self-acceptance and confidence necessary for psychic survival and emotional security—may be a loss of creative imagination: one may have to stereotype one's own creativity to be a success, whether as an imposter or an artist. Most artists in fact do so, however unwittingly. The imposter does so deliberately, to maintain consistency of identity. Both work hard to achieve a socially successful "look," and once they get it they stay with it, thus short-circuiting their creative growth, if cementing their success. After an initial spurt of originality, all one's creativity goes into reinforcing and perfecting the appearance that made one successful. It becomes

a matter of social course—a reified individuality, losing in emotional credibility what it gains in social carrying power.

Greenacre suggests that some imposters have a remarkable ability to change identity at will—convincingly inhabit any identity—while artists do not: they are who they are. It is regarded as a bit of an aesthetic miracle—but also suspiciously—when an artist changes stylistic identities, as Philip Guston did. But it in fact has become the trendy postmodern thing to do, suggesting that the postmodern artist is an imposter. It is worth noting that Goethe was fascinated by Count Cagliostro's change of identity—indeed, he was a quick change artist—even as he distrusted it. He seemed to have regarded Cagliostro as a kind of artist. This brings me back to the main point: in Greenacre's construction, both the artist and imposter are kinds of artist, however different their fates after they have been "found out."

This point is subtly reiterated by Otto Fenichel, who makes a valiant effort to distinguish between "the pseudo-artist and the real artist," but does not exactly succeed.[26] He ends up showing that both need the same thing—success—if in a different form. Fenichel writes:

> The pseudo-artist needs to be accepted as a person, requiring applause at any cost. He adapts himself to his audience to make sure of getting applause. The artist needs to have a specific fantasy of his accepted; he wants applause for his work, not for himself. He adapts the public to himself. This sharing of guilt through art is anticipated by the 'common daydreams' of children who feel relieved of their guilt feelings if their comrades participate in their fantasies.

But the point is that the pseudo-artist and the real artist have something fundamental in common: they both intervene in social or public space—the former with himself, the latter with his work—and make extraordinary demands on others, namely, applause and sharing, and in the case of the real artist, applause for sharing. And isn't the pseudo-artist sharing himself—his need for applause for his being, applause which gives or attributes value to his existence. Like everyone else, he has a basic need to feel fundamentally valuable—unconditionally positive about himself—which can only be satisfied by others, that is, the environment, as Fairbairn and Winnicott argue.

It is worth noting that the psychiatrist and novelist Hermann Broch

distinguished between "the pseudo-artist who accepts success as a proof of his quality" and "the few genuine artists . . . who know that art that does not render the totality of the world is not art," that is, art that does not "counterbalance . . . the hypertrophic calamity" of "splitting the world into fragmentary disciplines" is not worthy of being called art.[27] But the artist can only know if his art has successfully rendered the totality of the world, overcoming the modern "state of complete disintegration of values, a state in which each single value is in conflict with every other one, trying to dominate them all," if his audience is reintegrated by his art. Indeed, from Broch's modern point of view, the implicit audience is the individual who unwittingly reveals his disintegration by advocating only one value and attempting to discredit the rest, that is, the hypertrophic modern intellectual who pursues a fragmentary discipline for all it is worth. Art gives him a more inclusive sense of value—recognition and acceptance of other values than his own. The audience's rethinking of its values under the influence of a totalizing art—its reevaluation of itself rather than its usual tendency to devalue everything but itself—attests to the genuineness of the art, that is, confirms the fact that it has conveyed a sense of the totality of the world, emotionally and in foreshortened symbolic form. Once again, the object is necessary—the alien narcissistic audience to whom the art is addressed, and which is brought out of its narcissistic omnipotence, in a relatively painless way, by the art that has more values than it and does not judge its values—for the artist to believe in the rightness of his achievement, and with that to trust his creatively responsive self.

More consciously than Fenichel and less reluctantly than Greenacre, George Valliant acknowledges the similarity of the artist and the confidence man in the act of distinguishing them: "the charisma of the artist is never far from the character disorder of the confidence man."[28] Andy Warhol, André Gide, and Oscar Wilde are Valliant's "examples of individuals who bridged both worlds." He writes: "Like character-disordered individuals, successful artists know how to insert themselves in our very marrow, until we, too, become afflicted with their torment and share their desires. But unlike the charlatan, the imposter, and the Don Juan"—all seductive characters—"the artist, by penetrating our bones, allows us to join them in their salvation."[29] Similarly, Valliant asserts, "Only the artist manages to combine the honesty and morality of the user of mature defenses with the capacity of the confidence man and the sinner to penetrate our innards and awaken our oldest longings."[30]

From my point of view, this idealizes and mythologizes the artist. The artist, by being able to bridge the worlds of character disorder and charismatic creativity—by being able to be both an applause-hungry confidence man whose assumed identity or False Self is his art and the True Self that makes art seem genuine by its subliminal presence—becomes infinitely superior to the rest of us. We non-artists can only inhabit the world of character disorder however much we may try to enter the world of charismatic creativity, that is, we are presumably always more inauthentic and unhealthy than authentic and healthy, or always more compliant False Self than creative True Self. This view is problematic: why should the artist alone be able to integrate what remains split apart in everyone else? Valiant's view is yet another way of privileging the artist as more complexly alive, and thus having a more profound sense of self than the rest of us.

V

It seems to me that Winnicott is one of the most ironic offenders when it comes to the psychoanalytic privileging of the artist. His artist is not simply a confidence man and charismatic creator rolled into one personality, but simultaneously psychotic and mature. Winnicott writes: "clinically the really healthy individual is nearer to depression and madness than to psychoneurosis. Psychoneurosis is boring. It is a relief when an individual is able to be mad and to be serious and to enjoy the relief afforded by a sense of humour, and to be able, so to speak, to flirt with the psychoses. Through modern art we experience the undoing of the processes that constitute sanity and psychoneurotic defence organisations, and the safety-first principle."[31] This asserts that the artist, especially the modern artist—defensively full of humor as he explores madness and depression—is in principle the genuinely healthy individual. Are Franz Xaver Messerschmidt, the psychotic sculptor whose paranoia Ernst Kris analyzed, and the psychotic painter Christoph Haizmann, whose depression or "demonological neurosis" Freud analyzed, healthy individuals? Were these clinically psychotic artists simply flirting with psychosis, knowing what they were doing all along, and doing it to make art?

Similarly, Winnicott writes that "phenomena that are life and death to . . . schizoid or 'borderline' patients appear in our cultural experiences," and that they are "in direct continuity with play," and that in play "everything is creative"—one "begins to live creatively, and to use actual objects to be creative into,"[32] and thus feels real and alive—he in effect declares that the artist—the charismatic maker of culture—is psychologically and existentially superior to the rest of us, once we are no longer playful children. The creative artist is the eternal child who lives on the transitional cutting edge, as it were, while we ordinary adults tend to be on one side or the other of the divide between creatively experienced objects which we blindly identify with and socially given objects we naively share under the impression that they are necessarily separate from us. The artist is mad—"madness," declares Winnicott, "means simply a breakup of whatever may exist at the time of a personal continuity of existence"—but he is able to cure himself of his madness—"mends [his] ego-structure"—by making art.[33] He is in effect his own mother and mother-deprived baby at the same time.

In short, he is that sublime paradox, a creator of transitional objects that work for everybody, not just himself—that are part of culture, not just childhood. He gives us back the childhood creativity we abandoned when we became adults, that is, realized that the world was not "for fun," but a matter of life and death. Art condenses the traumatic effect of separateness and the healing effect of reunion in a single socially acceptable work. The work of art thus seems "self-facilitating," as it were, a parthenogenetically restored good enough environment and bad, failed, lost, destroyed environment in one: and it is experienced this way by everyone. The artist, then, does what nobody else can: he not only endures the same destructive and creative experiences and processes we all do, but takes to them like a duck to water. Above all, he presents them to us in socially acceptable form, that is, in a way that makes them less terrifying and personal to us if still strongly felt. His gift is that he can make such a gift to us. The artist thus mediates our madness and depression to us, making them more manageable because more conscious. But he does not make them more comprehensible, for the artist does not analyze them, but rather presents them in a socially palatable way—tailors them to fit the existing norms for understanding and governing them. He creates the illusion that he knows our inner life and suffering better than we do, not only because he maps the surface of his own, if

not always completely, but because his account of them conforms to our socially determined expectations of what they are about. Nonetheless, the artist does recognize his own particular brand of madness and depression, and in doing so he comes to realize their universality. More crucially for his art, he plays and experiments with them, overlooking their dangerous nature—toys with them out of a peculiar innocence, that is, with a child's naiveté, gullibility, and curiosity—which none of us dare or wish to do.

Fairbairn's and Hanna Segal's ideas about art are similar to Winnicott's, although their understanding of the psychodynamics involved is different if related. Fairbairn writes: "If art provides a channel of expression for sadistic phantasies, we have equal reason to believe that it provides a channel of expression for phantasies of restitution. Indeed, since the chief source of inner tension is found to lie in the pressure of destructive urges, and since artistic activity both relieves this inner tension and is essentially creative, we are justified in concluding that the principle of restitution is the governing principle in art."[34] Segal writes that "the world the artist creates is created anew. This . . . has to do with a reparative reconstruction. It is a restoring in one's internal world of a parental couple creating a new baby." There is a "shift from a narcissistic position, in which the artistic product is put forward as self-created faeces, with a constant terror that one's product will be revealed as shit, to the genital position in which the creation is felt to be a baby resulting from meaningful internal intercourse. And the work of art is then felt as having a life of its own and one which will survive the artist."[35]

For all the difference between Fairbairn and Winnicott, they make the same fundamental point: the artist can make the object look durable, good, and socially relevant while acknowledging the badness, brokenness, and destructiveness deep within it. Segal comes close to Greenacre and Valliant in writing "that the artist and the creator of the delusion are close to one another in the vividness of their feeling of the destruction of their whole inner world and their need to create a complete world anew."[36] Segal approaches Greenacre's distinction between the artist and the imposter when she writes that while "the artist is concerned primarily with the restoration of his objects," the deluded person "does not aim, in his creation, at restoring any objects: what he is creating is an ideal picture of himself, including an omnipotent potency."[37] Since society cannot function on the basis of absolute narcissism, the artist's creation carries social

weight because it is object-oriented. In contrast, the self-idealizing delusion fails to gain lasting social approval, for it conveys a socially disruptive grandiosity that suggests that it is the narcissistic product of an imposter. Of course there are mass delusions that carry artistic conviction, that is, grandly promise—and for many seem to deliver—a fearless new object and world. Prominent examples are totalitarian systems such as fascism and communism, with their cult of the ideal leader—the ultimate self-object—and their promise of perpetual paradise in daily life. But such delusional systems eventually break down from the weight of the disappointments and frustrations they themselves generate. For Segal, Fairbairn, and Winnicott, only the special individual called the artist can repair the world, and with that the self: make both more fresh and new—if only in illusion—than they ever were in reality. Thus the artist keeps alive the hope of reparation in an irreparable society. He symbolizes our need to be repaired and to repair the world, indeed, to idealize ourselves and live in an ideal world, even though we know that the ideal, by definition, can never be realized.

VI

However often psychoanalysis attempts to debunk the artist, it ends up privileging him. Janine Chasseguet-Smirgel writes: "I insist on the pervert's compulsion to idealise. Thanks to idealisation he tries to disguise from others and from himself the anal character of his impulses, of his objects, and of his Ego. The compulsion accounts for the pervert's affinities with beauty and the world of art: the pervert is often an aesthete."[38] Robert Stoller writes: "What difference is there, then, between the makeup of what is regularly accepted as aesthetic excitement, excitement in general, erotic excitement, and neurosis? Not so much. Content, mostly, more than structure."[39] Chasseguet-Smirgel and Stoller seem to disillusion us about the artist (and art aficionado), but they in fact imply, however ironically, that he is an exceptional individual, for he is more idealistic than the rest of us, and through art experiences life as more exciting than we usually do. Otto Rank makes perhaps the most unequivocally idealizing statement about the exceptional or noncompliant character of the artist. "The individual," he writes,

raises himself from out of the community by his inclusion in the genius-type in just the same way as the object is torn from its natural surroundings by its artistic stylization. The individual, as it were, abstracts himself in the style demanded by the genius-ideology and so concentrates the essence of his being, the reproductive urge, in the genius-concept. He says, more or less, that he needs only to create and not to beget. The novelty of our present view lies, however, in this: that we have good reason for assuming that this creativity begins with the individual himself—that is, with the self-making of the per- sonality into the artist, which we have described previously as his appointment to the genius-type. The creative artistic personality is thus the first work of the productive individual, and it remains fundamentally his chief work, since all his other works are partly the repeated expression of this primal creation, partly a justification by dynamism.[40]

Rank does not seem to realize that, from the point of view of Greenacre, this makes the artist a narcissistic imposter, that is, someone whose major work is himself, rather than objects that can stand on their own. Indeed, his works of art never quite do, for they invariably symbolize his ideal sense of himself—his sense of himself as a creative genius outside and above the com- munity—whatever their form and whatever else they represent.

Since Freud, it has been psychoanalytic practice to debunk culture by assimilating it to psychopathology. Freud famously wrote:

The different neuroses echoed the most highly admired productions of our cul- ture. Thus hysterics are undoubtedly imaginative artists, even if they express their fantasies mimetically in the main and without considering their intelligi- bility to other people; the ceremonials and prohibitions of obsessional neurotics drive us to suppose that they have created a private religion of their own; and the delusions of paranoics have an unpalatable external similarity and internal kinship to the systems of our philosophers. It is impossible to escape the con- clusion that these patients are, in an asocial fashion, making the very attempts at solving their conflicts and appeasing their pressing needs which, when those attempts are carried out in a fashion that is acceptable to the majority, are known as poetry, religion and philosophy.[41]

But poetry, religion, and philosophy gain rather than lose from this psychoanalytic understanding of them. For they are not only shown to be creative attempts to come to terms with the basic conflicts of human life, and thus not superficial social adornments, but shown to do so convincingly, for they communicate the conflicts in a socially acceptable way, implying that they have been resolved. Thus, Freud doubly privileges poets, believers, and philosophers—artists all: not only do they creatively transform psychopathology into culture, but their cultural creations seem autonomous and as such generally valid and emotionally useful.

Is there any cultural creation that privileges itself above poetry, religion, and philosophy—all species of art to the extent that they are original creations (rather than dogmas demanding compliance)? Yes, psychoanalysis, which scientifically demonstrates that they are psychologically determined however socially acceptable. Freud's comparison of poetry, religion, and philosophy with hysteria, obsessional neurosis, and paranoia places psychoanalysis above them all. In putting them in the proper psychological perspective, psychoanalysis positions itself as the arbiter of their meaning. Its scientific method indicates that it has a developed reality principle, while their seductiveness shows that they remain beholden to the pleasure principle and thus subtly infantile. It is worth noting that Freud's view has much in common with that of Comte, who regarded religion as infantile in its attitude to reality, metaphysics as adolescent, and science as adult. It is thus superior to religion and metaphysics, both of which have the character of artistic creations, and as such are not based on careful analytic observation of reality. They are thus of not much value in the struggle for survival, however much they have emotional value in that they seem to sustain a sense of self despite the environmental odds against it. Freud seems to have acknowledged that they had psychological survival value, for they integrate the individual and the group. That is, religion and metaphysics mediate the group's values and socialize the individual so that he adopts—internalizes—them. He is thus less likely to be neglected or destroyed by the group—cast out of the community to survive as best he can, like a scapegoat in the wilderness.

Psychoanalysis's privileging of itself because of its scientific character, while paying a certain lip service to art, reappears in Heinz Kohut's "hypothesis of artistic anticipation," as he calls it. While crediting "the great artist" with being "ahead of his time in focusing on the nuclear psychological problems of

his era," only "the investigative efforts of the scientific psychologist" can offer a "therapeutic" solution as well as systematic and comprehensive understanding of these problems."[42] Similarly, Winnicott writes that "if what I say has truth in it, this will already have been dealt with by the world's poets, but the flashes of [psychological] insight that come in poetry cannot absolve us from our painful task of getting [scientific] step by step away from ignorance toward our goal."[43] Donald Meltzer remains somewhat more deferential to the artist, but in the end, works of art are simply means to a psychoanalytic scientific end. "What the psychoanalyst can discover in his limited craftsmanship and virtuosity, and what in the increments of vocabulary he can evolve to describe, the emotionality of our life of the mind, he is still always lagging behind the artist, infuriating as that might seem." Nonetheless, "Our only recourse is to [scientific] description, endless description, through which the various symbolic forms expand and expand their various vocabularies, each new [scientific] delineation serving also as a tool for further probing and dissection [analysis] of the forms of life that we experience and share, in our fashion."[44] But however much psychoanalytic science is privileged over art, art is privileged more, however unwittingly, for it is first on the psychological scene, as it were, while psychoanalysis came second, however more thorough and psychologically realistic it is. Once again psycho-analysis idealizes art, if with a kind of backhanded compliment.

For all its implicit idealization of the artist, the psychoanalytic con-struction of the artist has much to recommend it. It places the intrapsychic achievement of the artist before his social position, making it clear that the respect accorded him has a good deal to do with that achievement, which the work of art represents. In transforming an asocial dream into civilized culture, the artist becomes the model of mature development. He overcomes neurosis, sidesteps psychosis, and rises above the temptation to become an imposter by achieving psychological insight into himself, and ingeniously conveying it to others, where it helps them achieve a similar insight, however more modest. The artist seems to maintain authenticity throughout his development, unlike the rest of us, who are normally neurotic and now and then psychotic, and often feel like imposters—feel that we are false to ourselves and others in the very act of trying to be true to ourselves and others—and are unable to convey to other people what little psychological insight we have into ourselves, at least in a way that makes it interesting and convincing to them, and thus of general use. Only

our psychoanalysts find us as interesting and convincing—almost—as we find ourselves. Erich Fromm thinks that only the artist is a "spontaneous . . . integrated personality," realizing his "emotional and intellectual potentialities" while the rest of us are, as he says, conformist automatons. "Spontaneity is a relatively rare phenomenon in our culture," he writes, but artists are individuals "whose thinking, feeling, and acting"—their whole being, no less—is a spontaneous "expression of their selves" because they alone have "positive freedom," as he calls it, that is, they alone are able to free their will from that of society.[45]

Can we really believe this, even if it is only a tautological equation of spontaneity and creativity, qualities of the generic artist? It is an unadulterated idealizing fantasy. The artist is neither more nor less self-realized than anyone else. And the difference between the artist and the conformist automaton is not as clear as Fromm thinks it is: many artists are automatons of their own social identity, and much of what seems like creativity is in fact conformist and automatic—even compulsive—rather than spontaneous, noncompliant activity. In any case, where Fromm privileges the artist by viewing him as the grand climax of successful development, Christopher Bollas privileges the artist by viewing him as uniquely intimate with the mysterious origin and catalyst of development. Indeed, he remains emotionally closer to and less forgetful of it than the rest of us, who tend to drift and even deliberately break away from it. The artist identifies with what Bollas calls "the transformational object," which is "the first object," namely, the mother in her function "as a region or source of transformation . . . an object that transforms the subject's internal and external world." This is "the earliest experience of the object," and the artist retains vivid unconscious memories of it—memories of the mothering function before the mother is "personalized . . . as a whole object."[46] Bollas states: "The artist both remembers for us and provides us with occasions for the experience of ego memories of transformation." The work of art may provide such an occasion, but it is hardly the only thing that does. We inform any object we deeply invest in with transformative power—the power to transform our internal and external world. Do we really need the artist and art to remember for us? I doubt it, but it is nice that they do.

VII

There is a kind of antidote to this flattering attribution of unique and absolute goodness to the artist—indeed, virtual psychological deification of him—in the psychoanalytic view of the modern artist. It began with Freud's derisive remark, in a 1922 letter to Karl Abraham, that he found an expressionist portrait of Abraham "horrifying," adding that the artist was "the all-too-undesirable illustration of Adler's theory that it is just the people with congenital defects of vision who become painters and draughtsmen."[47] Lucky he did not say art was a form of masculine protest.

In his letter, Freud found Abraham's "tolerance or sympathy for modern art" a "trifling flaw in [his] character." Today the flaw is entirely in the art, as Franz Alexander and Michael Balint suggest. Modern art, Alexander writes, is an "aggressive denial of the objects in the form they are commonly perceived," and as such involves "nihilistic perception" and "ridicule of . . . order or reason."[48] Balint seems to recognize the positive creative achievement of modern art when he declares that it "has made an immense contribution to maturity by demonstrating that we need not repress the fact that in and around us . . . discordant features exist," and that "such [unresolved] discordances can be resolved by artistic methods," and thus "tolerate[d] . . . without pain and even . . . enjoyed."[49] But then he argues that modern art involves "narcissistic withdrawal" from the object, with its attendant dangers of regression, retraumatization, and "immature 'pre-genital'"—and, in particular, "anal-sadistic"—attitude, in which "objects are dismembered, split, cruelly twisted, deformed, messed about," their "dirty, ugly qualities . . . 'realistically' and even 'surrealistically' revealed."[50] "Kind consideration for, and idealization of the object becomes less and less important" as "primitive 'anal' messing" takes over. While the modern artist is sensitive to any restrictions on his freedom and sincerity, and because of them has "less fear, . . . richer and more varied possibilities of emotions and enjoyments,"[51] he has "less and less regard [for] the object's feelings, interests, and sensitivities,"[52] even its right to exist. Indeed, "degrading the dignity of the object into that of a mere stimulus and laying the main emphasis on the sincere and faithful representation of the artist's subjective internal mental processes" leads to its destruction.

I have to say that I regard Balint's psychoanalysis of modern art as a welcome change from the naive idealization of it as revolutionary. Freud and Alexander are all too dismissive while Balint offers a considered analysis of its destructiveness, with the reminder that destructiveness is immature, and that maturity is the goal of life—a necessary however precarious achievement, as Balint says. Freud and Alexander prefer the whole objects of traditional art—as if there was no problem with them—while Balint accepts modern art's insightful ambivalence toward the object: perverse love as well as blind hatred of it, suggesting its inherent complexity as well as our own, and threatened the position of both the subject and the object in the modern world. Balint reminds us that the artist is not as psychologically different from the rest of us as he seems to be, and that his destructiveness is a response to the tragedy of modernity, inseparable from its scientific and technical achievements, which also involve a certain murderous analytic attitude, for which there is not always clear reparation.

Is there a happy position between the gross idealization of the artist and the image of him as a neurotic manqué, a psychotic manqué, an imposter manqué, and psychoanalyst manqué? Yes, art itself offers one. The best artists have a kind of healthy skepticism and mature criticality, rather than destructive envy of each other. Such critical consciousness is at its best when it takes humorous—ironically benign—form. Considered comical consciousness is the alternative to the aggrandizing idealization—and self-idealization—of the artist and his ironic elevation into a psychologically unique and complex specimen of humanity at its most heroic. Artists have a way of cutting each other down to size in a way no amount of psychoanalysis can ever do, for psychoanalysis is insufficiently playful, certainly not as playful as art can be.

In response to the publication of *The Secret Life of Salvador Dali*, James Thurber wrote *The Secret Life of James Thurber*. Thurber begins by noting some of the vignettes in Dali's book: "The youthful dreamer of dreams biting a sick bat or kissing a dead horse . . . the sighing lover covering himself with goat dung and aspic that he might give off the true and noble odor of the ram . . . Salvador adoring a seed ball fallen from a plane tree, Salvador kicking a tiny playmate off a bridge, Salvador caressing a crutch, Salvador breaking the old family doctor's glasses with a leather-thonged mattress-beater."[53] This is the same Dali whose "undeniable technical mastery" Freud admired. "What interests me in your art," Freud said to Dali, "is not the unconscious but the conscious."[54]

Thurber notes that "Señor Dali's book sells for six dollars," while his "own published history . . . sold for $1.75." Complaining about this unusual figure to his publisher, "principally on the ground that it represented only fifty cents more than the price asked for a book called *The Adventures of Horace the Hedgehog*," Thurber tries to figure out why Dali's book is priced so much higher than his own, especially at a time when "the world is in ten times a serious condition as it was in 1933" when Dali's autobiography was published.[55] Dali, Thurber realizes, had the jump on him "from the beginning." Dali "remembers and describes in detail what it was like in the womb." Thurber's "own earliest memory is of accompanying [his] father to a polling booth in Columbus, Ohio, where he voted for William McKinley. It was a drab and somewhat battered tin shed . . . filled with guffawing men and cigar smoke . . . far removed from the paradisiacal placenta of Salvador Dali's first recollection." Thurber comes to the "inescapable conclusion" that "the trouble, quite simply, is that I told too much about what went on in the house I lived in and not enough about what went on inside myself." This is a salutary rebuke to the general fawning over the artist's superior awareness and personality, which psychoanalysis furthers in its own inimitable way.

This is an expanded version of an address given in Toronto at the Annual Conference of the American Psychological Association in August, 1996.

Notes

1. For example, in *The Will to Power* (New York: Vintage, 1968), 421, Nietzsche writes: "Artists, if they are any good, are (physically as well) strong, full of surplus energy, powerful animals, sensual." They have an "overflowing fullness of bodily vigor" and "victorious energy" (422). At the same time, because "it is exceptional states that condition the artist—all of them profoundly related to and interlaced with morbid phenomena— . . . it seems impossible to be an artist and not to be sick" (428). But "the artist belongs to a still stronger race," so that "what would be harmful and morbid in us, in him is nature" (430).

2. Julia Kristeva, *Desire in Language* (New York: Columbia University Press, 1983), 89. The quotation marks with which Kristeva encloses the word "artist" point to a persistent ambiguity in the psychoanalytic literature. Sometimes "artist" means the creative personality as such, sometimes it means anyone who makes what society designates as works of art.

3. Daniel Bell, "Beyond Modernism, Beyond Self," *The Winding Passage: Essays and Sociological Journeys* 1960–1980 (New York: Basic Books, 1980), 279.

4. Silvano Arieti, *The Will to Be Human* (New York: Quadrangle, 1972), 47–48, states what is in effect the credo of psychoanalysis: "It is one of the aims of man to increase his capacity for choice and to decrease determinism in every possible way, to move away from physical necessity and toward free will. It is one of the aims of civilized man to fight all restrictions of free will, no matter from what directions they come." Lawrence S. Kubie, *Neurotic Distortion of the Creative Process* (New York: Noonday, 1959), 20–21, says something similar when he writes "the measure of health is flexibility, the freedom to learn through experience, the freedom to change with changing internal and external circumstances Any moment of behavior is neurotic if the processes that set it in motion predetermine its automatic repetition, and this irrespective of the situation or personal values or consequences of the act." Presumably such freedom and flexibility are innate to the artist, a mythical personality constructed out of theoretical and therapeutic necessity. Creativity is the alternative—irreconcilably opposed—to determinism, whether of the drives or of the environment. The artist, then, becomes the symbol of absolute, unconditioned—undetermined, unconstrained—creativity.

 It seems that the goal of therapy is to turn everyone into a kind of artist—an absurd idea, but the artist seems to be the emotionally necessary personification of the idea of complete liberation from internal and external determinisms. However much this vision of the artist is a mystification of freedom, it is a mystification in the service of health and civilization. However, the person who thinks that the goal of therapy is to make him an artist in the socially literal sense of the term may become seriously ill mentally when society rejects his art on the ground that it does not meet the current criteria for

significant art, however contradictory and thus bewildering they may be.

5. Quoted in Janet Malcolm, *Psychoanalysis: The Impossible Profession* (New York: Knopf, 1982), 80.
6. D. W. Winnicott, "Psychoanalysis and the Source of Guilt" (1958), *The Maturational Processes and the Facilitating Environment* (New York: International Universities Press, 1965), 26.
7. Quoted in Gilbert J. Rose, *Trauma and Mastery in Life and Art* (New Haven and London: Yale University Press, 1987), 15.
8. Sigmund Freud, *Totem and Taboo* (New York: Norton, 1950), 90.
9. Sigmund Freud, *New Introductory Lectures on Psycho-Analysis* (New York: Norton, 1933), 219.
10. Quoted in Rose, 15.
11. Quoted in Jack Spector, *The Aesthetics of Freud: A Study in Psychoanalysis and Art* (New York and Washington, D. C.: Praeger, 1972), 33.
12. Quoted in Rose, 14–15.
13. Sigmund Freud, *An Autobiographical Study* (New York: Norton, 1963), 122–123.
14. Ibid.
15. Quoted in Spector, 103.
16. W. R. D. Fairbairn, "Prolegomena to a Psychology of Art," From *Instinct to Self: Selected Papers of W. R. Fairbairn*, eds. Ellinor Fairbairn Birtles and David E. Scharff (Northvale, NJ and London: Jason Aronson, 1994), vol. II, 394.
17. Ibid., 392.
18. Quoted in Spector, 103.
19. D. W. Winnicott, "The Location of Cultural Experience" (1967), *Playing and Reality* (London: Tavistock, 1971), 99.
20. Winnicott, "Playing: Creative Activity and the Search for the Self," ibid., 54–55.
21. Phyllis Greenacre, "The Imposter" (1958), *Emotional Growth: Psychoanalytic Studies of the Gifted and a Great Variety of Other Individuals* (New York: International Universities Press, 1973), vol. I, 93.
22. Greenacre, "The Relation of the Imposter to the Artist" (1958), ibid., vol II, 533.
23. Greenacre, "Play in Relation to Creative Imagination" (1959), ibid., vol. II, 567.
24. Greenacre, "The Imposter," ibid., vol. I, 103.
25. Quoted in Sarah Kofman, *The Childhood of Art: An Interpretation of Freud's Aesthetics* (New York: Columbia University Press, 1988), 25.
26. Otto Fenichel, *The Psychoanalytic Theory of Neurosis* (New York: Norton, 1945), 498.
27. Hermann Broch, "The Style of the Mythical Age," *Gesammelte Werke, Dichten und Erkennen, Essays* (Zurich: Rhein, 1955), vol. I, 260.
28. George Valliant, *The Wisdom of the Ego* (Cambridge, MA: Harvard University Press, 1993), 204.
29. Ibid., 204–205.
30. Ibid., 283.
31. D. W. Winnicott, "Psycho-Neurosis in Childhood" (1961), *Psycho-Analytic Explorations* (Cambridge, MA: Harvard University Press, 1989), 71.
32. Winnicott, "The Location of Cultural Experience," 100–101.
33. Ibid., 97.
34. Fairbairn, vol. II, 297.
35. Hanna Segal, *Dream, Phantasy and Art* (London and New York: Tavistock/Routledge, 1991), 95.
36. Hanna Segal, *The Work of Hanna Segal: A Kleinian Approach to Clinical Practice* (Northvale, NJ and London: Jason Aronson, 1981), 213.
37. Ibid., 214.
38. Janine Chasseguet-Smirgel, *Creativity and Perversion* (London: Free Association Books, 1985), 14.
39. Robert J. Stoller, *Observing the Erotic Imagination* (New Haven: Yale University Press, 1985), 43.
40. Otto Rank, *Art and Artist: Creative Urge and Personality Development* (New York: Norton, 1989), 28.
41. Quoted in Kofman, 143.
42. Heinz Kohut, *The Restoration of the Self* (New York: International Universities Press, 1977), 285, 296.
43. D. W. Winnicott, "Fear of Breakdown" (1963?), *Psycho-Analytic Explorations*, 87.
44. Alberto Hahn, ed., "Sincerity: A Study in the Atmosphere of Human Relations" (1971), *Sincerity and Other Works: Collected Papers of Donald Meltzer,* (London: Karnac, 1994), 186, 187.
45. Erich Fromm, *Escape from Freedom* (New York: Avon, 1965), 284.
46. Christopher Bollas, *The Shadow of the Object: Psychoanalysis of the Unknown Thought* (New York: Columbia University Press, 1987), 28–29.
47. Quoted in Kofman, 222.
48. Franz Alexander, "The Psychoanalyst Looks at Contemporary Art," *Art and Psychoanalysis*, ed. William Philips (Cleveland: Meridian, 1963), 350.
49. Michael Balint, "Notes on the Dissolution of Object-Representation in Modern Art," *Journal of Aesthetics and Art Criticism*, 10 (June 1952): 326.
50. Ibid., 327.
51. Ibid., 326.
52. Ibid., 327.
53. James Thurber, "The Secret Life of James Thurber," *The Art of the Personal Essay: An Anthology from the Classical Era to the Present*, ed. Philip Lopate (New York: Anchor Doubleday, 1994), 514.
54. Quoted in Rose, 13.
55. Thurber, 515.

Philobatic and Ocnophilic Eyes

Philobatism and ocnophilia are Michael Balint's terms for the two basic modes of object relations. I want to use them to distinguish two basic modes of visual art. The analogy no doubt seems facile and speculative, not to say gratuitous and absurd. It promises to corrupt the clinical concepts without much conceptual gain for the cultural product. Nonetheless, as Roy Schaefer argues, there is no essential methodological difference between clinical and applied psychoanalysis. The difference is in the data and goal. Because of the basic rule of free association, there is more data in the clinical relationship, and the goal is mutative or therapeutic. In cultural analysis, the goal is expanded intelligibility rather than therapeutic transformation.

But such analysis, by convincingly changing the way the cultural object is framed, changes the way the viewer relates to it, and thus perceives and experiences it. This seems to change its substance by changing its effect. Moreover, while the data are technically limited, it is the pattern they invariably form that is the true datum. The cultural pattern is as coherent, dynamic, and recurrent as any psychic pattern, and thus as susceptible to analysis. It, too, is all too human, and arises out of and expresses humanness. Free association, after all, is only a source of information, not the ground of analytic truth. It does not supply its own meaning, only the facts out of which meaning might

be constructed, however much these raw symptomatic facts are latent with human meaning.

Moreover, as Schaefer points out, both clinical and applied psychoanalysis involve the same difficult problem of deciding what concepts will make the most sense of the data. Whether a person or a cultural phenomenon—and it is an extension of a person, addressed to a like-minded group of persons, and thus in effect an extension of their interests—the data must be given a shape, and the only way of doing so is by a judicious use of already existing ideas. But the choice of such ideas is fraught with uncertainty and never absolutely binding, and the insight their application affords is always limited and its transformational effect unpredictable, however much it may have worked in similar cases in the past. Also, in the course of both clinical and applied psychoanalysis the analyst realizes that what seems like free association or personal expression is neither so free nor personal, and what seems individual is less unique than it appears to be. Slowly but surely it discloses itself as typical—a consistent style of psychic functioning, as David Shapiro calls it, whatever the idiosyncrasies of its manifestation, usually due to the vicissitudes of personal history. Not that these idiosyncrasies are dispensable, but they are bound to universal issues, and the analysis proceeds by discerning the structure of those issues in order to redress the suffering the idiosyncrasies represent, indeed, perform as well as disguise.

Psychic styles and cultural styles are not inherently different, Schaefer argues, because cultural products serve the psychic needs of individuals. As Winnicott says, cultural experience is located in transitional space and the cultural product is a transitional phenomenon, which means that it is unconsciously experienced as a subjective object, however objectively it might be experienced consciously. As Schaefer, Winnicott, and numerous other psychoanalysts have observed, people are drawn to cultural products largely to satisfy relational needs. Whether or not we want to be, we find ourselves in a certain emotional relationship with the cultural product, at least when we decide to seriously interest ourselves in it—attend and attune to it. We then spontaneously experience it as good or bad, in effect projectively identifying with it. Whether or not we want it to be, it acquires the reality of an internal object, sometimes, for aficionados, not to say fanatical devotees, in a delusional way—in a way that makes it seem more real than reality.

Thus the style of a cultural product expresses an object-relational style. Assuming there are two basic object-relational styles or modes, as Balint says— philobatism and ocnophilia—then every cultural product must exemplify one or the other or some combination of them. That is, either a philobatic or ocnophilic motivation or attitude determines its character. We tend to like cultural products that reflect our own relational style, and to dislike those that oppose it. In the case of a work of visual art this occurs independently of its designation as representational or abstract. To say this another way, the eye is always an organ of relational desire, that is, the object it focuses into a depiction is always an object it is in serious and even urgent relationship with, which is true even when it seems to have no object and even seems to destroy its object. Abstract art appears to heed St. Paul's advice to pluck out the eye that offends you with its desire. But to blind yourself to the object of desire does not mean that it was not there to arouse you in the first place, and that it continues to exist in your mind, and may even endure there forever (if in symbolic form), making for a certain continuous if subliminal emotional excitement. Is this notion too fanciful to give new meaning and substance to the old term "nonobjective art," or have I actually uncovered its original disastrous relational and emotional meaning, hidden even from its inventors?

What are philobatism and ocnophilia? Heinrich Wölfflin seems to recognize their difference, and perhaps even their psychodynamic import, in his account of the difference between High Renaissance and Baroque art, which he characterizes as "universal forms of representation."[1] "Baroque . . . is neither a rise nor a decline from classic, but a totally different art," he writes, just as ocnophilia is neither better nor worse than philobatism, only a different style of relating. It is worth noting that for both Wölfflin and Balint each style is in developmental relationship with the other, and as such inconceivable without the other. Now when Wölfflin writes that "seeing by volumes and outlines isolates objects"—which is the way they are seen in High Renaissance art—he is describing an ocnophilic attitude to them. Similarly, when he writes that "for the painterly eye, [objects] merge," losing their distinctness and almost their definition as objects—which is the way they are seen in Baroque art—he is describing a crucial effect of philobatism. When he describes "the development from closed to open form," which involves the "relaxation of rules, the yielding of tectonic strength," so that the work of art seems "loose" rather than "self-con-

tained," he is describing the development from an ocnophilic to a philobatic work of art. Similarly, when he distinguishes the achievement of unity through "a union of parts in a single theme"—of "single parts [that] maintain a certain independence . . . however firmly they may be rooted in the whole"—and through "a harmony of free parts," he is distinguishing between ocnophilic organization and philobatic organization. In the latter part objects maintain their integrity however subordinate to the whole object, while in the former ostensibly autonomous part objects lose differentiation by harmonizing, so that they seem never to have been separated in the first place. Yet again, when Wölfflin distinguishes between "the representation of things as they are, taken singly and accessible to plastic feeling, and the representation of things as they look, seen as a whole, and rather by their non-plastic qualities"—art in which "composition, light, and color . . . have their own life" and art in which they "merely serve to define form"—he unwittingly distinguishes between philobatism and ocnophilia.

Wölfflin regarded "the transition from tangible, plastic, to purely visual, painterly perception" as a "psychological process," suggesting that the parallel I note between his differentiation of two basic "forms of representation or forms of beholding," as he calls them, and Balint's differentiation of two basic forms of object relationship, is far from absurd. Moreover, when Wölfflin writes "that it is dangerous to speak only of certain 'states of the eye' by which conception is determined," because "every artistic conception is, of its very nature [my emphasis], organized according to certain notions of pleasure," he speaks psychoanalytically, however unwittingly. Devoted clinging to the object and the feeling of being superior to it, and thus able to do without it—deep dependence on the object and pseudo-transcendence of it—are different ways of grasping the same straw of pleasure relating to the object may put within reach.

"All thrills," Balint writes, "entail the leaving and rejoining of security."[2] "The pleasure experienced in either of these two phases—that is, either when staying in security [ocnophilia] or when leaving it in order to return to it [philobatism]—are very primitive." This is in part because of "the appearance of ocnophilic tendencies in purely philobatic situations . . . suggest[ing] a kind of regressive trend." The ocnophilic person is reluctant to leave security, and while the philobatic person is ready and willing to do so, he is also eager to return to it. Balint states that "it seems that to hold on to something, to have

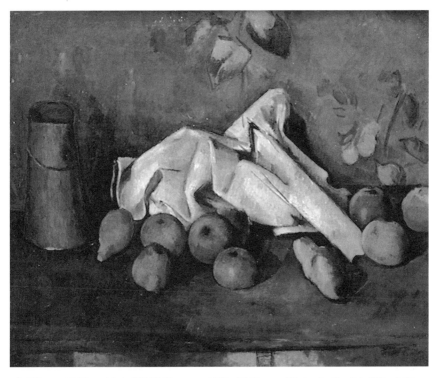

Paul Cézanne, *Milk Can and Apples*, 1879–80. Oil on canvas, 19³/₄" × 24". Museum of Modern Art, New York, William S. Paley Collection. Photograph © 1999 The Museum of Modern Art.

something in one's hand, is more primitive and more general than being independent, being completely on one's own, with hands empty. The things that we cling to—the ocnophilic objects—appear in the first instance to be symbols of security; that is, the safe, loving mother."

Is it an overstatement to insist that Pollock, in his best all-over paintings—the most impulsive, expansive, seemingly "free" ones—is in headlong and handlong philobatic flight from his mother? That is, he in effect empties his hands—even throws them away, I would argue, on the basis of the fact that he "dropped" the brush, as it were, by pouring paint directly and chaotically from the can onto the canvas—of any feelings associated with her. In a sense, he was not so much trying to escape her as acknowledging the unfortunate fact that she escaped him, that is, afforded him little security. He was desperately admitting—but not accepting—the lostness and abandonment that were hers to inflict from the beginning of their relationship. All the evidence indicates that

she was neither safe nor loving nor giving, and in fact somewhat overbearing and, at the same time, remote and indifferent—a spirit-crusher.

Thus, the sense of liberation Pollock's all-over paintings afford is an illusion, as a careful look at the tangled, tortured mess of paint suggests. Its anguished, forbidding crosscurrents—constantly conflicting gestures, oscillating so rapidly no stability is possible—make this abundantly clear. Pollock's all-overness seems to embody the freedom of an artist "on his own, away from every support, relying on his own resources." It seems, in other words, to be consummately philobatic. But the fact that Pollock had very few resources—no objects (no longer even the distorted ones of his early paintings), only their messy painterly remains—indicates that his freedom was more apparent than real. Indeed, there is an air of compulsive chaos in the all-over paintings, even of panic, implying his wish to return to a secure object and his recognition that there was none to return to—no motherly safety net to fall into after his philobatic flights of manic fancy, which pretended to leave what in fact was not there.

Pollock's all-over paintings suggest the intimate and ironic connection between ocnophilia and philobatism. They convey the difficulty of sustaining philobatic independence, and the fact that it is often an illusion. The object mysteriously reappears in several of the all-over paintings, cut out of the surface yet embedded in it. This enigmatic object is a grotesque phantom rather than a fully realized figure. It is an incoherent fragment of an inchoate figure: a nightmarish hallucination, implying its inherent defectiveness and emotional absence for the subject who phantasized it. Pollock is regarded as the exemplary heroic artist, philobatically defying all odds, but he was in fact profoundly immature and fearful. His relentless pursuit of an object to which he could cling, and which would securely hold him, indicates as much. He never did find such a good object: the moment he makes contact with what might become one, it dissolves into an unholy mess, losing its structure after revealing its monstrousness. Its grotesquely distorted nature conveys the fact that it is a very bad object, hardly a safe haven. Indeed, Pollock's object is a dangerous god that can never be placated. He accurately perceived his mother's emotional reality, although the monstrous object is also the bad object he was to himself for failing to win her love and convince her of his worth. The problem is common enough.

Pollock in effect went down on all fours to make his all-over paint-

ings, that is, made them on the floor rather than on the surrogate wall of an easel. This brings to mind Balint's observation that while "the outward expression" of the philobatic attitude is "a brave, erect stance . . . crawling on all fours . . . is not an heroic posture." Pollock may have strutted around—Balint associates strutting with philobatic grandeur—but when it came to making art—truly showing what he was made of—he was full of ocnophilic despair, however unconsciously. He regressed to all fours in order to find security in the act of painting and to cling to whatever object he could phantasize in and through the generative act of painting. Paint was in effect a substitute nourishing mother: the matrix of creativity was also the matrix of intimacy. Establishing reciprocity with paint, he emotionally survived, however much his painting was about his feeling of being annihilated for want of love and care. Mercedes Matter apparently saw Pollock literally caress a painting he was working on, which is one way of clinging to it, for all the treachery of its appearance.

Now "philobatic thrills"—they take ironical form in Pollock's all-over paintings—"represent in a way the primal scene in symbolic form," Balint writes. "A powerful and highly skilled man produces on his own a powerful erection, lifting him far away from security, performing in his lofty state incredible feats of valor and daring, after which, in spite of untold dangers, he returns unhurt to the safe mother earth." Pollock had no safe mother earth to return to, which is why he stretched out the feat of valor and daring that the painting was for him until it was all-over or everywhere, crowding out the horizon of possibility, and as such all that there is and will ever be. His wife Lee Krasner no doubt played the role of the assisting and admiring and receiving—containing—girl that accompanies the performing "hero-acrobat." But she could do so only so long; the primary mother object had failed too completely to allow for later repair of the victim of her failure. Pollock was clearly heading for a fall—are his all-over paintings the remains of his Humpty Dumpty tumble into the emotional void?—because he had no really safe ground to return to. He may have been stuck in the phantasy of the primal scene because he was unable to develop the scene of his own selfhood. "Acrobatics"—which is one convincing way of describing Pollock's all-over paintings—"are one special form which symbolically represent the primal scene." In a sense, Pollock did not know how to represent anything else. *Portrait and a Dream*, 1961, shows him trapped with-

in and by the primal scene, that is, the phantasy of parental intercourse as violent and destructive. As Balint says, "the philobatic world consists of friendly expanses dotted more or less densely with dangerous and unpredictable objects," which is an apt description of the all-over paintings, as well as others. Pollock tried to live "in the friendly expanses" he longed for, but he could not avoid "hazardous contacts with potentially dangerous objects."

Cézanne's still lives are an important case of ocnophilia. They suggest the paradox of "ocnophilic clinging to objects or part objects." As Balint writes, "perhaps its most important quality is that, always and unavoidably, it gets frustrated." Let me quote him at some length, because what he has to say is directly relevant to Cézanne's still lives. Indeed, it characterizes his object relations in general, insofar as they are symbolized in his peculiarly abortive representations of reality. Balint writes:

> Apart from the fact that the object clung to is—in adult life—always a mere substitute, never permitting full satisfaction, there are several features in the ocnophilic object relationship which make frustration inevitable. First, the object, however kindly attuned to the subject, has nevertheless its own life, and must occasionally go its own way, which means conversely that there is a constant danger of the individual being dropped by his object, which danger periodically becomes a bitter fact. If a part object is used for clinging, which quite frequently happens, the relationship can never be satisfactory for the ocnophil. The part object, more often in the individual's fantasy but occasionally also in reality, may be detached from the whole object, causing all sorts of complications such as that the whole object is now damaged, is of much less value, and, most important, that the detached part—i.e., the part remaining available to the ocnophil—is of no use whatever. . . . Lastly, the real aim is to be held by the object and not to cling desperately to it; this being held should happen without even the need to express the wish for it. It is the most cherished aim of every one of us that our environment should meet our wishes—especially our wish for security—without us even asking for it.

I think Cézanne tried to force the object to attune to him by an act of bizarre identification with it, indicated by his attempt to represent it in a completely concrete way. Indeed, he did not so much attempt to represent it as

articulate and possess its concrete givenness. To put this in terms developed by Hanna Segal, he moved from making images that were conscious symbolic representations of the object, to making images that, unconsciously, were symbolic equations for it. It is this concrete thinking about the object that is responsible for Cézanne's increasing emphasis on and obsession with the concrete materials of art making—on paint as such, as an autonomous, absolute substance, which could nonetheless contain his very concrete feelings.

His famous complaint about the difficulty he had capturing and articulating his sensations has to do with the fact that he became stuck on the horns of an emotional dilemma. He was trapped between the true and tried—not to say old fashioned and familiar—symbolic representation of the object and the urgent emotional ambition to find or make a symbolic equation for it. This meant to experience it as a *Ding an sich* and consume it completely with his art. Cézanne was unable to decide between traditional and avant-garde art— between an old established sense of the purpose of art and a new modern one— even as he was driven, by emotional forces beyond his control, toward the latter. In an ultimate act of psychomimesis, he was compelled to create a concrete equivalent for the object—an image that was emotionally and literally equal to it in every way—as though that would enable him to grasp and hold onto it in all its concreteness, once and for all time, while knowing full well that the usual use and task of art is to represent the object symbolically, which requires a certain degree of separateness from it, and ultimately complete, resolute separation. It is this conflict that gives Cézanne's art its intensity.

The irony, of course, is that what looks like aesthetic progress, innovation, unconventionality—altogether remarkable originality and creativity—was profoundly regressive emotionally. In clinging to the concreteness of the objects he painted, and trying to inhabit that concreteness in and through the concreteness of paint, Cézanne was going mad.

In a sense, Cézanne thought—hoped—that this would compel the object to identify him—give him its identity—that is, care for him unconditionally, and thus make him feel completely secure. But it did not and could not do so, for it steadfastly remained itself, which deeply frustrated him. I think this reluctance of the object (as he saw it) to completely submit to him generated his paranoid-schizoid response to it, that is, the experience of it as a persecuting presence that was unpredictably and absentmindedly benign. I think this dou-

bleness or self-contradictoriness is self-evident in his images, and is responsible for the eccentric appearance of his objects. They often seem to slide off into space, or be insecurely anchored in space, as though waiting to fall and be caught, but not daring to drop because they know there is no one there to catch them, only oblivion. I think this paranoid schizoid attitude is responsible for the bitter and destructive edge to Cézanne's images, and to his final fragmentation —at times pulverization—of the object.

The objects in his still lives are in effect part objects of his mother's body. Mont St. Victoire was her breast, now glorious, now withered into specks of light and shadow and half-hearted color, so that it can never be put back together into a coherent object. Cézanne seriously damaged Mont St. Victoire, and finally disintegrated it, chewing and spewing it out and off. It finally fades away, that is, loses all value and use, and as such becomes unrepresentable, that is, no longer worth the trouble of symbolizing. But of course in becoming an oceanic experience—a rhapsody of homeless sensations, however abortive—it becomes sublime. That is, for all its inadequacy Cézanne merges with it completely.

He became increasingly insecure with his objects, whether they were human or not, male or female, himself or other selves. His late works are informed by an aesthetic of frustration and insecurity. I think this is why they appeal to the modern spectator. For the modern world, as Margaret Mahler says, does little if anything to support and further motherhood, so that the mother can hardly be expected to support and further her baby—her supposedly prized object—in a satisfactory way. The world not being adequate to motherhood, the mother cannot be adequate to the infant she brings into it. Neither she nor it can support new life in a way that proclaims its worth and uniqueness. Cézanne relived this lack of support and security in and through his art, which was in fact overwhelmed by it. For it is the failure of empathy he experienced—his boyhood friend Zola's later attack on him epitomized its hurt—that is responsible for his frustrating uncertainty about his sensations and feelings—about what he really knew internally. It is also responsible for his own halfhearted attempt to empathize with his objects, evident in their skewed, awkward appearance in his art.

Cézanne never stopped clinging to them, although he was never really able to reach them. He never completely lost his attachment to them, but they

were never unequivocally gratifying, and unquestionably given. The environments he paints are not exactly facilitative. Cézanne's subtle abandonment of the object, suggestive of the world's abandonment of him, is one of the reasons he is regarded as an important precursor of nonobjective or nonrepresentational painting, that is, painting which abandons the object, no doubt in order to suggest the artist's feeling of being abandoned by the world. The ghost of the object haunts nonrepresentational painting, which in the end, like Cézanne's quasi-representational painting, becomes a gratifying object itself—a substitute object, or rather the part object of an always insecure body of art.

Notes

1. Heinrich Wölfflin, *Principles of Art History* (New York: Dover, n.d.), 14. All subsequent quotations from Wölfflin are from this book.
2. Michael Balint, *Thrills and Regressions* (London: Maresfield Library, 1987), 26. All subsequent quotations from Balint are from this book.

Art Is Dead; Long Live Aesthetic Management

Here the sociology of art overtly enters into the theory and practice of creation.

—Harold Rosenberg, *De-aestheticization*[1]

The only person who is in touch with the whole product is the manager, but to him the product is an abstraction, whose essence is exchange value. . . .

—Erich Fromm, *The Sane Society*[2]

L et's begin by comparing two works of art—works of art that are obviously different, even though they have one thing in common: they both represent Marilyn Monroe. One is by Willem de Kooning, the other by Andy Warhol. They are separated by only eight years—de Kooning's *Marilyn* was painted in 1954, Warhol's *Gold Marilyn Monroe,* a combination of silkscreen, oil, and synthetic polymer paint on canvas was manufactured in 1962—but they are worlds of art and attitude apart. What I want to do is to qualify their difference in yet another way: I want to say that the de Kooning image is artistically created, while the Warhol image is aesthetically managed. I want to try to establish a distinction between art and aesthetic management—between making

art and aesthetically managing a product. I think it is a momentous distinction, for I want to argue that art is on the way out, if still around, while aesthetic management is on the way in, if not already completely in, and is here to stay, if not forever. What will replace both art and aesthetic management in the distant future I have no idea—it may be that the aesthetic will disappear into the practical, which certainly seems a tendency in modernity, as airplane and ergonomic design suggest—but it does seem the case that in the present social interest in art has in large part to do with its high exchange value, and that the transformation of the artist into an aesthetic manager, which is well underway, and which to my mind states a key difference between modernist and postmodernist art, is the perhaps unavoidable consequence of this powerful capitalist fact. That is, by becoming an aesthetic manager the artist confirms and completes his marketing orientation, to use Erich Fromm's important concept, to which I will return in depth, for it reaches to the very depths of what we still continue to call art. The term "aesthetic management" is that of Bernd Schmitt and Alex Simonson, two professors of marketing, who use it in what I think is one of the most important books of the time, for both art and business, and their astonishing convergence—virtual seamlessness—in our time: Marketing Aesthetics: The Strategic Management of Brands, Identity, and Image.

It is worth noting that, in the eight years between de Kooning's Marilyn and Warhol's Marilyn, there seems to have been a heightened consciousness of the soaring exchange value of art, if Meyer Schapiro's 1957 observation that "the successful work of painting or sculpture is a unique commodity of high market value" is any indication. The "concreteness" of painting and sculpture "exposes them, more than the other arts, to a dangerous corruption," Schapiro writes. "Paintings are perhaps the most costly man-made objects in the world. The enormous importance given to a work of art as a precious object which is advertised and known in connection with its price is bound to affect the consciousness of our culture. It stamps the painting as an object of speculation, confusing the values of art."[3] Around the same time, in 1955, Fromm published The Sane Society, in which he observes that in capitalistic society "the essential point in the description" of any and every thing is its cost.[4] This holds for works of art as well as bridges, cigars, watches—and people. This means that the "concrete (use) value" of the thing (and people are simply more or less costly things in capitalistic society, according to Fromm) is "secondary to its abstract

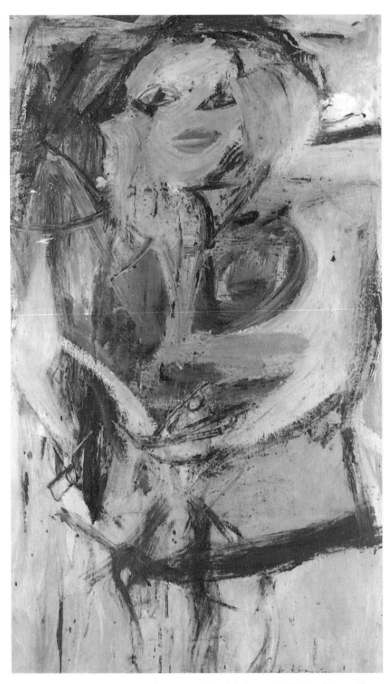

Willem DeKooning, *Marilyn Monroe,* 1954. Oil on canvas, 50" × 30". Collection of the Neuberger Museum of Art, Purchase College, State University of New York, gift of Roy R. Neuberger. Photograph by Jim Frank

(exchange) value in the way the object is experienced. . . . In other words, things are experienced as commodities, as embodiments of exchange value, not only while we are buying or selling, but in our attitude toward them when the economic transaction is finished." As Fromm notes, "newspapers will headline a flood, speaking of a 'million-dollar catastrophe,' emphasizing the abstract quantitative element rather than the concrete aspects of human suffering." Similarly, they will speak of the extraordinary price a de Kooning or Warhol picture brings at an auction, not of what, concretely and humanly, the picture is about and how it is experienced. This is underscored by the fact that increasing numbers of works of art are being stolen—more than 10,000 by the latest count—and that the international inventory which lists these stolen works does so in terms of their market value rather than in terms of their art historical let alone aesthetic significance. Of course, it is hard to believe that the thieves are connoisseurs who know a beautiful thing when they see one and cannot live without it.

Now I will argue, among other things, that the difference between the troubled way de Kooning pictures Marilyn Monroe and the garish way Warhol pictures her symbolizes the difference between the painting as an embodiment of artistic value and as an embodiment of exchange value. Even their difference in technique—de Kooning vigorously painting Marilyn's picture by hand in contrast to Warhol slickly painting over a photograph of her—signals this difference. It is symptomatic of the sea change that occurred in American art from the 1950s to the 1960s, more generally from Abstract Expressionism, which is a subjective, existential, relatively esoteric art and the more conspicuously collective and as such seemingly objective orientation of Pop art. It is symptomatic of something more: the emergence of the aesthetic manager, which is what I think Warhol was, as an alternative to the creative artist, which is what I think de Kooning was. Indeed, Warhol became the model for the aesthetic manager, and de Kooning was one of the last true creative artists, a dying breed.

It should be noted that Marcel Duchamp was probably the first artist manager, as his intellectual management of ready-made objects suggests, that is, his intellectual manipulation of them into artistic significance. But he was not yet an aesthetic manager, as Warhol was. The ready-made objects Warhol worked with were pure appearances rather than literal things, and as such more abstract than the ready-made objects Duchamp worked with. Indeed, Warhol

used celebrity human appearances as abstract things—they had already been abstractified, to use Fromm's term, by being commercially celebrated, that is, making a successful social appearance—which he quantified by serializing (repeating indefinitely, as though cloned), suggesting that there was in fact no human reality to be experienced. Indeed, the peculiarly inhuman character of the appropriated appearance, which is conveyed by its conspicuously manufactured character, giving it the look of automaton conformity, to use Fromm's concept, indicates the absence of real selfhood and individuality.[5] There is no real self behind the appearance of being a different kind of self, as Warhol implied when he declared that he himself was nothing but an appearance. He was a pseudo-self, just as the aesthetic manager is a pseudo-artist. "The pseudo self," Fromm writes, "is only an agent who actually represents the role a person is supposed to play but who does so under the name of the self. It is true that a person can play many roles and subjectively be convinced that he is 'he' in each role. Actually he is in all these roles what he believes he is expected to be, and for many people . . . the original self is completely suffocated by the pseudo self."[6] Similarly, a pseudo-artist plays the role an artist is expected to play, and as such loses his original feelings and thoughts, that is, those he thinks and feels for himself, whether or not anybody else has such thoughts and feelings.[7] Warhol seemed to be deliberately suffocating what original self he had, and his aesthetic management of human appearances seemed to suffocate the original self of the persons pictured—and for Warhol commodities were persons, and vice versa (successfully marketed, commodities acquired the aura of personhood for Warhol, just as successfully marketed "personalities" became expensive commodities)—finishing what the photographic process of turning them into celebrities started.

While the struggle between the creative artist and the aesthetic manager persists to this day—I think the difference between the German neo-Expressionists and the American Conceptualists carries it forward in a new way while typecasting the attitude implicit in each into a fixed position—the aesthetic manager type seems to be winning, at least in this particular capitalistic society. If exchange value is the highest value, then images that apotheosize exchange value—images whose every aspect reeks of exchange value, whose very aesthetic is exchange, implying that exchange value is immanent in life, that its commodification is its climax—will inevitably triumph over images on which no

clear price can be placed, because they are too full of life and as such all too human.

What, then, are the values of art that de Kooning's expressionistic *Marilyn Monroe* embodies—the values of art that I think disappear in Warhol's fabricated *Gold Marilyn Monroe*, that is, Marilyn Monroe as the ultimate golden girl, the most perfect embodiment of the bitch goddess of success, woman and her seductive sexuality as the symbol and embodiment of exchange value? I think they have to do with what genuine art can emotionally achieve. "The work of art," Alfred North Whitehead writes, "is a message from the Unseen," or, as I would say, the unconscious. "It unlooses the depths of feeling from behind the frontier where the precision of consciousness fails."[8] This, I think, is the credo and intention of all true artistic creativity—to reach into the unseen depths of the psyche and bring back a pearl of original feeling from them. T. W. Adorno says something similar. "Works of art," he writes, "do not, in the psychological sense, repress contents of consciousness. Rather, through expression they help raise into consciousness diffuse and forgotten experiences without 'rationalizing' them."[9] This artistic accomplishment is the basic source of artistic value, and whatever stylistic and thematic means are used to realize it acquire artistic value in turn. Such communicative means are of secondary artistic value, in contrast to the primary artistic value of a convincing expression of hitherto unfelt feeling. Artistic expression makes it seem unique and original to the spectator's psyche. Artistic expression thus undermines the pseudo-self and restores the original self. It uses unconscious feeling to undermine conscious reason. Diffuse feeling arises spontaneously, as though experienced for the first time or suddenly remembered, and so all the more meaningful. It is an unexpected message from the unknown depths, a surprise that cannot readily be explained, which makes it all the more resonant and urgent and profound—and makes the art that mediates it convincing.

De Kooning's *Marilyn Monroe* expresses his deep, contradictory feelings about woman. There is no attempt to rationalize this ambivalence, which would mean to accommodate it to traditional renderings of woman—rather than overthrow them, as it does. Submitting to familiar conventions of representation, de Kooning's feelings would lose their traumatic intensity and pathos—their overwhelming expressivity—and become decorative, cosmetic details in a convenient, familiar appearance of woman. Instead, the loving desire

that irresistibly leads de Kooning to woman in the first place and the protective hatred that keeps him from surrendering to her completely, fuse in his wild, unconventional gestures. Some gestures seem to caress and soothe her flesh, as though to encourage it to flourish, and some seem to sadistically gnaw at it, as though to strip her flesh from her body—violently rip and consume chunks of it. Whether grandly aggressive or touchingly tender, de Kooning's raw, raucous painterliness distorts Monroe's very familiar appearance and all but destroys her voluptuous body. Under pressure from his powerful gestures, her body loses cohesiveness and coherence, that is, unity and integrity, or clarity and logic. De Kooning in effect turns a benign external object into a malevolent internal object, bizarre and grotesque yet exciting and seductive. De Kooning's *Marilyn Monroe* is not your conventional Hollywood beauty—an ordinary girl hyped up by banal fantasy—but the anxiety-arousing figment of an overheated, nightmarish imagination, as well as a sexually importunate creature.

Now the important thing in this context is that de Kooning, as in all his numerous images of women, has taken a mass-produced, standardized image of woman—a collectively conceived image of the ideal woman—and treated it in a personal, idiosyncratic, absurd way. He has made what was socially precise emotionally imprecise. What was socially rational—however ultimately stupid—has become irrational, what was socially specific—however commercial—has become primordial. De Kooning treated a famous and successful woman "infamously," as it were, mocking and violating her—sardonically destroying the image that was her identity, her very raison d'être—and by implication the social machinery that produced the image and made it a commercial success. By irrationally generalizing her glamorous appearance until she has become all but unrecognizable—just another smiling floozy rather than a sex goddess, a kind of comic beast rather than a superior star—de Kooning in effect threw a monkey wrench into the Hollywood dream and success machine. He has not only taken the bitch goddess of success down a few notches—soiled and smashed an idol—but he has attacked the society that sanctioned her. De Kooning's expression of his unconscious feelings has a subliminal critical purpose, for it not only undoes the conventional dream girl, in effect declaring her a fraud, but slashes the photograph that is the precious instrument of her fame and fortune. It is a carefully manufactured simulation of seductive beauty rather than an emotionally and physically realistic representation of woman. It betrays

woman as well as misleads man. De Kooning heaps painterly scorn on the entertainment industry as well as a particularly flagrant manifestation of it. In attacking Monroe's photograph—a social treasure—he attacks the whole system of stardom. De Kooning's expression of his unconscious feelings about woman—he forces us to see and face feelings that are usually unseen and unacknowledged—disillusions us not only about the artificial, unrealistic image of woman that so many women try to live up to, but about the whole corrupt impersonal system that has mass-produced it for commercial gain. In short, to the extent he values personal expression, and annihilates Marilyn Monroe's image, de Kooning devalues and annihilates society.

Now the difference between Warhol's slick, self-contained, carefully composed picture and de Kooning's crude, splashy, all but nihilistic picture is that Warhol preserves the public image of Monroe, however much he modifies it. He changes it but he does not destroy it, and the way he changes it uses the same cosmetic mechanisms that were used to invent it. Monroe's features remain clear and decipherable, however garishly accentuated—cosmetically exaggerated, as though she had too much make-up on. Her flesh is maybe a little too pink, her hair maybe a little too yellow, her lips maybe a little too red, her teeth maybe a little too white, her eyebrows maybe a little too black, the shadows caressing her face maybe a little too ominous, her eye shadow bright turquoise where it should be mysteriously dark—this is perhaps Warhol's most extreme, heavy-handed, overdone transformation—but she remains unmistakably the glamorous Marilyn Monroe, elevated to iconic idolatrous status by being framed in gold, and isolated in a field of gold, as heavenly as the golden sky of a medieval altarpiece, however contaminated by hellish shadow, as though Monroe might, after all, be the devil in disguise. No doubt the point of the shadow is to suggest her tragic death—or at least a death that made her life seem tragic—but it also suggests the flat affect underlying her glamorous appearance and its subliminally monstrous character.

But the point here is that where de Kooning defied socially manufactured appearances, Warhol celebrated them, however ironically. Irony implicitly negates or debunks what it explicitly affirms and names, but Warhol's ironical treatment of Monroe's appearance affirms, indeed, apotheosizes Monroe, or at least does nothing to detract from or undermine her celebrity. Irony reminds us that things are not what they seem to be—appearances are not reality—but

Warhol's irony makes the celebrated appearance of the Hollywood thing called Marilyn Monroe more of what it seems to be, suggesting that its appearance is its reality—that it is nothing but appearance. No doubt there is a kind of irony in this, but it is an irony that supports illusion rather than disillusions us. We are, after all, left with a golden figure—however much a mythical figurehead— on a golden ground.

Warhol's rendering seems satiric on the surface, but reducing Monroe's face to a surface with no depth behind it does not so much make it a farce as acknowledge its ingeniousness and persuasiveness. It strengthens rather than shakes the cosmetic foundation of Monroe's appearance. For to make her face even more of a construction of cosmetics than it is in her publicity photograph—more purely a matter of surface—is to make it impossible to experience it as the representation of a real person. It is to nihilistically declare that there is no real self behind the glamorous appearance, and that there is no need for one—cosmetics, generating a sense of pseudo-selfpseudoself, will do quite well in a world of appearances and role playing. Warhol's cosmetic exaggeration of Monroe's already cosmetically exaggerated features seems to confirm the fact that her beauty is a frivolous fiction—that the face of a Hollywood Helen of Troy whose beauty launched a thousand films is completely fake, as might be expected—but it also announces Warhol's dead seriousness. Monroe died prematurely, a great commercial loss, and Warhol brings all his brilliance as a make-up artist, his cosmetic creativity and wizardry—as great as that of any Egyptian embalmer—to bear on her appearance, in an effort to make it enduring, and above all of continuing commercial value and use. He renders her face in the fantastic, overstated way it will be remembered by her devotees, in the quick glimpse of it they had after waiting in line for a long time to render homage to her appearance, a corpse glamorously laid out in an open coffin for society to adore. Warhol renders Monroe's face in the morbid way its beauty will be remembered and deified—not to say reified—in collective memory. And his memento mori is also a highly salable souvenir of one of the grandest illusions in Hollywood history. In Warhol's hands, the tombstone portrait—typically, Warhol's is simultaneously realistic and stylized, like any from Fayum— has made commercial history.

Thus, Warhol does not so much satirize the details of Monroe's beauty as animate and levitate them, so to speak. They become colorful little wings,

as strange as those on any putti, supporting a holy face. What was once banal becomes flighty and flamboyant, and as such mystifying. Intensified, Monroe's features become magical, making her face as a whole glisten with an unearthly light, even as it seems to putrefy. Brewed by an artist witch, it is a sacred concoction of features that, like magic mushrooms, glow in the dark, and are slightly poisonous and nauseating. Thus, like Lenin's embalmed body, Monroe's embalmed face is a secular relic that has been elevated into sacredness by brilliant artifice. Warhol cunningly suggests Monroe's immortality by cosmetically accentuating her death mask, making it seem transcendentally expressive. Her masklike face is neither tragic nor comic but decoratively different, which is all that is necessary to immortalize it. The friction between a vacuous face and its cosmetic overlay is all that is necessary to make the passage from everydayness to eternity. Does not the mystifying, stiff, unreal, aloof, mummified look Warhol gives Monroe resemble that the saints have in Byzantine art? The very staticness, even rigidity of her face, and its conspicuously composite, pseudomosaic character, confirms her more than mortal existence—her role as a shimmering martyred intermediary between this world and the other world. Indeed, what looks like a cruel, ironic, subtly comic treatment of Monroe's face makes it even more hypnotic and fascinating than it is in her photograph. It makes her into more of a star—a more transcendental star—than she was in Hollywood.

My point is that de Kooning's painting of Marilyn Monroe is a creative discovery and expression of feelings that violate the social repression barrier, designed to maintain the illusion and facade of rationality, and no doubt to make a certain space for actual rationality, while Warhol's painting of Marilyn Monroe keeps the social repression barrier in place and reinforces it, and thus amounts to its instrument, however ironically modified—or rather transcendentalized or mystified—to make it more tolerable. This confirms the fact—and here I return to the larger point of this essay—that Warhol's picture is a product of aesthetic management, while de Kooning's is a product of original art, that is, art as an original psychic act, to recall Fromm's idea of originality, which means art as full of original feelings, thoughts, and action. Aesthetic management always serves and reinforces social repression, while artistic expression cannot help but contradict and undermine it by reason of its originality.

It may be that de Kooning's *Marilyn Monroe* is laden with art-historical significance, as has been argued—that his emotionally and physically primi-

tive vision of woman has been thought and enacted before, if in different form—but we sense that it is original to him. This is not only because it is not a replica or combination of replicas of existing images of women, but rather because of its seemingly inexhaustible intensity, excruciating complexity, and ultimate unintelligibility. It remains primordially visual in a way that socially sanctioned and conventional images of women are not. As such de Kooning's *Marilyn Monroe* is unverbalizable, however much it can be described, if, unavoidably, inadequately. Indeed, it derives from a preverbal, infantile experience of woman—of the mother. De Kooning uses the image of Marilyn Monroe as an occasion to raise to consciousness a diffuse and forgotten experience of woman in all her primary majesty. It is a remarkable achievement: a profound regression handled in an artistically progressive way. De Kooning's painting is a paranoid/schizoid vision of the overwhelming, confrontational mother, on the verge of vanishing into the infant's self-annihilative depression. While it may have many affinities with earlier paintings of women, and have a certain place among them—de Kooning acknowledges "influences" ranging from the *Willendorf Venus* and Rubens's renderings of Venus to contemporary pinup Venuses—its expressive difference and radicality makes it unique among them, and gives it an emotional edge and uncanniness that they do not have, whatever feelings they evoke.

Now Warhol's *Gold Marilyn Monroe* is equally uncanny, but for very different reasons: it makes uncannily clear the manufactured, pieced together, devious, even outright deceptive character of Monroe's image. Warhol strongly suggests its socially repressive character: ironically sublime, it stimulates and manipulates its worshipper's desire even as it mocks and negates it. The image is manifestly fake, and so the desire it arouses must also be fake. The fakeness is evident in the all too emphatic features of Monroe's face, which isolates them without disintegrating the face. They remain in place but are ingeniously exaggerated, suggesting their malleability and artificiality. Warhol's picture of Monroe is a summary of abstract sensory details, all typical and even categorically the case—predetermined and stereotyped by the media—that add up to a foreordained whole.

This is exactly the character of an aesthetically managed product, as Schmitt and Simonson make clear. Everything that they say about aesthetic management and its purpose applies directly to Warhol's *Gold Marilyn Monroe*

and his art in general. Their book deals with "corporate and brand aesthetics, i.e., attractive visual and other sensory markers and symbols that represent the organization and its brands appropriately and dazzle customers through sensory experiences."[10] It is a study of "aesthetics" as "the new marketing paradigm," that is, the new way of selling products. This involves making the product "an appearance center." Aesthetics gives it "an irresistible appeal" and "an attractive and lasting identity," thus differentiating it from all other products. Aesthetics gives the product surplus value, indeed, embodies its surplus value, and makes it more satisfying than it might otherwise be. "Value," Schmitt and Simonson write, "is provided only by satisfying needs. In a world in which most consumers have their basic needs satisfied, value is easily provided by satisfying customers' experiential needs—their aesthetic needs."

Aesthetics establishes product uniqueness and market dominance. As Schmitt and Simonson say, "the willingness to market its aesthetics moved Absolut [vodka] into its enviable market position."[11] Without its "artistically imaginative" identity—its association "with a fashionable, arty scene"—it would be simply another vodka. Absolut vodka's "minimalist clear bottle," its "aesthetic image as part of an upscale culture," its hiring such artists as Andy Warhol and Keith Haring to create "artistic visions of the bottle marked by their own easily identifiable visual styles," was an "aesthetic strategy" that "revolutionized liquor marketing." Absolut's "ads, promotional material and the bottle . . . have become collector's pieces," that is, commodities in their own right. Clearly, "product aesthetic and its presentation in the form of packaging and wrapping is [the] key" to commercial success.

Today, retail relies heavily on aesthetics, not only because aesthetics— the "look and feel" rather than use value of a product—establishes its identity, but because aesthetic identity has "tangible benefits." It "increases productivity, creates loyalty, allows for premium pricing, saves costs, affords protection from competition, cuts through information clutter." Moreover, as Schmitt and Simonson emphasize, the "aesthetic management" of a product is not a matter of hit-or-miss guesswork, but scientific. It involves research, measurement, and planning. It does not rely on imprecise anecdotal evidence, but on the systematic study of aesthetic experience. Aesthetic management assumes that it is possible to control, manipulate, and exploit such experience, and attempts to do so on the basis of exact knowledge of its constituents.

Aesthetics, as Schmitt and Simonson demonstrate, can be quantitatively analyzed into its basic elements, and its qualitative effect—the impressions it generates—can be precisely measured. "All perceptions start with the eye," they write in emulation of Aristotle, and proceed to list and describe in detail the primary factors in visual perception, that is, the alphabet of "color, shape, line, and pattern." But such physical or stylistic elements alone are "insufficient to express an identity." As Schmitt and Simonson say, to establish an effective identity they must be combined with content or human interest themes. These also are systematically and exhaustively listed and precisely described, along with the various ways of expressing them. Schmitt and Simonson clearly try to make aesthetics easy—their reductive analysis certainly suggests that it is—in line with their view that a product can provide value or satisfaction easily, and that it does so in large part by having an easily recognized identity, which can be easily established by aesthetic means. The point of aesthetic management, which involves the scientifically controlled and planned synthesis of basic perceptual elements and human interest themes, is to establish a rich, seductive "associational network" causing easy recollection—"higher recall"—of the product, and thus likely to lead to its purchase. In short, the whole effort of aesthetic management is to make the consumer feel emotionally at ease about parting with his money.

As Schmitt and Simonson say, the secret of commercial success has nothing to do with the function of the product, or the communication of any central message about it, or the way people actually use it, but rather with its form, the peripheral messages associated with it, and its often subliminal symbolic meaning. These seemingly secondary features give the product an aura of significance that makes the consumer invest in it emotionally, which is what triggers sales. Aesthetically manipulated, it is no longer a product, but a "life experience," and it is only when it is such a presumably unique experience that its commodification is complete.

Now Marilyn Monroe's appearance is a consumer product, and Warhol's aestheticization of it adds to its irresistible appeal, and thus helps sell it. It adds value to what is already socially valuable and marketable by making it aesthetically satisfying—more of an aesthetic experience, that is, more visually dazzling and attractive, than it is in a Hollywood movie or publicity photograph, and thus more marketable. It is the surplus value added to a commercial

product that is already overvalued. Paradoxically, Marilyn Monroe's oversold image needs the surplus value of the ostensibly high art aesthetics that Warhol brings to it to keep its sales up. Warhol himself becomes more marketable by associating himself with Monroe—almost as easily identifiable and commodified as she is. His aesthetics add to her aura, and her aura makes him a star by association.

But the crucial point for me is Warhol's aesthetic method—his management of his aesthetic means, which are all predetermined and stereotyped by the media, as I suggested. For me the startling thing about Schmitt and Simonson's book is their assumption that aesthetics can be reduced to common denominator sensory features—a simple alphabet of aesthetic elements that can be used to make simple yet compelling everyday aesthetic sentences. Sensory features can be quantified and their qualitative effectiveness accurately predicted. Warhol works with the same assumption. He too conceives of sensory features as quantitative units, each having a specifiable qualitative appeal. Thus Monroe's hair, eyebrows, eyelids, eyes, nose, lips are each a distinct, measurable sensory feature, with its own particular emotional appeal. Each is an aspect of her marketability, and must be manipulated—overstated, as I said—to make it more marketable. There is nothing particularly marketable about the basic features of a woman's—anybody's—face, which are all more or less standard and commonplace—dumbly universal. But aesthetically isolated, enhanced, and individualized they become mysterious and seductive enough to be marketable.

Thus, Marilyn Monroe's otherwise ordinary face becomes a desirable commodity, which both men and women want to possess. The important point is that it is the need to market the face that makes both its Hollywood inventors and Warhol abstractify and quantify—reductively codify—its sensory features, so that they can be managed aesthetically, that is, aesthetically reworked. It is the marketing orientation that leads to radical aesthetic surgery on Monroe's face, simplifying and manipulating it to make it more attractive and exciting and thus salable. A natural face is turned into a manufactured face—the parody of a face—and a manufactured face can be marketed forever, for it remains the same, however much it may now and then need some aesthetic touching up or fine-tuning. It can even be prefabricated, as Warhol seems to do. *Gold Marilyn Monroe* seems to be assembled on the site of the canvas, its basic parts having been shipped from the Hollywood beauty parlor, and a few from

the art scene. Warhol may be parodying both—as well as Marilyn Monroe's famous image—but his complete dependence on them indicates that his so-called art has no substance without them.

Whatever contradictory, spontaneous, personal feelings—emotional confusion—Marilyn Monroe's appearance might arouse are beside the point, for such feelings have nothing to do with marketing it. The introspective awareness of such feelings in fact hinders marketing, for they distract from the appearance's seemingly objective, social, self-evident appeal and make one critically reflect on its character and construction and purpose, which is to distance oneself from it. Only the feelings of wanting to look like Marilyn Monroe or to make love to her because of her beauty help market her appearance, and those simple, socially sanctioned feelings can be predictably aroused by the aesthetic manipulation and manufacture of the features of her face in a simplified sensory way. The feeling of control, calculation, and premeditation—management—evident in Warhol's picture is quite different from the feeling of spontaneity, insecurity, and delirium—expression—evident in de Kooning's picture of her. The difference is crucial. De Kooning does not try to predict and control his feelings, or use fixed amounts of gesture and color—paint—to achieve a certain limited sensory effect. In contrast, Warhol uses colors in measured amounts, and turns the features of Monroe's face into fixed gestures, taking up just so much expressive space and not more.

It is significant that Monroe's face is only an incident in de Kooning's picture, while her voluptuous body and its environment seem more expressively intense. In contrast, there is no hint of her body in Warhol's picture, not only because of the convention of the bust portrait it follows, but because her body is not the secret of her lasting success, however much it contributed to it. Her marketability had to do with the photogenic character of her face (although, of course, any face can be made photogenic); her body was admired and desired, but its expressivity was somewhat limited. And it could and would decay, while the appearance of her face would last forever. Warhol concentrates on what is marketable, not what comes along with the product, however famous it also is. Monroe's face could be made into an "appearance center"—given "an attractive and lasting identity"—not her body. Voluptuousness easily turns to fat, but the face could be frozen in cosmetic amber forever. Warhol is a parsimonious artist, compared to the wastefulness of de Kooning, for Warhol only deals with what is

commercially necessary, while de Kooning has the luxury to deal with what is subjectively necessary.

The point is that Warhol gave Marilyn Monroe's face what Daniel Bell calls "the new look [that] creates an 'avant-garde' identity,"[12] the most desirable product identity there is, as Schmitt and Simonson assert. For avant-garde identity looks the most different, and as such draws the most attention, all the more so because it is the most risky identity, at least in terms of social appearance. Of course, it is never risky enough to be unnerving, only risky enough to pique curiosity. Thus artists who once enjoyed "special recognition," as Ernst Kris said, because they "had power over memory and could eternalize human appearance,[13] now enjoy special recognition because they labor on the consumer frontier, creating new looks that facilitate marketing and can be marketed in their own right. Power over memory and the eternalization of human appearance are used for marketing purposes. As Bell says, the avant-garde artist "swiftly shapes the audience and the market, rather than being shaped by them."

Kris notes that the work of art was once thought to have "magic power" and thus was in some sense sacred. The use of aesthetics as the ultimate marketing strategy—they explicitly converge in Warhol's work—suggests that, for all the demystification of aesthetics, that is, its reduction to the management of sensory experience, the work of art, as the ultimate aesthetic phenomenon, still has magic power, however much that magic is now more vulgar than divine. The "magic potency of images," as Kris calls it, which involves the notion that "images give power over what they depict," has been transferred to the product by way of simplistic aesthetics, giving it magical power over the consumer, who in effect finds his innermost wishes symbolized and simplified—and parodied—by it.

Warhol's *Gold Marilyn Monroe* is, then, pure exchange value, in both its aesthetic character—every one of Marilyn Monroe's features has been exchanged for a more marketable one—and its social purpose. "The marketing orientation," Fromm writes in *The Sane Society*, "is closely related to the fact that the need to exchange has become a paramount drive in modern man. . . . With increasing division of labor, there is increasing exchange of goods, but normally the exchange of goods is nothing but a means to an economic end. In capitalistic society exchanging has become an end in itself." For Fromm, this "need for exchange" is not "an inherent part of human nature," as Adam Smith

thought, but "a symptom of the abstractification and alienation inherent in the social character of modern man." In Warhol's *Gold Marilyn Monroe*, aesthetics has become alien and abstractified, a means to an economic end but also an economic end in itself. It cannot help but be alienating, since it is used to enhance and increase the exchange value of a commodity—what Fromm calls a "personality product"—and meant to have exchange value itself, and as such does not exist for its own sake, that is, it has no intrinsic value. Rather than generate passion for what it informs, and even an empathic feeling for what it adorns, in Warhol's hands aesthetics is used dispassionately and indifferently, confirming the alienation embodied in his subject matter. Aesthetic management confirms the preexisting abstractness and alienness of Marilyn Monroe's appearance, for it was a commercial product to be exchanged for money from the beginning of its existence. Paradoxically, Warhol's Marilyn is not seductive but expensive—golden indeed. Of course, some people find gold seductive, but this has nothing to do with sexuality, except of course in Freud's sense of the term. Nor does Warhol's Marilyn have anything to do with beauty, for she is more ugly than beautiful, if beauty has to do with harmony. Warhol's Marilyn is beautiful only because she costs a great deal of money, which alone is beautiful in capitalism.

In short, Warhol's *Gold Marilyn Monroe* fuses and confuses aesthetic value and exchange value. This is exactly what aesthetic management is supposed to do. It turns consumption into aesthetic contemplation, and aesthetic contemplation into consumption. It turns the consumer into a spectator, and the spectator into a consumer. It degrades art by equating it with exchange value, and it glorifies exchange value by associating it with art. This amounts to the dumbing down of art and the smarting up of commerce. It shrewdly gets the better of its devil's bargain with art. The aesthetic manager packages exchange value under the guise of making art, which is why the result cannot help be a failure as art—as expression.

Warhol is the aesthetic manager par excellence, for he makes it absolutely clear that a product's aesthetics are its selling point. Moreover, idolizing Marilyn Monroe, who was already an idol, Warhol aestheticizes alienation, making it seem the normal state of affairs. As Fromm writes, "idolatrous man bows down to the work of his own hands. The idol represents his own life forces in an alienated form." Projected into the idol, they never come back to

him, however much he submits to the idol. Warhol makes it seem normal to do this. He makes it seem normal to worship an image, to waste one's life forces on a clearly fabricated fantasy, to find vitality in exchange value, to be stimulated and excited by it as the be all and end all of life. Thus Warhol suggests that the aesthetically managed avant-garde work of art is the capitalist idol par excellence—the ultimate commodity, for it ends up costing more than the appearance it idolizes.

Warhol is not alone. Aesthetic management has become the dominant mode of art making, if one still wants to call it that. It has become completely comprehensible—simply a matter of manipulating prefabricated stylistic and thematic variables, as Schmitt and Simonson say, to predictable aesthetic and emotional effect. The final confirmation that one is an artist is that your aesthetic product is marketable—sells, usually because of the associational network it evokes. This is a kind of decadence, and the core of the so-called postmodernist condition of art. It means that the artist has become a product designer, and that his specialized products exist to supply new ideas for marketing. In short, art making has become marketing chic. All the irony with which it seeks to defend itself only makes it more marketable.

We see this in the works of Alexis Smith and Richard Prince, to take only two conspicuous examples. One could mention others, for example, David Salle, who uses images from art rather than the media, although such images also seem predetermined and collective by reason of the reproduction that has made them everyday. One could also mention any number of photographers, installation artists, and conceptual artists. They gain their credibility, such as it is, through the identity and celebrity of their sources, not because of their supposedly ironical relationship to them. Their art gets its aesthetic value from the exchange value of the images they appropriate. Many of these aesthetic managers think appropriation as such is ironical, and they are certainly right in thinking that irony has become standard aesthetic strategy in the postmodern situation. But the subliminal point is that ironically enhanced images have high exchange value, for the speculative character irony gives the images confirms the speculative character of exchange value. Only the ironical character of exchange value can give ready-made, thinglike images expressive value, for such otherwise objective, untransformed images—images incapable of symbolizing the subjective unseen—have none.

Even Duchamp, the beatified role model of the aesthetic managers, was not above commercialism, as his project to market the ready-made word "dada" in the form of silver, gold, and platinum ornaments—a product for each pocket—suggests. It was the last dada joke: these precious materials, ironically used, would no doubt enhance the value of dada, which had become a stale, boring joke and commonplace word. Duchamp's heir is Steve Wynn, a Las Vegas entrepreneur, who is filling his new casino with blue chip art—art no longer known for its aesthetics, but for its exchange value, or rather art whose high exchange value has become its aesthetic calling card—in the hope of attracting high rollers. Taking a gamble on art, he shows that art is a gamble for high stakes. It may or may not pay off, although the art in his casino certainly has. Wynn has clearly understood the capitalist destiny of art, as Duchamp did. Was the epistemological problem Duchamp made of art really a ploy for using "art" to make ordinary things—ready-mades—more commercially valuable than they would otherwise be? He, too, saw that art had its price, and that by associating everyday products with art, and also with the life force of sex, their exchange value would be enhanced and increased. They would become expensive avant-garde idols, confirming our alienation from the life force, however inescapable it is.

This essay is reprinted in a slightly different form with kind permission from the New Art Examiner, *April, 1999.*

Notes

1. Harold Rosenberg, "De-aestheticization," *The De-Definition of Art* (New York: Collier Books, 1973), 29.
2. Erich Fromm, *The Sane Society* (New York: Fawcett, 1965), 105.
3. Meyer Schapiro, "Recent Abstract Painting" (1957), *Modern Art: 19th and 20th Centuries* (New York: George Braziller, 1980), 224.
4. Erich Fromm, 106.
5. Erich Fromm, *Escape from Freedom* (New York: Avon, 1965), 208.
6. Ibid., 229.
7. See Ibid., 267, for Fromm's discussion of "the elimination of spontaneity and . . . the substitution of original psychic acts by superimposed feelings, thoughts, and wishes." As Fromm says, "by original I do not mean . . . that an idea has not been thought before by someone else, but that it originates in the individual, that is, it is the result of his own activity and in this sense is his thought." The same holds for feelings and actions, he argues. I would add to this that original thoughts, feelings, and actions originate in an original experience of life—in experience that, if truly lived, cannot help but be original.
8. Alfred North Whitehead, *Adventures of Ideas* (New York: Mentor, 1955), 270.
9. T. W. Adorno, *Aesthetic Theory* (London: Routledge & Kegan Paul, 1984), 82.
10. Bernd Schmitt and Alex Simonson, *Marketing Aesthetics: The Strategic Management of Brands, Identity, and Image* (New York: Free Press, 1997), xiii. All subsequent quotations are from this book.
11. Their excited discussion of Absolut vodka's avant-garde image (176) also implies their advocacy of avant-garde identity as the most marketable identity. It is worth noting that there is an odd reciprocity between the avant-garde art appropriated and the newly avant-gardized product: the product gains a new avant-garde lease on commercial life, and the art gets its avant-garde credentials extended beyond the normal short duration avant-garde art has. Indeed, avant-garde art is notoriously short-lived, as the history of avant-garde movements in the twentieth century indicates—one quickly "criticizes" and supplants and dismisses the other, and each seems fickle in itself (as though it was a capricious gesture of novelty rather than a well-thought out investigation of an idea)—and cannot help but benefit from lending itself to a product in quest of market dominance, for if and when the product achieves dominance and becomes a household name, so will the avant-garde artist, by reason of his

association with it. (Warhol is a case in point.) Each rides on the coattails of the other, and both have much to gain by their association.

12. Daniel Bell, *The Cultural Contradictions of Capitalism* (New York: Basic Books, 1978), 39. Aesthetics managers are not the only ones concerned to create a superficial new look of avant-garde identity, in lieu of making substantial material and social changes. But they remain the implicit model for all image managers, for aesthetic artistry becomes absolutely essential when the old ruling class feels that its authority, power, and wealth are threatened by those who lack authority, power, and wealth. A new avant-garde identity helps the old ruling class maintain its monopoly on authority, power, and wealth by giving it a new look that "proves" that it continues to be fresh, vigorous, and competent even when it isn't. The new look seduces those without authority, power, and wealth into complacent acceptance of the status quo. It excites, exhausts, distracts, and narcotizes them with spectacular appearances, leaving them with little critical consciousness to rebelliously think about their social misery and inferiority, let alone to act on that awareness. Warhol's avant-garde adumbration and reification of Marilyn Monroe's glamorous appearance strengthens the authority, power, and wealth of the entertainment industry, and, more insidiously, confirms that it is the ideal path to social authority, power, and wealth (whatever the existential and emotional expense).

 In general, our society is image-management conscious, and tends to differentiate between the image manager and genuine character. I believe that the more a society lets itself be taken in by images, the more extreme its underlying conflicts are, that is, the riper it is for existential and emotional disaster. The better designed the images the greater the existential and emotional horror they mask. Thus, presidential historian Michael R. Beschloss argues that "the core of [President] Clinton's authority is political management, not character." Political management includes the creation of a new avant-garde look for politics, supposedly giving politicians such as Clinton fresh credibility. Quoted in Dan Balz, "Clinton's Confession," *Washington Post National Weekly*, 24 August 1998, 8.

 One might say that the core of Warhol's authority is the management of images that are already in the public domain, and as such political, that is, shape the character of collective consciousness, while de Kooning uses his personal depth to bring deep emotions and character-shaping existential experiences to the social surface, where they seem aesthetically monstrous and disturbing. Warhol makes socially shallow, ephemeral images seem aesthetically deep and enduring, while de Kooning uses his personal depth to bring deep emotions and character-shaping existential experiences to the social surface, where they seem aesthetically monstrous and disturbing.

 It is worth noting that British Prime Minister Tony Blair was regarded as little more than an image manager on first taking office. He undertook a "style offensive" to give Britain a new avant-garde identity. "It was time to 'rebrand' Britain as 'one of the world's pioneers rather than one of its museums'," asserted "Demos, a social policy research center close to Mr. Blair." Quoted in Warren Hoge, "Blair's 'Rebranded' Britain Is No Museum," *New York Times*, 12 November 1997, A1. Successful image making or aesthetic rebranding adds to the power, authority, and wealth of the image maker, for he seems to be an efficient, competent, knowledgeable manager of reality, even if he is not.

13. Ernst Kris, *Psychoanalytic Explorations in Art* (New York: Schocken, 1964), 48.

Art at Odds with Itself

The artworld, as we know, is highly fragmented, not unlike a Humpty Dumpty that can't be put back together. This has been benignly read as live-and-let-live pluralism, but I liken it to a pack of feuding sects, none of which talk to each other except with contempt. Just as, after the Protestant rebellion against the universal Catholic Church, religion split into a variety of churches, each claiming a monopoly on the truth—the smaller the church, the greater the monopoly, and the more outrageous its understanding of the truth (in comparison to the previous "universal" understanding)—so, in the aftermath of the avant-garde, the religion of art now contains a number of competing churches, each self-righteously claiming to be the true one. This is not the division of artistic labor it looks like, but a fight to the death for control of art history.

Two recent events give us some perspective on the conflict. On September 29, 1995, the Church of Realism formally lodged a protest against the Whitney Museum, noting its "pronounced bias [against] contemporary American realist painting." The museum's assertion that it has "a sense of responsibility and fairness to all the styles that at any moment make up the totality of contemporary art" was called "a lie." The details of the indictment are worth noting: "The Whitney biennial—excludes art that demonstrates compe-

tence in drawing and form; excludes art which reveals a breadth of emotion beyond anger and irony; excludes realist art that is uplifting, positive, tender, or beautiful; excludes realist art that reflects maturity and humanism rather than juvenile irrationality; excludes art that has no obvious political, sexual or social agenda." The other event was the trendy exhibition "'Brilliant!' New Art from London" at the Walker Art Center in Minneapolis (October–December 1995). This supposedly iconoclastic group of mostly under thirty-five artists included such neo-art stars as Rachel Whiteread, who received the 1993 Turner Prize, Britain's major award for contemporary art, and known for her inside-out casts of domestic objects and especially her politically motivated mold of an old East End rowhouse in the process of being destroyed, and Damien Hirst, whose September 1995 exhibition *No Sense of Absolute Corruption* at the Gagosian Gallery—an installation of four dead cows, placed so that they seemed to be copulating—was postponed until March 1996 because of health and environmental problems. (I remember seeing Whiteread's house late at night in a driving rainstorm; I suspect it wouldn't have looked as lively in better weather and during the day, when it was not dramatically lit up like a stage set.) With Marc Quinn, known for a self-portrait bust cast in his own blood, and Mona Hatoum's use of an endoscopic camera to give us a guided tour of her intestines, the Walker exhibition was the Whitney biennial revisited. That is, a grungy version of the aggressively revamped, activist Church of Conceptual Art, which for both the Whitney and Walker management seems to have become the high church.

What do these more or less simultaneous events mean? First, realism and conceptual art are equally *retardataire* and weary—all too familiar (however redone), like everything else these post–avant-garde days. There is an enormous sense of déjà vu in both schools—the lack of spontaneity and predictability that come with decadence. To look to the Old Masters for inspiration, as the neorealists say they do, is no help: such a return to tradition, a leapfrogging back to pre–avant-garde art, is another symptom of decadence—an uncertain way of going forward. Similarly, the "brilliant" British conceptualists are also decadent—tired if extravagant (and secretly desperate) Duchampians. It no longer matters whether you exhibit moldy meat or a bicycle wheel as art: just as a cigar is not always a penis, as Freud said, so today we have come to realize that a bicycle wheel and moldy meat are not always (never were?) art. Nor even, as Duchamp thought found objects were when exhibited in galleries and muse-

ums, a "provocation" and "joke." They're just tedious spectacles. The dandy farceur has seen better days, and the fact that s/he's had a revival in Britain, which has always been backward in the visual arts, suggests as much. Of course, there's more radical chic to the British conceptualists than the American realists—the former would feel at home in the Whitney—which is no doubt a social and commercial advantage.

But secondly, and more importantly, the realists have a point, whatever the character of their art. The emotional range of recent art has been rather narrow, however strident the emotions. Anger and irony do seem to be on regular view—a while back, in his classic essay *The Dehumanization of Art*, Jose Ortega y Gasset described avant-garde art as "doomed to irony" and immaturity, and would-be avant-garde art still seems to be—and there seems precious little art that is positive, tender, or beautiful. The British conceptualists are a case in point. Indeed, there is almost no maturity and humanism in contemporary art, but, in the words of the psychoanalyst George Frankl, an ongoing adolescent "declaration of war against the cultural Superego," a regressive "demand for a right to express any impulse previously considered taboo," and finally an attack on "sublimation itself, the very foundation of culture." The result is that in art, as in society, "aggressive urges [have] become an end in itself" and "anal impulses . . . humiliate and vilify everything that is considered normal or decent." One has only to think of Gilbert and George's 1995 exhibition of color photomontages of their feces—besting Piero Manzoni, who kept his feces in cans—to see Frankl's point. "Regressive desublimation" reigns and sets the emotional tone, which, as Renato Poggioli said in his famous analysis of avant-garde art, is one of antagonism and nihilism.

What the realists, then, are calling for, is restoration of the cultural Superego, which is what the Old Masters symbolize. And with that a change in the emotional tone of the art world, which in fact exploits that of the larger world. But that's just the point: to protest, and suggest an alternative, to both— to stake out a new, genuinely "postmodern" emotional position—a healthy sensibility. Thus, while it's not clear that the Old Masters make the best Superego, for culture has clearly changed since their day, it nonetheless makes good emotional sense to take them as models, for the range, subtlety, and depth of emotion conveyed by their art is often greater than that of much avant-garde art, especially neo–avant-garde art.

This also involves a restoration of the boundaries of art—a refusal to accept any spectacle as art—a rejection of "anything goes." The concept of art has no doubt to be rethought, but it invariably involves sublimation. If, as the psychoanalyst Gilbert Rose has argued, art is an emotionally necessary illusion, one must begin to examine how emotionally necessary many things that institutionally present themselves as art are. In short, the Whitney and Walker events point to a need for change in the emotional atmosphere of art, as well as in the way art is made and conceived. They have made us aware that art is an allegory of attitude, and as such humanly answerable.

Craft as Art, Art as Craft

In the last few years the idea of craft has achieved a new prominence. There has been a new emphasis on craft in the "fine" arts, to the extent that many so-called fine artists have begun producing craft objects, or objects in which the boundary or difference between fine art and craft is not easy to determine. The vogue of furniture art is an example, as is the renewed sense of autonomy of the ceramic object, functional or not.

There has also been, within fine art, a new emphasis on the craft involved in the making of the fine work of art—a new emphasis on how well or poorly it is made, whatever the idea that motivates it may be. That is, there has been an attempt to return to the traditional conception of the artist as an expert in a particular medium. An example is a story Eric Fischl told me about his education. He realized, after graduating from art school, that he knew nothing about how to draw a figure—in the art school he attended, which was a fairly prominent one, to "draw" meant simply to drip paint on paper from a certain height.

The return to the idea of craft clearly means that the days of "anything goes" are over, as craft becomes an increasingly serious issue in contemporary art-making. Actually, this is the second time craft has become generally important in twentieth-century art. In Modernism, the Bauhaus movement reflected

an attempt to integrate avant-garde ideas of art and traditional ideas of craft in objects that would "popularize" the avant-garde aspects by investing them in ordinary, useful objects, while at the same time leading to a general change in lifeworld attitudes and lifestyle, a change symbolized by the avant-gardizing of the craft object. This integration of fine art and craft was carried out under the auspices of the idea that the avant-garde revolution in art was part of a broader revolution in life. Now, in Postmodernism, the new integration of art and craft is postrevolutionary, if not exactly reactionary. The avant-garde revolution in art has become old news to the extent of becoming completely institutionalized, and nobody expects art to revolutionize—radically change—life. In fact, the idea of revolution itself has gotten a bad name.

Why, for whatever theoretical as well as practical reasons, has there been a return to the sense of craft as the basic mode of art-making in the Postmodern world? It is a new emphasis on what is irreducible in art, which turns out to be craft, or the fact that art is made in a certain way. I want to suggest that this has occurred because of the exhaustion of Modernist idealism—the recognition that Modernism is no longer relevant to the reality of either life or art.

As a point of departure, I would like to remind you of the significance craft has had in the general definition of art since antiquity.[1] For Aristotle, art was inherently a matter of craft; for him, art was a mode of making before it was anything else. It was a practical rather than theoretical activity, an idea reiterated more elaborately by Aquinas. This idea remained basic to the sense of art until the notion of "fine art" arose in the eighteenth century. Prior to that time, craft and art were regarded as inseparable. The Renaissance discussion of the perspectival construction of space was at bottom a craft discussion, however intellectual the craft involved. Perspective was conceived as a new technique for picture-making, as the discussion of it by Leon Battista Alberti suggests.[2] It was only when it began to be felt that art could mediate a unique kind of experience called the "aesthetic"—an idea first given cogent and relevant form by Kant—that the idea of art as craft seemed to sink away into insignificance, or came to seem less to the point of the work of art. Kant accepted the traditional distinction between theoretical and practical reason, but he was innovative in that he separated art from practical as well as theoretical reason. Art was given autonomy and refinement by being associated with taste. It was because one had a fac-

Jeff Koons, *Michael Jackson and Bubbles*, 1988. Glazed porcelain, 42" × 70½" × 32½". Collection of the San Francisco Museum of Modern Art. Photograph © Jeff Koons Studio, New York.

ulty of taste that one could have aesthetic experience, and it was because one had a taste for art that one could refine one's aesthetic experience, that one could have a finer aesthetic experience from art than one could have from the perception of nature.

Aesthetic experience is a privileged mode of existence, rooted in the idea of heightened sense perception. Indeed, ancient "aisthesis" has to do with the experience of sensing as an end in itself. The philosopher Louis Dupre makes the point by sharply distinguishing between an aesthetic response to an object of perception and an "objective or pragmatic" response.[3] He regards the aesthetic response as essentially affective, that is, subjective, and as such "impractical" in contrast to the objective response.

Thus, just to the extent art has aesthetic purpose—which is what makes it "fine"—it loses practical purpose, which also means that the way it is made becomes secondary to its aesthetic purpose. New techniques of making can generate new intensities of subjective aesthetic experience. It becomes less and less important how well an object is made—the very notion of "well made" collapses—than how intense an aesthetic experience can be generated by what-

ever way it is made. In my opinion, one of the reasons Impressionists began to paint without preparing the canvas—one of the reasons there was a new emphasis on what Clement Greenberg called the "frank declaration of the surface of a painting"—was to achieve a new aesthetic sensation and feeling. There was an implicit recognition that different materials and surfaces evoked different subjective aesthetic responses.

This is why artists began doing everything from putting coffee grounds, among other materials (I have recently encountered mica), in the painterly surface, to making works of art out of junk materials. Each material, properly manipulated—and the root meaning of "manipulate" is to craft by hand—could have unexpected and new aesthetic effects. The craft manipulation of material became subservient to aesthetic purpose, whereas the craft manipulation of material was once—for example, in the Renaissance—on the same level of importance in art-making as the articulation of important ideas, such as those of a particular religion, state, or class. Thus, when art became "fine," the ideas it communicated became secondary, even irrelevant—a "literary" excrescence and tumor on it, as Greenberg suggested—and craft became relevant only to the extent it could generate new aesthetic effect. All that mattered was the aesthetic experience, at whatever cost to intellect and craft.

Now one of the things that has happened in Postmodernism—one of the things basic to it, in my opinion—is the debunking or discrediting of the aesthetic as an elitist ideology. Terry Eagleton's analysis of it as such is perhaps the most intellectually sophisticated example of this kind of destruction of the idea of aesthetic experience.[4] Part of this anti-aestheticism—that is, this opposition to the "fineness" of the work of art and the experience it can mediate—has to do with the definition of the work of art as a kind of text—a text among social texts. As a social text, the work of art is far from disinterested, as it is supposed to be for aesthetic purposes. That is, it has objective and pragmatic purposes, ranging from being an instrument of ideology to being a sign of status and authority, and, of course, to being a commodity—sometimes the most precious and presumptuous of all commodities.

But there is even further reason why art has lost the "fineness" it had for a few centuries—has lost aesthetic credibility—which is what paved the way for the current renewal of the conception of it as craft enterprise. The very root of the aesthetic is the subjective or the affective, as Dupre calls it, and the sub-

jective has become exhausted, as it were—analyzed to death—in our day. To put this in other terms, if, as the historian Peter Gay has written, art has three dimensions—tradition, privacy, and craft[5]—then just as avant-gardism indicated the exhaustion of tradition (as an idea as well as a functioning, influential reality), so Postmodernism signals the exhaustion of privacy (or the subjective) as a source in Modernism. That means art is craft or it is nothing—and for some people it is indeed nothing but a money-making institutional game. Art history has come full circle back to the idea that art is necessarily a craft, because it can no longer be conceived of with any depth as a statement of tradition or as a subjective statement. That is, both tradition and subjectivity have become unworkable as sources for art. The idea of art as craft has become a defensive fall-back position, even a cynical idea of art. Nonetheless, it is of great theoretical interest, and awaits new intellectual justification.

It is worth noting that the idea of art as craft brings in its wake a peculiar revalidation of traditional works of art, simply on the grounds that they are well crafted, whatever else they are. The idea of art as craft has also brought in its wake the contemporary surge of interest in so called "object art," art that manipulatively quotes objects. In making this ironical quasi-Duchampian point about art, it involves a subliminal emphasis on the craft that made these objects. Jeff Koons's sculptures, for example, are more significant for the craft that went into their making than for the idea of them as satire of popular consumer culture. (Koons pays the best craftspeople to make his sculpture, which is partly why they are so expensive. Certainly the triviality of their concept is not worth the price.)

To demonstrate what I am driving at a little more particularly, I would like to quote from Susan Langer, who gives the most consummate argument I know in favor of "fine" or aesthetic art. I would then like to argue that, from a Postmodern point of view, Langer's argument is passé. Craft, not "feeling," or for that matter "form"—to allude to the title of Langer's book, Feeling and Form—has again come to matter most in art, because feeling and form have been exhausted as reasons for making it. This is in no small part because feeling has been so thoroughly studied that it has lost its mystery, and because so much novel form has been produced that the very idea of it has come to seem like a hollow cliché. In a sense, feeling and form have been so demystified and democratized—we have learned that everybody, not just artists, has deep feel-

ings and style (if only lifestyle)—that they no longer make an aesthetic difference. Aesthetic perception, being a "different" and in effect privileged mode of experience, depends on the idea that some of us are more privileged to feel and recognize good form—in general are more inherently "artistic"—than others. Postmodernism disputes this idea; indeed it involves deidealization of the artist as well as of the subjective mystery of art and the authenticity of unique form. Feeling and form no longer being to the aesthetic point, art must only be significant as craft—no doubt by default.

Art once again means making something well, rather than making a fine form that can meditate a disinterested subjective experience. The implication, of course, is that we all know what it is to make something well, or rather, that all professionals can agree on what a well-made object is. This may or may not be the case, but the key point is the reprofessionalization of art. It is worth remembering that it was deprofessionalized only in the twentieth century—anybody could become an artist, or one was an artist if one said one was, or, as artists as different as Duchamp and Beuys have said, everyone could be creative. The craft definition of art makes it once again the privilege of the few; namely, craftspeople.

Trying to distinguish between art and craft, Langer writes:

The artist's work is the making of the emotive symbol; this making involves varying degrees of craftsmanship, or technique. Beyond the rudiments which everyone learns . . . the artist learns his craft as he needs it for his purpose, which is to create a virtual object that shall be an expressive form. But craft, or technique, is not [a] mechanical, routine, dictated procedure . . . every artist invents his technique, and develops his imagination as he does so . . . Because every artist must master his craft in his own way, for his own purpose of symbolizing ideas of subjective reality, there may be poor art, which is not corrupt, but fails to express what he knew in too brief an intuition . . . An unfamiliar tool, an inadequate musical instrument, but also a physically uncontrollable hand may contradict imagination, and, in the earliest moments of a dawning idea, may ruthlessly put it out. The result is a poor and helpless product, sincere enough, but confused and frustrated by recalcitrance of the medium or sheer lack of technical freedom.[6]

Thus, continues Langer:

Artisanship [and] artistic expression . . . stand . . . in some intimate relation. And the connection is really obvious: the crafts . . . furnish the materials and techniques of artistic creation. A person who is by intuition an artist cannot shape a pot . . . without feeling the artistic possibilities of the project . . . The crafts, in short, provide opportunities to make works of art; they have actually been the school of feeling (feeling becomes clear and conscious only through its symbols), as they were the incentives to articulation and the first formulators of abstractive vision.[7]

What is of interest in the context of this discussion is that Langer conceives of craft as a necessary—and necessarily flexible—instrument of the process of symbolization of feeling, which is a fine-art way of conceiving it. I, on the other hand, am arguing that in Postmodernism this is no longer the case—art is no longer a matter of symbolization of feeling, or for that matter an act of creative symbolization in general (when it uses symbols today they tend to be routinely given and completely conventional rather originated in intuition), but rather a matter of craft. Craft has only a minor expressive or affective effect, which means the perception of it is not, strictly speaking, a matter of aesthetic concern. For if, as Dupre argues, aesthetic experience involves introspective recognition of one's own subjectivity, catalyzed by the work of art, then craft, being art's means rather than end, can by definition have little if any subjective resonance or impact, that is, cannot be a stimulus to self-awareness. Also, the craft object does not originate in intuition, as Langer thinks the art object does. It is thus less an expression of creative freedom than the art object. But Langer is speaking from the point of view of fine art, and fine art, I suggest, has come to an end, or is hanging on for dear life. And with that, the importance of aesthetic experience has diminished, as I have also suggested, to the extent of it being regarded as an illusion.

If craft is all that is left of art, what then is art, or rather what can we say positively of craft? What is craft conceived as an end in itself and not simply an instrument of art? No doubt the craft object has the same ideological import as any social artifact, but what is it, if anything, beyond that inescapable import? If craft does not mediate aesthetic experience—if the craft object is not an

"emotive symbol" (indeed, if the idea of art as emotive symbol has become hollow)—then what is craft about? I think it has one major purpose: to save the dignity of work, ultimately, of the "work" of art. The idea that art is work has been all but forgotten in the preoccupation with it as precious object on the one hand and symbolic embodiment of feeling on the other—an unholy bifurcation that hardly bespeaks the wisdom of the modern attitude toward it. Craft involves, at the least, a reemphasis on art as hard work, more particularly a kind of working through and mastery of matter. In the end craft is mystic participation in the material, which is the rock bottom of art. (This idea makes someone like Jackson Pollock into a craftsman, when he is at his best, as in the all-over paintings.)

Not much work has gone into the production of a kitsch object—which is part of its definition—and avant-garde objects have increasingly tended to embody little work. We have come a long way from the day when Jasper Johns justified *Painted Bronze*—more familiarly known as *Two Beer Cans*—by the hard work that went into it. Today the work that goes into the making of art is secondary to the concept behind it, which is why an artist like Peter Halley can, without embarrassment, appear in a film with his assistant making his work and Halley applying one finishing stroke, cynically saying, "anybody can do it." Both Pop art and Minimalism began to undermine the idea of art as work by separating the concept behind the art from its execution, relegating the latter to secondary, minor significance. Thus, you bought a LeWitt concept, and had it executed by whomever you wished. No doubt there was ironical tension between the concept and the results of the execution—indeed, the seemingly infinite number of possible executions of a single concept—but the point is that the execution counted less than the concept. The work of transformation from photograph to silk screen that went into a Warhol picture was rather minor and predictable, and more of a matter of formulaic machine manufacture—recall Warhol's *Painting by Numbers*—than individual work.

What the idea of craft can do is restore the dignity of the idea of individual work as well as of working at art. What I am arguing is that craft today has the same mission it had when John Ruskin and William Morris advocated the so-called craftsman ideal, which was influential in America from circa 1887 to 1915. The craftsman ideal was a response to what Ruskin and Morris felt was the degradation of work in industrial capitalism. Craft became a way of

restoring the "lost utopia of unalienated work" and as such symbolized the "joy of work," and above all that work was a means of individualization. Genuine craft always represents unalienated labor—the labor of love—which is why it has gained new appeal in our technological society of ever more ingeniously alienated work. In industrial capitalism work tends to stunt rather than encourage the growth of the individual, indeed, industrial work even reverses growth. The sense of being engaged in a process of work that is, at economic bottom, a means of accumulating capital undermines one's existential sense of individuality. It is ultimately altogether deindividualizing—robotizing. Downsizing confirms the dispensability of the worker if not the work, which is now carried out more efficiently by technology. But this not only depersonalizes it, but peculiarly devalues it. That is, the technological reification of work, as it might be called, destroys its human meaning. If, as Freud says, work and love are the pillars of health—facilitators of development—then to make work "selfless" renders it useless for emotional and intellectual growth, and thus beside the human point. Craft means repersonalization of work in a world of depersonalized work. Avant-garde art developed simultaneously with and in response to industrial capitalism, and became the one social space in which work could still be individually meaningful, an essential part of the process of becoming an individual person. The avant-garde artist was assumed to be the individualist none of the rest of us was allowed to be by reason of our submission to the industrialization of work. For Ruskin, craft represented the return to individual work, and its enjoyment. "Was the carver happy while he was about it?" asks Ruskin of the craftsman carver. "It may be the hardest work possible, and harder because so much pleasure was taken in it: but it must be happy too, or it will not be living."[8]

For Ruskin, the craftsperson was a whole person. Might not the mission of craft today be to restore the individual's sense of wholeness in a society that denies it? No doubt this seems obsolete and irrelevant, and in fact an unrealistic social goal today, but it remains necessary for the individual to have a sense of wholeness to survive emotionally. The craft object is thus not only a means of revitalizing the idea of work but an unexpected means of restoring the individual's sense of wholeness, thus serving his or her emotional health. This is increasingly important goal in a society in the midst of a mental-illness plague, just as devastating as the AIDS plague.[9]

Two quotations from Ruskin are still relevant today—relevant to the opportunity afforded by the unexpected demise of fine art and the return of the sense of art as craft, or of art as an involuntary return to craft basics, in part because to symbolize feeling and enjoy aesthetic perception no longer seem significant in the Postmodern world. The first quotation:

It is not . . . the labor that is divided; but the men;—Divided into mere segments of men—broken into small fragments and crumbs of life; so that all the piece of intelligence that is left in a man is not enough to make the point of a pin, or the head of a nail, but exhausts itself in making the point of a pin or the head of a nail.[10]

The second quotation:

It is only by labor that thought can be made healthy, and only by thought that labor can be made happy, and the two cannot be separated with impunity. It would be well if all of us were good handicraftsman in some kind, and the dishonor of manual labor done away with altogether.[11]

The renewed interest in manual craft today suggests that the task of redeeming work is more pressing than ever—certainly more urgent than the need to symbolize our feelings and refine our perceptual experience, both of which seem like luxuries in an anomic world in which work has become more alienated and deindividualizing than ever for more people than ever, and in which people are more fragmented—less whole—than ever, as the psychoanalyst Heinz Kohut has suggested.[12] Craft remains a viable response to the problem of work, and the new craft ideal that is slowly infiltrating contemporary society, as an antidote to the Postmodern society that unwittingly generated it, posits a craftsperson who is more whole—has more integrity—and works for a different purpose than the Postmodern artist, who has become a specialist in creativity, perverting its meaning, as his or her ironical appropriation and reification of the creative work of the past suggests. The new craftsmanship is a last-ditch attempt to defend the idea of art as work and a way to wholeness, and a rejection of the Postmodern notion of the art object as one that bespeaks

alienation, with its fragmenting effect—an object that hides its unwholesome-
ness behind its commodity value.

This essay is reprinted with kind permission from the New Art Examiner, *April, 1996.*

Notes

1. Although this discussion is limited to the Western tradition of art, I believe the same holds true for non-Western artistic traditions.
2. In *On Painting,* written in 1436, Alberti discusses linear perspective as a practical technique for constructing space, showing how the "triangle of vision" can be built of parallel lines in spatial recession, which appear to converge on a single vanishing point (one-point or central perspective).
3. Louis Dupre, "Aesthetic Perception and Its Relation to Ordinary Perception," *Aisthesis and Aesthetics,* Erwin W. Straus and Richard M. Griffith, eds. (Pittsburgh: Duquesne University Press, 1970), 175.
4. See Terry Eagleton, *The Ideology of the Aesthetic* (Oxford: Basil Blackwell, 1990).
5. Peter Gay, *Art and Act: On Causes in History—Manet, Gropius, Mondrian* (New York: Harper & Row, 1976), 17.
6. Suzanne K. Langer, *Feeling and Form: A Theory of Art* (New York: Charles Scribner's Sons, 1953), 387–88.
7. Ibid, 388.
8. John Ruskin, "The Seven Lamps of Architecture," *Works* (London: George Allen, 1903–12) vol. 8, 218.
9. See Mihaly Csikszentmihalyi, *Flow: The Psychology of Optimal Experience* (New York: Harper & Row, 1990), 15, for a discussion of the current epidemic of social pathology in the United States. In general, my sense of the importance of craft, and its usefulness as a means of improving the quality of experience, leading to what Maslow calls peak experience and Csikszentmihalyi optimal experience (this strengthening and enhancing the sense of individuality), is informed by Csikszentmihalyi's conception of the need for the "individual to take things personally in hand" when "values and institutions no longer provide as supportive a framework as they once did" (16), and when "every desire that has become part of human nature, from sexuality to aggression, from a longing for security to receptivity to change, has been exploited as a source of social control by politicians, churches, corporations, and advertisers" (17).
10. Ruskin, "The Nature of Gothic," *Works,* 198.
11. Ibid, 201.
12. Henry Kohut, in *The Restoration of the Self* (New York: International Universities Press, 1977), 287, speaks of the "break up of the self"—its "enfeebled, weakened, fragmented" state—in the modern world. This occurs, he suggests on page 271, in part because "the environment, which used to be experienced as threateningly close, is now (in the modern world) experienced more and more as threateningly distant." Certainly technology has distanced us from work, that is, our instruments have come to dominate its significance, to the extent that they seem more significant to us than we do to ourselves.

PHILOSOPHICAL WALKS

Elizabeth Murray's Dandyish Abstraction

Jean Paul Sartre, discussing "one of the most fundamental tendencies of human reality—the tendency to fill," asserts that "a good part of our life is passed in plugging up holes, in filling empty places, in realizing and symbolically establishing a plenitude."[1] Well, in Elizabeth Murray's painting, the plenitude seems to have been there from the start, masked by, yet emanating from, the planes of the picture. The problem is to puncture this plenitude (to break the bubble, so to speak) by making holes in it—symbolic holes which may seem to imply, if not an emptiness, an alternative, less complete, presence than the plenitude itself. One way or another, usually by what have been called "small markings,"[2] Murray interrupts the surface in a way that initially seems absurd, but finally makes pictorial and, as we will see, "emotional" sense.

Murray's project of painting, then, seems to involve two "steps": first to establish symbolically a plenitude, then to puncture it—not so much to dissipate as to deflate it, implying that however much it is tangibly there, there are still other things that are intangibly "sensible." The sense of generalized plenitude is established by adumbrating the surface into a matrix of sensations by means of what has been called an "intimacy of gesture," or more precisely, with seemingly uniform strokes that in fact "vary according to the size of an area and remain visible according to the way each color dries; often a seemingly monochrome

Elizabeth Murray, *Children Meeting*, 1978. Oil on canvas, 101" × 127". Collection of the Whitney Museum of American Art. Photograph © Whitney Museum of American Art.

area will be an animated flurry of matte and shiny patches."[3] However refined or unrefined it may be considered, and however much it involves the use of "pate reticent" colors (as in Murray's early work) or "stronger" ones (more recently), this surface articulates through its "vocabulary of expressionist minutiae" the "animalian energy" of an undifferentiated plenitude.[4] This "skin" is punctured by "figures" which are like "brightly colored scars," or, as I prefer to think of them, like warpaint applied in a tentative, even fugitive, design. The particulars of this abstract design—"little figures that play," "quirky little arcs and loops, or accent-mark dots and squares"—go against the generalized plenitude established by the "elusive surface incident" with its "urgent . . . energy," while at the same time mapping it, giving it a center, often an off-center—that is, making it a form, even if an asymmetrical one. We see this in *Flamingo* (1974), where the figure asymmetrically spans the plenitude; in *Untitled* (1975), where a wobbly spiral maps the plenitude into a terrain; and in *Beginner* (1976), where a central,

inconclusive loop labors to stabilize a setting that is half morphic, half amor-phous. In general, the contrast between a "crawling" surface and the neat if eccentric figures settled, often uncomfortably, on it—and functioning as a kind of quasi-system of coordinates for the surface—shows the typical "play" of "ele-gance against awkwardness" which has been much noticed in Murray's work. In fact, any individual work, particularly from about 1975, seems a contrived, arch "gaucherie" which amounts to a species of elegance.

If there is any single method characterizing Murray's development to date, it is—more than the new eccentricity of shape in her recent work—the repression of predictable, known shapes, such as had appeared in *Up Step* (1973), and *Möbius Band* (1974). These are replaced by accents, mere sugges-tions of shape—that is, by Murray's "little figures": a reduction of shapes to schemata even greater than that which took place in the history of Cubism. In a sense, the recent eccentrically shaped canvases, with their curious crudity of shape, which might be regarded as forced primitiveness, as in *Desire* (1976–77) and *Singing School* (1976)—these restore the fully articulated shape now literally lost by the turn to "accents." In such works as *Evil Spaceship* (1976), *Searchin* (1976), and *Anticipation* (1976–77), where regularity of canvas is the rule, the accents enlarge and become eccentric, as if humorously to insist on irrationality whatever the rule and however much that irrationality, that sense of strange, primitive form, must be induced rather than trusted to arise spontaneously.

How can we locate these works in the history of formalism, where they belong? We might begin by accepting Robert Pincus-Witten's recognition of a "resurgent Romanticism" in much recent abstract art, "linked to the fact that external epistemologies . . . are no longer sufficient" in themselves.[5] There is, of course, the question as to whether they ever were sufficient. But in the context the point is that the "external epistemologies" are insufficient not, as Pincus-Witten thinks, because of their public interpretation as signs of "transcendence—crypto-religious experience impervious of analysis," or their "sentimentalized and mythologized content," but because they are no longer expressively or emotional-ly significant. Admittedly, the effort expressively to redeem such abstractions by regarding them as "images" of transcendence is ill-advised, but the implication that epistemic abstraction has expressive problems remains correct. The point is that "formalist art values," whose "central tenet," as Pincus-Witten says, is "the absolute congruency and inseparability of form and content," are always in dan-

ger of becoming overly dry—sterile. The congruence threatens to become unstrung, to lose its resoluteness, because the tension which makes form and content seem truly inseparable is inherently hard to sustain. This is partly because of the hermeticism of the formalist approach—content is self-referenced (one almost might say self-acting) form—and partly because the catalyst for self-action or self-referentiality is the mundane, uncertain energy (shall we say "temperament?") of the artist, which is usually forgotten in the equation of congruence, in the self-identity of form established by the inseparability of form and content. The attempt to create the illusion that form is self-acting is compromised the moment one recognizes that the energy with which it acts and the emotion which this action generates are humanly intended.

Now what Murray does is restore dialectical tension to the equation of congruence (form = content), by artful, even coy, techniques. These techniques create an artificial ("artful") paradise of expressive escapades, amounting to the creation of a dandyish abstraction. The generalized effect of asymmetry, a somewhat forced effect—which some recent criticism treats as spontaneous, if only by not noticing that it is forced—restores those "audacities of 'eccentricity'" which Camus notes were among the hallmark of dandyism.[6] The point is that where, in nineteenth-century France, such aesthetic audacities signified rebellion—even if only personal and "vain," rather than social rebellion—today they signify domesticity with a lilt, i.e., thoroughly domesticated abstraction trying hard to be lyrical and adventurous. Contrived eccentricity restores provisional audacity—improvised rebellion—to a tamed, even commonplace, visual "purity." Purity made primitive—murky, elusive, "touchingly" expressionistic—or seemingly disrupted by a counter-purity—the accents—makes for an authentic decadence, that is, a new "rare sensation" of formalism instead of the old jaded sense of its inevitability. Murray, as it were, proves Camus's point that "dandyism is a degraded form of asceticism"—she gives us a degraded and thereby enlivened, freshly expressive, formalist purity. This is perhaps most clear in the subtle, almost perverse, historicism of her work, which seems to borrow tidbits and inspirations from a whole range of abstractions. There are Malevichean and Nolandish moments, as well as more generally systemic and Minimalist and, more guardedly, expressionist looks—some obvious, some impacted, all summary. There is above all an overconsciousness of the medium, if that is possible, in the sense that planarity and touch at times seem to matter more than the limits

and shape of the individual plane and the kind of touch—just that which gives them their particularity.

Murray, then, in the name of an admirably tense congruence and inseparability of form and content (call this romantic if you wish, but the word is too weak from overuse to carry the weight of the idea) dandifies reduction. She makes it both elusive and eccentric, seemingly unclear in its "formal" direction and seemingly "unruly"—unprincipled, unprogrammed. Perhaps *Beginner,* with its coil or chain in the center and its murky royal purple and chalky gray, all constituted by elusive touch, most clearly shows this artificially (in the sense of artifice) unprogrammed, dandyish reductionism. For while the coil is a literal center to the canvas it does not "control" the purple and gray planes, which go their own way—especially the purple one, with its eccentric shape. Petrus Borel once remarked, in a statement that has come to be accepted as epitomizing the dandy's position, or is at least taken as "causing" the dandyish acts which are a way out of the impasse it articulates, "I was conscious of my power and I was conscious of my chains." Of course, Robert Morris's 1974 Castelli-Sonnabend poster of himself in chains is a direct exemplification of this situation, and the best example of the neodandyism which pervades a part of the art world. But Murray, in her own indirect way, relates to the statement. She poetically pictures it (where Morris grandiosely yet prosaically applies it to himself). For she is conscious of the power in her paint—in the painterly (the much noted energy, arbitrarily called "animal" and compared to scratchings, or traces of scratchings)—but chains this power, however loosely and eccentrically, in form. Yet like the loop-coil-chain trinket-ornament in the center of *Beginner,* form never wraps it up. And this new sense of form—even reduction-achieved form—as no longer "wrapping up" the painting, amounts to a dandyish rebellion against it, but also an elegant, equally dandyish, articulation of it.[7] The results are slightly comic, whereas Morris means to be tragic (?), but the main point is that both imply a plenitude of presence—whether of "active" paint or "struggling" persona—which they don't quite know how to deliver, to wrap up. Perhaps they can never do so, because they are, in the last analysis, only interested in giving an already familiar issue—an issue which has become "formal"—a dandyish stance. They give new life to an abstraction that has become a formality—these days a Lazarus that needs regular miracles to sustain it—by treating it informally, with all the self-conscious, stylized abandon of the dandy.

This essay is reprinted with kind permission from Artforum, *February, 1978.*

Notes

1. Jean-Paul Sartre, *Being and Nothingness* (New York: Philosophical Library, 1956), 613.
2. Carter Ratcliff, "The Paint Thickens," *Artforum,* June 1976, 46.
3. Roberta Smith, "Elizabeth Murray, Paula Cooper," *Art in America,* March–April 1977, 114.
4. Alan Moore, "Elizabeth Murray, Paula Cooper Gallery," *Artforum,* April 1975, 82.
5. Robert Pincus-Witten, "The Neustein Papers," *Arts Magazine,* October 1977, 109.
6. Albert Camus, *The Rebel* (New York: Viking, 1956), 52.
7. Consider Charles Baudelaire's remark in his essay, "The Painter of Modern Life" (1863): "Dandyism appears above all in periods of transition, when democracy is not yet all-powerful, and aristocracy is only just beginning to totter and fall. In the disorder of these times, certain men who are socially, politically and financially ill at ease, but are rich in native energy, may conceive the idea of establishing a new kind of aristocracy."

Sue Coe

Sue Coe doesn't think of herself as a "political artist," so let's call her work "message art." By that I mean an art that speaks in a public language in a public situation. It is not an art that thinks of itself as above its audience—reaching up for grapes of transcendental art tantalizingly out of reach—but rather as a public response to the inhuman conditions of social life. It is a communication that occurs within social life rather than from a vantage point outside of it: Coe's art is not immune from the conditions it describes, but carries them within its body. One might think of it as the desperate reaction of the immune system of the body politic to a widespread cancerous infection within it.

Coe's art is the powerful protective reaction of an immune system that itself feels threatened, feels itself to be in danger of breaking down, so widespread is the plague of inhumanity that it is responding to. With Coe's work, art has become humanity's last line of defense against corrosive social forces. Each of her pictures is a kind of seismographic record of the signs of social shock, the fault lines where social catastrophe is likely to occur. Coe's art is a reaction which tends to be an intervention—a reaction which intends to influence and change the course of history and the conditions of social life. Sue Coe is one of the few artists who genuinely believe in the possibility of creating an art that speaks to the

socially oppressed and outcast, the disenfranchised and miserable. She means to give voice to the underclass that seems to have become a permanent feature of the capitalist system of society. To give them voice is already to begin to overthrow that system: Coe wants to create a confrontational, revolutionary art. She is the greatest living practitioner of such an art.

The fact that her preferred mode of distribution is through inexpensive paperbound books—not glossy coffee table art books—suggests the journalistic dimension of her work. Yet it appears in art galleries, and it is as an artist rather than social commentator that she has prominence. She creates political cartoons for the Op-Ed page of the *New York Times,* but her work there is relatively anonymous. She is not a Herblock; she is not featured for her point of view, but only for her images. Compared to the dramatic power of her pictures in her books, the *New York Times* pictures are toned down illustrations. Their visual impact is softened to make their messages readily communicable. For all their complexity, they are more populist than the book pictures. This is an old problem, going back at least to medieval art: how to make an urgent message of salvation immediate in the minds of visually illiterate viewers—so vivid that they will act on it, that it will create social awareness, moral determination, and political purpose in them—without giving up the highest standards of art known to the times.

This image is a crucial means to inform those who are not yet convinced about why their destiny has just the shape it does. The image is a crucial means of inviting them to take command of it. For the image is physically and emotionally more concrete, and in that sense more convincing—exerts more pressure—than the word. Coe uses text, but always in the context of the image. Text is an instrument of the image rather than an end in itself. Even a page of pure text in one of Coe's books looks like a magical picture, in part because of its choppy look and the stark color contrasts that constitute it. In general, Coe's art is driven by various contradictions. She has managed to harness the poles of each to a single purpose. Her work exists both as significant high art, and as important critical commentary on capitalist society. How did Coe achieve this double success, resolve the greatest contradiction?

To answer this question, we need to understand something about the postmodernist situation of art in which Coe's work was created and achieved recognition: we need to understand postmodernist decadence, which has a posi-

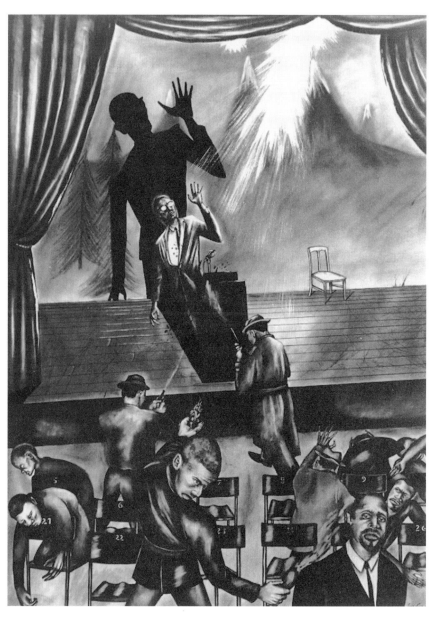

Sue Coe, *The Assassination of Malcolm X*, 1985. Graphite, collage, and gouache on paper, 30" × 22¹/₄".
Copyright © 1985 Sue Coe. Courtesy Gallerie St. Etienne, New York.

tive as well as negative meaning. In general, to be postmodern means to give up the modernist pretense of making a fresh start in art—a fresh art. It means to give up avant-gardism for decadentism, as it might be called. It means to accept the fact that contemporary art-making is regressive: its credo combines two familiar ideas, "ontogeny recapitulates phylogeny" and "regression in the service of the ego." That is, by working through old, "family" styles a little "progress" might be made, a little gain of pure gold of art eked out of its already well-worked soil.

This strengthens the weary ego of art, battered both by a capitalist society eager to commercially appropriate it—a society asking art to live down to it rather than asking itself to live up to art—and a fragmented ("pluralistic") art world which has no clear sense of values, and so is always threatened from within by a failure of nerve. The retreat to and sophisticated manipulation of—fortification behind—old art values is partly a response to these external and internal pressures, which synergistically compound. Traditional methods and ideas seem to restore the old feeling of the absoluteness of art just because they are old. That is, they are no longer problematic and "incredible" inventions, no longer experiments or "hypotheses" which may or may not prove to be "correct" art. They have become socially accepted and so historically credible, and seem durable and communal because they have become institutional.

The two poles of postmodernist production are epitomized by the recent work of Frank Stella and Georg Baselitz: the stylistic gymnastics of the one and the expressionistic revival of the other. Stella plays hard and fast with traditionally contradictory methods of art making—constructivist and gestu-ralist—to regenerate a fresh, if hollow—contentless, messageless—sense of presence. At present he is in fact perhaps the leading synthesizer of tradition-ally contradictory modernist styles into a grand modernist manner. A mod-ernist eclectic without peer, he uses widely different styles in an additive man-ner to build up a work of art which seems to proclaim the omnipotence of art. His union of stylistic opposites is the last dialectical stand of the doctrine of art for art's sake, the grand final form of art's delusion of grandeur. It is a bar-ren baroque art—a baroque art without its visionary character.

In Baselitz we have something different, more positively decadent: against all odds, the inhabiting and revitalization of the supposedly dead style of German Expressionism, the original German modernist style. Baselitz might be

expected, as a German artist, to feel affinity for German Expressionism. Such creative appropriation of a national style is an artistically and socially provocative act, especially since German Expressionism was regarded by many bourgeois Germans—the Nazis are only the most extreme, outspoken, notorious example, who acted on their belief—as "degenerate," that is, decadent. I am of course alluding to the 1937 exhibition of Degenerate Art organized by the Nazis, which largely featured Expressionist art, but I want to emphasize the Nazi belief that there is something fundamentally wrong with Expressionist art, something innately unhealthy and degenerate about it, which made it unfit to be the art of a rejuvenated, "healthy" German people. German Expressionism, whatever else it might be, bespeaks, through its disjunctive distortions, the suffering of interior conflict—an existential agony which, whatever its pathological intrapsychic aspects, can be understood as a "critical" reflection of inhuman social reality. It is this critical dimension of German Expressionism—simply to publicly reveal pain usually privately repressed, to break the veneer of civilized art by offering grotesque form (so uncompromisingly grotesque it could not be twisted back into civilized, human shape)—that repelled the Nazis. Baselitz in effect takes a liquidated style and brings it to life. His Expressionism is a vigorous Lazarus, all the more full of unusual expressive possibilities—heroic expressive capacity—for having been dead, socially repressed. Indeed, it can continue to represent, as it did for the Nazis, what is socially repressed: the underlying horror and absurdity of existence, made all the more evident and invincible by the horror of modern existence.

It is this sense of existential absurdity and social horror that are compounded in Coe's Expressionism. It is postmodernist in that it inhabits a traditional Expressionist art, while synthesizing Expressionist and Surrealist methods in a search of a grand manner. This "baroque" aspect of Coe's art is most apparent in her paintings, but the pictures in her books can be read as compressed grand-manner images—a sort of grand-manner picture in miniature. The abysmal abstract blackness of her space, and the way her scenes tend to exist as snatches of representation which seem about to sink into the blackness as if into quicksand—a slime of nightmarish hallucinations which floats on the surface of the Styx of the personal and collective unconscious—convey the visionary substance of Coe's works. Like the German Expressionists, and such Dadaist/Neue Sachlichkeit artists as George Grosz, Coe's dark vision is ground-

ed in her obsession with social misery. She seems particularly to identify with the oppression of blacks, as in *How to Commit Suicide in South Africa* (1983) and *For X* (1986), a kind of visual biography complementing Malcolm X's autobiography. Coe has Stella's baroque ambition and Baselitz's existentialist orientation, adding to both a documentary sense of timely content. In general, her art, like theirs, is mannerist in its decadence, that is, it uses familiar modernist styles to create new dramatic effect. But she is closer to Baselitz, who, while he uses a style that has been brought to a certain perfection in the past and so seems over and done with (Stella uses several such styles), uses his style to communicate an imperfect reality (unlike Stella, who tries to communicate a perfect art). But Coe differs from both Stella and Baselitz in her insistence on the socially realistic character of the unhappy existence she depicts. She wants neither the fictionality of philosophy (Baselitz) nor of art (Stella), but the oppressive reality of society. She wants no filters. Yet clearly, she achieves her "realistic" effect through "unrealistic" means.

In the last analysis, her art is as sophisticated as her shrewd choice of social realistic subjects. She tends to concentrate on content which can become symbolic of the oppression of a whole class of people—black, or, in her work dealing with the rape of a woman by four men while twenty watched (1983), women. But what makes Coe unique among contemporary social realists is that she is as interested in people as in causes. Her figures are not simply emblems in the test-tube revolution of the picture, but charged with personal as well as social pathology—profoundly "pathetic" ("degenerate") in their existentially extreme social situations.

Henri Lefebvre wrote "the old classic humanism ended long ago, and ended badly," but a new postmodernist humanism is in the offing through Coe's art. It is a pessimistic rather than optimistic humanism—a humanism which offers not a utopian vision of human integrity, but a pathological vision of human and social disintegration. The peculiar lack of cohesiveness of Coe's pictures reflects this disintegration—this "decadence." The reason Picasso's *Guernica* has become, in the words of Michael Ragon, "a 'masterpiece of art,' nothing more," that is, "an object of aesthetic consumption" rather than a "political weapon," is because it retains vestiges of the classical humanistic approach to the figure and the catastrophe it depicts. This is shown in part by the fact that Picasso has turned the historical catastrophe into a natural one, and by the

fact that his approach to his figures is representative: despite their wounds, they remain harmonious wholes. Despite the suffering that distorts them, they do not fall apart, but remain "integral," cohesive, as does the scene as a whole. In Coe, scene and figures tend to come apart, or else figures are reduced to puppets in a drama and space beyond their control. Coe's irrationality is greater than Picasso's, which is always framed by a classical rationalist ideal of order. Coe gives us raw psychological irrationality, verging on chaos.

Picasso's victims retain their humanity despite being victimized. They seem to heroically resist their suffering as it occurs: they defy the mutilation which makes them monstrous. The bodies of Coe's figures are inherently monstrous, if with a different kind of monstrousness for victim and victimizer. In Coe, the lurid blackness, an all-pervasive and all powerful shadow of death, reflects society's lack of empathy for the suffering figures, helping to reduce them to tragic puppets. There is no mechanical sun in the gloom, as in Picasso, who also offers us gray, not black, hope despite despair, not despair pure and simple. Picasso paints *Guernica* in the gray tones of the preconscious, which suggests that the meaning of the event has not yet sunk in. The bombing of Guernica has not yet become a haunting memory, its trauma repressed. Picasso's *Guernica* is not about the nightmarish return, and working through, of the repressed, but the monumentalization of an immediate event to prevent it from being repressed, and so to preclude examination of its unconscious meaning. In contrast, Coe creates images that seem to have been brought up from the depths of the unconscious, images that collective memory tries to bury alive. Coe deals with realities that society prefers to forget, that it is not eager to aesthetically idealize, like Malcolm X's catastrophic life and the catastrophic *Crystal Night* (1984), the title of which recalls Nazi atrocities, but in fact refers to drugs; or realities that it wishes away as fast as they recur, like rape and racism. In Coe's images this history comes back in all its inhumanity, wet with the black water of death. Coe's pictures can never be reduced to objects of aesthetic contemplation, as little as Goya's black paintings or *Desastres de la guerra* (Disasters of war), which is why she is superior to Picasso as a socially engaged artist. There is no false classical humanism in her art, no secret bourgeois idealism.

Coe's pictures spew black bile and spit blood in an Expressionist scream of agony and anger. Brechtean in their didacticism—their repetitive hammering home of certain themes, such as Malcolm X's figure, is meant to be

"instructive" and convey conviction and commitment—it is their image of inconsolable suffering which in the end seems most significant, both as art and social truth. She is at her best when she shows us what people have become, not what revolutionary leaders are possible. That is, she is at her best when she is a visionary artist, not a propagandist. She is at her best when she de-idealizes capitalists and the oppressed into the truth of their being, not when she idealizes a Malcolm X—which doesn't mean that he shouldn't be idealized, but that as an image in her art he is less convincing than the image of misery that surrounds him. She is at her best when she debunks—shows the animal character of the ruling class, the fatheads with phallic tongues that men can be, the brutalization of everybody by the universal system of suffering—not when she dignifies, that is, tends to "classically" humanize. She is psychologically richer and socially more pointed when she shows the world's unbalanced character and disintegration than when she shows one "whole man." She is more at home with inner and outer ugliness than she is with the "beauty" that comes of integration.

Her postmodern "re-vision" of Goya's images of the Inquisition in her witch and Ku Klux Klan images, and of Grosz's compositions and figures (for example, his use of the priest figure), confirms the radicality of her realism. She is not so much looking for spiritual ancestors—locating herself in a tradition of protest art, the art of accusation—as creatively appropriating images that have become fundamental to our understanding of modern social reality. All her images, however monstrous, are rooted in a firm grasp of social reality. They are all admirable in their economy of means, which is at once universal and modern in import, and serves her realism's intensity. From her deft use of the primary colors of red and yellow in the field of black death—symbolic of the universal unconscious as well as modern consciousness of the oppressive world—to her texts, which, whether informational or sloganeering, never fail to hit their targets, Coe's work is lean and mean. It is at once propaganda out for a clean kill and a radical visionary art. Her oeuvre as a whole amounts to the greatest triumph of Death in postmodern times, as her use of black, and her many images of skeletons, climaxing in The Landlord, indicates. Her art has the lethal clarity that one expects from such a vision—a lethal clarity that makes it commanding.

This essay was originally published in the catalog accompanying the exhibition Sue Coe: Police State, *Anderson Gallery, Virginia Commonwealth University, January 20–February 28, 1987.*

The "Madness" of Chicago Art

As I begin to write about the "Chicagoness" of Chicago art—as though it is possible to give an essence to what has a vigorously diverse existence—I am in dread of incurring Franz Schulze's wrath. Schulze took Russell Bowman to task for arguing that "the central concept of the Chicago Imagists was that commonplace imagery, and vernacular, *kitchy* imagery in particular, could be sources for intensely personal expressions" (*New Art Examiner,* October 1984). Schulze retorted: "The characterization hardly fits Chicago as of the period 1945 to 1965. Campoli, Petlin and Statsinger were either indifferent or consciously hostile to kitsch and the vernacular, preferring to explore themes more nearly mythic or universal in intent" (*NAE,* December 1984). Schulze will no doubt feel I am guilty of even greater misapprehension of Chicago art than Bowman—of overlooking even more of the details of its history. For in a calculated attempt to avoid all the clichés about it, the redundant, hackneyed, Procrustean terms in which Chicago art has come to be discussed— "prodigal funk," "retarditaire and provincial pastiche of Pop and Surrealism," "exacerbated figuration," "monster roster"—I want to change the terms of the discussion by locating Chicago art in a larger context of understanding than is customary. It is in fact the largest context: I want to understand its place, function, and "philosophy" in modern art as a whole.

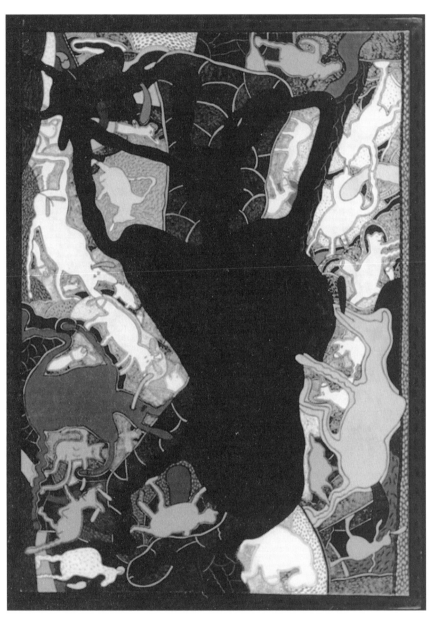

Gladys Nilsson, *Reclyning Blackveenus Rabit*, 1971. Acrylic on canvas, 20³/₄" × 39⁵/₁₆" × 3". Collection of the Museum of Contemporary Art, Chicago, gift of Albert J. Bildner. Photograph copyright © Museum of Contemporary Art, Chicago.

Such an enterprise is no doubt filled with the pitfalls (pratfalls?) of overgeneralization—although it promises to end the usually defensive character of discussions of Chicago art (or else put it more on the defense than ever). But it seems the only way of breaking the stranglehold imposed by the conventional categorization of Chicago art, which has unexpectedly made it seem banal by too vigorously insisting upon its way-outness. (For way-outness is the most habitual, banal characteristic of modern art.) I believe Chicago art has a truly extraordinary position within what Harold Rosenberg called the "tradition of the new." I would like to generate a fresh respect for Chicago art, create a new perspective from which it can be appreciated. It is an important innovative art; but the implications of its novelty for modern art as a whole have not been spelled out. Critics have been too busy defending its right to its "difference" to examine the full meaning of that difference.

For me Chicago art is a special demonstration of the troubled character of modern art—more particularly, of the two problems that have shaped it from the start. First, its profound dissatisfaction with and distrust of all modes of articulation, which keeps it restlessly on the move inventing novel modes of articulation, all of which remain haunted by the aura of inarticulateness, that is, by the suspicion that they are futile as articulations of reality and subtly inarticulate or confused in themselves. Another way to state this is to say that the most serious modern art has always thought of itself not only as art but as anti-art, the viper which grows within its bosom—yet that is what makes modern art "modern." For anti-art expresses the "nihilistic" relationship of art to the modern world. That is, its devaluation or deprecation of itself in the very act of making itself is its internalization of its "inferior" status in the modern scientific world, an implicit acknowledgment of its doubtful reason for existing in this world. In overt anti-art, we see art banalizing itself into another dumbly "positive" material fact of the modern world in the very act of asserting its triumph over—negation of—that world. Modern art is full of morbid self-doubt. While it makes a virtue of its self-doubt, uses it to drive itself towards ever more revolutionary articulation, this Faustian pursuit of revolution is itself a sign of the rot/rottenness brought about by self-doubt. Second, as a correlate of this, modern art is profoundly uncertain as to whether art has anything to say in the modern world. For implicitly the modern world is, because of the scientific outlook which makes it modern, indifferent to art, regarding it as essentially trivial

("decorative"). From the positivistic point of view, art belongs with religion and metaphysics to the childhood and adolescence of mankind. It is inherently beside the point of reality and presumably has nothing to do with developing a "reality principle."

The one is a methodological anxiety, the other an anxiety about meaning, involving art's uncertainty about its relationship to reality. It does not know what "stand" it should take to modern reality—how it should locate itself within this reality, as a major recognition of or witness to it, yet at the same time offer critical resistance to it. Methodological anxiety about the proper mode of art-making leads to art's restless preoccupation with basic values—a perpetually changing sense of what is formally significant, leading to an awareness of stylistic relativism, coincident with a constant expectation of aesthetic revolution. Anxiety about meaning leads to art's insecurity about its "message," even doubt that it has any. (Its defiant proclamation of its "uselessness" simply acknowledges a social fact.) I have in effect restated the "dissociation of sensibility"—the schizoid separation of thinking and feeling—that T.S. Eliot thought pervaded modern art, infecting the conception as well as development of it. (It is perhaps worth noting that from this perspective Postmodernism is simply another statement of the modern double-edged anxiety about art-making, rather than a solution to it.) The dissociation is perhaps most succinctly expressed in Bernard Berenson's distinction between stylistic and illustrative values in art, reformulated by Clement Greenberg as the distinction between aesthetic and literary values.

This distinction has become commonplace in contemporary art-thinking. It has come to be regarded as normative, controlling our understanding of art, and has become hierarchical, controlling our sense of artistic value. An art in which stylistic/aesthetic/formal concerns dominate is regarded as inherently superior to one in which illustrative/literary/message concerns dominate. I think this distinction, and especially its hierarchicalization, represents a major tragedy for art—a major loss of unity of purpose. I think Chicago art is an important response to the dialectical insecurity and frustration implicit in the distinction. Chicago art is an important attempt to rearticulate and at the same time overcome it.

In an up-front way—it is this "indiscreetness" which may be responsible for the way Chicago art has offended many people—Chicago art is fraught

with the complex anxiety of modern art: stylistic restlessness, insecurity about message (doubt that art is a privileged cognition of reality, implying a special relationship to it), and the realization that the only way to lay these anxieties to rest is to reconcile the vital opposites of thought and feeling they represent. But Chicago art offers no premature, utopian reconciliation—another reason it is offensive to modern art lovers. Its continuous agony is the expression of its implicit recognition that the world-historical situation—the external condition necessary for reconciliation—promises no reconciliation of thought and feeling, and of the antagonisms that generally animate the world—and so no "sanity" for art. Chicago art knows the world offers no pastoral possibilities, and that the condition of hypostatized contradiction in which it exists is hardly a condition of peace or reconciliation. How can the internal contradictions of art change, when the external contradictions of the world seem unchangeable? How can art lose its anxieties about itself when the world still arouses profound anxiety? The internal contradictions must be lived with, however much they continue to bring the nature and stability of art into doubt. This is the "philosophy" of Chicago art.

Thus, Chicago art is to some extent "mad." One way of living with contradiction is by going mad—a seeming rebellion against contradiction which in fact articulates it and the anxiety it embodies more fully. (Madness, with its hardened frustration and disbelief in the possibility of any reconciliation between the opposites that constitute the contradiction, is the extreme opposite of utopianism, which believes in inevitable, if historically postponed, reconciliation. Utopianism, I think, unconsciously motivates more modern art than madness, for utopianism seems to bring contradiction under control, reconciling us to it as mad art refuses to do.) Chicago art is the example of a deliberate if risky attempt to make "mad art." It is an artifaced "outsider art." Chicago art acknowledges the self-contradictory, anxious condition of modern art by refusing to accept stylistic repression of its anxious self-doubt. It operates with no fixed sense of style; it tends toward a condition of stylelessness rather than stylization. This helps generate a sense of its "drivenness." Hence its so-called eccentricity. Paradoxically, the deliberate attempt to be mad in art makes its repressive stylistic structures all the more visible by "bending" them. Thus Chicago art reveals the inner contradictions of modern art with special flair and intensity.

I want to look at Chicago art from the perspective of these ideas not only because I think they are key ideas for understanding modern art in general, but once and for all to get beyond the essentially dead distinction between sophisticated cosmopolitanism and provincial regionalism. This distinction once permitted a New York critic to speak of Chicago artists as "Midwestern eccentrics." Why should Midwestern eccentricity be any more or less credible than German eccentricity, or the eccentricity that was central to modern art from the start—that in retrospect can be seen to be inseparable from its nature? Or rather, the sense of eccentricity—reflecting uncertainty about norms, even a sense of their arbitrariness—that has pervaded the modern sense of reality, and that Midwestern eccentricity is another articulation of.

Expressionist-type art has usually been labeled as eccentric, while Cubist-type art has usually been regarded as normative, but this distinction— Greenberg's—is false, arbitrary, and political. It shuns critical awareness of the issues rather than expounds them. It conventionalizes one type of art at the expense of the other in an attempt to give it social status, to signify that it is the approved type; but such conventionalization represses recognition of the complex distinction that underlies it. Indeed, the moment such an absolute distinction is established, it begins to rot. Several scholars have argued for an expressionist understanding of Cubism—a recognition of its eccentricity of vision, its troubled dialectical character as an anxious mode of art and anxious message about reality. No one today can say, with the confidence that they are speaking a fundamental truth, what is or is not normative in art, what is or is not eccentric—"distorted." For no one knows how to make the distinction convincingly in life. This is the point of Freud's assertion that the normal and the abnormal exist on the same continuum, are describable by the same concepts. We find ourselves in a situation, in art as in life, of discovering the normative within the eccentric, and the eccentric within the normative, with no sense of the priority of one to the other. The best Chicago art is a revelation of this simultaneity.

The anxieties of modern art are reflected in Chicago art through what I think is its basic concern: trying to tell a story. I experience most works of Chicago art as isolated episodes in an open-ended plot. They are moments in a tall story, which exists to make the point that there is a story to tell, and that there is a story still untold—that there is still more story to come. It is a sort of Thousand-and-One-Nights situation, trying to seduce us to the idea of the

story itself—to the belief that understanding is still organized in terms of stories. Sometimes Chicago art offers us balladic tales—for me, much of the Hairy Who—and sometimes its tales seem full of sound and fury signifying nothing, that is, the being of nothing, or the secret, frustrating nothingness of it all—for me, much of the post–Hairy Who Expressionism—but it is always about the possibility of telling a story, always arguing that it still makes sense to think in terms of stories. Chicago art is a polemic in favor of storytelling, crucifying the story in order to resurrect it as valid beyond any possible doubt. There is a fundamental anxiety to hold on to the story in Chicago art—even when world and art history seem to have no plot to them, or no teleological point to their "plot."

I think this is true of all kinds of Chicago art that is stylistically different, but in which the difference expresses frustration with finding the proper way of telling a story in a world in which plot no longer takes a linear form and in which an object or detail can act as or expand into a "character." Nicholas Afrikano, Ivan Albright, Roger Brown, Leon Golub, June Leaf, Gladys Nilson, Ed Paschke, Irving Petlin, Seymour Rosofsky, Peter Saul, Hollis Sigler, H. C. Westerman, Karl Wirsum, and even, I submit, such abstract artists as William Conger, Miyoko Ito, Frank Piatek, Barbara Rossi, and Evelyn Statsinger are storytellers. The nonimagistic artist tells a story in abstract form, very much in the manner, if not with the same terms, as El Lissitzky's *Story of Two Squares* (1922). In general, much abstract art, if not disguised or subliminal narrative, treats various nonrepresentational forms as "characters" in a dramatic plot, giving them added animus—adding to them a dynamic that they do not often have in themselves, supposedly thereby giving them more "human interest." In much of the current crop of Chicago Imagist work there seems to be a deliberate attempt to fuse representational and nonrepresentational modes, but the narrative intention remains central.

In an art world in which narrative was for a long time declassé, even though much art was subliminally narrative, Chicago art's "mad" clinging to narrative seems to have paid off, in view of the new sense of narrative's potential—the new sense of "advanced narrative." Does the new narrative art look to Chicago for any of its standards? Is Chicago art in any way a model for neonarrative art? I don't think so. The difference between Chicago narrative art and neonarrative art can be stated quite simply in terms derived from Schulze. "Imagism," he says, "implies the summoning of figural/iconic symbols to convey

personal psychic states and metaphorical responses to experience, as distinct from the organization of pictorial elements into formally expressive, psychically neutral configurations." The neonarrativists want to deconstruct narrative, writing large the configurations that structure it. The Chicago narrativists don't want to deconstruct narrative; they want to use it to metaphorically convey psychic states. At the same time, the neonarrativists want to use the neutralized, semiotically reconceived configurations to ideological effect. The Chicago narrativists do not accept the semiotic neutralization of narrative configurations, and in fact seem to deny that there is any optimum form narrative can take. For them, narrative is in a state of flux, with no fixed conventions. That is, Chicago art seems to deny that narrative configurations exist as signs having a certain function in a certain kind of discourse before they exist as "moving" or as responses to experience. Kiefer's landscapes are semiotic restorations of an ideology before they are metaphors of experience. The postmodernist/narrativists restate the double-edged anxiety of Modernism as a semiotic problem: the absence and conceptual nature of the signified conveys the problem of art's anxious relation to "positively" given modern reality, and the character of the stylistic signifier as part of a historical tradition of art discourse conveys the problem of art's unhappiness with its modes of articulation, leading it to become "revolutionary."

Is Chicago narrative art hopelessly antiquated? No, because it does one thing neonarrative art doesn't do: it reminds us, through the insistent diversity of its stylistic modes, that there is no one privileged mode of narrative, and that the very idea of narrative is inseparable from art as an attempt to hold its own in a positivistic world that implicitly disbelieves in it, or believes in its "immaturity." Chicago narrative art's supposed reference to experience is beside the point of the larger issue it articulates, and that neonarrative art subtly evades in its semiotic ostrich hole: the fact that art can only make a case as narrative—a kind of narrative of narratives?—in a world in which scientific theory has not only told the greatest story that can be told—the story of reality—but has incorporated aesthetics into itself by making aesthetic contemplation seem the appropriate mode of recognizing and respecting reality.

Neonarrative art, for all the subtlety of its reflection of the basic anxieties of modern art, in a sense neutralizes those anxieties without working them through. It thus amounts to a repression of them. To see stylistic configurations

as raw signs of a kind of discourse called "art" is to ignore the question as to why we need that kind of discourse in the modern world. It is also to end art's self-doubt by assimilating it as one more kind of discourse, having the same nominal power as other kinds. Neonarrative offers us a compromise position: art is anxious about itself and its place in the world, but it has a place (and so it can be less anxious) as one among many discourses—which is a sophisticated way of positivistically neutralizing it, denying its "difference" and treating it as another matter of fact.

Chicago narrative art makes a general point about the difference it makes: it tells a story in a world which seems to have no stories left to tell. Above all, it tells the story of the madness of making art in a world of science. That is, it tells us that we are still driven, caught up in plots while full well knowing there is no grand, over-all plot. It tells us that even in a society in which art has become another mode of simulation, that is, exists as no more than a sign of itself—in a world of neoart—there is still art which is unwisely engaged in making up stories about the lifeworld that exists behind the various simulated ones.

The pathos of Chicago art is not that it is about pathos, but that it still sees art as able to escape the institutional destiny which will invariably make it into a simulation—a sign of itself—by asserting itself as primary madness. To oppose the madness of the simulated world of signs with the madness of story-telling in a world in which all the stories seems to have been told over and over again—this is truly to be psychotically realistic.

This essay is reprinted with kind permission from the New Art Examiner, *May 1986.*

Donald Lipski

Donald Lipski's objects exist to be psychoanalyzed. They are "poetic objects" in street clothes, wise-cracking, street-smart poetry. Their components are found in the garbage dumpsters of consciousness as well as those of the world. Rapacious rummaging through obsolete ideas as well as obsolete objects—discarded knowledge as well as discarded artifacts—are their starting point. Indeed, Lipski has an encyclopedic approach, as if he were trying to put all the waste of the world together into an order that made occult sense. He is a great alchemist, creating an extraordinary collection of poetic monsters—incongruous new realities, whose parts fit together yet loudly bespeak the lack of any necessity for that togetherness. They are "force-fit" composites which don't quite compound; and yet they are facts of art, independent entities of mixed motives. I tend to think of Lipski's poetic object as a kind of platypus—a dead end of some bizarre evolution of objects that occurred on an isolated continent of consciousness.

Obsessive collecting is truly crucial to the method of his madness. It is a deliberate strategy—an involuntary reflex to objects that has turned into a strategy for bringing out their "power." His sense of the hyperstrangeness—momentousness—of objects that are ordinarily understood as far from extraordinary follows compulsively from this collecting, which during its course "pro-

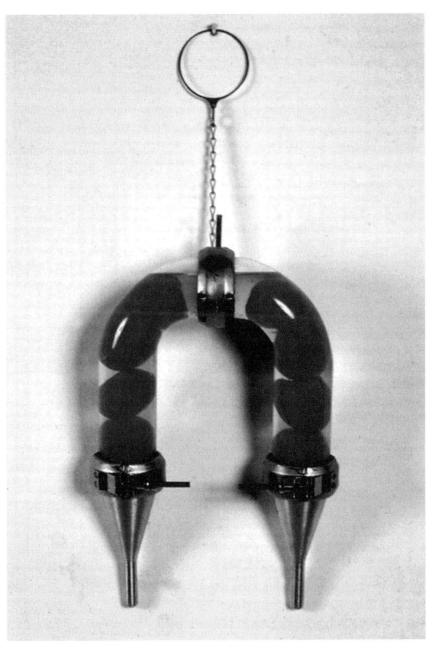

Donald Lipski, *Untitled #84*, 1986. Tomatoes, liquid, glass, hardware, 16" × 10" × 3¹/₂". Photograph courtesy of the artist.

duces" accidental conjunctions of objects that catalyze strange recognitions. Lipski cannot help himself: objects simply do not exist for him in the same straightforward way they exist for the rest of us. He breaks our habits of thinking about them, showing they exist in a more unsettled state of relationship than we ever thought possible. Lipski has the true artist's wit to see the inherent waywardness of objects—their eagerness to break the boundaries of their givenness, forfeit the terms of their familiar appearance, and become strange and present in a far from clear way. He has an involuntary mystical attitude to objects, in Alfred North Whitehead's sense of mysticism as "direct insight into depths as yet unspoken." For Lipski, objects speak for themselves through mystical marriage with other objects.

His poetic objects, then, are made of the dregs of thought as well as of things—of whatever has lost its place in life and found its place on the street, with no hope of making it into the museum of mind or beauty—nor wish to do so. Lipski in fact says he starts with junk store or street-found objects—objects so impoverished they have sunk beneath the contempt of ordinary usage; they obviously exist to be given new life in and through art. Lipski's poetic objects depend on American society's surplus of things and ideas—which is inseparable from built-in obsolescence, for room must be made for more things and ideas. The American larder is as full with cast-off—outcast—things as with brand new ones. Lipski's poetic objects are unthinkable in a world in which every object and every idea was to be cherished and squeezed dry for the last drop of use. Lipski is a scavenger of our bewildering excess; his objects are the arcane, poetic residue of a mechanically productive world, generating things and ideas for their own prosaic sake, and innocently letting them deteriorate into garbage—a carelessness balanced by the assumption that there will always be more where they came from. Yet the assumption of unending abundance is not innate to Lipski's art, which is why I think it tries to redeem found objects, the way a psychoanalyst redeems the garbage of consciousness by scavenging for treasured connections within it. Similarly, Lipski's poetic objects are "constructions" made of the detritus of dailiness.

While Lipski's poetic objects can be understood in terms of the surrealist ideal of incongruity—they make the surrealist screw excruciatingly tight, violently forcing "poetic" commensurateness upon seemingly absolutely incommensurate "prosaic" objects in the hope of tapping unconscious depths through

metaphor—they are best understood through the concept of anti-art, its most exemplary realization today. While his poetic object does function as a divining rod pointing to buried psychic treasure—in the proper condition of risk to make the strike—it manages to avoid the happy aesthetic ending of the surrealist poetic object, that is, its unequivocal conversion to a "positive" work of art. Lipski has no interest in aesthetically justifying his poetic objects, as the surrealists secretly wanted to do with theirs. He doesn't really intend to show us the secret unexpected aesthetic in ordinary things—a latent surrealist ideal— although his works have a certain bizarre beauty (the bizarre as a crystalline end in itself). On the contrary, he wants to make clear just how unreducible to aesthetic terms things are—and thus the extent to which they exist in a kind of limbo beyond all reflection, however much they are—necessarily—reflected upon.

It is this limbo effect—the demonstration of the peculiar inaccessibility of things despite their apparent accessibility and aesthetic reification—that is the source of the poetry of Lipski's objects. It is the heart of his brilliant resurrection of the almost forgotten moment of anti-art in contemporary art. Ever since Duchamp, with whom Lipski has been favorably compared, anti-art has become an increasingly lost cause as its poetic objects have been understood as one of art's many disguises. This way of looking at anti-art objects implies that the negativity at the heart of modern art—which such objects make brutally explicit—has been made falsely positive and inconsequential. Its "countercultural" power to challenge the very concepts of orthodoxy and authority has been castrated. Lipski restores, with a new vehemence, the message of anti-art: the awareness that any conformist insistence on orthodoxy—in art and in the life-world—is essentially authoritarian, and as such specious. It is an attempt to deny the relativity of authority—especially the authority of art in the modern world. From this point of view, the motive behind the elevation of the aesthetic into the host of art is essentially authoritarian. Lipski's art is a major rebellion against the aesthetic suppression that tries to establish artistic orthodoxy or normativeness—a rebellion that was once inseparable from what it meant to make avant-garde art.

Lipski, then, is not really attempting to make art out of non-art through the "mechanism" of spontaneity, but rather the opposite: to show that all art is basically non-art, "extra-artistic." He undermines every possible con-

ception of art, showing its fundamental unintelligibility for all its interpretability, by emphasizing the anti-art element in art: its starkly empirical aspect. On the one hand, this seems to offer direct access to the art; but on the other, the empirical blurs the understanding of art as art. Calling attention to the irreducible—untransformed—empirical reality in the art, puts it in a kind of limbo. But it is also exactly what makes it bizarrely "poetic." It catalyzes awareness of the sublime incoherence of art. Lipski can be said to stylize this incoherence into an absolute—which opens the way to a tempting variety of interpretations of it but gives credibility to none. For the work of art always "regresses" to its irreducible incoherence—source of its intransigence or enduring heterodoxy. This incoherence de-essentializes its aesthetic aspect, making aesthetic awareness a transient moment in its perception. By offering works of art which repeatedly break down—disintegrate—into their empirical components, Lipski suggests that art in general refuses, as it were, to offer either aesthetic or intellectual satisfaction, that is, so-called consummatory experience, and refuses to rise to the heights of autonomy—to become "true" art.

Empirical reality in its most intolerable, inescapable form is time. The things that are eccentrically synthesized in Lipski's anti-art poetic objects are strongly associated with time, in part by their very nature as discards, in part by the fact that they function as durations by reason of their character as absurd syntheses. The works of each series are so many petite perceptions on a temporal continuum—this is part of the point of their consecutive numbering and seemingly infinite number—as well as an attempt to articulate a certain kind of time. The open-endedness of Lipski's series suggests the ultimate ungraspability of time—the impossibility of objectifying it even as a kind of time: of saying what is past, present, or future. (This is part of the confusion—really a profound recognition—that art catalyzes, or that it did before it was misconceived as pursuit of the eternal aesthetic, and that Lipski's anti-art attempts to recover.)

The empirical constituent of Lipski's poetic objects integrate in a strangely fluid, inevitable way, despite the seeming impossibility of the integration, by reason of Lipski's ability to operationalize the logic of time as it exists in the unconscious, where one easily moves through all dimensions of it. (This is the "psychoanalytic moment" in Lipski's poetic objects.) Lipski's larger achievement is to connect the individual poetic objects through the same "unconscious" logic; that he thinks in series is almost miraculous given the

fluidity and eccentricity of his sense of object relations. The titles of Lipski's series call direct attention to different kinds of subjective time—*Gathering Dust, Passing Time, Building Steam*. For him, anti-art is a way of articulating a sense of time in a world which finds both the organic (cyclic, seasonal) and mechanical (irreversibly linear) conceptions of it inadequate, and must fall back on an internal time consciousness. Anti-art, with its advocacy, as it were, of internal time consciousness, stands opposed to art, which thinks it can transcend all time, including the time of its own making, by representing the eternal in the form of the aesthetic. Lipski's poetic objects imply acceptance of the ephemeral—yet recurring (acknowledged by his use of the series)—character of every kind of subjective consciousness of time, a transient character directly presented through the innate incoherence of the poetic objects.

T. W. Adorno has written: "If art were to discard the long demystified illusion of duration and incorporate into itself its mortality out of sympathy with the ephemeral, which is life, then it would live up to a concept of truth at the core of which is time rather some enduring abstract essence." If art were to do this it would be anti-art. "From now on," says Adorno, "no art will be conceivable without the moment of anti-art. This means no less than that art has to go beyond its own concept in order to remain faithful to itself. Hence, even the idea of the abolition of art is respectful of art because it takes the truth claim of art seriously." It is as though Adorno were describing what it means to be authentically contemporary. Behind the obsessional purity of novelty is the intimation of mortality—recognition of the rapid deterioration of autonomous works of art into their empirical components. The tension between integration and disintegration—the one with its promise of autonomy, the other with its insistence upon reality—that rules the work of art constitutes its sense of being contemporary.

Such contemporaneity is at the heart of the poetry of Lipski's objects, and is already implicit in the idea of their surreality, or synthesis of ordinarily incommensurate things in a single "situation" to create a new context for consciousness. For that synthesis, as forced as it is, implicitly acknowledges that the poetic object is what Adorno calls "disintegrated art." (The poetic object's grotesque character alone suggests its disintegrated nature, and precludes any misunderstanding of its synthetic character as an attempt to effect a lasting harmony—to create a false consciousness of the poetic object as a perfect integra-

tion of "impossible" materials.) Today art only exists—can only be conceived—as disintegrated art, with the attempt to create integrated art appearing subversive and weird, as Lipski's poetic objects demonstrate.

Lipski's poetic object makes the necessarily "negative" aspect of contemporary art explicit, whereas the traditional surrealist poetic object was still eager to "prove" the "positive" character of art by showing it to have the power of integration. Lipski makes no apologies for the fact—basic to an understanding of his work—that he is "poetically" (in a poetry demonstrating disintegration) putting objects together which could just as well be kept apart, and that his putting of these objects together involves an attempt to name his own subjectivity. Clearly, it can only know itself "perversely"—through perverse acts of integration, which involve relating the ordinarily unrelatable in a dialectic of disintegration. Lipski integrates to demonstrate the impossibility of integration—integrates to demonstrate that every integration generates a disproportion between the variables integrated that disintegrates their relationship. One or the other element will be taken as "unreal" to uphold the dominance of the other—a situation which in and of itself signifies a state of disintegration. As Adorno says, describing "the aesthetic moment in anti-art," "the disproportion between the all-powerful reality and the powerless subject creates a situation where reality becomes unreal because the experience of reality is beyond the grasp of the subject." In Lipski's poetic objects, one of the constituent things takes on a subjective role while the other seems hallucinatorily objective; one cannot keep both in mental balance as completely objective or completely subjective (although their synthesis is necessarily understood as subjective). The generation of this situation of disproportion—as an end in itself (not for its psychic potential in understanding the unconscious)—is crucial to the survival of any sense of art as positive today, while at the same time the heart of its definition as anti-art. This disproportion is the childish moment of anti-art, yet inseparable from an understanding of art as "positively" dialectical. As Adorno says, "art is no longer art when anti-art is completely weeded out because it smacks of childishness."

Lipski's brilliant "toys"—Baudelaire could have had them in mind when he wrote his "A Philosophy of Toys"—exist to be played with by the adult mind eager to find an analogue for the struggle between integration and disintegration that it recognizes as raging in it (a recognition central to adulthood).

Lipski's poetic objects refuse to grow up and be art, yet in refusing they signal the most immanent dialectic of both art and mind, which makes them once again "difficult." Insistent, carnival-like anti-art is the only way to once again make art opaque to itself—to dialectically transcend the social fact that, in Adorno's words, "art has become transparent to itself (and to everyone else) down to its core."

Lipski's most recent works take on a new particularity by reason of their large scale, which threatens to suspend their function as anti-art by fetishizing them into monuments. Yet this new monumentalization only makes the double-bind "insanity" of the pieces more terrifying, more wondrous. The works which most intrigue me are those which take practical things and "de-instrumentalize" them by partially obscuring—"subjectivizing"—their objective identity. In *Building Steam #262,* a saw is meticulously wrapped—Lipski always works with great precision, like a surgeon sewing up an incision after an operation (in Lipski's case, the incision is gratuitous and the "sewing" is the operation)—and in *Building Steam #308,* a pitchfork's prongs are hidden by rubber tubing. In their cloaked aggression, they are like hooded falcons. Effectively put out of commission, the objects become extraordinarily enchanting—alluring beyond aesthetic value. The childish dialectic of covering/uncovering created reminds me of Freud's analysis of his grandson's game of throwing an object away and retrieving it. Freud said his grandson was accustoming himself to separation from his mother by acting it out symbolically. Lipski, too, is enacting a separation anxiety—or rather, generating it, so he can have a sense of self. But the uniqueness of that unconscious self is trapped between the Scylla of the wrapped and the Charybdis of the unwrapped object.

I have a particular fondness for the perverse, malevolent operation Lipski performs on books, giving them a brilliant poignancy—the poignancy of no longer being able to be read, yet of being freshly contemporary by reason of their new voyeuristic potential. To look at a naked book, pornographically trussed, is edifyingly perverse. Lipski intimates the mortality of books, and so of mind, by pouring paraffin between their pages, as in *Building Steam #272,* or by sealing them permanently shut, as in *Building Steam #384.* Their transformation into poetic objects through a process of anti-art brings out all the more the fact that they are sedimentations of information which can just as easily sink out of consciousness as dominate it—or, as in the form of Lipski's poetic objects, float

in it like the deadweight of a drowned body that has risen to the sea's surface. Lipski's poetic objects lure us with the power of their entropy to the black holes in our own consciousness.

This essay is reprinted from the exhibition catalog Donald Lipski, *Germans Van Ekk Gallery, May, 1985.*

Breakfast of Duchampians

I remember a very vacant period . . . when all sorts of commonplace objects, deliber-
ately thwarted in their meaning and application, rejected by memory and as though
copied from themselves, came to birth and died in an endless round of new existences;
when the word that had hither served to describe them no longer seemed adequate;
when the properties usually ascribed to them obviously applied no longer; when a
pessimistic desire for supervision that some may consider absurd demanded that what
was already sufficiently characterized by its appearance should nevertheless be han-
dled, that what required to be presented in its entirety should be examined in the
closest individual detail, that the necessary should no longer be distinguishable from
the accidental.

—André Breton, *Surrealism and Painting*, 1928

The Duchampian mode of artmaking has been exhausted. This realization turns out to be the unexpected point of a wide range of contemporary ready-mades, most of them coming out of the United States. For this reason, I call them post-Duchampian rather than Duchampian ready-mades: they are objects that represent the leveling, even the bankruptcy, of Duchamp's origi-

nal complex intention, rather than a fresh application or extension of it. Whether in the work of Jeff Koons or Haim Steinbach, Ashley Bickerton or Meyer Vaisman, the current simplification of the concept of the ready-made amounts to an undermining of it. Where Duchamp took one-dimensional ordinary objects and made them multidimensional, made them seem overdetermined rather than underdetermined in their meaning, the post-Duchampians strip even the most ordinary meanings from the objects they exhibit, leaving the viewer with a void, a kind of false innocence.

Where Duchamp made ordinary objects insinuating and intimidating, the post-Duchampians make them more straightforward than they actually are. The post-Duchampians give us well-groomed objects, whereas Duchamp's ready-mades were emotionally messy. They have cleaned up Duchamp's "dirty act" of intellectual art, offering us in its place an unintellectual art that brings the banality of the marketplace into the gallery—makes it explicit that the gallery is a marketplace, a clean, well-lit one, no doubt far from the oily bazaars of the past, but still full of snake oil charm. The argument usually made in support of the post-Duchampian ready-made is that it finesses consumerism. In fact, it only confirms that consumerism is the presiding ethos of our culture. The post-Duchampian ready-made asserts not only that art is a more princely commodity than other commodities, but that it cannot be anything but a commodity, can have no meaning other than its exchange value. It is the explicit consumerism of the post-Duchampian object that reduces it to ordinariness, to the prelapsarian state of banality—to the state before Duchamp got an intellectual hold on it.

Duchamp's original ready-mades were ironic inventions, intellectually incisive, emotionally potent, and materially insignificant—indeed, as objects they were dispensable. They were not made with the market in mind. The ready-mades we see in the museums are not "originals," but copies that Duchamp made once he had become sufficiently famous—and the ready-made had become a sufficiently familiar concept—for the museums to want to collect them. Duchamp discarded the original ready-mades once they had made their point. They became commodities after their significance was realized; their significance was not bound up in their status as commodities. Duchamp's recreation of the first ready-mades for museum purposes was another ironic act on his part—a sardonic response to his own fame.

His ready-mades are not arty commodities like the post-Duchampian ready-mades. They can even be regarded as deliberately rejecting the appropriation of the work of art as a precious commodity, its reduction to just another commercial product. They attempt to outsmart, even mock, the money economy: Duchamp's ready-mades are not cunning new products, but old products that have been "revitalized" simply by being regarded as art. If, as Georg Lukács has written, the tendency of capitalism is the "objectification of production," the separation of the product "from the personality of the producers," then Duchamp's ready-mades restore "personality" to mass-produced objects, "resubjectivize" them through the artist's ironic treatment of them. If, as Georg Simmel has said, money produces "a kind of moral depreciation" of objects since it is "applied" to all objects regardless of their character, and if the fully developed money economy results in "a kind of decoloring of existence," then Duchamp's ready-mades restore color to the products that money can buy—implicitly to all of them, for he uses the most humble and inexpensive ones—and morally re-appreciates them. In contrast, the post-Duchampian ready-mades become simply the art products of our hyper-developed money economy. It is through their explicit consumerism that they reacquire the one-dimensional meaning of ordinary (consumable) things—no doubt to the surprise of their makers. They mean nothing more than that they cost a certain amount of money.

The double-entendre object was invented by Duchamp. He simply took a commonplace thing and changed its context. This supposedly renewed the object; it now had two "lines" or dimensions of meaning, the one from its original context and the new line it acquired by being inserted in a new context. The everyday line and the noneveryday—call it the "art" line. It used to be thought that what Duchamp did was elevate, and thus dignify, ordinary objects by relocating them to the inherently dignified art context. Thus, Breton described ready-mades as "manufactured objects promoted to the dignity of works of art through the choice of the artist." But it has come to be realized that works of art have no inherent dignity. The effect of dignity—of being art—can be achieved simply by changing the context of the object, by displacement. The true revolution of the ready-made was that it made us aware that art exists wherever there is a discrepancy between an object and its context, or between an object and other objects. Art stirs in us the disquietude we associate with awareness of the uncanny.

The complicated history of the Duchampian object in the end involves little more than a refinement of the sense of the arbitrary: giving direction to the seemingly directionless decontextualization of the object by evoking and exploiting latent dimensions of meaning. In art, there must always be the sense that the ordinary object that has become the art object may regress to its ordinariness at any moment. But it does not, by reason of the strong act of will that made it art. Art can be thought of as a temporary, if prolonged, sickness. We may be cured of it as spontaneously as it came into being: our minds may clear, our senses come clean, and the repressed everyday character of the ready-made may again become manifest. But the sense of art as a constant potentiality of things continues to haunt our consciousness.

Picasso's *Head of a Bull* (1943) epitomizes the treacherous situation in which art finds itself. Coming across a bicycle seat and handlebars in a garbage dump, Picasso fantasized them into a bull's head. It is often forgotten that he hoped that someday someone would look at his sculpture and recognize that it was really just a bicycle seat and handlebars; this person would then dismantle the sculpture and put its components to practical use again. Picasso wanted this to happen, not simply because of his awareness of the ironic uselessness of ready-made art, but because to restore the constituents of his sculpture to their normal context would be to restore them to "health." Indeed, to greater health than before: art becomes simply an incident in life, an episode that makes life more immediate and vivid. Thus, the bicycle seat and handlebars, made freshly significant through their adventure as art, could now be more fully appreciated in their everydayness. Their destiny was not to be "art," but to be enjoyably quotidian. The ready-made suggests that the transcendence of everyday life that art affords is a temporary measure, intended to help us endure everyday life by providing alternative perspectives on it.

Earlier in this century the double-entendre object was used sometimes aggressively, as in dada; sometimes poetically, as in surrealism; and sometimes with ironic neutrality, as in pop art. Once the "nonartistic object" was the basis of art-making, the artist discovered that it could be used in a variety of stylish ways. In all cases, the artist had to keep its original context in mind: to be aware that the nonartistic object could always regress from its provocative status as art to its uninteresting everyday usage, to a settled state of meaning. The single dimension of everyday meaning the object always had in reserve acted as its

bottom line, off which the artist had to keep bouncing. To appropriate the design of a chocolate grinder for *The Bride Stripped Bare by Her Bachelors, Even* (1915–23), as Duchamp did, is to give it the primary ironic meaning of being serviceable as art. In losing one kind of identity to acquire another, thus implying that identity is not fixed forever, it acquires an aura of irrevocable freshness. The chocolate grinder's sexual significance—the fact that it functions artistically for Duchamp as a sexual machine—is a secondary ironic meaning. The same is true of the images in Max Ernst's collages and the objects in René Magritte's pictures.

The original Duchampian ready-made was conceived for radical psychosocial reasons. The innovative appropriation of everyday objects for artistic use—their conceptual complication in defiance of their perceptual simplicity— became a conscious demonstration of Freud's "psychopathology of everyday life." It represents both the expression and the frustration of artists' transformative impulses. It is easier, after all, to transform the ordinary object into the artistic object than to transform the world; as Breton said, "the increasingly urgent transformation of the world is different from the transformation that can take place on canvases." The transformation of actual objects into art objects is closer to—and symbolically effects—a revolutionary transformation of the world than the transformation that occurs in paintings. But it still falls short— far short—of being an actual revolution. This pathos must inform our sense of it if we are to appreciate its full flavor.

The ready-made also implies a particular mental process in the designation of certain objects as art. It is a means of understanding the original existential choice that the artist's signature represents—of grasping the self that produced the choice, perhaps the self that was produced by it. In any case, the issue of the artist's selfhood is inseparable from the ready-made. The artist who makes the ready-made declares that it is enough to will in order to produce art, to be creative. The strong will-to-art produces a "good enough" art, that is, an object is made valuable enough to convince nonartists that it is art. The ready-made may look like the emperor's new clothes, but in fact it represents a sovereign power—the power of the artist to compel the public to emotionally and intellectually invest in an ordinary object because it is art. The ready-made both conveys the artist's determination to be creative, and transmits to nonartists some of that determination.

In the end, the ready-made is a mediumistic device, as Duchamp recognized. It functions, in Nietzsche's words, as a "medium of overwhelming forces," of the pressure to create. It is the presence of this pressure that identifies certain individuals as artists.

Without the aura of uncanniness suggesting a complex of repressed meanings that seem perpetually about to surface but shy away from articulation, an object becomes trivially everyday; it lacks what Marcel Jean calls the expectant air of the arbitrary, that sense of harassed silence that constitutes its depth. Unless the object seems to speak in tongues that do not ordinarily pertain to it, to exhaust itself in the use of unknown languages, it seems inconsequential. Presumably the point of transforming the ordinary object into art is to undermine its immediate external being, so that it can declare the secret pathos of the artist—that pathos which shows the artist that he or she has no real freedom, but is instead the victim of chance, of the lyricism of indeterminate connection. As Breton said, the ready-mades were "always utterly unforeseen productions," their random conception reflecting the "absolute dialectical unrest" that is consciousness itself.

The ready-made, then, involves not only the pathos of unsuccessful social transformation, but of successful personal transformation: the transformation of a person into an artist—yet another alchemical transformation of the ordinary into the extraordinary, of lead into gold. This is the ultimate transformation the creative will effects. The ready-made is a way of mourning for a total social revolution that will never occur, of painfully foregoing a utopian dream of world transformation for transformation of the mundane details of everyday life, while professing personal revolution as its poor substitute. The impossible social revolution is replaced by the possible personal revolution—a revolution actually within one's power to carry out, in contrast to a revolution that by definition is beyond the power of any one person to effect. However difficult personal transformation through art may be, it is easier than world transformation through means that are not entirely creative. Indeed, the ready-made, with its implication of regression from conscious to unconscious choice in art-making—implying that art is no longer an expression of civilization, but uncivil and uncivilizing—is not simply a personal alternative to the task of a revolutionary remaking of the world, but the abandonment of that idea, an

implicit recognition of art's limited power in the world. At the same time, this power is asserted unconditionally as an end in itself: once it is recognized that the world cannot be completely transformed for the better, what remains is the will to be creative. It is a position of retreat, seemingly invincible, in a darkening world.

In the last few years a new generation of ready-mades has been born, including, among others, John Armleder's furniture sculpture, Ashley Bickerton's logo objects, R. M. Fischer's lamps, Robert Gober's sinks, Jeff Koons's statues, Haim Steinbach's suites of objects, and Meyer Vaisman's pseudopublic utility objects. As I have said, these objects are fundamentally different in kind from their apparent ancestors. They lack the spirit of the authentic ready-made, for they have only one line of meaning. That is, for all their apparent transformation into art, they remain militantly unambiguous. They cannot be said to represent a relapse into the commonplace from the Duchampian object; rather, they never transcend it, for all their gallery posture of detachment.

The post-Duchampian object does not successfully stand outside of both traditional sculptural space and everyday three-dimensional space, as the original ready-mades did. Unlike the Duchampian object, this new sculpture does not propose an alternative third space, a philosophical space which is not that of self-conscious art, the space of formal innovation that presents objects that cannot be touched, nor that of the everyday world, whose space contains objects that can be handled un–self-consciously. The new objects are formally clever—their bright newness is the glaring sign of their cleverness—and conspicuously ordinary. Some critics think this is an indication of their sociopolitical character: they are time-bombs waiting to explode both the art space and world space they simultaneously inhabit, in an ultimate act of vengeful nihilism.

Supposedly they are anticommodities with a commodity look, but essentially they are art commodities, or ordinary commodities that are made to look artistic, and thus able to enjoy the best of both the critical and capitalist worlds. They can be successfully ironic, yet also successfully commercial. They are thus simultaneously oppositional and acceptable. Indeed, they may be the most successfully administered art objects in our highly administered society. But the point is that they conscientiously pursue success, of whatever kind.

They want acceptance. But they don't really want to pay the price; they don't want to sacrifice criticality for commercialism, or vice versa. Indeed, they want to make commercialism critical, and criticality commercial—a witty ambition that is by now commonplace. (A recent study argues that idealistic criticality was first successfully commercialized by Herwarth Walden and his Sturm enterprise.)

The Duchampian object generated critical irony by way of its mediumistic function. The assertion of the will to create was necessarily ironic in a world whose objects were emotionally and intellectually bankrupt, since that world could not be changed for the better. These objects were kept alive by the investment in them of the artist's will to create, which changed their context. The post-Duchampian object artists, in accepting without question the existence of the capitalist commodity and the whole process of commodification, indicate that they have never thought of the possibility of world revolution, that they do not feel the pathos that comes of giving up that possibility of world revolution, that they are insensitive to the plight of the psyche in a capitalist world. The post-Duchampian artists produce objects that have no latent import, are without pathos, and are motivated solely by the capitalist will to commodify. They indeed celebrate the "creative" commodity—creativity as a process of commodification.

These artists' objects never transcend the single dimension of capitalist meaning—the status quo that asserts that everything has its price, an exchange value that supersedes its intrinsic value or rather is, capitalistically speaking, its intrinsic value. In this one-dimensionality lies their lack of a critical function. It may be that the moment of mourning for world revolution has come and gone. It is possible that the psyche has been so turned inside out that nothing about it is hidden, suggesting that we no longer need a mediumistic object, that there are no longer any significant possibilities or desires for world and self transformation. It may be that the pathos of society and self to which Duchamp was implicitly responding no longer seems so urgent. And yet that pathos is clearly evident in everyday life. The post-Duchampian object-makers do not really look closely at everyday life, only at its commodity aspect. They will not be critically and creatively significant until they acknowledge and find ingenious new ways to articulate this insidious pathos. No doubt Duchamp's old irony no longer works; but theirs is hardly worth the name, for their objects in no way

contradict the capitalist line of meaning that is their point of departure. Only if they come to experience the pathos of everyday capitalist life—the pathos of the commodity, of the capitalist object—do the post-Duchampian artists have the chance to be authentically critical and authentically creative.

This essay is reprinted with kind permission from Contemporanea, *May 1989.*

Ana Mendieta, Autonomous Body

Darkness of Night, our mother, are you here to watch?

—Aeschylus, *Eumenides*

T he body—her body—was there from the beginning of Ana Mendieta's art: its theme, its obsession, its burden. Already in 1972, at the age of twenty-four, in three performances, Mendieta worked with the body, woman's body, as an autonomous object, liberated from male desire, yet still tainted by it, still a victim. How to disinter it from the desire that buried it alive: that is one way of looking at what Mendieta attempted in her art.

The performances are interlocking: in *Venus Generosa*[1] and *Feathers on a Woman*, Mendieta applies chicken feathers to the body of a young woman. The white feathers quickly cover her flesh, leaving only her hands and feet exposed. She has lost her humanity and identity. The *Bird Transformation*, as the core performance is called, has reduced her to an animal. What this means becomes clear in *Death of a Chicken*, in which the naked Mendieta—and of course there is, proverbially, truth in nakedness—ritually slaughters a very white—virginal— chicken. Clearly she identifies with the chicken: the murder is displaced suicide

Ana Mendieta, *Untitled* (from the *Silueta* series), 1978. Gelatin sliver print, 19¹⁵/₁₆" × 15¹³/₁₆".
Collection of the San Francisco Museum of Modern Art, Accessions Committee Fund.

and, simultaneously, a metaphor for sexual initiation. The white chicken is
stained with its own red blood. It becomes the white sheet hung out to prove to
the curious community that the bride was, indeed, a maiden—as "clean" as the
sheet—when she married. The community has a vested interest in virginity, and

in marriage. Both must be ensured: virginity can only be sacrificed to marriage, which is itself a sacrifice to the community and species—a social and biological ritual and necessity.

The question is, who is the woman at the center of this public ritual? What is she thinking and feeling as she participates in it? She may satisfy social expectations, but what are her private expectations? Outwardly she is obedient. Is she, on the inside, a rebel?

Mendieta's performances seem dispassionate—altogether matter-of-fact, unmysterious. It is as though she is a somnambulist going through a sacred ritual. But their meaning is ambiguous: something is lost, something presumably is gained—an emotionally rich, maturing experience, that is, a true expansion and discovery of womanhood. In being sexually penetrated by man, woman supposedly realizes her true being, the difference of her body, its special power and allure; but, at the same time, she feels—and is—victimized, reduced only to a body, appreciated only as a body. She becomes aware of the identity nature has given her, while being denied her individuality—her personhood. The sexual experience is, after all, a mysterious transformation, for better and worse. As short-lived as it is, it thoroughly changes woman's sense of herself and her relationship to society.

But there is something peculiar about Mendieta's performances: taken together, *Bird Transformation* and *Death of a Chicken* show her as both man and woman. She is the active, male partner in both performances: she anoints the woman's passive, naked body with the bright white feathers—a mock marriage gown—and she kills the helpless female chicken. At the same time, she is the innocent chicken: the young girl sacrificed on the altar of sexuality—the young girl remembering and reenacting and perhaps emotionally reexperiencing her first, traumatic sexual experience. What may look like Mendieta's grandiosity and bravado is in fact an attempt to grasp the totality of a primal, inescapable life experience—to comprehend it in all its contradictoriness and complexity. Mendieta wants to experience it from both sides, as suggested by the fact that, in *Bird Transformation,* she is dressed, her femaleness hidden, while in *Death of a Chicken* she is naked, her woman's body self-evident. This is not simply an ironic display of bisexuality, psychic and perhaps physical; it is an attempt to see woman's body from opposite sides of the sexual equation: from that of the man who "uses and abuses" woman's body, and from the side of the woman who

owns the body and suffers, willingly and unwillingly—ambivalently—its appropriation, which is experienced as a brutal rape, as Mendieta's *Rape Performance* (1973), suggests. Mendieta wants full consciousness of what is usually unconscious and silently endured, and the only way to have it is to be both man and woman—to experience the terror of sexuality as each does. Thus, Mendieta wants to keep the fate of her body in her own hands. She is in search of self-recognition through body recognition. If, as Freud said, the first ego is the body ego, then the ego is first known through the body.

It is the unflinching sobriety and deliberateness of Mendieta's search—which is what her metaphorical performances are about—that must be emphasized. They are a kind of Yoga exercise in self-control and self-determination. They are an attempt to achieve psychological autonomy in defiance of existential dependence on the physical body in the very act of acknowledging that dependence and physicality. Mendieta wants to separate from her female body—she represents that separation by destroying the symbolic chicken—while respecting its right to be, simply and confidently. Mendieta's performances are not ordinary exhibitionism, so pervasive in our society of spectacle, but paradoxical, mystical exhibitionism: exhibitionism whose ambition is to transcend the body exhibited in the very act of displaying it as the inescapable fundament of human being. Mendieta's performances are full of extraordinary will-power as well as submission to fate, in the guise of the body.

Death, as a demonstration of the vulnerability of the body, and, at the same time, an occasion for psychic resurrection—an opportunity to achieve freedom from the body and the world, and thus triumph over death, if only in fantasy—are her constant concerns. Mendieta is a body artist, and she performs the body as both death and living memory, a surviving silhouette—a transfigured body—to allude to the title of her famous *Silhouette Series* (1973–80): she performs her ambivalent experience of the generic body as well as woman's experience of her particular body. Body is simultaneously substance and elusive shadow for her. One possesses it, but it possesses one, victimizing one's emotions. Is one's ego ever more than its inner shadow? This is another question Mendieta asks.

Mendieta's art, I am suggesting, is profoundly religious—eschatological. This is not simply a matter of her fascination with Santeria, a primitive religion involving animal sacrifice, but because she experiences the body as a sacred

space: a kind of cathedral in which consciousness can soar. Again and again we see her turning the physical body into a numinous presence, that is, an awesome absence—a haunting, enduring silhouette. Her art is informed by a strong sense of the necessity of the sacred, as a state of mind that can withstand the pressures of the secular world. Mendieta wants to reconsecrate the body, that is, restore the sense of it as a miracle, and with that restore the value it lost by its reduction to a kind of machine—its modernization, as it were. The body becomes increasingly less differentiated—grandly simplified and emblematic—in her art, and finally becomes a vital aura, a ghostly abstraction of organic life. Mendieta's mystical body stands in opposition to the body as it is conceived by science. Hers is the body as it is experienced from the inside, rather than the body as it is understood from the outside. Her art is an attempt to demonstrate that woman's body is holy, not profane, as science and man have conceived it to be.

Organic life is in fact everywhere in her work, implicit or explicit. It is self-evident, above all, in many of the Silhouette works. In the very first one, made in 1973 in El Yaagul, Oaxaca, Mexico, she completely covers her inert, seemingly dead body—it is laid out like a corpse, arms rigidly at her sides (she presents herself in the same "distanced" way she performs in *Death of a Chicken*)—with an immense green "bouquet," alive with crisp white buds. Her head, breast, and loins are hidden, as though overgrown by the plant—the soil out of which it grows, and which dissolves it. It is a startling image: the tree of life grows from Mendieta's seemingly dead body, feeding on her mortified flesh, a conception derived from medieval representations of the mystery of Christ's death and resurrection. Life is eternally renewed, miraculously reborn from death. Something similar occurs in a 1976 *Silhouette,* in which Mendieta lays a wreath of red flowers, in full bloom, on an ancient Zapotec tomb in Oaxaca. Life comes from death, and death comes from life, in an eternal cycle of nature, of which the human body is a part. The female body, which has the power to give birth to life, "understands" this cycle better than the male body. The female body participates in it directly, while the male body seems shut out of it— doomed to die and not be reborn. In sexually penetrating the female body, the male body struggles to grasp and uproot and appropriate this creative power, which it can never do. The female body always belongs to the landscape of life, however much it may be violated and destroyed, as *Mutilated Body in Landscape* (1973), another early performance, makes clear.

But there is more to Mendieta's sacred experience of life-in-death—a kind of antidote to the modern secular experience of death-in-life, or of sickness unto death, as Søren Kierkegaard called depression, that most antilife emotion—than meets the eye. Again and again she embeds herself in the earth, or leaves traces of herself—often a full outline of herself—in it. Sometimes this takes the form of a cavity, sometimes of a mound. *Incantation a Olokun-Yemayà* (1977), another Oaxaca piece, is a startling example of a cavity piece. A work from the *Fetish Series*, from the same year, executed at Old Man's Creek in Iowa City, Iowa—she studied art at the University of Iowa—rather than Oaxaca, is an important example of a mound piece. At the same site, she imprints herself on the shore of the creek, and in 1981, at a site in Cuba, she carves the outline of her body in a rock wall, and fills the outline with mud. At Amana, Iowa, in 1980, she used gunpowder to ignite her outline, leaving the charred residue— the ashes of her body, as it were—in a shallow cavity, protected by raised earth. At Old Man's Creek, in 1978, she made a more impressive, consummate fire, as part of the *Silhouette Series*. Presumably she is the phoenix that will miraculously rise from the flames.

Whether lowered into the earth or buried on its surface, she always dissolves into it—becomes one with earth. Whether conceived as a place of death (dust to dust) or of life (the rebirth symbolized by the seasonal renewal of flowers), she completely identifies with the earth. She gives herself to it—loses herself in it—with a remarkable lack of hesitation, all the more unusual because it suggests that she experiences no barrier, personal or cultural—no inner or social restraint—between herself and the earth. She not only repeats, with almost morbid compulsivity, nature's rhythm of death and rebirth, but ecstatically abandons herself to it. Is she a Dionysian maenad or a virginal Diana, or a strange mix of both? She is extraordinarily at home in the earth, completely uninhibited in her love for it, as is suggested by a performance from the *Serie arbol de la vida*, (1976) in which stands, her arms raised as though crucified and her naked body completely covered with mud, in front of a giant tree, split at its base into two thick trunks, inverted diagonals forming an attenuated, upside-down Gothic arch. If there is such a creature as a Christian wood nymph, she is it—a daring mystical fusion of pagan body and Christian soul. The performance site is an amorphous matrix of vegetation, dynamically green and brown— earth-colored—into which Mendieta completely blends, even as her body nom-

inally stands out from it. Again and again we see her inscribing her body in the earth—establishing some magical, peculiarly innocent relationship with it. She absorbs herself in it, and it absorbs her, presumably to the emotional benefit of both.

All this suggests something profoundly elemental about Mendieta's relationship with the earth, traditionally one of the four basic elements or material fundamentals of organic being. Fire, as we have seen, also appears in her performances, most conspicuously in the *Nanigo Burial Series* (1976), in which she arranges sacred candles in the shape of her body. Most of her performances take place outdoors, that is, in fresh air and bright light, and, as at Old Man's Creek, near water—*Nile-Born* (1984), explicitly alludes to water—suggesting her wish to associate herself with all the elements. Blood—another elemental, organic material—also appears in Mendieta performances, most conspicuously and abstractly in the indexical markings of *Body Tracks* and *Corporales,* both 1982, where—as in the early *Death of a Chicken*—it is a symbol of woman's suffering, the basic or elemental sacrifices life and nature demand from her, indeed, regularly impose on her body. But earth is the most fundamental element for her, as *The Labyrinth of Life Series* (1982), the delicate drawings on leaf and bark (1982–84)—materials "derived" from the earth—and the *Mud Figure Series* (1983–84) and *Earth Archetypes* (1984), make abundantly clear.

This earth is the enduring Mother Earth or Mother Nature, at once mythical and concrete, an archetype or imago and the material source of all being. Mendieta identifies with Mother Earth—merges with her in a passionate, mystical embrace, a so-called oceanic experience—partly for "regressive" reasons and partly for "creative" reasons. The merger is meant to solve two deep problems, one personal, the other social: Mendieta's feeling of abandonment, experienced when, in 1961, as a child of twelve, she was sent to the United States, separating her from her mother and especially her beloved, powerful grandmother; and her adult wish to be an autonomous woman, more precisely, a woman who could live without men, who did not define herself through her relationship with them—a woman who would be sacred to herself, rather than be profaned by their desire for her. One can regard Mendieta's performances as purification rituals: bathing herself in the purity of the elements—once again innocently naked in nature—she becomes, emotionally, a sacred virgin, that is, liberated from sex, untouchable by man. The former problem is archaically nar-

cissistic; the latter problem, while equally narcissistic, involved not only a rebel-
lious assertion of independence in a male-dominated society that had predeter-
mined the character of woman's existence, but the achievement of a mature
identity. Both ambitions are capsulated in the idea of the goddess; Mendieta's
art is clearly related to that school of feminist thinking.

Mendieta clearly had a troubled sense of self, as her very self-centered
art—in which there are not only no men, but no other women—suggests. Her
trouble had to do with her relationship with her mother and various mother
surrogates: she found it hard to separate from her matriarchal family, even
though she was forced to do so, and kept her relationship to it alive through her
relationship with the earth—and at the same time used her profound attach-
ment to the earth as a way of declaring her separateness and independence from
man, thus gaining the power to identify herself rather that be identified by him,
especially by sexual intercourse with him. One might say—no doubt extrava-
gantly—that Mendieta preferred to have narcissistic intercourse with Mother
Earth than sexual intercourse with man. Indeed, after leaving Iowa City and
moving to New York, all signs of it disappear from her work: there are no more
references to rape, nor to the male conception of woman as a sexual object.
Indeed, sex is no longer an issue in her art: autonomous womanhood is.
Mendieta's more or less rigid, isolated appearance—her stiff, fixed pose—in her
work represents this autonomy, but also registers the effect of separation: she
goes stiff in the absence of the mother's embrace. But then again she symboli-
cally recovers it, as I have suggested—repairs and freshly consummates, through
her art, her relationship with her mother. Thus, Mendieta becomes her own
exclusive object by way of her relationship with the earth, symbolic of her
mother(s). She makes the emotional best of her forced separation from her
mother: a true creative achievement, contradicting the conventional psychoana-
lytic wisdom that the young woman needs her father to help her separate from
her mother and achieve her own identity.[2] But then again Mendieta's rigidity
and uprightness has a certain phallic as well as mortified quality, suggesting a
certain identification with her father, who in fact came from a long line of
prominent Cuban political figures and was sufficiently firm in his convictions to
resist Castro, paying a high price—imprisonment from 1965 through 1979,
when he was allowed to leave Cuba—for doing so.[3] In other words, Mendieta
became her own mother and father—her tree of life is a representation of the

primal scene, that is, the father's phallus implanted in Mother Earth—because of the circumstances of her separation from both. Mendieta, in her own statements, has emphasized the mother rather than the father, but the latter is implicit in her relationship to the earth, if seemingly not as important—and yet subliminally very important.

Mendieta herself has said:

> I have been carrying on a dialogue between the landscape and the female body (based on my own silhouette). I believe this has been a direct result of my having been torn from my homeland (Cuba) during my adolescence. I am overwhelmed by the feeling of having been cast from the womb (nature). My art is the way I re-establish the bonds that unite me to the universe. It is a return to the maternal source. Through my earth/body sculptures I become one with the earth . . . I become an extension of nature and nature becomes an extension of my body. This obsessive act of reasserting my ties with the earth is really the reactivation of primeval beliefs . . . [in] an omnipresent female force, the afterimage of being encompassed within the womb, is a manifestation of my thirst for being.[4]

Mendieta seems to have no ambivalence about her mother, but I want to suggest that in emotional fact she was highly ambivalent about her mother—profoundly angry unconsciously, however consciously loving—because of the separation. This, I think, drove her to her father, however unwittingly. I suggest—qualifying my earlier formulation—that while Mendieta consciously regarded the earth as a mother, she unconsciously regarded it as a father. More particularly, she had a hadean as well as heavenly relationship with it: her performances show her reconciling with—returning to—her mother after a season in hell with her father. I contend that the fundamental myth of Mendieta's art is that of Demeter and Persephone, not simply Demeter alone: of the daughter who is raped by the father, symbolized by Pluto, and thus "belongs" to him half the time, and returns to her mother the other half. There is a positive as well as negative Oedipal complex at the root of Mendieta's art. She deliberately buries herself in the earth, sinking into its infernal depths, entering the hell of her unconscious desire for her father, as her use of fire suggests. But then she reappears on the earth, in the form of the flowers of Spring, thus reaffirming her

connection with her mother. The story of Demeter and Persephone is the story of deathlike Winter and Spring rebirth, but is also the story of union with the father as well as reidentification with the mother. Thus, the cavity Mendieta digs in the earth—the grave in which she places her body—is not only the cavity of the mother's womb, but the entrance to the underworld, the world of desire for the father.

It is the prison in which her invisible but potent father is hidden, a father with whom she also relates by her symbolic descent into the earth—into Hades. Earth is a dialectical—doubly sacred—substance for Mendieta, for earth is the realm of both the desired mother and desired father. The strength of Mendieta's desire for reunion with both is the major motivating force of her art.

Mendieta's performance and body art is not only profoundly feminist, but encompasses and evokes the deepest psychological issues of life. She was able to plumb the depths and bring back the sacred fruit of her own being, purified and resonant with integrity. She is important for her authenticity and outspokenness, her passion and consistency. Fearless and driven, she managed to rise above the storm of her own desire: her earthen images of herself have an Apollonian as well as Dionysian dimension. Her art has a timeless as well as contemporary validity. She was not only a "stonewoman," to allude to the title of her *Stonewoman Series* (1983), but an autonomous modern woman: a woman able to rise above the social constraints imposed on woman's self-expression and self-determination. For all the tribulations of her body ego, it remains remarkably self-contained and intact in her art: she is always self-contained—concentrated in herself—and self-certain, which is why she will remain a role model—a kind of ideal self—for both men and women.

This essay was originally published in the catalog Ana Mendieta, *Barcelona: Fundacio Antoni Tapies and Los Angeles: Museum of Contemporary Art, 1997.*

Notes

1. "Venus Generosa" is in fact a term taken from a text used by Hans Breder in his performance piece entitled "How Faustus Had a Sight of Paradise," produced at the University of Iowa in 1974. Mendieta was Breder's student at the time, and performed the "Feather Woman" vignette in the piece.

2. Janine Chasseguet-Smirgel, "Feminine Guilt and the Oedipus Complex," *Female Sexuality: New Psychoanalytic Views,* ed. Frederick Wyatt (Ann Arbor: University of Michigan Press, 1970), 117, argues that the young woman's "penis envy is caused by the desire to liberate [herself] from the mother." The "basically feminine wish to incorporate the paternal penis" (102) is a means of doing so. That is, by identifying with the paternal penis the woman disidentifies with—separates herself from—the mother. Mendieta maintains this identification with the mother to separate—liberate—herself from men in general, as well as to gain narcissistic strength in a situation of actual and premature separation from the mother. Also, her identification with the mother means that she, too, is omnipotent and dominant—takes her place among the matriarchs of her family. But, paradoxically, this identification with the mother and disaffiliation with men throws her into the hands of the one man who truly counts, her father. The tree she identifies with in the performance in which she stands against it, covered with mud, is the symbol of the father's penis, as much as the mud is the symbol of the mother's missing embrace.

 Chasseguet-Smirgel writes (116):

Realization that possession of the penis presents the possibility of healing the narcissistic wound imposed by the omnipotent mother helps to explain some of the unconscious significance of the penis, whether it is that of a treasure of strength, integrity, magic power, or autonomy. In the idea connected with this organ we find condensed all the primitive ideas of power. This power becomes then the prerogative of the man, who by attracting the mother destroyed her power.

As her reiterated, insistent use of earth indicates, Mendieta has a profound need for and attraction to the pre-Oedipal mother, and restores her power. Mendieta does this in part to overcome their real separation, but also to deal with her own sexual conflicts, and conflicts about men, by returning to a "prelapsarian," that is, paradisiac virginal state, in which she has no adult sexual needs and no awareness of man.

But then the father's powerful penis unexpectedly appears in her unconscious, for Mendieta has a lingering resentment, even hatred, of her mother—no doubt irrational—because of the separation, for which she blames her mother. It inflicted a narcissistic wound, which, ultimately, only the father can heal, however much Mendieta tries to heal it by returning to Mother Earth. Mendieta's state of forced separateness echoes that of her father, who is also radically separate from her. Thus, she identifies with his penis to separate, by her own initiative, and in a display of autonomy, from her mother, who abused her power by distancing herself from Mendieta—by exiling and ostracizing her, as it were. That is, Mendieta identifies with her father's penis—her relationship with the earth is also a symbolic sexual relationship with him, a symbolic receiving of his mysterious penis—to achieve the narcissistic strength to accept her separateness from her mother—and, finally, him.

3. Mendieta was born into a politically powerful, relatively wealthy Havana family in 1948. It was completely matriarchal, and dominated by her maternal grandmother, who was the daughter of General Carlos Maria de Rojas, a leader in Cuba's War of Independence (1895–98). Her granduncle, Carlos Mendieta, was the president of Cuba in the 1930s. Her father, Ignacio, was blacklisted for participating in counterrevolutionary—anti-Castro, anti-Communist—activities, and could not find employment. Already before he was imprisoned in 1965, Mendieta's parents, correctly fearing the worst, sent her, age twelve, and her older sister Raquel, age fifteen, to the United States in 1961. They were part of Operation Peter Pan, a Catholic program to encourage emigration of children from Cuba, while preserving their Catholic heritage and faith. Her separation from her parents, which was supposed to have been only for a year, lasted five years, when only her mother joined her. Mendieta and her sister spent several months in a camp in Miami, from which they went to live in an orphanage in Dubuque, Iowa. Mendieta seemed to have been mistreated by the nuns, and was eventually shuttled from foster home to foster home, at one time becoming so depressed that her foster family sought psychiatric help for her. Mendieta had, in fact, come to regard herself as an orphan—motherless and fatherless.

 Her performances act out both her sense of helplessness and hopelessness in this lonely situation, as well as the traumatic mistreatment of her body—apparently beatings—she suffered at the hands of the nuns. I am grateful to Danielle Knafo, "In Her Own Image: Self-Representation in the Art of Frieda Kahlo and Ana Mendieta," *Art Criticism 10* (Spring 1996):8, for this information, as well as that in note 2.

4. K. Horsfeld, B. Miller, and N. Garcia-Ferraz, Ana Mendieta: *Fuego de Tierra* (New York: Printed Matter, 1988). Mendieta's mother was a Professor of Chemistry and Physics who worked full-time, and left much of the daily care of her daughters to nannies. There were many, especially one Chinese-African nanny, to whom Mendieta became attached, and who left for the United States when she was eight. She was also strongly attached to her grandmother, with whom she spent every holiday and summer. When Mendieta had to return home, she apparently had intense crying fits. Mother Earth has more to do with her preference for her "primitive" nanny and warm and powerful grandmother—both conventionally "earthy" women—than with her own intellectually sophisticated, unconventional, and liberated mother. Mendieta's occultism seemed to involve a rebellion against and rejection of her emotionally disappointing "scientific" mother. Ironically, this suggests that Mendieta was not as liberated or enlightened—feminist—as she may have thought she was.

Antonin Artaud: Works on Paper

"Words rot at the unconscious summons of the brain," Antonin Artaud wrote in "The Umbilicus of Limbo" (1925), and the question his drawings raise is whether images also rot. Or are they a summons from the unconscious, however much they may lose something of their mystery once they arise from it? Artaud's works on paper seem to begin in mystery and end in platitude: begin with the so-called *Spells* (1937–39)—letters to real and imaginary friends (from Jacqueline Breton to Hitler) whom Artaud tries to bewitch with cryptic emblems as well as words—move through barely coherent images that resemble "the bouillabaisse of forms in the tower of Babel," to use the inscription on one of them (1944–46), and terminate with a series of portraits that become increasingly commonplace, suggesting a blunted sensibility, for all the expressive uniqueness of some of them, particularly the self-portraits (1946–48). There is something pathetic about the progress, which is in fact a series of regressions, from rage to mania to feeblemindedness.

Rot is evident in Artaud's technique: it is as though his abusive treatment of the paper on which his letters are written—it is ripped, punctured, burned, the ink and gouache splotched and smeared—is meant to hasten the process of their decay. The paper becomes virtually cancerous, paradoxically undermining the text. Artaud's magical thinking—his omnipotence of thought,

as Freud called it—is self-defeating: he in effect enacts on himself what he means to do to others. Meaning to be sadistic—he is famous for his conception of the theater of cruelty—he shows himself to be masochistic. The bouillabaisse pictures—ranging from eccentric composites of body parts, often indiscriminately male and female, suggesting a certain "sexual awkwardness," to use the phrase on one of them, that is, a disturbed sense of gender identity and body ego, to unexpectedly solemn and simpleminded renderings of states or "rages of ill-being," to use Artaud's term—are equally disintegrative, the products of a wrecked life. (Artaud was a heroin addict; the "Spell for Roger Blin" attacks "all those who banded together to prevent me from taking heroin." It is as though Artaud wants to take revenge on them for stopping him from becoming the hero the drug made him feel like—the promise of heroism its name held out. The mental illness that led to Artaud's hospitalization was probably a form of drug-induced dementia. The world never "suicided" Artaud, he suicided himself, just as Van Gogh—one of the many disturbed artists with whom he identified, as though to justify himself—did. Artaud blamed society for what he did to himself, which is the easy way out.)

The portraits show the final phase of Artaud's disintegration: the human face becomes "an empty force, a field of death," to refer to a poem he wrote in 1947. Especially his own, which in the *Self-Portrait* of May 11, 1946, and *The Blue Head* of ca. May 1946, is a shrill ruin. Other faces are less virulent, if at times distorted and self-estranged—but this hardly gives them the emotional power and edginess of the Austrian and German Expressionistic portraits they invite comparison with. Artaud's portraits of his acquaintances suggest his inability to relate to them successfully—to establish a convincing intimacy, and convincingly comprehend them. The Other stands alone, unapproachable, and no longer annihilated as in the Spells—intact, however twisted. There is something futile about the portraits; the faces, however flawed, become increasingly plain, even banal: Artaud no longer attempts to violate the other—no doubt projecting his own feeling of being violated by society—indicating that he has lost faith in himself, and in the power of art. He no longer believes it can cast a spell—give him power (however imaginary) over anyone—suggesting that he is at the end of his tether. The portraits are less theatrical than the Spells and bouillabaisse pictures because cruelty no longer works: it is no longer as magical as it once seemed to be. Perhaps Artaud's portraits are a kind of Pyrrhic—aes-

thetic—victory over others, but they remain emotionally unconquered, unhurt, aloof, and threatening. Clearly Artaud has projected his own fear of annihilation into them—his own sense of being a helpless victim, and of impending doom—even as he tries to defend himself from the fate he has created for himself by identifying with them: he hides his face under theirs, as though in an ostrich hole. Behind his grandiosity, was a feeling of nothingness, which others could not cure. (One cannot help thinking of Breton's observation of Artaud "slapped by Pierre Unik in a hotel hallway, calling to his mother for help!")

Artaud's works on paper are pseudoprofound and pseudoanarchistic—as pseudoprofound and pseudoanarchistic as the unconscious. His role model was the adolescent Roman Emperor and tyrant Heliogabalus, "The Anarchist Crowned," as Artaud called him in a 1934 essay. Ostensibly a sacred monster but really a dangerous fool, Artaud argues that Heliogabalus lived by his unconscious—"his own personal law"—and thus was freer than the rest of us. But the unconscious also has its laws—it is not as anarchistic as it seems—and they are more unforgiving and harsh than those of society. Artaud anarchistically declares "Neither God nor master, I alone," but the unconscious is a demanding, controlling God and oppressive, vicious master. To be enthralled by it is to be in the thrall of a tyrant. It destroys the self, the I: there is none left to control. Heliogabalus was out of control, selflessly shredding and discarding others the way Artaud did in imagination. The unconscious is not profound—it lacks insight into itself—but rather compulsive and blind, and fixed in its ways: conservative, as Freud said, and Heliogabalus, and with him Artaud, was emotionally conservative and redundant. Artaud identifies with Heliogabalus's "rebelliousness," but it was not what it seemed to be: not a complex transvaluation of values but a simplistic reversal of values. It was a nihilistic performance, like Artaud's theatricalized cruelty. Both used art as a cover for inhumanity: Artaud enviously celebrates Heliogabalus's antisocial behavior, and his power, by reason of his royal position, to impose his will on others. In short, both thought they were subversive, when in emotional fact they were infantile: the license Heliogabalus and Artaud advocated is that of the "imperial infant," as Freud called him. Its only result is a reign of terror.

Thus, Heliogabalus's "mythomania," like Artaud's, is an excuse for regressive desublimation, masquerading as orgiastic liberation. Heliogabalus enters Rome with a ten-ton Phallus—it "bears on its inner face a kind of female

sex"—and proceeds to defile the city, sacrilegiously marrying the vestal virgin that is the symbol of its integrity, and selling himself (cheaply) as a prostitute "at the doors of Christian churches or the temples of the Roman gods," thereby humiliating "the Roman monarchy which he has had sodomized in himself." Viciously castrating his enemies and identifying with women (he replaced the men in the Roman Senate with them), he advocated a "pederastic faith" and "religion of the menstruae"—ritualized polymorphous perversity— that outraged Rome's faith in its own masculinity. But the question is Artaud's masculinity, which seemed in question; indeed, his bouillabaisse drawings in particular, with their apparent bisexuality, seem to be an unresolved debate about it. Similarly, the question is Artaud's aggression—his fabled cruelty, a nice literary word that belies the clinical reality of sadism. Heliogabalus acted out what Artaud only wrote about and fantasized, which suggests his impotence: as if in compensation, he wanted to as all-powerful as Heliogabalus—wanted to be a ruthless tyrant. This is the hidden agenda behind his pseudo-Dionysianism, which has more to do with the death instinct than libido and love (of which he was terrified). (As he said of Paolo Uccello, sexuality for him is "as cold as ether.")

Artaud's drawings have been understood as his attempt to exorcise his demons, but he was in fact ridding himself of the vestiges of his mind. As Wilfred Bion argues, psychosis not only "destroys existence, time and space," but the mental apparatus—the destruction of the capacity to think. In "The Umbilicus of Limbo" Artaud declared that "we must get rid of mind," and in his drawings he finally succeeded in doing so. He made them while he was a mental patient, and after he had electroshock, which ostensibly "unlocked" his creativity: but he used it to acknowledge his nothingness—the lack of sense he made to himself, which appears in the disintegrated language, verging on nonsense, that form part of the drawings, as well as in their disintegrated character. In them we watch him running down, until he is finally leveled in entropic emptiness. He drew to confirm that he was completely destroyed—in the inescapable grip of the death instinct, which in fact had been his master since he first formulated his theater of cruelty, his message of hate. It is a projection of his self-hatred: part of madness is to refuse to be responsible for one's thoughts and feelings, and one way of disowning them is to project them onto society, and to blame them on it. It becomes the enemy, rather than one's

unconscious. Since society puts them in one, one must destroy it. That is, put it out of mind, which in the end means one must destroy every trace and hint of mind—every stray thought. In the end, that is all Artaud's drawings are, at most.

And yet there is something calculated—all too "mental" (and arty)—about Artaud's advocacy of Heliogabalusian anarchy and destructiveness. It is another intellectualized, sophisticated return to a nature, not unlike Rousseau's: a canny, willful rejection of civilization, in order to be one up on it—indeed, to dominate it with one's daring. Only now nature is the unconscious—human nature at its most raw, indeed, "natural." And that is the problem: with it, one cannot pretend to be more than one is. The unconscious promises release to the inhibited and over-intellectual, and Artaud was inhibited and over-intellectual, like the surrealists he associated with, and to whose belief in the dream—the avenue to the marvelous—he remained loyal, even after his excommunication by Breton. But the unconscious is a devil: it can be intellectualized into an angel of artistic mercy, but it sooner or later turns on those who seek its indulgence. Let loose, it treacherously produces the unexpected (foreordained, for those who study it): ten surrealists once attempted mass suicide by hanging, while in an unconscious trance. Artaud's drawings are the record of a long-drawn out sui-cide, the climax of an unsuccessful self-analysis, or rather the confusion of "self"-expression with self-analysis.

This essay is reprinted with kind permission from Artforum, *January, 1997.*

Joel Shapiro's Figurative Constructions

Construction is able to do two things: it can codify the resignation of the emaciated subject, and promote absolute estrangement by incorporating it in art; or it can project the image of a reconciled future situated beyond statics and dynamics. There are many linkages between the principle of construction and technocracy, linkages that reinforce the suspicion that construction belongs inevitably to the administered, bureaucratized world. Yet it may also terminate in an as yet unknown aesthetic form, the rational organization of which might point to the abolition of all notions of administrative control and their reflexes in art.

—T. W. Adorno, *Aesthetic Theory*[1]

A strangely turbulent array of geometrical sculptures, uncannily resembling and evoking human figures, confronts us in a grand, quasi-palatial space. The space is triumphantly larger-than-life, however hollow the triumph may seem—however inwardly as well as physically empty the space feels—while the sculptures are human in scale, even though some of them stretch in space, far beyond the confines of the human body. All are built of rectangular blocks or planes; their simple geometry, solidity, and inherent monu-

mentality are self-evident. Where the blocks join, usually at an odd angle, the corner edge is often cut away, creating an irrational effect, however precisely triangular the cut. Some of the blocks function as limbs, others as torsos, still others as heads, although many of the figures are headless, adding to their bizarreness. Some stand on a single leg, others on two legs, and others recline on the ground, as though fallen: strange geometrical beings that seem to have collapsed in on themselves, as though, having lost their balance and fallen over, they can no longer stand up, and have resigned themselves to their fate.

All are genderless, which presumably adds to their universality, already established by their geometry. Many are of painted wood, others are cast in iron or bronze; the texture of the wood—line after repeated line, in a consistent rhythm—is often quite conspicuous. The figures are meticulously constructed, and oddly graceful. Each has its own idiosyncratic identity, and uncanny unity. Virtually every part is at odds—discontinuous—with every other part, yet however askew, they abruptly add up to the semblance of a whole. They are fragments of an inconceivable human integrity, evoked by their broken continuity. Disruption is built into the work, but also wholeness, as a foreshortened, elusive potential: wholeness is the genie held captive in the construction, felt but not forthcoming. The result is a sculptural mot juste: a demonstration of spatial relationships, at once dynamic and static, internal and external—between the parts of the sculpture, and the sculpture and the architectural environment— that, for all its complexity, seems aphoristic, pithy. The constructions hold their own against the space, indeed, more than hold their own: some are suspended from the walls, as though in protest against gravity, in the double sense of that term. For in climbing the walls they wittily mock the gravity—dull earnestness—of the architecture, as well as the less easily surmountable, if ultimately more fatal, gravity of the earth. They declare their transcendence, despite the contradictions of their structure—in defiance of their own self-contradiction.

How are Shapiro's figurative constructions to be understood? Shapiro understands them in abstract formal terms. He is obsessed with their cropped, constructed, open-ended character—"Chop off parts, rip the form apart, and reassemble. It is an open process"—and "idiosyncratically" painted surface, which uses "color as [an animating] material."[2] At the same time, Shapiro is sensitive to "the emotion of the piece," and the "intrinsic metaphoric quality" of color, that is, its emotional resonance—some colors convey a sense of elation,

some of depression, as he says—which is to acknowledge that the piece, however much a formal abstract construction, is also a figure, more particularly, a metaphor for the human body in a certain emotional state.

Shapiro's sculptures are abstract "inventions" with a human identity, and their dialectical core—the ambiguously resolved relationship between their parts, and their overall split, self-subverting character—is human as well as formal in import. Indeed, the dialectic between the human and the formal that pervades the construction is evident in their innermost character: each part has a geometrical self-sufficiency and self-evidence, whose strong, determinate presence is compromised by its ambiguous—insecure, tenuous—connection with the other parts. The overall result is an open, inconclusive form—a form hardly as geometrically clear, distinct, and self-contained as each part—whose dramatic incompleteness is at once agonizing and liberating—expressionistic in effect. Each geometrical part becomes a kind of gesture: strange as it may seem to say so, Shapiro's sculptures have an impulsive, abstract expressionist—antitechnocratic, unmanageable—dimension, which becomes explicit in the "touchy" way they are painted: the way, if one wishes, feeling is integrated with the form, confirming its absurdity—its resistance to technocratic administration.

It is as though each block is the bar of a Piranesian cage that has been dismantled and rebuilt in free form, obliterating the very idea of imprisonment, yet also making it clear that freedom is emotionally precarious. It is as though to be free is to be in danger of imminent structural collapse—self-loss, loss of inner organization—however durable each of one's parts is. Thus the doubleness of the construction enhances its emotional intensity—gives it an unexpected emotional depth and complexity. Shapiro's sculptures, then, are not just ingenious exercises in construction, but statements about the human condition. The intricate syntax of their structure, and the resulting "posture" of the figures, are a body language as well as a technical feat. At the same time, the relationship between Shapiro's figures and his constructivist technique is far from arbitrary: at issue in the figures is the technological rationalization and denaturalization of the body, and more generally human existence, in modernity—the conception of it as a kind of construction, which however intricate is at bottom mechanical. A technological triumph of nature, it is no longer exactly natural, for we can master the method of its construction and reconstruct it, and above all make it more perfect. Human beings can be reengineered into ideal machines.

I submit that Shapiro's reconstructed figures deal with the modern ambition to denaturalize the body—to deny its organic character—and the crisis in the sense of the body, and with it in the threat to the self—the body is the first ego, as Freud said, and when its naturalness is denied the ego loses any ground on which to stand—that results. If the will to reconstruct humanity itself is the narcissistic core of modernity—if the will to power over human nature (not simply nature at large) is the ultimate modern hubris—then Shapiro's reconstruction of the figure shows the unexpectedly shaky—emotionally destructive—results of this ruthlessly Faustian will. For Shapiro's figures are irrational and unbalanced, and on the verge of disintegration—literally coming apart, or barely holding together, at the seams or joints—however exquisitely balanced—aesthetically intelligible—they are. They do not convey the "constructivist certainty" that has been the goal of modernity, but rather, paradoxically, constructivist uncertainty: Shapiro's act of construction is simultaneously an act of deconstruction. Construction unwittingly becomes its opposite, betraying the technological imperative that motivates it. Constructivism, carried to an extreme—regarded as an absolute—does not inevitably lead to perfection and certainty, but their opposite, entropic fragmentation and uncertainty. It may reintegrate human beings on a "higher" mechanical level, making them more manageable, but this is to isolate and emaciate them: there is a tone of morbid isolation and deprivation to Shapiro's figures. While there is an attempt to restore by way of color the emotional substance lost to geometrical reduction and clarification, the human result remains subjectively doubtful. An elongated 1996 cast bronze figure—it has an odd affinity with Lehmbruck's similarly elongated, melancholy figures—typifies this emotional emaciation of the subject.

One idealistic, indeed, utopian credo of modernity, and of one kind of modern art, is that, to quote Theo van Doesburg, "the needs of our age, both ideal and practical, demand constructive certainty" and "only the machine can provide this constructive certainty."[3] But Shapiro's troubled humanoids suggest that the machine model has failed humanity. Its results may be socially beneficial (not unequivocally, as has been argued), but its effect on the individual—who obediently internalizes the socially given model as a source of personal identity—are horrific. Le Corbusier once said that a house is just a machine for living, and designed a house that was the simplest of machines—an elemen-

tary structure of interchangeable, mass-produced parts. Shapiro's figures disclose the unconscious suffering the human beings who live in such a machine house—and unavoidably identify with it—experience. Reduced to geometric fundamentals, they have no personality, and have all but lost their humanity. They have become machinelike, but because they remain human—however submerged their humanity is in their machine identity—they do not function smoothly: they are robots distorted by anguish. A 1996–97 cast bronze figure, its arms extended in despair, its head bent at an absurd angle, epitomizes this. It may be abstract, but its form is not far removed from Grünewald's tortured medieval Christ on a cross, his arms extended in a V-shape. Similarly, a 1996 cast bronze figure, its arms extended to their limits, conveys desperation in its stride. It is a walking crucifixion. The parts of Shapiro's figures do not rationally synchronize, as they would in a true machine. Shapiro's figures are absurd machines: they are haunted by a sense of self—the famous ghost (illusion) in the machine—which interferes with their workings. It is a self that believed it would find security and salvation—selfless perfection—by reconstructing itself in the form of a machine, but it found painful self-contradiction instead. Thus the irrational construction of Shapiro's figures represents their unconscious existential resistance to their socially conscious submission to mechanization and administration—robotization—as well as the confused sense of identity that is its result.

In a sense, the most existentially telling work in the exhibition is Shapiro's 1991 combination of a figure and a house. They face each other in a standoff, and are unbalanced in themselves: the house is upended, and stands precariously on edge, while the equally precarious figure stands parallel to the ground on one leg (also "on edge"). Shapiro formally balances, with subtle aesthetic insight, the small house and the large figure—the block which is the basis of the house is the same block that appears in the figure, and the pitch of the roof forms the same angle as the edge of the leg on the ground—but the point is that their combination states a predicament and paradox: the figure cannot fit into the house—it is not a home, as the proverb states. And yet it has the shape and intimate, private feel of a conventional, old-fashioned home, rather than of Le Corbusier's modern machine home, an impersonal abstract construction of glass and steel that affords no privacy. It lacks inwardness, as indicated by its openness—exposure—to the world: anyone can look inside it,

and there is no place to hide from their curiosity. Presumably there is nothing to hide, for everyone is like everyone else. Shapiro's house contains a secret, while Le Corbusier's house is nothing but the sum of its functions and structural parts.

I think Shapiro's work encapsulates, in metaphoric form, a central issue of our time: the search for community in a world that has become all society. In its inorganic anonymity, and the interchangeability and impersonality of its parts, Shapiro's figure shows its social character, while its precarious position and conflicted structure convey its anxious, frustrated longing for community, ambiguously represented by the little house. A community, Ferdinand Tonnies writes, has "real and organic life," while society is an "imaginary and mechanical structure."[4] In a community there is "intimate, private, and exclusive living together," while society is the "mere coexistence of people independent of each other." Shapiro's hermetically sealed little house conveys a sense of intimacy and privacy, however inorganic its blocklike geometry makes it. Similarly, the "expressionistic" precariousness of Shapiro's figure makes it oddly real and organic, even if it is ostensibly mechanical in character. Shapiro plays endlessly with this ambiguity, to the extent that his entire installation forms an environment that can be ambiguously read as an intimate community and an indifferent society—a mere coexistence of figures, that at the same time form a community, however uncertainly, insecurely and ironically. That is, they form a "modern" community—a contradiction in terms.

In another work (1996–97), the same little house appears in blonde wood and black cast iron—a contradictory repetition, all the more so because the houses are at odds, that is, radically separated. The luminous wooden one (symbolizing community) is out of reach—transcendentalized (el(ev)ated)—on the wall; the depressing black iron one (symbolizing society; Max Weber's "iron cage?") rests on the floor, where one can trip over it. The unresolved dialectic between the houses extends the fundamental psychoformal ambiguity of Shapiro's constructions into new emotional territory. Even more telling and climactic is an intricate untitled work of 1993–94, where the scattered parts of a broken figure fall over a "bleeding" house standing on edge—propped up, but clearly unable to sustain the position, and about to fall over. One side of the house is painted black, the other is not, again conveying a split identity—a recognition of the contradiction embedded in modernity. The house is a

Humpty Dumpty about to fall, and the figure a Humpty Dumpty that has fallen and cannot be put back together again.

No doubt the equivalences I suggest between the formal and emotional are familiar and all too "humanistic." But one of the triumphs of Shapiro's art is its synthesis of formalism and humanism, resulting in what might be called abstract symbolism. (Abstraction, we may recall, grew out of Symbolism, and, I would argue, never abandons it, however "pure" it apparently becomes.) His forms are subliminally fraught with basic human meaning, and as such can be read psychosocially as well as aesthetically. It is this doubleness—this metaphoric potential—that gives his art its punch and outreach. The red and black Shapiro uses are Suprematist colors, but they are also symbols of passion and depression, blood and death, and the colors of the Nazi flag. Shapiro can hardly be unaware of this, in view of his concern with the emotional meaning and effect as well as the material nature of color. I think Shapiro's linkage of—oscillation between—the light and dark has gnostic import, and also suggests an attempt to balance the life and death instincts, one of the basic psychological tasks of the self.

The conflict between the machine (robot) and the organic model of human being—basic to modern thought, according to Ludwig von Bertalanffy[5]—and the correlate conflict between society and community, are transparent in Shapiro's figurative constructions. They have features of the organic communal as well as social machine models, ironically reconciled yet also quite separate and opposed. The drama of their difficult relationship is enacted in terms of the correlate aesthetic conflict between "decorative idiosyncrasy and animal spontaneity" and "heroic monumentality" (van Doesburg's terms), indicating how rich with meaning Shapiro's sculptures are. On the one hand, their parts are more or less interchangeable modules (their Minimalist aspect) and simply coexist as in a (social) machine, and on the other hand their woodenness suggests the deadening effect of modeling oneself on a machine—one is well-administered, but just like everyone else—as well as their subliminal, not quite repressed naturalness. That is, they are "wooden" in more ways than one: their woodenness represents their vestigial organicity—enhanced and confirmed by the idiosyncratic, spontaneous paint that often "decorates" ("sensationalizes") and animates (animalizes) them—and latent communal character, but also their uniformity and psychic deadness, to use Michael Eigen's term,[6]

which is a result of their oversocialization and administrative control. Shapiro says he works in wood because it is convenient and easy to do so, and asserts that he wants to deny its "woodiness"—he thinks color and paint (and no doubt casting or metalling) do so, "dematerializing" it—but its materialness remains texturally evident, and is even reflected, however obliquely, in the texture of paint (especially when it organically flows to amorphous effect). Thus its symbolic meaning remains intact and subliminal, all the more so in the context of a figurative sculpture.

I am suggesting that Shapiro's figures have more in common with those of Giacometti than might be evident at first glance. Shapiro admires Giacometti's painted bronzes and painted plasters—they justify his own painted sculptures (which makes them "impure," false to the medium, by Greenbergian modernist standards)—for their abstractness, but his figures also have an odd emotional affinity with the sacred, peculiarly archaic figures of Giacometti. Giacometti's painted, frozen figures also embody the conflict between socially reified and spontaneously communal humanity—between compliant, uniform, isolated figures trapped in public space and figures that have a spontaneous, bodily, autonomous existence, however latently, and are in intimate relationship with one another, however ironically. There is a line that goes from Giacometti's figures through de Chirico's metaphysical figures and Schlemmer's mannequins (and other modern robots, including the surrealized ones) to Shapiro's figures. In this development the tension between the true creative self and the false compliant self increases. The organically alive, spontaneous, nonconformist part of the self—the self rooted in the body, that is, the truly first self—and the static, socially conformist, depersonalized aspect of the self remain at odds, and almost break apart. For the true self, life is sacred, for the false self it is living death: Shapiro's figurative constructions convey both the primary and secondary selves simultaneously. (I am playing on D. W. Winnicott's famous distinction between True Self and False Self.[7])

Shapiro realized from the beginning of his career that the Minimalism that was his point of departure was a dead end, aesthetically and emotionally. He realized that the perceptual epiphany supposedly afforded by placing geometrical gestalts of different materials in anonymous space had a limited significance. He wanted to move beyond the flat affect of the Minimalist gestalt and the inhumanity of the modernist grid, symbolizing the administered,

bureaucratized world, in which difference is made sameness, as Adorno said. In a sense, Shapiro dismantles the grid, using its parts to rearticulate the anxiety and uncertainty inherent in modernity, an anxiety and uncertainty expressed through seemingly awkward, distorted figures. Their awkwardness and distortion are a cry for freedom, and in fact their only freedom within the constraints of the technological society, that has invaded and transformed their bodies, making them into machines.

Modernity has made "the human condition of fallenness, the precariousness of the position of each of us as subjects,"[8] more explicit than ever. But modernity has also connected it with freedom. There is no cure for that fallenness and precariousness, only the struggle to become conscious of them so that we can have the strength to face and endure them, and so that they can indeed lead to freedom. Shapiro's peculiarly tragic, strangely unencumbered, weirdly robotic figures accomplish this in a completely modern way: by the uncompromising use of formal means. In Shapiro's figurative constructions, anxiety becomes austere, fallenness epigrammatic, and freedom a delicate balance of abstract forces. As Hanna Segal writes, tragedy involves an "emotionally ugly" content—a demonstration of "the forces of destruction"—but this content is conveyed, counterbalanced, and contained by the abstract "rhythm"—"inner consistency" or "unity"—of form.[9] As Shapiro has said, he is determined to "unify the form" without sacrificing contradiction, which tends to pull form apart. The significance of his constructions is that they use the same geometrical means to create contradiction and suggest unity, which is a way of making a virtue of estrangement without denying reason.

This essay was originally published in the catalog Joel Shapiro: Werke 1989–1996 *[Haus der Kunst, Munich, October, 1997].*

Notes

1. T. W. Adorno, *Aesthetic Theory* (London: Routledge & Kegan Paul, 1984), 319.
2. "Interview with Joel Shapiro by Ellen Phelan," *Painted Wood Sculpture and Drawings* (New York: Pace Wildenstein, 1995), 11. All Shapiro quotations are from this interview.
3. Theo van Doesburg, "The Will to Style: The Reconstruction of Life, Art and Technology" (1922), *De Stijl*, ed. Hans L. C. Jaffé (New York: Harry N. Abrams, 1971), 156.
4. Ferdinand Tonnies, *Community and Society* (New York: Harper & Row, 1963), 33-34.
5. Ludwig von Bertalanffy, *General System Theory* (New York: George Braziller, 1968), 140, 191.
6. Michael Eigen, *Psychic Deadness* (Northvale, NJ and London: Jason Aronson, 1996).
7. D. W. Winnicott, "Ego Distortion in Terms of True and False Self," *The Maturational Processes and the Facilitating Environment* (New York: International Universities Press, 1965), 140–52.
8. E. Edward Robins, "Spirituality and Psychoanalysis," *Psychologist Psychoanalyst* 17 (Spring 1997):16.
9. Hanna Segal, *Dream, Phantasy and Art* (London and New York: Tavistock/Routledge, 1991), 90.

Helmut Federle: Abstract Narcissus and Gnostic

*Meine Handhabung des abstrakten Vokabulars betreibe ich mit derselben
Emotionalität und derselben Symbolisierung, wie wenn ich eine Landschaft malen
würde. Vielfach liegen sogar diesen abstrakten Arbeiten realistische Gedanken
zugrunde, oder eben nicht.*

—Helmut Federle[1]

What does Federle do for abstract art? He forces it open, or
rather, insists on keeping it an open, "evocative" language. He defeats its tendency to become a complete language, a metaphysics of form, a structure readable at a glance, by his mannerist use of its conventions. (This tendency has been especially strong since so-called postpainterly abstraction, but it was latent in abstract art from the start. From their first self-awareness, the pioneer abstract artists—Kandinsky, Malevich, Mondrian—wanted abstract art to be a total system of art. Perhaps this was in compensation for the fact that it did not seem to have the richness of resources to draw upon that realism apparently has, with the supposed infinity of observable contingent shapes. Abstract art first seemed a liberation, but then it became a tyranny, another system and code, as

though to put itself entirely beyond chance, beyond the suspicion that its vocabulary was arbitrary.)

At the heart of this mannerist use is Federle's play with the difference between the geometrical and gestural; he seems to blur it without denying it. Geometrical shape becomes vigorous with the spontaneity that is proper to gesture. Federle's geometry seems not simply given but existentially thrown, and unstable because of it. He imbues gesture with the aura of axiomatic givenness typically inseparable from geometry. His gesture seems like an enduring construction, for all it inchoateness and "atmospherics." Both geometry and gesture become unexpectedly "susceptible": they are the recognizable conventions of abstract language, but appear in a self-contradictory way.

Out of this play with their difference—this sense that each finds an important part of its identity through the other—Federle generates his sense of emotionality, both as drama in itself and as an emblem of gnostic struggle. The sense of subliminal emotional intensity in Federle's abstract paintings to the point of strain, even disintegration (correlate with his disintegration of geometry)—is another consequence of his mannerism. It is also the vehicle of his gnosticism, as well as a reflection of gnosticism's existential import. (The tendency to repress the subjective in abstract art—under the guise of ridding it of literary allusions, "purifying" it—is as strong in the history of abstract art as the tendency to systematize it; the two tendencies are correlate.) The biased assumption that abstract art plays no role in the construction of the modern subject—in general reflects no desire—is absurd, especially if we take seriously the view that abstract art is the modern art.

Art-historically, the sense of latent subjectivity makes Federle's abstract painting postformalist—indeed, the problem of abstract painting in the last decade has been how to get beyond formalism, with its predetermination of the painting's constituents. He deobjectifies an overobjectified abstract painting, in the process renewing the original goals of nonobjective art, evident in the work of Malevich, Kandinsky, and Mondrian. Subjective goals were lost sight of by postpainterly abstraction, which tended to reduce abstract art to an exercise in technique—another aspect of the attempt to strip it entirely of any sense of the subject. But Federle goes one step further than the pioneer abstract artists. He makes the gnostic import of their subjectivism overt. One of the reasons for an abstract articulation of subjectivity—uprooting it from realistic associations—

Helmut Federle, *Construction Time Again II*, 1983. Oil on canvas, 78¾" × 55".
Photo by Peter Bellamy. Courtesy Peter Blum Gallery, New York.

was to articulate inner conflict in a universal language. The next step—
Federle's—is to realize the universal import of the inner conflict: to realize that
subjective conflict reflects a universal contention, not unlike that between
Freud's life and death drives, but even more absolute.

The urge to gnostic statement is the true inner necessity of authentic
abstract art, implicit in it from the start. Federle's paintings are an unusually
direct visual realization of gnosticism, saved from intellectualism and glibness by
mannerist disequilibrium and precarious emotionality, that is, by disequilibrium
intensified to the point of no return to equilibrium, so that the emotionality
correlate with it seems "mad," uncontrollable. (A painting by Federle may seem
more geometrical or more gestural, but it generally has a driven look suggesting
not simply a loss of control, but its refusal, as though control, and the stability it
brings, was a premature solution to a standing problem.) This aura of subtle
uncontrollability or precarious control supports the look of eschatological reve-
lation belonging to Federle's abstract paintings. They confront us with signs and
portents suggestive of apocalyptic catastrophe and healing into an awkward
wholeness—neither the one nor the other, but the mixed blessing of damnation
and salvation that is the living final truth. In other words, they show gnostic
uncertainty about the outcome of the struggle between the forces of light and
darkness. This is why their integration is inherently uncertain or precarious. As
D. W. Winnicott writes, there is a connection "between the deepest conflicts
that reveal themselves in religion and in art forms and the depressed mood or
melancholic illness. At the centre is doubt, doubt as to the outcome of the
struggle between the forces of good and evil, or . . . between the benign and
persecutory elements within and without the personality."[2] Federle's painting is
a melancholy, religious art, using abstract means to heighten the tension
between the benign and persecutory—to sharpen existential doubt until it has a
gnostic cutting edge.

Federle utilizes a late Minimalist aesthetic, allowing him to articulate
gnostic dualism with an extraordinary economy of means and concentration—
genuine restraint—that makes it seem indisputable. It also allows him the dou-
bleness of conveying gnostic conflict as both an existential and cosmological
matter. In a sense, the simplest forms allow for the most complex reading,
because we invest them with symbolic meaning to offset the sense of vacuum
they generate. They suggest an irreducibility that implies intense conviction as

well as analytic rigor, bedrock intuition and universal statement. Irreducibility also carries with it the sense of climactic revelation—so crucial to gnosticism. Federle's use of irreducible dichotomies is climactic in itself. He works at the cabalistic intersection between written and visual language, the articulate and the inarticulate, representation of autonomy and presentation of universality, light and darkness equivocally natural and supernatural. It is a zone where opposites seem to converge in occult equivalence, yet where they also reveal how impossible it is to truly fit them together, how entrenched in separateness they are. Paradoxically, only in this zone is visionary sureness of statement possible. Indeed, Federle's abstract paintings have a complex visionary import that has not been seen in abstract painting since Newman and Rothko. Operating in the zone of radical equivocation and unintelligibility, he achieves enigmatic precision. He makes clear that enigma is fundamental to art, its last frontier, and that it can be rendered precisely.

Federle's cabalization process, as I call it, is perhaps most evident, and certainly most to the main point of his art, in his "playful" conversion of the letters of his name into enigmatic objects of contemplation by his treatment of them as purely formal entities. This Aufhebung—narcissism transcended but also raised to a universal level—empties them of referentiality, but makes them signify another, "higher" (or at least radically different) reality, more enigmatic than the one in which names are used, indeed, inherently enigmatic—the reality of enigma itself. "HF" abstracted in the direction of inarticulateness becomes enigma articulate. From the start of his career, as in *Ohne Titel (Wappen HF)* (1959), where it is perceptually obvious, Federle's abstraction derived from his formal manipulation of one or both of the initials of his name, reinventing them as abstract variants (mandalas) available for meditation. This manipulation—at once disfiguration, dismemberment, and disembodiment—is quintessentially mannerist, in that it denies the normative character of its starting point, the form it "distorts," as well as the form's conventional communicative power. The meaning of the initials, and by extension representational language, are repudiated. They are transformed into an abstract "language" which does not communicate in the ordinary way, but becomes what Winnicott has called a "cul de sac communication"[3] or what I call an "incommunicado communication."

But the salient—mannerist—feature of an abstract painting by Federle is that it never stabilizes: an equilibrium between its elements is never

convincingly established. Disequilibrium is inescapable, absolute—a mannerist idea and discovery. It is the basic modern condition, as Arnold Hauser has argued.[4] As one might expect, disequilibrium is fraught with ambivalence, for it is at once progressive and regressive in import. At first it seems like emotional relief or liberation, for through disequilibrium emotion becomes released from objects—becomes free-floating, as it were. Disequilibrium sets in motion a process of detachment, if not complete abandonment of attachment (the Buddhist dimension of Federle's work). At the same time, mannerist disequilibrium represents a regression that has not been overcome—a stalemate in a hell of conflict and a general shattered state of being (the expressionist dimension of Federle's work). In general, in modern art disequilibrium suggests disinvestment in the lifeworld in the very act of being deeply enough involved in it to articulate its fragmented and conflicted inner as well as outer reality. Federle often shatters the initials of his name and sets the parts at odds, suggesting his narcissistic injury and the disjointed character of the world that injured him, and at the same time his emotional liberation from his ordinary, worldly self. It is as though because the parts of the world do not fit together he cannot and dare not fit the parts of his selfhood together, which at the same time gives him a certain "selflessness."

Thus, Federle's mannerist abstraction involves a process of disengagement, in which the disequilibrium between light and dark, geometry and gesture, seems to articulate a liberated expressivity. But this only allows for a recognition of it as irremediable suffering. Perhaps this doubleness is most evident in the disequilibrium of geometry and gesture in themselves. Disequilibrium prevails in Federle's geometrical organization, where basic formal parts never truly fit together into a coherent geometrical whole. And disequilibrium is obvious in the sense of turmoil—sometimes verging on overt chaos—of his gesturalism, most noteworthy in *Russischer Skorpion* (1983), *Bild für einen Arbeiter* (Bad Work) *11* (1983), *The Death of Vladimir Majakowskij* (1983), *Körper und Linie* (1983–84), *For J. D. Autry, Waiting for the Final Hour* (1984), and *Innerlight* (HRI) (1985). Federle's mannerist abstraction sometimes seems like a deliberate process of disequilibration, as though he was hoping for a new emotional start while acknowledging that he was caught in an old emotional trap—the original sin of unresolvable emotional conflict and disintegration.

Can we say that Federle, through his abstract, cabalistic play with the "realistic" symbol of his name, has accomplished no more than create yet another sophisticated variant of mannerism? In a sense, yes, but the mannerist mentality has proven to be relatively rare and difficult to achieve in abstract painting, especially a Minimalist abstract painting. One thinks of early Frank Stella and to a lesser extent Robert Mangold and Brice Marden. Even more rarely (Lucio Fontana alone comes to mind) does mannerist abstraction achieve—does its disequilibrium have the power to effect—the enigmatic transformation of an "economy of scarcity" into an "economy of abundance," to use Nietzsche's distinction. This is not simply a matter of making the familiar "less" seem like an unfamiliar "more" but of making less seem completely adequate—seem a cosmos unto itself. This is the enigma effected by the transformation—its enigmatic result.

Federle's cabalization of the symbol of his name is the mannerist underpinning of his work. Indeed, "H" and "F" superimposed constitute a kind of gestalt whole—harmonious, absolutely stable shape—but Federle rarely fuses them. When he does, as in *Two Side Painting (No. 2 East Side Series)* (1982), the result is not unequivocally harmonious. He creates accents—the two small corner rectangles at odds with one another in the upper left and lower right corners—that put pressure on the central geometrical form, pulling on it, denying its sturdiness. Or else he surrounds it with a potentially disintegrative atmosphere. More typically, Federle actively disrupts or complicates the letters, which is part of his cabalistic strategy—his method of giving them gnostic import. He diagonalizes the initials, as in *S/S* (1981).

H. Fridjonssons's *New Corridor* (1984) also shows the use of diagonals (here both as appendages disputing the integrity of the structure and as an element integral to it, in both cases implying an "impossible" structure)—or, more often, he creates an incomplete or open structure. This—not their symbolic meaning (whether Nazi or Buddhist)—is the true point of *Asian Sign* (1980) and *SS Painting* (1982), as well as such works as *Zwei symbolische Formen Übereinander* (1980), *Hell* (1981), and even *Motor City* (1980), among many other works involving less obviously incomplete structures, such as *2 gelbe Vierecke* (1980). Such subtly incomplete structures, more or less "impossible," and susceptible to stress and collapse, or openly disequilibrated (occult) structures, as in *Dark Night Three* (1984) (reminiscent of Malevich's strategy in the aerodynamic

phase of Suprematism), make clear the mannerist thrust of Federle's work and the import of his use of the symbol of his name. The narcissistic character of mannerism has been emphasized by Hauser[5] but in Federle narcissism is transformed. He effects a symbolic transcendentalization of the self—which, as I have suggested, involves its disintegration as well as idealization—as the solution to the problem of self-love. One might say that Federle uses the libido involved in secondary narcissism[6] not simply to cathect the everyday existing self but to change it into an existentially authentic self, capable of gnostic intuition. Withdrawing from the pathology of the world in general, from particular human relations infected with irremediable pathology—family relationships, as the titles of some works suggest as well as from his own pathology, into nonobjective art, Federle creates a zone of solitude in which healing is possible.[7] Indeed, Federle's transformation of his initials seems to imply an attempt to heal himself—at the least, to cure himself of everydayness, which is always pathological. (Nonobjectivity's refusal to function representationally—to represent the world—and its insistence on pure or nonobjective emotion, can be comprehended as both an implicit acknowledgment of the world's pathology and a rejection of pathological involvement with it. Both imply the gnostic conception of the irredeemable darkness of the world.)

Federle's open or disequilibrated form—structuring incompleteness, that is, simultaneously disintegrating and reintegrating the form of his initials— can be said to be a way of disintegrating an old, everyday self and realizing a new integrity of self, based on gnostic intuition. It is as if Federle, in a kind of compulsive repetition born of a sense of higher necessity, took his ordinary self (symbolized by his initials) apart, teased out the universal forms that constituted it (the universal geometry implicit in the shapes of the letters), and put the (geometrical) forms together in "transcendental symbolic form," generating a sense of "higher self," that is, a self that intuited its constitution by abstract/universal elements. Federle implies that this is the only redemption possible for the self—the only way it can be healed.

The cabalization process seems depersonalizing, but it makes abstract universal forms intimate—internalizes them, so that they are available for personal communion, thus reinforcing the sense of autonomous selfhood, strengthening the ego. The link with the universal confirms self-identity, that is, the integral self experiences itself as a tautology. We may recall that God, when

asked to identify himself, declared "I am who I am." The cabalization process generates a sense of ecstatic awareness, in which the self, in the very act of becoming as definitive as crystal—coming into its own and intuiting its completeness—seems to dissolve. (This completeness is monadic, in Leibniz's sense. That is, it contains—mirrors within itself—the world at its most fundamental. As is well-known, many of Federle's abstractions are mirror constructions; they suggest this monadic selfhood.) Unexpectedly, it experiences its boundaries as more universal than individual, that is, more cosmic than personal in import. Federle's abstractions successfully achieve this ecstatic effect, in which the seemingly insurmountable gap between limited, particular and infinite, universal existence is bridged.

It should be noted that the ecstatic dimension of Federle's art implies that he is thinking, in abstract language, about the "problem" of immortality—struggling to articulate the peculiarities of the sense of immortality that pervades human life. His "solution" to it is not unrelated to what Alfred North Whitehead called "objective immortality."[8] Federle, like Whitehead, refuses to regard the sense of immortality as an illusion. Whitehead interpreted the conscious wish for subjective immortality as the expression of the unconscious desire to be part of the concreteness of the objectively given other. In Federle's case, the other is an abstract, eternal form; emotional attachment to it—the desire to be part of it—suggests the immortality of desire itself. (Desire is not only the feeling for the other but the feeling that the other is the same as oneself, formally as well as existentially.) Federle's art generates a sense of the subtle unity of desire and form. By displacing or transposing the feeling for an object—for example, a tree, as in certain of Federle's works—on a form (or what Whitehead calls an "eternal object"), the feeling seems to become as immortal or eternal ("pure") as the form. The form itself comes to seem subjective—a projection of interiority. The form comes to seem like feeling crystallized—a manifestation of basic desire, that is, the wish to be, which includes the wish to be oneself and other than oneself (the only way to adequately be).

Gnosticism is a kind of mysticism, as the best abstract art is. Hans Jonas has shown how gnostic mysticism and existentialism correlate.[9] The gnostic interpretation of abstract art—to which Federle's art lends itself particularly—makes its existential implications explicit. Jonas points out that gnosticism is inseparable from nihilism, that is, the existential experience of the groundless-

ness—"darkness" or nothingness—of the world. The true source of existence is the divine; authentic existence seeks to return to its divine source. It is not clear that it can: gnosticism posits a Manichean conflict between the darkness of being-in-the-world and light, the sign of the absolute transcendence of God, who has nothing to do with the darkness of the world. "Absolute transcendence" means that for the gnostics the light of God had nothing to do with the creation of the darkness of the world. For the gnostics, the demiurge is responsible for the creation of the world (and can undo it). As Jonas notes, this is why both pagan and Christian philosophers (Plotinus included) repudiated and suppressed gnosticism. For Jonas, gnosticism is very contemporary, because of the pervasive if unconscious feeling of the human as thrown into nothingness/darkness and, if it wants to sustain any sense of itself—any sense of a reason for being—having to reach for "gnosis," that is, insight into the light of God, while falling in the nothingness/darkness of the world. Federle's abstract painting articulates this gnostic "predicament."

Kurt Rudolph points out that gnosticism is an attempt to achieve a knowledge which is not simply intellectual or theoretical, "but a knowledge which has at the same time a liberating and redeeming effect. . . . It is a knowledge given by revelation, which has been made available only to the elect who are capable of receiving it, and therefore has an esoteric character. . . . All gnostic teachings are in some form a part of the redeeming knowledge which gathers together the object of knowledge (the divine nature), the means of knowledge (the redeeming gnosis) and the knower himself."[10] Federle attempts to gather the divine object (light), the nonobjective means of knowledge, and the dark, worldly, all too material subject himself—the narcissistic geometry is its emblem—into a single painting. I submit that Federle's esoteric painting, when it is not an articulation of the gnostic predicament, is an attempt to offer gnostic liberation and redemption. Can a painting liberate and redeem us? I don't know, but it can attempt to do so, as much as any magic. Federle articulates both aspects of gnostic teaching—the predicament of the conflict between the divine light and the dark world, and the desire for liberation from the dark world by union with the divine light—in one ambiguous abstract painting, sometimes tilting more one way than another. Let me hasten to say that this does not mean that Federle's abstract paintings are expressions of faith. For the gnostic, faith is not revelation and insight. It is ignorance—enslavement—"since it knows nothing concerning

itself and remains attached to what is immediately in the foreground," that is, the dark world. If Federle's paintings remain attached to the dark world, it is such an abstract attachment—the world is so far from the foreground of his painting—that it is best regarded as a desperate acknowledgment of the feeling that the darkness may well be inescapable. Also, the subtlety of Federle's articulation of the "divine spark," often called "pneuma" by the gnostics, which has fallen from the divine world into this dark world of fate, suggests direct revelation. Federle affords insight into pneuma, however much he may communicate thrownness into fate.

Jonas points out that in antiquity fate's clearest manifestation was cosmic order or law, which structures the world. Such cosmic order is not divine for the gnostic, but the invention of the demiurge. Cosmic order is represented in Federle, as it was in antiquity, by geometrical form. And Federle presents it as a dark, demiurgic ("demiurgent") creation, subtly coming undone, losing the equilibrium which is the mechanism of its order—by the light representing the divine. It is infected by the seeming lawlessness of light, a lawlessness (or tendency to formlessness, beyond all notions of order) evident in many of Federle's works. The world picture subtly becomes, to use the title of a major painting (1986) by Federle, an *Unruhiges Bild,* often enough *mit einseitigem Gewicht.* ("Restless Picture, [often enough] with Weight on One Side.")

Federle's paintings tend to be either yellow and black/gray or white and black. Jorg Zutter has connected this with Frank Stella's use of the color combination black and yellow in the early sixties, colors which Stella associated with New York City: "psycho—color the city—yellow + black."[11] I have no wish to dispute this connection, only to point out that in the gnostic cosmogony yellow indicates the "circle of light," which stands in contrast to the "circle of darkness." The "extreme opposites" which Zutter speaks of in his fine essay on Federle are gnostic opposites, whatever else they may be.

Jonas points out that for the gnostics light appears in the world as hidden divinity—the deus absconditus—buried in matter's darkness. *Innerlight (HRI)* (1985) seems to make this gnostic point explicitly, offering us a kind of intuition into light in the midst of the world's material darkness. It articulates, in Jonas's words, the gnostic situation of "potentiell Wissenden inmitten der Wissenslosigkeit, des Lichten inmitten der Finsternis."[12] At the moment of "katastrophale Entwertung und geistigen Entleerung des Universums" the res-

cuing light appears. It is the light of the deus absconditus, transcendent of the dark, material world. When Federle is not articulating the gnostic teaching of the absolute difference between darkness and light or order and potential chaos (which is not the same), he is dying unto the world in the act of knowing the enigmatic light beyond it. Light, after all, is and remains the enigma. It alone rescues us from darkness.

This essay is reprinted from the exhibition catalog Helmut Federle: Bilder und Zeichnungen 1975–1988, *[Museum Haus Lange Krefeld, Austria, Jan.–May, 1989].*

Notes

1. "I handle my abstract vocabulary with the same emotionality and symbolization as if I would paint a landscape. It's even possible that realistic ideas are the foundation of these abstract works, or then again they may not be." Author's translation of statement by the artist, 1988.
2. D. W. Winnicott, "Psycho-Analysis and the Sense of Guilt," *The Maturational Processes and the Facilitating Environment* (New York: International Universities Press, 1965), 25.
3. D W. Winnicott, "Communicating and Not Communicating Lead to a Study of Certain Opposites," *The Maturational Processes and the Facilitating Environment,* 183.
4. Arnold Hauser, *Mannerism: The Crisis of the Renaissance and the Origin of Modern Art* (London: Routledge & Kegan Paul, 1965).
5. Hauser, Part I, Chapter 7, "Narcissism as the Psychology of Alienation," 115–30. For Hauser, "mannerist anti-classicism," through "its abandonment of the fiction that a work of art is an organic, indivisible, and unalterable whole, made all of a piece," articulates the structure of narcissistic injury. It is clear that postmodernism in general—from which Federle's work is inseparable—is mannerist, and articulates art's narcissistic injury in the modern world with a vengeance. We can speak of Federle's work as a vehemently postmodernist abstract art, utilizing a restricted modernist vocabulary to make its narcissistic point.
6. Secondary narcissism has been psychoanalytically described as regression to narcissism—inwardly relating only to oneself, as it were—after relationships in the world, or external relationships, have proved pathological or altogether failed.
7. Michael Balint, *The Basic Fault: Therapeutic Aspects of Regression* (London: Tavistock, 1968), 24, describes "the area of creation" as one in which "there is no external object present. The subject is on his own and his main concern is to produce something out of himself." The sense of solitude communicated by Federle's abstract paintings is inseparable from such narcissistic activity. It is also correlate with the gnostic—and generally mystic—notion of withdrawal from the dark world to the light within oneself.
8. *In Process and Reality* (New York: Humanities Press, 1955), 44–47. Whitehead describes objective immortality as a perpetual creative perishing into the other. It is the process of concrescence as such.
9. Hans Jonas, "Gnosis, Existentialismus und Nihilismus," *Zwischen Nichts und Ewigkeit Zur Lehre vom Menschen* (Gottingen: Vandenhoeck & Ruprecht, 1963), 5–25.
10. Kurt Rudolph, *Gnosis: the Nature and History of Gnosticism* (New York: Harper & Row, 1983), 55.
11. Jörg Zutter, "Helmut Federle: Bilder Extremes Gegensätze," *Helmut Federle: Bilder, Zeichnungen* (Basel: *Museum für Gegenwartigeskunst,* 1985; exhibition catalogue), 10.
12. Jonas, 14.

Pierre Bonnard: Beauty with a Touch of Pathology

In a 1945 self-portrait, the frail, aged Pierre Bonnard (1867–1947) blacks out his eyes. It is an extraordinary morbid touch in an otherwise luminous, lively painting—the kind of Impressionist painting he was famous for. Bonnard already sees death, with the same quiet clarity and subliminal intensity—evident in the gestural surges carefully compartmentalized in everyday objects and spaces—with which he saw life, embodied in his wife, Marthe de Méligny. He painted her naked body over and over again, most famously in the bathtub, where she apparently spent much of her time. She was eternally young. In 1925, when Bonnard, for the first time, painted her stretched to her full length in the bathtub—*Nude in the Bath* and *The Bath* are the notorious works—she was in her mid-fifties, but, as has been much noted, he showed her as she was in her mid-twenties, when he first met her—when her name was the less aristocratic Maria Boursin.

Curiously, in Bonnard's paintings of her from the time the same blackness that appears in Bonnard's eyes in his late self-portrait—he made many throughout his life, looking more and more moribund in each—appears in her stockings. Bonnard is obsessed with them, at the expense of her rather plain face, as *Nude with Black Stockings,* the two images of *Woman with Black Stockings,* and *Marthe on a Divan* (all 1900) indicate. In these early works the

blackness is a lurid symbol of sexuality, which was not exactly a happy event for Bonnard, as the naked postcoital *Man and Woman* (1900) suggests. About to get dressed, Bonnard stands apart from Marthe—a screen divides them—who remains in bed, her eyes downcast in affected demureness. Is the bit of blackness in Bonnard's eyes, then, all that is left—the ashes—of his sinful sexual longing, which once spread over her lower body? Does it mean that his love for Marthe's body blinded him to the reality of her person? Does it mean, like the blind Terisias, he has at last seen the truth about Marthe—the veil of the lust that hid it has finally dropped from his eyes—which he is helpless to do anything about?

For Marthe, it seems, was mad. She was paranoid, possibly schizophrenic, and agoraphobic. Is this why she preferred the safety of the bathtub, a closed space, which helped her compose and contain herself? Her obsessive bathing has been understood to be a symptom of her mental illness, however much bathing, at the time, was associated with upper-classness—the lower classes supposedly didn't bathe (at least not everyday and sometimes twice a day, and not for hours on end)—and however much hydrotherapy was the popular cure for a long list of ailments.

If we look carefully at Bonnard's paintings, we see that a certain morbidity contaminates their beauty, from the beginning. Such early works as *Grandmother and Child* (1897), *The Meal* (1899), and *The Lamp and The Pears* or *Lunch at Le Grand-Lemps* (both about 1899), are allegories of the passage of time—of the stages of life, from childhood through youth to old age. Sex is a kind of wild interlude in this inevitable movement to death, as *Faun or The Rape of the Nymph* (1907) suggests. Sex remains a memory informing Bonnard's observation of Marthe's naked body, giving it a certain succulent luminosity, as in *The Bathroom* (1908). But it is an afterthought and instrument of narcissism, that is, self-love, which remains more essential, more necessary for emotional survival, which is the issue of Bonnard's paintings.

Their beauty at once compensates for and masks the narcissistic injury—the sense of puzzled hurt and naked vulnerability, even emotional impotence—evident in virtually all his self-portraits, as *Self-Portrait with Beard* (ca. 1920), *The Boxer* (1931), *Self-Portrait in a Mirror* (1938), and *Self-Portrait in the Bathroom Mirror* (1943–46) indicate. The first work mentioned has been compared to Edvard Munch's portrait of himself in hell, and the last one to the

photographs of concentration camp inmates that appeared soon after they were liberated. Similarly, Marthe's endless bathing and primping—her anxiety about her beauty, that is, her determination to turn herself into a beautiful work of art, and thus a fit subject for her husband's obsessive observation of her body— bespeaks her profound narcissistic anxiety. Bonnard's paintings witnessed Marthe's narcissism—they held a mirror up to her body, telling her that it was the fairest of all female bodies—and Marthe's narcissism supported his own, making him feel less helpless: painting her admiration of her body, he could admire his ability to create beauty out of what was, after all, banal. In short, Bonnard needed narcissistic gratification more than he needed sexual gratification, and he found it by painting Marthe's endless attempts to narcissistically gratify herself—to find self-satisfaction. One might say that he bathed in the aura of her narcissism, which allowed him the secondary narcissistic gratification of painting. It was ultimately a way of gratifying her wish to be beautiful—a way of transforming ordinary, commonplace matter into a painterly substance that seemed extraordinary and uncommon.

Indeed, Bonnard's paintings are full of ordinary scenes—everyday domesticity, symbolized by numerous tabletop still lives and gardens. Beautified—charged with seemingly spontaneous color and light and texture, verging on free form (for it was in painting that he also found freedom from Marthe)—these scenes became narcissistically gratifying. The shadow of death continues to haunt Bonnard's pictures, as *Bowl of Fruit* (1923) and *The French Window* (1932) make clear, but it is counterbalanced by the intense light of the Mediterranean (he lived in Le Cannet, a small town above Cannes), which infiltrates the depressing blackness, emptying its appearance of grim reality, if not exactly conveying happiness and joie de vivre.

Bonnard's paintings, then, are full of human content, which gives them an Old Master cast, as though paint existed only to confirm the intensity and depth of human experience. At the same time, he was a Modern Master in that he extended Impressionism into areas in which it had never felt comfortable— into interior space, that is, architecture. The usual Impressionist strategy was to treat interiors as though they were temporarily displaced exteriors. It was as though they really were part of the wild outside—belonged to untamed nature—but were held captive in social space. The point was to show that it was not really a social space—civilized—but still peculiarly raw with natural light

and color. Indeed, the whole effort of Cézanne's still lives is to suggest that they are not tamed by the social space they exist in—not really domestic, but implicitly wild. A Cézanne still life is like a Samson ready to tear down the philistine temple of commonplace architecture.

Bonnard became extremely dissatisfied with this. As André Lhote wrote in 1929, he grew "more and more out of sympathy with the impressionistic fragmentation of objects." It gave them a natural, wild look, implying that they could break the boundaries of any room that seriously tried to contain and restrain them. In contrast, Bonnard tried to integrate natural objects into architectural space, as Lhote said, and in the process created rooms that seemed as alive as natural spaces and natural objects that had a certain architectural character. He realized Cézanne's failed ambition to make natural objects whose geometrical structure was self-evident—but not dominant—and geometrical spaces that glistened with natural vitality. In other words, Bonnard reconciled natural and social space in the same objects and rooms, without losing the differentiation between them, as Matisse—who alone approached Bonnard in this—failed to do, for he tended to collapse social into natural space, fulfilling the basic Impressionist dream. (In Renoir, woman was never more than natural space.)

Bonnard also has a unique place among the post-Impressionists because he was able to integrate the natural space of woman's body and the social space of architecture. What else was Bonnard saying when he showed Marthe in her bathtub but that woman, despite her narcissistic insanity, was a natural vessel, and that the bathtub was an architecture—a social space—in which the water that flowed freely in nature—both are associated with woman—could be contained, so that it could benefit—heal—everyone. Without water there is no life, and Bonnard, after all, was about life, not death. It was water he was painting, as his rippling surfaces—nowhere are they more like flowing water (sometimes flowing fast, sometimes slowly) than in *Large Yellow Nude* (1931), where a white bath towel is saturated with abstract expressionist gestures—suggest. Was, he after all, more interested in the water in Marthe's bathtub, and its reflection on the walls and tiles of the bathroom, than in her body?

This essay is reprinted with kind permission from Art New England, *August-September, 1998.*

Alex Grey's Mysticism

What is for me particularly striking about Alex Gray's figures is their transparency: one can see right through their skin, to the substance of their body. This gives them an uncanny innocence: they are truly naked, down to the least detail of their body ego, the first ego, as Freud said. The next thing that strikes me is that, for all its rawness, the inner body is meticulously rendered—not just anatomically precise, but crystalline in its clarity. The revelatory—visionary—character of the rendering is confirmed by the aura of luminosity that surrounds the pellucid figure, confirming its own inner light: a radiance that, by reason of its wavelike rhythms, does not simply complement the figure, but seems to extend the force of life within it infinitely. The figure is at once encompassed by organized patterns of abstract yet organic illumination, and itself an organic structure of luminous, rhythmic patterns. There is a reciprocity between its inner rhythmicity and the rhythmic space of its surroundings: a correspondence between the natural structures of the inner body and the seemingly supernatural structures of outer space. Rhythm-rich organic organization, personal and cosmic illumination and space, and humanity at its most transparent and fundamental: these are the sophisticated resources of Gray's mysticism.

By "mysticism" I understand two things: Freud's idea, stated in a note he wrote at the end of his life—indeed, the very last entry in his collected

works—that mysticism implies recognition of universal energy, more particularly, libido or the instinct for life that informs and underlies living beings, who are in effect its manifestation or emanation; and Winnicott's idea that the mystic withdraws from the world of external reality to communicate with his deepest or most embedded introjects, who alone can give the mystic the will to live when society does not suggest any reason for continuing to do so—who alone can give the narcissistic supplies or emotional fuel (the succor and solace, if one will) necessary to survive. Grey's figures are at once representative of the life force and externalizations of his deepest introjects—of the beings closest to him, under his emotional skin, as it were—the beings who are the saving grace of his being.

These two psychoanalytic ideas of mysticism are not incommensurate, as suggested by the fact that they both imply a merger with the fundament of life—a kind of orgasmic recognition of it, in which one's particularity seems to dissolve into it or become one with its generality. And yet in Grey particularity is always maintained: his figures are distinct, even hermetically self-contained individuals—this is suggested by their invisible yet taut skin, which keeps their inner parts together, and gives them a human appearance and identity—for all their "universality," that is, "merged" quality. They retain their integrity and reality, however engulfed and irreal they seem. This points to the Winnicottian side of the "cosmic" or "oceanic experience," as Freud called it: the experience of immersion in universal energy—and correlate with it the intuitive recognition that the organs and systems of one's body are universal—leads to renewal of one's sense of unique selfhood, that is, a kind of regeneration of one's being in all its specificity. Most of Grey's figures are in a state of perpetual regeneration: feeling and seeing the life force flow through them—for it is their inner vision of themselves that Grey pictures—they feel and look perpetually fresh. Grey's *Holy Child* and (implicitly holy) *Family* (both 1996) make this particularly self-evident, with their whorls of rainbow colors and sacred centers, and incredible vitality.

This, I think, is what Grey means by describing his figures as "transfigured." One recalls that Christ, when transfigured, seemed to become, literally, pure universal light, that is, everlasting energy, transcendent of material being. Grey's Christ, even when crucified, is identified with the energy of light, as *Nuclear Crucifixion* shows: the aura surrounding him, and in effect emanating

Alex Grey, *Birth*, 1990–91. Oil on linen, 44" × 60". Courtesy of the artist.

from him, and in which he ambiguously participates, is the famous mushroom cloud of the hydrogen explosion, in effect a mystical cloud of pure energy, as the light at its center—directly behind Christ's head—suggests. (*Nuclear Crucifixion* pictures, as it were, Einstein's famous formula, energy is equivalent to mass [matter] and the speed of light squared.) Thus even in agony and surrounded by signs of death, Grey's figures are radically alive on the inside, as *Insomnia* (1995) and *Despair* (1996) suggest. Their transparency is meant to reveal their irreducible if at times troubled vitality.

But they also have a programmatic character, as Grey states. Each is, however unwittingly, an impersonal—better yet, "transpersonal"—actor in a "miracle play," as it were: a figure that has its appointed place in a fated ritual. In a sense, it is no more than a transient moment in the universal cycle—eternal narrative—of life and death. All of Grey's figures represent some phase or other in an everlasting, continuous process of decay and renewal. They are shown either waning, that is, discharging or losing their life energy, which leads to mental and physical disintegration and finally death; or waxing, which means to be reenergized, mentally and physically, by the cosmic life force. Grey wants to make religious art, as he says, and he is aware that all the religions—he mentions Buddhism, Christianity, and Hinduism, among others—converge in a cyclic vision of existence, which is reflected in the ups and downs of emotional as well as physical life. They also converge in the sense that life, however mortal, is anchored in a certain immortal—recurrent, unavoidable—reality. Life is a limited organization or channeling of seemingly limitless energy, and when it dies this energy is released, as in *Nuclear Crucifixion*. Life is universal energy at its most manifest and concrete—universal energy in definite, differentiated, particular form (indicated by the various systems of the body Grey illustrates)—but in light it exists at its purest or irreducible and, from the point of view of life, most abstract and detached.

Grey is determined to articulate and communicate, as unambiguously as possible, the ultimate truth of existence as all religions understand it: the fundamental truth that all living beings are finite forms or manifestations or materializations of infinite, universal energy, and that when they die they become pure energy once again, which means that they return to the larger universe of energy. Every living being is, so to speak, a temporary expression of universal energy—a vision not unlike Lucretius's more materialistic one. To recognize

this—to recognize that there are no exceptions to the rule—is liberating. Realizing that we ourselves, in our bodies and minds, are part and parcel of a universal process or cycle of energy, eases the pain of material existence, particularly the awareness of decay and death—loss of vitality—it brings with it. Understood as a necessary part of a universal process, they no longer arouse anxiety. Religious enlightenment has always sought to free human beings from suffering by helping them understand their limited lives in universal terms, and Grey's pictures serve the cause of religious enlightenment. They are therapeutic in intention, like religion at its best.

Their lack of ambiguity—indeed, focused intelligibility—is a great strength, all the more so because modern art has come to prize ambiguity as a truth in itself, which is to defensively avoid facing certain fundamental truths, including the ultimate truth about life. Grey has no need to equivocate, because this truth is too important to play intellectual games with. Similarly, he does not have to manufacture enigma—there is nothing deliberately mysterious about his pictures, which are straightforward, conscientious constructions—because this energy is enigmatic in itself, by reason of its primordiality. It is necessarily represented imagistically, for awareness of it exists below the threshold of verbal language. It is something we know in our bodies, which is the only way to truly know it. Images have a visceral appeal, unlike verbal language, which appeals to our intellect. When Grey pictures words, they tend to be cabalistic, which means that we are invited to see them as images (however abstract and obscure) not just words. An image lurks in them, like an underlying vision. The point is to undermine words, which are not as fundamental as images, which communicate with greater immediacy and efficiency. They seem part of the substance of our own mind in a way that words do not.

Grey uses many traditional symbols, which, whatever the difference in their "cultural construction," have a similar import. But these symbols, which are well-known, are not presented as ends in themselves, nor to demonstrate their universality. Rather, Grey wants to breathe new life into them by conveying the energy behind their idealism. He is aware that symbols of birth and death (for example, his self-portrait being born, by caesarian section, as a baby, and his self-portrait being torn apart by destructive forces representative of inner conflict), the fall of man (*Adam and Eve*) and heaven (*Collective Vision*), charts of the chakras and the image of the abstract mandala, have become

clichés—an exotic but empty part of the social spectacle, more particularly, a facile, degraded spiritual currency. Grey wants to restore their primordial impact—liberate them from social and intellectual reification. He wants to show their transfiguring power, and the transfiguration contained in them, waiting to be released by the viewer's inner vision, that is, by the viewer's own mystical enlightenment.

His pictures are meant to awaken and catalyze the viewer's mystical potential, and thus transfigure his consciousness and body. To be transfigured is to be "healed," as Grey says, and the healing purpose of his art is crucial: to be healed is to experience the intense life energy that flows through one's body— the flow of Ch'i, Grey says, using the Chinese word for it—and thus to realize, in kind of epiphany, that one is not simply dumb matter. It is to become a New Man, to refer to the title of two of Grey's pictures—to become transparent to the depths of one's being, so that it becomes self-evident that one is a creature of light, for all the darkness and degeneration in one. Ultimately one's Body [becomes] as a Resonant Field of Energy, to refer to another work, which means that inwardly one feels one is pure spirit.

Grey's magnificent, all-encompassing altarpiece, with its numerous signs and images of the cycle of life and death, and the radiant meditative mandala at its center—it is the grand climax of his art, his most consummate statement of his ideas—is not meant to dazzle us with information and knowledge. Grey never uses any of the traditional religious signs and images in a dogmatic way, for that would be to make them seem inevitable, and only the flow of the life energy is inevitable. Nor need one understand the official spiritual meanings and purpose of Breathing and Firewalking and Tantra or the Lingham and Yoni, to refer to other pictures. Rather, the altarpiece, like all of Grey's works, means to give us a unique visual experience—mediate a vision that we spontaneously internalize, by reason of its luminosity, which breaks through the everyday darkness or unawareness of our consciousness.

Grey is one of the great painters of light, in all its subtlety and intensity: his paintings are permeated, indeed, saturated with—transfigured by—light, in a way that is rare in art history. He has a unique feeling for light; for him it is not something that is added to enliven an otherwise pedestrian image, as occurs in much realism, nor is it naively given, that is, a simple matter of physical fact, as in the positivism of Impressionism. Rather, light is something that flows

through the image, giving it an uncanny resonance that makes it seem to transcend itself. It is something that seems to exist independently of the image, however much it fills it. It is at once the backbone and flesh of the image. Grey's light has its own complex, subtle rhythm apart from the rhythm of the body it infiltrates and subliminally informs. It is the light that is sublime in Grey's oeuvre—which is the most important innovation in religious light since the Baroque (perhaps the last art to emphasize the sacredness of light, as well as its function as an emblem of the spiritual)—and that makes the mundane beings in them seem sublime, in every realistic detail of their exquisite being. (In modern art, only Paul Signac's *Against the Enamel of a Background Rhythmic with Beats and Angles, Tones and Colors, Portrait of M. Félix Fénéon in 1890* [1890], comes close to Grey in rendering the rhythmicity of light, and in Seurat's painting it is more illustrated than inwardly felt, and the light is more spectacular, indeed, pyrotechnical, than indwelling and uplifting. Painters of course have always dealt with light, and some of them, for example, the tenebrists and the many great masters of chiaroscuro, from Rembrandt to Rothko, as well as Van Gogh in *Starry Night* (1888), and Mark Tobey by way of his so-called white writing, seem particularly attuned to its qualities. But few of them have Grey's sense of light as having a certain character, indeed, of being a character in its own dramatic right.)

This is why it must be emphasized that Grey is a painter, whatever his mysticism. No doubt his mysticism inspires his painting, but his painting is mystical in its own right. His painting may exist in the service of mystical healing, but it is illuminating in itself, indeed, more illuminating than any of his symbols, which are themselves transfigured by his light. We need not know the meaning of every one of Grey's virtually encyclopedic array of symbols—we need not know the cultural source of any of them. We only have to experience the forceful luminosity and overwhelming rhythms of Grey's images and surfaces to have a so-called mystical, oceanic experience, that is, to be transfigured. The image, after all, is more fundamental than the word, and the light that energizes the image is more fundamental than it, and it is that light that shines from every pore of Grey's paint, even when it seems completely opaque, as in its rendering of the blackness of outer space. This is the ultimate transcendence.

Warhol's Catholic Dance with Death

I realized that everything I was doing must have been Death.
—Andy Warhol, interview with G. R. Swenson[1]

At about the middle of the journey through life, I found myself in a dark wood in which I had lost the right way. Ah! How difficult it is to speak of this wood, wild, rough and dense; to remember it renews my terror. It is so bitter that death could hardly be more so.
—Dante, opening of the *Divine Comedy*

In addition to sadism, the passion to destroy life and the attraction to all that is dead (necrophilia) seem to develop in the new urban civilization.
—Erich Fromm, *The Anatomy of Human Destructiveness*[2]

The intriguing thing about Andy Warhol's endless output of death images is that they invariably deal with premature and public death, instead of what death is supposed to be: a solitary event in which one meets

one's maker and oneself. Marilyn Monroe and Jesus Christ, the 129 people who died in the crash of a jet airplane, suicides and the people who died in automobile accidents and other manmade disasters—none of them had much of a chance to look themselves in the eye before they died, and no chance at all to prepare to meet their maker. Certainly not Christ, who died feeling abandoned by God his father. There was no time to reflect on one's life—not even the split second to see it pass before one's eyes, as it is supposed to at the moment of death—nor to ready oneself in private for the Infinite's evaluation of one's finite existence. With death, there is only instant nothing, the complete and uncomplicated negation of life—implicitly the same "nothing" that Warhol said was behind the surface of his paintings and films and himself.[3] Why, then, if there is nothing behind the surface of art and life—if they are, as it were, self-negating—have faith in them?

This is the question Warhol's oeuvre addresses, or rather the quandary it states. It offers no answers, only states a fundamental difficulty: the problem of keeping faith with what keeps faith with no one—life, and its meager reflection, art. Sooner or later, both die, betraying one's faith in them. Warhol's art, and life—persona—signal his personal crisis of faith and, more broadly, his fascination with eschatology—his speculative engagement with death, immortality, judgment, and resurrection, and the uncertainties surrounding them. Warhol's art is implicitly Catholic—he was apparently brought up in an atmosphere steeped in Catholicism and regularly went to church (whether out of habit or piety is not clear)[4]—but it is the Catholicism of Doubting Thomas, in need of physical proof of Christ's divinity. No simple trust—the innocence of the childlike believer—for Thomas; no taking Christ's bodily resurrection, the sign of his immortality, on faith; instead, the body must be touched, the wounds probed: matter-of-fact literalness—commonplace actuality—alone could induce conviction. Warhol subjected his "immortals"—his divine celebrities—to a similar reality-testing. He played the Doubting Thomas to their Christlikeness. His famous coolness—detachment—was the mask of his skepticism. He touched, probed—pawed, felt—their person, presence, in the immediate physical intimacy of making and remaking their images. It was an act as intense and demanding and erotic and involving as sexual intercourse. He tested them again and again—repetitively resurrected them—and found them wanting—discovered, to his horror and despair, that they were false idols, empty effigies.

Where Thomas finally came to believe, Warhol never did. Materiality is proof of meaninglessness for him, not meaningfulness. Warhol's art is about his letdown, despite his wish to be lifted up: about his inability to transcend his doubt—that important suffering and temptation on the way to sainthood—about his inability to make the leap of faith. For the physical evidence spoke against it. Indeed, mocked it—mocked immortality: the celebrities his art resurrected proved to be illusions, for their bodies disintegrated on touch, indicating that their immortality—the aura created by their glamour—was a sham. They may seem intimidating, by reason of their fame, but they are in fact as banal and doomed as everyone else, as their fragile, decaying appearance indicates. They offer the demeanor not the reality of immortality; they are the Anti-Christ not the true Christ. They die on contact, indicating that immortality is a big lie. Intimacy gives the lie to their fame. Closeness shows they are frauds.[5]

And yet, and yet . . . Warhol never lost his yearning for the immortality fame seemed to confirm, his Catholic wish to believe that there was life everlasting after death and that fame was its sign, despite his inability to bring himself to do so—despite the hardhearted positivism which demanded concrete proof, despite his all-American put-up-or-shut-up attitude. In the end, under the scrutiny of Warhol's surgical eye, with its enlightenment insistence on the facts and only the facts, its hard look at life, the famous—those offered that ultimate narcissistic gratification, the admiration of the anonymous crowd, the mirror of millions of curious eyes, that true sign of success, which convinced them that they were immortal, or at least that they deserved to be, for the love of the crowd felt like the happy outcome of the last judgment—betrayed even the possibility of immortality. (Fame itself came to seem self-debunking, because it was short-lived and universal: if everyone could be famous for fifteen minutes, it was hardly worth the trouble, even as a surrogate—second best—for immortality.[6]) It is this conflict that is at the core of Warhol's art and life: he hoped that the famous and glamorous would live up to the faith and hope that he, and millions of others, charitably invested in them, but they failed everyone, for they, also, died, however much their image lived on, as a wishful symbol— the visual embodiment of magical thinking—of what they did not really have and what did not really exist: immortality.

As indicated by the numerous images of everyday death and disaster in America, as well as the implicitly interminable series of skulls and shadows

(ancient, indeed, archetypal symbols of death) and guns and electric chairs (modern instruments of death)—and perhaps above all of crosses—Warhol was fixated on death, the most undeniable fact of life once it came to exist, indeed, the apparently irreversible, bottom-line truth about it. (Repetition itself is a kind of kiss of death, for it cancels into insignificance and ennui, while superficially elevating into universality.) And yet the Catholic religion claims that it can be reversed—that it is a transition to everlasting life: if one believes in Jesus Christ—if one is "saved"—then one will endure forever, in paradise no less. Death is a passage to immortality—paradoxical proof of it—if on terms decreed by God's judgment, and eventually confirmed by the resurrection of one's body. Warhol was conditioned to believe in this, but he could not bring himself to do so. He became burdened by doubt, and made an art that embodied it and mocked faith, even as it ironically suggested it—toyed with the idea of it. His acute awareness of death became the vehicle of his insurmountable doubt. Like the Buddha, he was disillusioned by death, but unlike the Buddha he did not achieve the enlightenment about life that freed him from attachment to it (and thus from the doubt that death cast on it)—an attachment which took the form of art and the desire for money, which converged in his idea of "business art."[7] He struggled hard to be detached, but he was more depressed than detached.

Warhol's saving grace was that he had the self-consciousness and depth to understand his own lostness in the surface of life. His art depicts lost souls like himself: souls who want to be saved, and think they can be saved, but have made the fundamental mistake of thinking they can be saved in this life, that is, become immortal in this life, on their own and by themselves, which is what gaining fame signals. This is a fundamental error, indeed, for the Catholic Warhol—and I think his art is as Catholic as that of any Italian Renaissance artist, but in modern vernacular terms—a grave, mortal sin. For one can only be saved through Jesus Christ, and in the next immortal life, not in this mortal one. Like Dante, Warhol shows souls who have more faith in themselves than in Christ, and so who are damned forever, but unlike Dante he does not show souls who have purified themselves and ascended to paradise. He is unable to do so because he has no faith, only doubt that there is salvation, and with it self-doubt.

Warhol portrays people trapped in hell, individuals who are damned

not because, like Paolo and Francesca, they loved each other too much, but because they loved only themselves, rather than God or anyone else. Such self-love seems to shut out all the doubtful others in the world and eternity, but it is an indirect way of acknowledging the self's need for them, indeed, wish for their love. Warhol is fascinated not so much by the glamorous appearance of the famous, as by the extreme narcissism it signals. It is their pseudo self-sufficiency that he portrays, in an attempt to see the nothingness behind it. He wants to see through their narcissism to the self-doubt—the sense of being nothing—that it masks and denies: a sense of being nothing that can only be overcome by taking others—especially God—on faith, to the extent of loving them uncondi-tionally. But the famous cannot do so; they can only love themselves, and use others to confirm that self-love—use others as narcissistic extensions of them-selves.

Warhol knows he is one of them: one of those who hide their enor-mous self-doubt and great need for love by doubting others and God, who can give them the true love they need. Because of their doubt—their refusal to trust, to believe in others and God—they will never get the love they need to grow, and never accept and love life, which is why they are in hell, forever. Warhol shares this private hell—but he intuitively understands its psychodynamics, whereas his fallen stars refuse to. Indeed, their profound narcissism has made them too stupid to understand anything, even themselves. Warhol offers us a new, accurately modern vision of inferno, an inferno he understands from the inside, because he knows better than anyone what it is to live in the self-decep-tive narcissistic inferno called fame. His art is thus a necessarily incomplete *Divine Comedy:* there is no paradise to reach, for there is no escape from hell, and so no purgatory.

Nonetheless, Warhol had to pretend that there was paradise—had to manufacture a paradise—however false he knew it to be: the paradise of art, which can make anyone seem immortal, or the next best thing, glamorous. Glamour is a mode of idealization, and as such a blessing. Social in origin, it is ultimately confirmed—even seems to be bestowed—by the Godlike make-up artist. Warhol was one of the best yet. With insidious dexterity and craft, he was able to confer the ultimate glamour on the already glamorous: he turned them into glamorous art—the last and best judgment on them life could possi-bly make. He in effect saved them from their mortal selves by giving them a

heavenly appearance (however much it was a chimerical caricature subliminally)—as close as they were ever likely to come to immortality. In giving the gift of eternal artistic life to the famous and would-be famous, as though to ensure that they would be stars forever, as well as to his numerous worshippers, socially big and little—for why else be portrayed by an artist unless one believes in him, that is, believes that his art will last?—Warhol arrogated to himself Christ's power to perform miracles and pass the last judgment on life.

This is Warhol's ultimate blasphemy, but it is redeemed by his ironic realism—his morbid talent for superficializing everything he artistically touched, which is his way of doubting it. In turning the people he represented (and their social attributes) into appearances that, however spectacular, are essentially banal and empty, Warhol indicates that he has little or no faith in them.[8] The ironic aura with which he surrounds—indeed, in which he submerges—his subjects is conspicuously superficial—literally nothing but a surface, indeed, a surface treated as a thing in itself; and their peculiar inertness suggests that they are inwardly dead, however outwardly—superficially—alive. Warhol ironically immortalizes them, but his portraits are ultimately a Triumph of Death over life, with Warhol as Death, corrupting the flesh of the living, as indicated by their blurred, washed out look, suggesting their ephemerality, and perhaps above all that their life was a slow suicide—unwittingly self-destructive. In the grand tradition of such Triumphs, Death appears on stage, usually in the form of a corpse or skeleton—comes in person for the living, terrifying them—but in Warhol's portraits Death is the invisible hand of the artist, insinuating itself into his famous subjects to confirm their superficiality, without disturbing them.

Ironically, it is perhaps because they were chronic, indirect suicides that they became celebrities.[9] They became secular immortals because they profaned their life by playacting it in public, indicating that they did not really take it seriously, let alone regard it as a sacred trust. They in effect threw life away by treating it superficially, turning it into a kind of farce—the performance of a frivolous dream, rather than a serious reality. This suggests that they had no faith in themselves. In fact, Warhol's cosmetic treatment brings out the farcicality of his subjects in the very act of heightening their glamour, indicating that he regarded glamour as a kind of farce and the glamorous as too superficial to do anything but clown their way through life. In the end their failing was that

they lacked religion, which is why they betrayed themselves—lost their self-respect—and life. Warhol's eschatological treatment of them showed that he had religion, however insecure his faith.

One last point: Warhol was fascinated with death because it can occur, unpredictably, at any time and any place, which means there is no point in worrying about when one will die—no point in being terrorized by death. Thus Warhol's stoic coolness towards death—his "wisdom" about it, and even about life; if one could face death calmly, nothing could disturb one. (In its unpredictability dying is like falling in love, which is why Warhol may have been half in love with death.) Nowhere is this cool attitude to death—no doubt masking an uncanny awareness of it—more clear than in the city, where it is a daily occurrence, treated matter-of-factly—superficially—even when it is sensational. To jump off the Empire State Building may give one one's fifteen minutes of fame—if that—and no matter how famous one is it rarely takes more than fifteen minutes to read one's obituary. And then one is forgotten, as though one had never existed. It is as though one had no value and authenticity to begin with, which is why one's life is instantly devalued and rendered inauthentic. No matter how famous, death demonstrated that one was a false idol—which is what Valerie Solanis declared Warhol to be by trying to kill him (1968)—and thus one's life a deception.

Oblivion is the ultimate theme of Warhol's pictures, and oblivion is characteristically urban, a feature of life in the crowded city—a fatal feature: everyone dissolves in the crowd, becoming a hadean ghost—which is what a Warhol portrait is—to everyone else in it. Obscurity is the rule in urban life, and obscurity is oblivion in action. However much one may rise above it—become famous—one remains forgettable, a drop in the crowded bucket, one's fame a passing fancy in an engulfing reality. Fame is never more than a temporary reprieve from oblivion, and in the city this truth is transparent. The city may give fame, but it always takes it away, which is the lesson of Warhol's urban art.

In other words, this characteristically superficial recognition of death signals the city's death instinct. It is the city's annihilation anxiety turned inside out. It is a defense against the sense of annihilation—the sense that one is nothing—one feels in its crowds. The city may barely skip a beat for this or that person's death, but this instant sinking into oblivion and obscurity, this treatment

of death as a superficial event in a world crowded with superficial events, this sense that no one is truly memorable whatever they do, is death at its most absolute, insidious, cynical, and effective. The reluctance, even refusal to remember the dead—the unreflective quickness with which their place is taken—is the death instinct in ironical action. Death treated superficially is death at its most triumphant, and nowhere is it more triumphant than in the crowded city. I think it was Warhol's ability to render the urban public's unconscious ambiguous attitude to death that caught the public's imagination, more than his stargazing.

The city shows its love of death—"deadliness"—another way: by its fast pace and inhuman scale. Warhol's dehumanized figures, innumerable series, and rapid production—as though in a race with death—are the artistic equivalent of this necrophilia. They suggest that everyone is secretly dead and redundant, perhaps a robot marching in place. In the city, everyone seems machine-like—matter in mechanical, programmed (if hyperactive) motion—because one has no intimate relationship with anyone, at least in public. One's intimate, trustworthy, "organic" relationships are few and far between in the mechanical city. In short, the city is a society not a community, as Ferdinand Tonnies says.[10] In a community there is "intimate, private, and exclusive living together," while society, epitomized by the city, is the "mere coexistence of people independent of each other." The city is, as it were, a necropolis in spirit, if not literally. Warhol is a city artist par excellence—a trafficker in pseudoindependent urban types. And like all urbanites, he is implicitly necrophiliac—indeed, perhaps the ultimate artist-necrophiliac—as his assertions that he "want[s] to be a machine," that he "like[s] boring things," and that "everyone should think, act, and look alike" indicate.[11] To be a bored look-alike machine is a defensive strategy against the sense of living death that in fact confirms it. Fortunately, Warhol's Catholic doubt —the painful conflict between his wish and failure to have faith—kept him alive, however much it was a form of slow, deliberate, self-conscious suicide, and as such the only thing that gave him a true sense of self.

Notes

1. Quoted in G. R. Swenson, "What is Pop Art?," *Art News 62*, (Nov. 1963): 60.
2. Erich Fromm, *The Anatomy of Human Destructiveness* (Greenwich, CT: Fawcett, 1975), 191.
3. Quoted in Kynaston McShine, ed., *Andy Warhol, a Retrospective* (New York: Museum of Modern Art, 1989), 457.
4. See John Richardson's eulogy for Warhol, ibid., 454
5. As Warhol said, in *The Philosophy of Andy Warhol (From A to B and Back Again)* (San Diego: Harcourt Brace Jovanovich, 1975), 68, "the only people I can ever pick out as unequivocal beauties are from the movies, and then when you meet them, they're not really beauties either, so your standards don't even really exist." This statement, which mingles disillusionment and doubt, is confirmed by Warhol's assertion that "being famous isn't all that important" (78).

6. Warhol quoted in McShine, 460: "In the future everybody will be world-famous for fifteen minutes."

7. See Ibid., 459

8. Warhol's art clearly belongs to what Guy Debord called *The Society of the Spectacle* (New York: Zone Books, 1995), in that it transforms what "once was directly lived" into "mere representation" (12), thus effecting a "negation of life" (14) into a "realm of appearances" (15). In such a world "appearing" is all (16), and "individual reality" has only a "social character" (16). "The spectacle is... a specious form of the sacred" (20), and the commodity par excellence. Its function is "the concrete manufacture of alienation" (23). All of this directly applies to Warhol's spectacular art, even if it is not its whole story.

9. I am thinking of Karl Menninger's idea of "chronic, indirect suicide"—prolonged, unconscious self-destruction—as distinct from "acute suicides," that is, those who consciously destroy themselves. Warhol was drawn more to the former than the latter, who no doubt are more necrophilically fascinating. Actors particularly fascinated him because to be an actor was to live an imagined life rather than a real one, and so to commit suicide without knowing it. See Menninger, "Psychoanalytic Aspects of Suicide," *A Psychiatrist's World* (New York: Viking, 1959), 346.

10. Ferdinand Tönnies, *Community and Society* (New York: Harper & Row, 1963), 33–34.

11. Quoted in McShine, 457–58.

The North Stripped Bare: Odd Nerdrum's
Norwegian Existentialism

Again and again we see in Odd Nerdrum's paintings a bleak, altogether lifeless landscape, or else, what is the equivalent, a neutral ground. Sometimes it is mountainous and stony, sometimes a broad flat plain, sweeping through the picture like a trace of the infinite. It is a kind of placeless space, and while there are exceptions to it, perhaps most noteworthily *Summer Day* (1982) and *Early Morning* (1984), with their luminous nature, it is almost always empty. The figure has no impact on the space, which abides eternally.

This raw void—more oppressive than liberating, that is, more abysmal than sublime—is an image of the Northern tundra. It is the same wasteland we see in the far distance of Leonardo da Vinci's *Mona Lisa* (1503) and Albrecht Altdorfer's *The Battle of Alexander* (1529). It is no doubt a real landscape—no Norwegian can be unaware of the Arctic world, where the earth seems inorganic, and Nerdrum has visited Iceland many times (lava appears in several works, and others have a sulphurous tint that reflects volcanic activity)—but it is also an existential landscape: a space where life and death are at war.

The battle is never decided; the struggle is perpetual. The human beings in Nerdrum's pictures are often at odds with each other and themselves, but most of all they are at odds with the environment they inhabit. They define themselves—become themselves—in defiance against it. Yes, they are constantly

Odd Nerdrum, *Five Persons around a Water Hole*, 1992. Oil on canvas, 113" × 142".
Courtesy of the artist and Forum Gallery, New York.

on guard against one another, as the guns they carry indicate: on the defensive, but the guns also signal their innate hostility. And their relationships are far from loving; *Iron Law* (1983) and *Woman Killing Injured Man* (1994) make the point succinctly. And they are often confused about their identity, as the various images of hermaphrodites suggest. But they are most vulnerable to the landscape.

Heidegger has said: "The being that exists is man. Man alone exists." In Nerdrum's pictures we see man alone; in no space is he more alone than the desert—Nerdrum's desert, all the more harsh because it is a Northern desert. There he can "outbrave the utmost," that is, "Being toward death," to use Heidegger's term, and realize his own existential nature, that is, stand "in the openness of Being." Nerdrum's desert landscape has a contradictory meaning: it is both the thrownness to death which man bravely faces and the openness of Being in which he can stand. Nerdrum's desert is a place of threat—impending catastrophe, as The *Black Cloud* (1986) suggests—and possible grace, symbol-

ized by the water hole that *The Water Protectors* (1985) surround—it also appears in Five Persons around a *Water Hole* (1992)—and above all by the majestic *Woman with Milk* (1988), who appears in the desert like a divine savior. (The apocalyptic cloud is both sacred and profane, a sign from God that the world will end, and the man-made atomic cloud or pollution that will bring the end.)

The question is whether thrownness can become openness. Death dialectically participates in Being, and Being in death, but Being must triumph over death if man is to endure. The question Nerdrum's paintings asks is whether man, isolated and thrown in the desert, can open himself to Being. Must he, like Nerdrum's *Revier* (1986), remain wounded and closed in on himself, protecting himself from attack, that is, always aware of—thrown toward, even possessed by—death?

It is a constant threat in Nerdrum's pictures because his people are unable to care for each other. Indeed, they seem inherently incapable of care. "'Standing it,' . . . enduring, is experienced under the name of 'care'," Heidegger writes, but Nerdrum's people do not care. They seem constitutionally unable to understand that to care for each other—to help each other endure, stand existence—is to stand toward Being, indeed, take a stand for Being, and thus to realize the nature of their existence—their humanness. Caring is a fundamental way of being human, and thus of opening toward and finally standing in Being—enduring in the deepest sense. In a sense, Nerdrum's figures do not really exist—they are not fully human—because they do not care for—indeed, love—each other. There is an opening to Being through care—man can begin to stand in Being if he cares—but Nerdrum's figures do not deeply care for each other, indicating that subconsciously—to use Nerdrum's word—they do not really care whether or not they exist. As I would say, they are terminally sick with the death instinct.

Yes, there are certain wonderful exceptions, such as *The Lifesaver* (1995–96), which shows a warrior lovingly holding a newborn baby, and certainly Nerdrum's numerous images of infants suggest that he cares, as do such sacramental still lives as *A Pear* (1990) and *Bread* (1991). But by and large Nerdrum's human beings are radically defective. Indeed, many of his figures lack a limb or two, a physical crippling that symbolizes psychic crippling. Many are in fact conspicuously demented. Other figures, while physically whole, seem

psychically disturbed, even mad. Nerdrum's human beings are damaged, and even when they seem ideal, as many of his women do—perhaps because they care for children—there is something that disturbs the picture. Some nameless dread afflicts them, as in *Night-Light* (1981–98), or one is reminded all too strikingly—with Swiftean perversity—of their bodily functions, as in *Twilight* (1981), where a woman shits in our face, and *Pissing Woman* (1997–98; another cripple).

Norway has a long existential tradition in literature and art—Henrik Ibsen, Knut Hamsun, and Edvard Munch come to mind—and Nerdrum's painting is the contemporary extension of it. It can be argued that the tradition goes back to the Old Norse literature—the Eddas—of the Middle Ages, which is the source of Germanic and Northern mythology in general. Wagner used Norse mythology to convey the human condition and comment on contemporary life; Nerdrum also has a mythological cast of characters, which while not derived from the Eddas nonetheless remain conspicuously Norwegian or at least Scandinavian. He too comments on the quality of contemporary life, and deals with such issues as the threat of nuclear holocaust (the black cloud paintings), Vietnamese boat people (*Refugees at Sea*, 1979–80), and terrorism (*The Murder of Andreas Baader*, 1977–79). Like Munch, he has a "special psychic sensitivity," and deals with "profound existential tragedies," in which "neurotic elements" assume great importance, to use the language Werner Haftmann brought to bear on Munch. Nerdrum's paintings, like Munch's, form a "frieze of life."

But there is a great difference between them: they part company, for Nerdrum is a neotraditionalist, obsessed with Old Master beauty, while Munch is proto-Expressionist, that is, a pioneering modernist. Nerdrum's painting represents a massive rebellion against modernism, even as it reaffirms Norwegian existentialism. Nerdrum in effect declares that modernism is dead and, more crucially, that it had more to do with art than life. Hence Nerdrum's controversial assertion that his work is kitsch, and that kitsch is superior to art in that it has human appeal. Kitsch is not, as Broch and Adorno argue, an ideological mass-mentality phenomenon, aesthetically and ethically defective, but rather "concerns the individual, not politically—but passionately," as he has said. Modernism states that "a work of art . . . must be new, it should contain colors we are used to in the modern world, it should not have tears, emotions, it should be discreet and contained [and] ironical." It is kitsch that has tears, emo-

tions, passion—a reinterpretation of kitsch that not only goes against the intellectual grain, but that allows Nerdrum to distinguish between good and bad kitsch—Rembrandt and Disney, that is, kitsch that stirs the psychic depths, reminding us of the irrationality of our existence, and kitsch that skims the surface, falsifying the meaning and drama of life.

A crucial aspect of kitsch for Nerdrum is beauty. One might say he puts beauty to kitsch use, that is, uses it irrationally, or rather to heighten the irrational feelings his figures and landscape evoke. The Old Masters are masters at staging, and Nerdrum has learned his theatricality from them. Gericault's *Raft of the Medusa* however transformed, is the model for his somewhat more idealistic *Refugees at Sea* and any number of Crucifixions and/or Depositions shape his sadistic Baader Meinhof painting. But what he really learned from the Old Masters was the "beautiful delivery" of "complicated [human] themes," as he says. Above all, he learned to use beauty ambiguously: it both sensuously enhances the archaic psychic phenomena he presents—makes them seductive rather than repellent, thus helping to draw us into the picture, not only out of curiosity but as participants (the real trick of Old Master staging)—and defends against their irrationality. Beautified, they arouse less terror; one can even contemplate them with calm detachment, which is the beginning of an understanding of them. Thus beauty gives us the strength to face what we would rather not face, and modifies it enough so that it seems comprehensible. This amounts to transcendence of the irrational—not only toward a rational understanding of it, but toward the tranquillity such understanding gives, which permits us to endure the inescapable irrationality of life—of others. By mediating the irrational truth about existence, beauty teaches us to care for ourselves and each other.

In short, good kitsch, Nerdrum suggests—beautiful Old Master kitsch—helps us weather the storms of life—helps us, as individuals, endure the terror of existence—and as such is a form of caring. Bad kitsch—the collective, ideological Hollywood kind that Broch and Adorno attack—is less beautiful than manipulative, for it uses irrationality to intimidate people into social compliance, as though society alone can protect us from ourselves—from the irrationality we inevitably harbor. Bad kitsch channels it socially, superficially rationalizing and legitimating it—which is not the same as confronting, understanding, and transcending it. Kitsch, Nerdrum argues, is truly aesthetic, while mod-

ern art—he singles out Pollock and Rothko—is glorified design pretending to be metaphysics.

Nerdrum's beauty is essentially tenebrist. He acknowledges that he learned his tenebrism from Rembrandt, the Northern master of it. But why the extremes of Northern tenebrist beauty, rather than the more harmonious, softer beauty of the Renaissance Italy—the South? Because tenebrist beauty is inherently psychodynamic—the epitome of psychodrama—as the conflict between light and dark—libido and death—inseparable from it suggests. Tenebrism is psychologically realistic, as it were, for it conveys the depths of the psyche as no other mode of beauty does. The real subtlety and brilliance of Nerdrum is the way he blends light and dark, giving the picture an ego—integrity. His works can be understood as a progressive effort to integrate them. Sometimes the balance tilts toward darkness, sometimes toward light, but in the most aesthetically intriguing and satisfying works—usually his portraits—they come together to convey a sense of human beings who are masters of their own irrationality. This is certainly the case in his *Self-Portrait in Golden Gown* (1998), where he rises above the darkness he stands in, even as it informs his presence. Indeed, his presence of mind, as the ingenious blend of light and dark that shapes his head suggests. All his irrationality is epitomized in his erection—no doubt a sign of his pride in fathering two children with a young new bride—and all his rationality in the Rembrandtesque gown, at once luminous and gloomy, he dramatically lifts to display it. Its irrational presence is the trophy of his self-understanding. He has at last become truly existential man.

This essay is reprinted with kind permission from Art New England, *April–May 1999.*

SELECTED INTERVIEWS

An Interview with Donald Kuspit

Suzanne Ramljak

Suzanne Ramljak: What led you to make the shift from philosophy to art history and art criticism?

Donald Kuspit: Philosophy gave me certain fundamental ideas, which then I wanted to apply to something that had greater existential and emotional interest for me, and that was art. The shift also involved a movement from ideas to objects and finally to people, and the effect art has on them. I came out of the hermetic cocoon of philosophy to the art object it could not subsume and finally to the person for whom the art object was made.

SR: Still there's the question, why art? There are other tangible objects that you could have philosophized on.

DK: I had the illusion that art involved a kind of inner freedom and spontaneity. It was no doubt part of the clichéd distinction between the logical and the less-logical, between philosophy's neat package of categories and what did not fit into them.

SR: Do you still have that illusion?

DK: No, although I do think art is somewhat less logical than it looks. Art is

invariably over-determined by sociolinguistic codes and unconscious structures. However, genuine creativity does create the illusion of inner freedom, which I think is necessary for survival.

I was interested in Hegelian dialectic, as it was used by the Adorno, my *Doktorsvater* and one of the key thinkers in the Frankfurt school. Art appeared to me as a sum of contradictions that did not add up to a coherent whole. I was seduced by the endless play of contradictions in it, which seemed to reflect those of society and the psyche. Art is an illusion that brings into focus the perversity of reality.

SR: How would you characterize the difference between philosophy and criticism? I would think as a trained philosopher you would be impatient with a lot of criticism owing to its faulty logic or lack of rigor.

DK: Philosophy generates theories that seem to stand on their own, and are then "applied" to practice. Criticism understands theory as part of practice, and subsumes both into experience. Criticism begins with a responsibility to experience, moves through awareness of practice, and ends with theory that seems to clarify the depth with which a particular practice is experienced. Criticism is more than either theory or practice, has fewer presuppositions and expectations than either, and is aware of the larger lifeworld in which both occur and which both try to shut out.

SR: You clearly have a diverse repertoire of ideas and theories, from Hegel to Marx and Freud and numerous others. Do you intentionally avoid one theory or aesthetic?

DK: There no longer seems to be one dominant, uniquely relevant theory, nor much common ground between different theories. So, I feel free to use them all, hopefully discretely, as so many facets in a Cubist collage, each made ambiguous by the company of its neighbor. Hopefully there's some coherence in the picture I create, but it is not binding, and its ground can shift. There is also undoubtedly too much inadvertent irony, but that's a good way of not being dogmatic. It's a way of using my own uncertainty as a critical weapon, making it a conspicuous part of the picture.

SR: So no single model can capture the complexity of art and culture today. Do you think such an encompassing theoretical model is hopeless, or is it that you personally have no desire for one?

DK: It's not that I have no desire for one—everyone wants a true model—but it is part of being a critic to question this desire. Every such model is a kind of intellectual totalitarianism, masquerading as an intellectual utopia. Also, I think the wish for one true model reflects anxiety about the abundance and complexity of art today. It is a kind of arrogance masking fear of engulfment. It's an attempt to cut a straight path through a jungle; which is not exactly exploring the wonderful, different kinds of life. For me, the wish for one model, whether of art, criticism or philosophy, is inherently suspect.

One has to be open to the variety of models, even though this may seem to lead to chaos and self-contradiction as Cubism seems to. Critics who develop a fixed understanding of art do so to privilege a particular art and theory, implicitly demeaning every other art and theory. They want to close down the field of production and understanding, while for me it is the overall field that is interesting. You cannot simply dismiss all kinds of art because they do not measure up to some tyrannical critic's version of the avant-garde. There are many critics who are ready to betray all of art in the name of some sacred cow they happen to worship.

SR: Though you want to avoid "closing down the field," as you put it, you have to admit that we must exclude and draw a line to assert anything.

DK: In practice one does exclude, for unconscious as well as conscious reasons. However, one has to make hard choices on the basis of experience rather than determine them beforehand on the basis of some preconceptualization. One has to be flexible in critical practice, and out of that flexibility one can discover the art one prefers and the art one is willing to privilege, if not absolutely.

SR: You repeatedly privilege terms like freedom, openness, authentic, and expressive. . . .

DK: True, although I'm not interested in expressionism per se. I am interested

in what it means to say that an art is "expressive." There is no such thing as an expressively neutral art, although there is art, such as Minimalism, which seems so. One has to understand why it aims at expressive neutrality, what the complexity of the attitude is behind that.

SR: How do you define something like authenticity or attitude? How do you know you are in the presence of an authentic work?

DK: The critic's sense of the work's authenticity is the final result of his or her interaction with it. This interaction involves the stylistic and iconographic character of the work, and its location in art history in general and the contemporary scene in particular. There must be some effort to pinpoint its significance in the field of art operations. This is all intellectual. But whether a work seems authentic or inauthentic also has to do with its emotional effect on the critic, assuming he or she can become genuinely attuned to it. Like any spectator, the critic is a prepared ground—hopefully better prepared than any other spectators—in which a work of art can take root and grow in meaning and value. But it may wither in the critic's perception and seem conceptually trivial. Subjective as well as objective factors contribute to one's sense of a work's authenticity or inauthenticity. That is, one's own sense of authenticity is at stake in any determination of a work's authenticity. It is invariably a treacherous dialectical process.

SR: I assume you are impatient with much of postmodernism and its attempt to efface originality and be inauthentic.

DK: It depends. Some of it is very funny, and I like wit and humor in art. However, as with the desire for one model, one has to understand the wish to efface originality and be inauthentic. It's another attitude, and the question is, "what is it about, and why is it happening now?" It has its own "authenticity" and "originality," although it has become hackneyed rather quickly. Copying copies— canceling already canceled originals—has become pseudo–avant-garde chic, as facile as fashion. I don't know any postmodernist who had the courage Duchamp had when he restored Leonardo's *Mona Lisa* to its pristine condition, suggestion that antioriginality and inauthenticity were mass culture clichés, and originality

and authenticity were "in" again. Duchamp suggested that mass culture, which once seemed naive and so liberating, had become cynical, and it was time for art to again become sincere.

SR: Even so, given a choice, you still prefer what you call "wet" art—richly drenched, personable work. I find it hard to believe that you are totally comfortable with all versions of inauthenticity.

DK: I can be comfortable with anything. Whether I like it is another matter. At certain times the "wet" is desperately necessary because the dry has become a parched desert. I think William Tucker is exemplary in this respect. He spent twenty years making sculptural constructions, following the objectivist machine model of art. As he said, what seemed at first exciting and modern soon became routine and passé. He realized that the promised utopia had turned out to be an inhuman desert. So he began to model, turning to the body—making sculptures that imply what he calls the "inner body." He became wet. This shift is important and is beyond the question of whether an art is avant-garde or retardataire. Tucker realized the existential necessity of revitalizing the sense of being a subject through engagement with the body, including the body of sculpture. This has been a recurrent issue of twentieth century art, and it is basic to the modern lifeworld, which tends to be hostile to the subject.

SR: So you are looking for what you call the "archaic naiveté of the senses" or primordial, indiscriminate sensuality to give us a sense of self?

DK: Let me answer by saying that I believe that art has to facilitate our belief that we can be spontaneously creative selves. It is necessary for psychological survival in our society, which however materially wonderful—and clearly it is not materially wonderful for everybody—is hardly fit to live in psychologically. If art doesn't help us believe in ourselves, it will become another wretched part of our unfit environment. My senses of the service art has to offer are strongly conditioned by my sense of the suffering and general stupidity and waste of life in modern society, especially the United States.

No doubt I'm idealizing art as a kind of last hope, but I see a radically sensual art as the private alternative to the big social lie, as an oasis in the

wasteland. I am interested in art that seems to suggest controlled regression to polymorphous perverse freedom rather than art that is a pseudointellectual game, and as such seems as manipulative as the big social lie, however much it pretends to debunk it.

SR: To realize that anything and everything can have a certain physical appeal. . . .

DK: The erotic is everywhere in our society, but that doesn't mean it involves a return to psychosomatic fundamentals. It has become the sugarcoating on the bitter medicine of one's daily depression. Many people take drugs to get that old, primordial feeling, which gives them a sense of being real and alive and "different" to counteract their sense of unreality and indifference and the deadening effect of the world they live in. Art is a less self-destructing way of freaking out, as it were, of counting oneself out of the world, yet very "in." Art does less damage to one's mind and body. Also the feeling of being real and alive and different lasts longer when it comes through art.

SR: So of all the different functions of art you would stress its regressive potential?

DK: I suppose so. For me it is ultimately a way of getting in touch with the subjectivity I forfeit everyday in dealing with the objectively given world. It is way of getting beyond the reality principle by going back to the pleasure principle.

I think of a work of art as a toy for adults. It is a kind of transitional object, to use D. W. Winnicott's concept. It is simultaneously subjective and objective in import. The child uses the toy to make the transition from the subjective to the objective, from dependence to autonomy, from pleasure to the reality principle. The adult uses the toy of the work of art to make the transition back to the interior reality he or she tends to forget in his or her dealings with exterior reality. It evokes a self that has been hidden so successfully that the adult tends to forget he or she has it. The regression, if you want to call it that—I tend to think of it as the recovery of a buried treasure—is no doubt risky and dangerous, but it is ultimately refreshing and revitalizing, and it reminds us of the great power interior reality has over us.

The child and the adult have different, equally unavoidable needs. We encourage the child to become objective, for its own survival. There is little in modern society, however, apart from art, that encourages us to become subjective, which is equally necessary for survival—emotional survival. Many people blindly act out of their subjectivity—it sort of explodes unexpectedly in their lives, as it will do when it is denied (our epidemic of social pathology testifies to this explosion)—while art affords a subtle, considered way of coming to terms with it.

SR: Specifically what kind of art best lends itself to this regression, to a heightened sense of subjectivity?

DK: It really depends on one's state of mind, one's unconscious affinity for the work. I believe one's relationship to art is a matter of elective affinity, to use Goethe's term. One doesn't know when an elective affinity will occur. And then one has certain elective affinities, and they grow a little stale. It's like the crystallization process Stendhal described in his book on love. That is, it's like falling in love. Rothko in fact spoke of one's relationship to a work of art as a kind of marriage. Stendhal pointed out that if you left a dead branch in a salt mine for a while, it would be covered with salt crystals when you took it out. It would look dazzling—utterly enchanting. But then, slowly but surely, the sun would melt the crystal, and then you would be left with the dry stick once again. In terms of art, the work, left in the mine of one's psyche, comes out looking magical and profoundly significant, but after a while, seen in everyday light, it seems just another object in the world. The process of elective affinity has run its inevitable course. One wonders what made love work in the first place. The critic is invariably a victim of this process of illusion and disillusionment, but he or she should be self-critical enough to understand its workings and compensate for it. Thus, he or she may err on the side of intellectuality, denying his subjective affinity for the art.

SR: We've talked about the work of art opening us up, and we've talked about the viewer opening the work of art. On the one hand, the viewer gives the work value, on the other, the work makes the viewer more subjective.

DK: That's the dialectic of it. They make each other! That's the elective affinity. I really think it's almost a sexual model. Certainly it involves the illusion of reciprocity. One has a consummate relationship with it which makes it seem consummate. One overestimates or idealizes it, as Freud said one does with any object one loves. There are a variety of possible reasons why this can occur—why one can fall in love with a work of art or a person. To me the interesting question is why certain works seem to be of enduring interest or fascination—why people keep falling in love with them, why society regards them as masterpieces. Why has the *Mona Lisa* been celebrated over the ages? Perhaps Freud tells us in his essay on Leonardo. Certainly there's a deep emotional reason why her smile continues to seem enigmatic and engaging. I think there's usually some perverse reason one loves a work of art, as well as, no doubt, intellectual reasons why it seems to have universal validity. The viewer has to risk serious emotional as well as intellectual involvement with a work to know whether it is worth loving. But in the end every work is frustrating, because the crystallization process, which is intellectual as well as emotional, runs its course.

SR: For the statisticians out there, would you say that the relationship between viewer and work is 50-50, with each mutually affecting the other? Or do you give the viewer more leeway?

DK: Like Duchamp, who distinguished between what he called the pole of the object and the pole of the viewer, I give the viewer almost complete leeway. As Duchamp said, the viewer creates the object as art. I think the viewer does this by swallowing the object whole. In his or her belly, it becomes art. So converted, it is regurgitated into the world—like Jonah regurgitated by the whale—where it is testimony to the magic of art, that is, the possibility of changing the profane into the sacred.

SR: That sounds like 98 percent to me.

DK: It's 99 percent. No doubt the artist will be offended by this idea, as he or she was by Duchamp. For the artist, the work is sacrosanct from the start, by reason of being an extension of his or her self. But this narcissism doesn't mean a thing to the viewer, who has to find his or her own good reason for taking the

artist's production seriously—not just perfunctorily—as art. I've mentioned some of the reasons. It may be that the ultimate reason has less to do with either the critic or the artist, but with society, which projects its own sense of intrinsic value onto certain objects, putting its belief in its immortality in their care, which is what really privileges them as sacred. They will last after it is dead—so it doesn't really die.

SR: That's a lovely way of explaining the value we accord works of art. But still the tension between viewer and work continues, and at the root of almost all tension there is fear, in this case the fear of losing control that an artist or a viewer might feel.

DK: I don't think that fear is necessarily behind every tension. Tension acknowledges difference. Neither side has to be afraid of the other, only hold its own against it. However, let's say that behind the tension there is anxiety, the viewer's that he or she will lose his or her autonomy to the work, the artist's that he or she will lose his or her work to the viewer. Without that anxiety, the viewer doesn't perceive the work in its autonomy, and the artist doesn't perceive the audience in its autonomy. Thus, the tension is necessary to the relationship between viewer and work. The tension is what makes it truly critical. Without the tension there is no edge to the experience of the work, and for the artist no recognition of the fact that his or her art is made for someone other than him- or herself.

SR: You're describing a rather difficult, anxiety-filled relationship with art. That goes against the notion that art has universal appeal and is democratically accessible. We still have the expectation that everyone can "get" art.

DK: Well, I don't think that everyone can. There is no easy, ready-made access to art. It's not even easy to establish a subjective relationship with it. You "get" it by challenging it and yourself, putting it and yourself in a critical position, and many people don't know how to do that nor do they want to. They want to worship art blindly because they've been told it's such a superior thing, but that hardly affords access to it. The real issue is why art is supposed to be so accessi-

ble. It's a sop to the audience, which finds everything else about life difficult to "get." At least art shouldn't be; it should just be fun.

SR: I want to underline what seems to be yet another contradiction. Words on the one hand can kill a work. And yet words—thought, pursuing possible meanings—can also bring a work to life.

DK: It's a judicious balance that's called for. To use Baudelaire's distinction, one needs to be both a mathematical and a poetic critic. The former tries to analyze the work exhaustively and precisely. The latter acknowledges one's subjective relationship to it. The use of words in a mathematical context is one thing; in a poetic, another.

SR: Or if you want to stick to the sexual metaphor, it would be the difference between going to your gynecologist versus going to your lover.

DK: That's the difference. The gynecological versus the romantic approach. The disenchanted versus the enchanted approach.

SR: Lastly, how would you trace the intellectual evolution you've undergone?

DK: I think I've traveled in the reverse direction than Duchamp did. He made the journey from the physical, or wet—from Matisse, from the pleasure principle—to the conceptual, or dry. I think I've started with the conceptual and moved the other way. I may bounce back. I may find that the art I like has become a soggy swamp in which I've lost my footing. I don't like the sinking feeling. I may return to dry land. My kind of evolution is not unfamiliar, but I never took off my intellectual lifejacket, for I don't intend to drown in any art.

This interview is reprinted with kind permission from Sculpture, *November–December, 1992.*

An Interview with Donald Kuspit

Barbara Bennish

Barbara Bennish: I thought we should start with a little about your background, since you have a unique history for an American art critic.

Donald Kuspit: Yes, I have a doctorate, which certainly makes me different.

BB: (Laughs.) You have it on paper?

DK: I have it on several papers. I was not one of those people who graduate from college with a bachelor's degree and decide to be a writer because I'm not capable of being anything else—who thinks it's easy to write about art, where there are almost no standards for writing. Such young people are hired by the magazines by the dozen, for they are cheap labor. But the real point is that they're shameless.

 In any case, I have a doctorate in philosophy from the University of Frankfurt in Germany, and a doctorate in art history from the University of Michigan. I was an undergraduate at Columbia University. I also have a Master's in philosophy from Yale University and in art from Pennsylvania State University. I taught at the University of North Carolina at Chapel before moving to the State University of New York at Stony Brook. I am also the A.D. White Professor-at-Large at Cornell University. I have also completed the

course of study at the Psychoanalytic Institute of the New York University Medical Center. Do you want to hear more?

BB: That sounds like it will do. Can you talk about the time you spent in Europe, specifically in Germany, where you studied with Theodor Adorno? I believe this was in the late fifties and early sixties.

DK: Yes, those were the good old revolutionary days, full of hope about the possibility of a new society, which art was supposed to help build. I'm now doubtful about the possibility of genuine revolution, and about the significance Adorno attributed to avant-garde art—it's so-called negative criticality. Nonetheless, I'm grateful for the belief in the integrity of art that Adorno gave me, and his sense that it could be integrated into society, if negatively and ironically. Also, at the time I acquired the notion—it was and probably still is naive—that high art was as integral a part of people's lives in Europe as popular culture is in the United States, where it is a kind of secular religion.

However, until I met Adorno, I wasn't very interested in art. I was a philosophy-snob rather than an art-snob. But in Germany I met Otto Dix, whom I admired as a person as well as an artist, and various other prominent artists. Poetry had always been an avocation, and now art became one. It began to seem more important and daring than poetry, and, in some perverse way, to make more philosophical sense. No doubt this was an illusion, but it was necessary to me at the time. I needed some alternative to the great American pressure to make money—to be a businessman. Culture, especially art, seemed the happy alternative—which indeed is naive, because it is part of capitalism. Anyway, high culture seemed to have more emotional and intellectual weight in Europe than in America, where it seemed to reduce more quickly to a sign of wealth and status. I think my point about America's lack of seriousness toward high culture is proved by the fact that the entire budget for the National Endowment for the Arts is less than the budget for military marching bands. That shows where the values are—those of the government, and presumably the society.

BB: Of course, from the Central European perspective, if you talk about the

National Endowment for the Arts and what that represents in federal support, it is a completely different situation.

DK: Well, the NEA grants awards by peer review, rather than by bureaucratic fiat. Professionals from all areas of art—critics, curators, administrators, other artists—are involved. I've been on the review panels, and at one time was on the NEA's policy committee. They were both completely democratic. However, it is true that they are advisory; the final appropriation decision is made by the head of the NEA, who is a political appointee. And sometimes problems develop, as with the stink about the Mapplethorpe exhibition.

BB: Which involved censorship.

DK: Yes, censorship, which has less to do with politics than with American Puritanism. And also with a concept about what you spend public money on—certainly not on private fantasies. Just as there is separation of church and state in America, there is separation of culture and state, even when it is a credit to the state. So there is the belief that the state should not support private enterprises. But they supposedly exist for the greater good of America, in the sense in which a previous head of General Motors said that "What's good for General Motors is good for America." Let's hope so. And of course, General Motors is supposedly less controversial than Mapplethorpe, although its automobiles do a certain amount of damage to the environment and people. I think it should be more controversial than anything having to do with sexuality.

BB: Last fall in Prague, there was an Art and Commerce symposium, sponsored by the Philip Morris Company. They talked about the integration of art and business and how this would be for a new boom to the economy and culture in Central Europe.

DK: Cigarettes as well as automobiles should be more controversial than sexuality. But Philip Morris's idea is not the worst one. I recently read a book about the art sponsored by major corporations. It was first-rate, and clearly enhanced the corporate work environment. It seemed no different in principle from the art sponsored by the church and the aristocracy in the past. Art has

always supported the ruling class—has always sheltered itself under the wing of power—and the current situation is not different. If one wants to criticize the art, and the artists who lend their talents to the corporation as artists once did to the church and aristocracy, one would have to begin by criticizing the corporation, the same way the church and the aristocracy were criticized. If art is privileged, it is because the corporation is as privileged—it thinks itself above society as a whole—as the church and the aristocracy once were. If the art has value and authority, it is because the corporation determines values as the church and aristocracy once did, and has their authority. So the problem begins with social institutions, not art.

Recently there was the twenty-fifth anniversary of Woodstock. One of the flower people of the time now has a flower business that is part of a corporate conglomerate. Thus the power of the corporation to assimilate even so-called radicality. And the willingness of the radicals to become part of the corporation. It's the American way, carried out without realization of the irony involved.

BB: That's a great metaphor for the 1960s.

DK: Yes. You can look at it several ways. It's a contradictory situation. Money corrupts but also lubricates culture. It makes things happen, but raises the question whether the work of art is nothing but a glorified commodity—whether it has any value left after it has been reduced to exchange value. I suppose—certainly hope—that there are people who are interested in it not only because of its commodity value. In our capitalist society a new art tends to look like a speculative stock before it looks like anything else.

BB: That reminds me of when you were in California a couple of years ago at the Pasadena Art Center. At one point in your lecture you alluded to Winnicott's distinction between the True Self and the False Self.

DK: That's right.

BB: You had a set of slides illustrating the distinction. On one side you showed Cindy Sherman's image of a young woman sitting by a telephone waiting for a call. You analyzed this as a representation of the False Self.

DK: Yes, the hollow, empty, conformist self. I think that's what Sherman's art is all about: the stripping or emptying of the self. She wants to demonstrate its inauthenticity, particularly the inauthenticity of woman's self. I think she's wrong—she sees only half the story. The self is not just a matter of role playing; it's a matter of conviction: the woman in Sherman's photograph has a false conviction about who she is. Of course, Sherman is not a thinker, she's just taking a position, which is all that her type of angry, ideological artist can do. Nonetheless, she has a certain point—if far from the whole one, as I said.

BB: I remember that at that moment during the lecture Mike Kelley (who was in the audience) defended her, or at least agreed with Sherman's interpretation.

DK: His art also has only half the story, and also deals in truisms. Maybe it's impossible for an artist today to recognize the whole truth, even allow the truth to be complex and contradictory.

BB: Kelley also talked about the Hallmark greeting card as a typical representation of American culture. As I recall, the discussion continued about the involvement of American society with popular culture. And Kelley felt that the latter is beautiful. Can you comment on that?

DK: Again, it's the one pathetic notion—a kind of capitulation to the inevitable. Kelley's tragedy is that he has allowed certain images to totalize his thinking. Just because there are Hallmark cards and Hollywood stars doesn't mean they're God-given models of art and humanity. He's lost his autonomy and criticality. Also, to repeat myself, while there is a false, compliant self—and it is necessary for purposes of communication and relationship (at least message-making and relationships of a certain sort)—it's hardly the whole truth about the self. The false self follows the rules, and allows for a certain functionality. But we also try to use it to convey something of our own sense of being true to ourselves, something of our own feeling of being authentic despite our awareness of our inauthenticity, something of our spontaneity despite all the pressure to give it up. I think it's a complete error to think that being true to ourselves is another socially created illusion—another way we have been manipulated by society to suit its own purposes.

One of the problems of living in American society—one of Mike Kelley's problems—is that there seems to be a conspiracy to get you to accept the media interpretation of reality. In a sense, such an interpretation—a processing of reality—denies that there is anything hurtful about it. The media gives you the sense that reality is just a routine matter of information or a game or a simulation with no human effect or resonance. This makes it seem inauthentic. And yet there are all these real events happening: wars, rapes, murders, violence, abuse—incredible inhumanity. But the media—the Hallmark mentality—sentimentalizes all this into a facade behind which nothing is happening. Thus it numbs us to reality, even as it mediates it. The media is an ingenious kind of Potemkin's village hiding our lack of imagination about reality, and more deeply our refusal to see its truth and the effect of its truth on the truth of our own existence. I think both Sherman and Kelley are trapped by media representation and interpretation, which they want to use against itself—critically. But after they have suggested its bankruptcy they have nothing critical to say— nothing to say about the rottenness of reality. So they both—especially Sherman—get more and more attracted to violence, thus emulating the media. Increasingly, her images "apply" and stylize the inauthentic representation of violence that we find in the media.

BB: I had a similar feeling of the stylization of violence regarding the recent O. J. Simpson melodrama. It was something of a culture shock to come back to America and see this image on TV. Only in this country could an ex-football star be seen driving down the freeway "live" on television, with people cheering him on, no less, after he supposedly murdered two people, including his wife. But this removal from the original experience is what struck me as strange. Instead, people were reliving the secondary experience through the television.

DK: The real horror of it is the way America celebrates so-called celebrity. Who is Simpson really, except a man who could run with a football? Is that some special contribution to the world, on any level? What kind of achievement is that exactly?

BB: That brings up another issue.

DK: Aren't we getting far removed from art?

BB: Aren't the two related? You've talked a lot about the idea of artist as hero.

DK: There is an old tradition of privileging the artist. It goes back at least to the Renaissance. It has been given a new lease on life because works of art can become extraordinarily precious commodities and because of the delusion that the artist is in some mysterious way different from other people—more authentic, ultimately because he or she is supposedly more creative. That's highly debatable: art has become a symbol of creativity that is remote from the creativity of life. That is, creativity—creative solutions to lifeworld problems—is more widespread than one might suppose, even though most people have had their creativity crushed out of them by society.

But I think the commodity issue is particularly to the point. Meyer Shapiro once pointed out that certain paintings are worth more per square inch than any other property in the world. More even than property in Tokyo. So the artist is privileged because he or she may produce such a rare, expensive piece of property. I'm not sure what else sustains the myth of the artist as special—as heroic. I've heard people say that art can be a profitable business. No doubt that's true, but it always surprises me. Art is profitable only after the fact, and then only by mythmaking, which is a kind of packaging. I respect what artists do, but art's accidental profit is beside its point, like the hype that surrounds it.

BB: Is there a place in the contemporary world for art that is noncommodified?

DK: That's the key question. For me, the only use of art is psychological. High art is the last one-to-one kind of experience, that is, it's not made for a mass audience, the way television and movies are. You can photograph works of art and mass distribute these photographs, but it's not the same thing as experiencing the work of art firsthand. It doesn't generate the same kind of complex involvement.

BB: So what do you think of Walter Benjamin and his idea of aura?

DK: Well, he's against aura, and he uses photography to support his "disillu-

sionment" with high art, which I think he unconsciously despises. He certainly misreads it when he regards it entirely in class terms. I think ultimately he's rather naive about art. And I think he's naive about psychology, and has no understanding of the emotional reasons people relate to art. I recall him writing that the bourgeois psyche was depressed, as though the proletariat psyche was not—as though depression is a class phenomenon, the underside of bourgeois power. That's total nonsense, even stupid. I think the proletariat are probably twice as depressed as the bourgeois.

BB: Didn't you tell me that something like 25 percent of Americans are now on Prozac?

DK: Apparently 25 percent of people who visit their doctors are given an anti-depressant of some sort. But depression is more than an American issue. The December 1993 issue of the *Journal of the American Medical Association* had a terrific documentary article on the incidence of depression in modernity. Apparently it's the only major mental ailment that increases with moderniza-tion—with modern "enlightenment." This is cross-cultural. For example, the article traces modernization in Japan, and the correlate increase in depression—of the feeling of hopelessness, helplessness, and great vulnerability, among other feelings.

BB: Do you think it is a response to postindustrial society in general?

DK: I don't know. There have been a variety of hypotheses about its etiology, many of which probably have some validity. I think that it has something to do with the collapse of the idea of transcendence and the reality of community. There seems to be no escape from everydayness, and people seem less trustwor-thy, which they probably are. It's a very complicated matter. I think the environ-ment of the work place has a good deal to do with it. Our society is more pro-ductive than agrarian medieval society, but at a great human cost—at the cost of the emotional quality of life, which everybody struggles to restore during so-called leisure time. Perhaps we've lost the sense of being part of an extended family, but that also was insidiously destructive of creativity—emotionally reac-tionary.

BB: What I was leading to, with regard to this mention of social pathology, was your theory about the therapeutic aspects of art.

DK: Call it the therapeutic possibilities of art. I think the so-called unity of the work of art can function unconsciously as a metaphor for the integrity of the self—a kind of model for a hard-won equilibrium of the self. One internalizes the work of art as a kind of ideal self—a self that has survived despite all the forces that conspire against it, forces that are often represented or implied in the work. In general, the work of art forms an alternative emotional space, in which one can, metaphorically, work through one's issues, however incompletely. It all depends on how seriously one takes the work. One gets from it what one emotionally and intellectually puts into it—hopefully more. But I should mention this kind of relationship with art may no longer be possible today, for it depends on an idea of art which has been destroyed. You might say that I'm asking for a more "conservative" relationship to art than those who advocate an ideological relationship to it. They in fact resent its emotional significance—which they're blind to anyway—as Harold Bloom suggests.

BB: What does that mean? What do you mean by conservative?

DK: What I'm getting at is that the frame of art has been broken, as it were, and that it may be time to put it back in the frame—to think of art as a kind of self-containment rather than facile exhibitionism that arrogantly spreads itself over the environment. I'm thinking of all the Duchampian installations that think they have something to say about the environment—all the pretentious junk that imagines it's a thinking man's art, and that ignores emotional realities. I'm thinking, for example, of the performance artist who raised a stink in the Walker Art Center in Minneapolis.

BB: The young man who had AIDS and performed with dripping blood (from someone else without AIDS), which he apparently dripped on the audience?

DK: I've read conflicting accounts about what occurred. Anyway, he made some sort of symbolic gesture about AIDS. No doubt it had a certain point. But I want to separate it from what Kiefer and Polke do, even from what Acconci did

in his early performances, which were more to the emotional point than his current social pieces. Shocking and threatening people is not what art's about. Intimidating them with one's own illness is absurd as art. He can really reach his audience only by getting back in the frame and trying to reach them emotionally—through the condition of reflection that the frame sets up. Overt violence is going to drive the audience away, as it should.

BB: One thing I understand as breaking the frame in the last decade is a kind of recontextualization of artworks. Especially as a foreigner now living in another society and culture, I've felt that social and cultural context has changed, and so has art. I'm not talking about the standard picture frame of course. But I'm curious if, in a more metaphoric way, a type of art exists that is not "international" but perhaps global? That would still be able to incorporate a certain formal standard that could be maintained in the art work?

DK: I don't mean the literal frame either. I mean a certain power of focus simultaneous with a deferring of reality. But you have stated the contemporary issue. The question remains whether Bruce Nauman spitting water and calling himself a fountain has any point as art. No doubt it's comprehensible globally, but that's because it's a simple-minded joke. The situation I'm addressing is similar to the one Cervantes describes in Don Quixote. At one point Quixote outfits himself with a barber's basin, which he regards as a helmet—one, moreover, which he thinks makes him invulnerable. He's not just playacting, he seems to believe this. In other words, he's insane, although, no doubt, he's only human in his wish for magical power. He's not unlike Native Americans who thought that a dance could make them immune to bullets. Like Quixote, they have given up on reality testing. Similarly, when we accept Nauman's performance as art, we are giving up testing for the reality of art. We are saying we don't know and don't care what it is and what its purpose is. That's our problem, and it lets us delude ourselves into respecting Nauman as an artist. Duchamp introduced the nihilism—the idea that there is no way of testing for art—that it has no reality.

BB: But isn't that the very definition of art?

DK: I don't think so, but then the idea that there is no definition of art—that anything goes as art—has become the avant-garde definition of art. But I think that definition is having credibility problems. It has lent itself to too many behaviors.

BB: Well, it is one definition of art.

DK: It has certainly become an institutional definition of art. Professional philosophers can have an infinite amount of fun with it. Duchamp's ready-mades have become museum-worthy—just the opposite of what he wanted—which makes one wonder whether the museum has become all too ready-made.

BB: Today I was walking down Forty-Second Street. Have you seen the haiku installations on the old theater marquees there? I enjoyed it, because public art is a phenomenon that has not happened much yet in the Czech Republic after 1989; art integrated out into the public sphere. One of the pieces had a water-fall coming down into the sidewalk. People were stopping and looking. It was a great interaction, and quite beautiful poetry too. And I thought, "this is work-ing."

DK: I'm glad it is. I didn't think it worked the first time around. I thought it was show business. And a version of gentrification. The *New York Times* invent-ed a wonderful ironical word to describe it: they called it the "re-decadencing" of Times Square. It took these last few crummy places and made them "neo-crummy" by turning them into so-called works of art. It's terrific public rela-tions, but I think most of the pieces are problematic—as art—whatever kick someone who walks down the street might get.

BB: So you feel it's become institutionalized?

DK: Yes, indeed. That's why it's art—officially. I like it better than the Marlboro Man advertisements, just as I think the snippets of poetry the city is putting in buses and subway cars is a great alternative advertisement—an adver-tisement for culture, which needs all the good publicity it can get these days. I like the fact that it disturbs our ordinary expectation of what we'll see as we

walk the street. But on another level it's pitiable, both as a drop in the art bucket and as art itself. It really misleads people about what art can be.

BB: I was recently reading some essays by the Las Vegas writer David Hickey. Several of them were about beauty, which seems to be an issue again in America. Even the next Whitney Biennial is supposedly focusing on it. Anyway, Hickey has a wonderful line about how absurd and strange it is that we even question the idea of beauty, as if our culture is totally devoid of aesthetic principles.

DK: Before Hickey, the Jungian psychoanalyst James Hillman had an essay in *Tema Celeste* on the repression of beauty. He said that is something the Right believed in and the Left didn't, and he wondered why beauty should be left to the Right. I myself think it has been questionable since the beginning of modernism, and that the idea of "modern beauty" has never quite replaced the traditional idea of beauty. Not even the romantic notion that there is an element of strangeness in everything beautiful has been used to sustain a modern idea of beauty. We really don't know what we're talking about when we talk of beauty today, unless we're talking nostalgically.

BB: It seems to me that the idea of the aesthetic has been denied, until recently, in much of postmodernism.

DK: You're right. But I think the idea of aesthetic has to be revised. We need the idea of the psychoaesthetic. Greenberg undermined the idea of aesthetic without realizing it when he separated the expressive from it. But the notion of the aesthetic has become a facile term, like beauty. The only redemption for both terms is the Kleinian psychoanalyst Hanna Segal's notion that all beauty acknowledges destruction within it. It is a formal *Aufhebung,* as it were, of a tragic reality, emotional and social. It involves making whole what has been fragmented, seemingly irreversibly. This seems impossible today—her model was Shakespearean tragedy, and tragedy has become all too real, general, and un-Shakespearean in these mass society days. But no doubt it's better to try to make a beautiful work of art than to succumb to emotional and social chaos.

BB: It almost seems that you're suggesting that beauty has to do with epic.

DK: That's an interesting idea.

BB: I wonder if it's possible in an art such as ours, in America, that deals so much with material culture.

DK: Well, you can try to find the lyrical element in material culture, which may be like looking for a needle in a haystack. Or you can delude yourself into believing there's something lyrical about Mickey Mouse. But you're probably right: the transformation of the material popular culture into beauty of any kind is impossible, just like the transformation of violence into benevolence—the age-old problem of how to beat swords into plowshares—is impossible these days. Unless you want to delude yourself into believing that violence and the material popular culture are beautiful.

BB: This leads me to the next question on kitsch. You wrote that Milan Kunc "in effect satirizes the totalitarian management methods implicit in kitsch style, and would-be utopian society, by using the former to represent the latter." This of course is, or was, an issue for Czech artists.

DK: In the United States I think that kitsch is clearly a totalitarian mode—a form of brainwashing and thought control. Hollywood is perhaps the most characteristic form of American kitsch. It takes every significant event, situation, and feeling in life—love, suffering, war, family, etc.—and simplifies it until it becomes emotionally unrecognizable, even if the Hollywood representation of it generates its own kind of sentimental ("softened") emotion. Thus it trivializes—de-existentializes—life. It reduces the tensions, complexities, anxieties of life. Hollywood levels life out—treats everything in it on the same common denominator level, which is to seriously falsify it. And that's totalitarian in principle. Hollywood is even more treacherous; it tells you what to think and feel in basic life situations. And thus it makes you crazier than you might be. That's what kitsch does. What Kunc was able to do was to turn the big lie of kitsch—its betrayal of life—against itself. He was able to use kitsch against the system. But I don't know of any American artist who has been able to use the dictator-

ship of Mickey Mouse against the Hollywood tyrannization of life. No artist would dare. He or she would be sued by the Walt Disney corporation.

BB: Stalin is the new kitsch.

DK: And so is the Soviet art that idealized him and Soviet society. The artists have formed some sort of underground resistance to him, or at least used his image in some ironical way, to make an antitotalitarian point, a symbolic gesture against the dirty use of art for social manipulative purposes. At least Warhol tried to do it with Mao's image, but then Warhol didn't live in China, so it was easy to do. Warhol always played it safe, like many so-called radical artists. After all, he was a businessman first and foremost.

BB: How influential do you think the filmic image has been on artmaking practices?

DK: There are artists who have used the medium.

BB: I'm not thinking of formal influences, but of Hollywood imagery.

DK: I think many artists are trying to hook into popular imagery because they know it is the dominant mode, and sometimes they want to use it as a weapon in a critique of the "system." The question is whether they appropriate it, or it appropriates them. The Hollywood beast is likely to swallow you when you play with it. Jenny Holzer's high-tech works, for example, degenerate into just another sideshow—a bit of avant-garde spectacle—which Hollywood does better.

BB: So you think it has been co-opted.

DK: It is co-opted by its own method. You may be better off using traditional, supposedly conservative means, such as abstraction. However, Cindy Sherman uses the Hollywood kitsch method to advantage in her representations of violence. She almost outdoes horror films with her *Grand Guignol*. Kunc's use of the populist mode, and that of Ray Smith, are ultimately more successful,

because they don't compete straight on with populist imagery the way Sherman does. They're more ironical and insidious.

BB: Once you talked about contemporary work as being divided between the perceptualists and the conceptualists. I thought it was a good distinction. You described a possible third category, that had more to do with the imagination. To refresh your memory, you said the perceptualists were artists like Kiefer, who were working with a certain emotionally charged perception of the world, and the conceptualists were artists like Kelley and Holzer, who were trying to use their intellect alone. I wonder if the third category, nameless so far, could have to do with experience, or what you would call a "real" experience, as compared to a reformulated or simulated one.

DK: Yes, I had in mind Coleridge's distinction between imagination and fancy, and Baudelaire's concept of the imagination. I think both are still valid, for all their romanticism. For me they're important because they're psychodynamic in import, and they both imply that art has a basis in personal as well as social experience. What they miss is the sense of the "real" in Lacan's sense, which is what my third category would acknowledge. That is, I am interested in an art that exhausts the symbolic, that goes to the boundary of the speakable, that is ineffable without mystery, for it is as concrete as experience and embodies concrete experience. For me it is the most primary kind of art, but I don't know if it exists, or is even possible.

This interview was originally published [in Czech translation] in Vytvarné Umen: No: 1–2, *1995.*

An Interview with Donald Kuspit—The Art of the 1990s

Mark Van Proyen

Mark Van Proyen: How do you think that the art of the 1990s will register itself into art history's memory?

Donald Kuspit: I don't think the nineties will count for very much in the long-term view of art history. What you have is endgame irony and the leveling out of the neo-Expressionism that came to prominence in the eighties. Irony for me is a sterile dead end, and the normalization of neo-Expressionism indicates that the new subjectivism has become old. Both are now symptoms of decadence. I take Kiefer's recent exhibition of works on paper at the Metropolitan Museum of Art as indicative of the institutionalization of neo-Expressionism. The works in fact summarize all his techniques and iconography, and suggest that his art is a compendium of true and tried, if now tired, avant-garde methods and ideas. And I take the fact that Damian Hirst's *Lovers (Spontaneous, Committed, Detached, Compromising)*—a series of four cabinets containing jars of cow's organs—sold at auction for $229,350, and that Chris Ofili's painting *Them Bones*, showing a skeleton holding in each hand balls of the artist's signature elephant dung, sold for $36,052—$17,000 was the expected high—as an indication that irony has been institutionalized and capitalized—money in the bank and museum immortality (for the moment). There are other examples, but the fact that Hirst won the Turner prize in 1995 and Ofili is this year's winner suggests the complete decadence of the art administrators. Art has stooped to a

tired sensationalism, all but scatological, and in this it emulates the media, suggesting who is really in charge in the artworld.

If we compare the 1890s, which were a time of experimentation and innovation —I prefer the terms exploration and discovery—with the 1990s, which are a time of entertainment and hackneyed stereotypes, we see the difference clearly. The 1890s saw the emergence into serious social visibility—if still disapproval—of the avant-garde, while in the 1990s we see the neo–avant-garde becoming an extension of media visibility, and thus achieving approval and acceptance. Your brilliant remark that "art is now the research and development wing of the media" hits it on the mark. And yet there seems to be no new imaginative space to explore and nothing artistically new to discover. Development means refining and miniaturizing the old, the way the Japanese do with overfamiliar technology. Today to be an avant-garde artist is to be a conformist, not a nonconformist. Scatological conceptualism and technological fine-tuning are just cheap compliance.

There is another point worth noting. The avant-garde used to be associated with youth, and it still is, but youth has now become trivial and redundant, especially because the society is aging. I am more interested in an artist maturing and sustaining his or her creativity—in seeing what someone does with his or her creativity over the long run—than in a fresh young thing who is the current weekly wonder. Also, the young avant-garde artists at the beginning of this century—those who developed such movements as Fauvism, Cubism, German Expressionism, Suprematism, De Stijl, Dadaism, Surrealism, etc.— were in revolt against an old tradition, and trying to create an alternative. For today's young would-be avant-garde artists revolt has become an empty habit, and avant-gardism a Pyrrhic victory, as the fact that it tends to take the form of parody indicates. Parody is the last frontier of novelty, and novelty has run its course. (Such parody is usually more entertaining than critical, and bounces off other art rather than psychosocial reality.) The difficult task today is to build on what has been achieved, and offer a positive vision of both art and life—of life imagined through art—but the artists today can only mimic the old negativity, which has become the status quo in society as well as art.

Having said all this, I do think an important new thing slowly but surely happening in the nineties is the emergence of what I call a new Old Masterism—the return to the Old Masters as models, in both method and

imagery (if also incorporating certain basic ideas of the tradition of the new, such as planarity and gesture). This seems to be the only significant alternative to the prevailing pseudo–avant-garde. The new Old Masterism shows that there is life—new possibilities—in what was once thought to be dead. It signals the restoration of the traditional conception of art, and a possible new maturity for art, as well as the end of anti-art, which nihilistically broke down the boundaries between art and life. It took out the middle step—the imaginative transformation of life into art—and thus left both art and life in the lurch. Such a breakdown may have given epistemologists something to chew on but it did not help creativity.

MVP: Some have suggested that the glib affectlessness of Pop Surrealism makes it the emblematic style of the decade.

DK: I think you're quite right that "Pop Surrealism" is the durable label of the nineties. To me the work that epitomizes Pop Surrealism perfectly is Gabriel Orozco's *Ping-Pond Table*, 1998, which places a lily pond in the center of an X-shaped ping-pong table. So much for Monet's lily pond at Giverny, and for his painting. Pop Surrealism indicates the dumbing down of art. Cleverness substitutes for talent and craft, and imagination has been reduced to manipulation. But, as you suggest, the affectlessness—coldness—of it all is the crucial thing. In the last few years I have seen a number of photographs of rather dead-looking young people, sometimes in rooms of elegant furniture, which seem much more inwardly alive than they do. Psychic deadness—a complete numbing out—is epidemic in our society—it carries depression to an extreme. The cleverness of Pop Surrealism masks the passivity and inertia signaled by the new lack of feeling. I think the new affectlessness is a reductio ad absurdum of "coolness"—the supposedly sophisticated unresponsiveness to what in fact one is helpless to do anything about. Indeed, the current wave of affectless art signals the art world's sense of futility about having any influence on anyone. It indicates a kind of fatalistic resignation about the emotional possibilities and outreach of art. In a certain sense, it mirrors the indifference of our society. It also suggests that contemporary art has no human value, and exists merely as temporary distraction—more temporary and less entertaining than TV or the movies. Current affectless art signals the inner deadness of immature artists—

the inner deadness that follows from institutionalizing immaturity, and expecting more from it than it can give. But then the immature artists themselves realize that they have nothing to give, which is why they deny all feeling, for to feel something about someone or anything is to give and add something to it—to give it human significance. In short, from an art-historical perspective, the new affectless art completes the dehumanization of art that Jose Ortega y Gasset and Hans Sedlmayr described. But that dehumanization involved an expressionist and surrealist explosion of demonic spirits, while today the expressionist and surrealist party is over and the demons have emigrated to Hollywood and the rock culture, which uses hand-me-down avant-garde ideas. Sometimes immature artists hide their affectlessness behind ideology—ideological commitment is supposed to show seriousness—but they forget that ideology once aroused passionate engagement or repudiation. The current failure of passion suggests that there is not even any ideology—PC or otherwise—worth advocating. Everything is flawed, so why bother?—that seems the immature message of feelingness.

MVP: Does this new affectlessness lead us to see object-relational disappointment on a generational scale ?

DK: I don't think there is object-relational disappointment, although that is everyone's lot. I rather think that the young people can't imagine that they're subjects. There's been so much pseudointellectual debunking of the idea of the subject, and it comes to jaded fruition in the "unsubjective" young. The death of the subject has been an old theme, and now the subject seems to have really died, at least among those who have insufficient experience of life—insufficient suffering—to discover they are subjects despite themselves—despite their supposed objective coolness and detachment about life. But coolness is no longer grace under pressure; it is emotional stupidity. It is the refusal to accept and mature through the inescapable suffering of being alive that makes young people emotionally mute and vacuous.

MVP: It sounds like you are reviving that old cliché, "the artist must suffer."

DK: I am not reviving the old cliché "the artist must suffer," but rather saying

that everybody suffers, intrapsychically, and that artists are no exception. The old cliché was used to privilege the artist, as though only he knows what it means to really suffer. On the contrary, I am suggesting that it is our common lot to suffer, and that the failure of much contemporary art is that it does not speak to universal suffering, and as such is humanly irrelevant. If the artist would stop thinking of himself as an exception to the human condition—making "exceptional" art (or what used to be avant-garde art) doesn't exempt him from humanity—we might begin to have some art that could speak to other human beings, not just masturbate art history. I agree with the Prague semiotician Jan Mukarovsky that what makes art interesting is the artist's attitude, which he uses all his skill to evoke in the viewer, but I don't see many artists with interesting attitudes these days—although there is much attitudinizing—because a significant attitude is (in part) the result of introspection, and I don't see much introspection in current art. Indeed, the young people that a good deal of contemporary photographic portraiture focuses on—for example, Thomas Ruff's—clearly show this lack of inwardness. The subjective realm must be constantly reconquered and worked through, and many young people and young artists are afraid of doing so because they have been indoctrinated with the political belief that the outside is responsible for who and what they are, rather than they themselves, to a larger extent than they care to admit.

MVP: It sounds like you are describing what psychoanalysts call "the schizoid position."

DK: One doesn't want to get footloose and fancy-free with such terms as "schizoid," nor indulge in so-called wild psychoanalysis, but it does seem clear that something akin to the schizoid position is rampant. Fairbairn argued that "the basic position in the psyche is invariably a schizoid position," in that "some measure of splitting of ego is invariably present at the deepest mental level," but I think the key thing is that, as Fenichel says in criticism of Kretschmer's distinction between schizoid and cycloid personalities, "both types have in common . . . the tendency toward loss of objects and toward narcissistic regression." Thus, as Fenichel says, "schizoid personalities . . . are characterized by an augmented narcissism which may manifest itself in an intense need of approbation by others, but more frequently is of the nature of a primary and omnipotent

narcissism, independent of other people and distorting . . . reality testing. . . . In many ways object relationships and emotions may be supplanted by pseudocontacts and pseudoemotions." Well, the artworld reeks of pseudocontacts, and pseudoemotions seem to go naturally with them. And augmented narcissism, indeed, omnipotent narcissism, seem rampant, at least among many New York artists. No doubt it alternates with a desperate need for unconditional approbation. One can say that this is defensive—it's a crowded artworld out there, and unfortunately not many artists get their due, that is, the recognition they deserve—but it also seems to have something to do with the modern idea of art. Zbigniew Herbert writes: "A major part of contemporary art declares itself on the side of chaos, gesticulates in a void, or tells the story of its own barren soul." I think there was once some point in this, for modernity has stripped us bare and thus induced psychic barrenness, as it were, and the difficulty of sustaining relationships in the modern world makes one's individual existence seem like a gesture in the void, and the modern world always seems to be on the verge of chaos, mistaken for genuine revolution, but really the impulsive underside of its own subtly self-defeating instrumental and administrative rationality. But modern emptiness has become so extreme and at the same time routine as to reduce to absurdity.

In contrast, Herbert writes, "The old masters—all of them without exception—could repeat after Racine, 'We work to please the public.' Which means they believed in the purposefulness of their work and the possibility of interhuman communication. They affirmed visible reality with an inspired scrupulousness and childish seriousness, as if the order of the world and the revolution of the stars, the permanence of the firmament, depended on it. Let such naiveté be praised." I would like to see a return to this Old Master attitude, as the only viable alternative to the augmented narcissism and schizoid insularity that denies external reality, except as an instrument of desperate vanity. The Old Masters wanted an art that related to other human beings, and that articulated a certain relationship to the world—that had an interhuman attitude. So yes, contemporary art does advertise a schizoid imperative, which is why art must get beyond contemporary art. At this time a regression to an Old Master attitude respectful of external as well as internal reality—relationality as well as narcissism—would be a regression in the service of the ego of art.

MVP: Nothing could be more anathema to the current theoretical climate.

DK: Yes, it is. The so-called theorists, who are often legislators in disguise, however interesting their ideas, have come to dominate art. It is worse than when Tom Wolfe wrote about the power of Greenberg, Rosenberg, and Steinberg. They, for all their theorizing, loved some art and hated other art—they had an intensely emotional as well as intellectual relationship with art. In contrast, current theorists lead with their ideas, and their ideas tend to be trendy and prescriptive, rather than the result of critical and self-critical reflection on their experience of art (however much we all begin with preconceptions and expectations—a certain horizon of expectation and a certain cognitive orientation and style). They never get around to feeling—to integrating emotion and thought. Thus, they exemplify T. S. Eliot's "dissociation of sensibility," namely, the splitting off of feeling from thinking and vice versa—his accurate version of the schizoidism prevalent in modernity. The artists who sycophantly submit to these theoretical legislators will make an art that is emotionally inadequate and art-historically irrelevant, that is, it will end up as the illustration of an idea rather than an encoding of experience that will be of interest to future generations. It is suicide for an artist to sacrifice his creative instincts to theoretical prejudgments, but there seem to be many artists who, out of anxiety about the value of their art, are happy to commit creative suicide by making an art that will please the theorists whose ideas will supposedly give it value, but in fact make it less of an experience than it could be.

MVP: So, we are seeing a resurgent aesthetics of mastery because avant-garde "innovations" have lost their capacity to shock?

DK: What I call the "new (old) masterism" does indeed suggest that art has lost its shock value—that it no longer "épater le bourgeois" (shocks the bourgeois), who are in fact eager to buy it, as an investment property if not as an entertaining novelty. Psychologically speaking, the aesthetics of mastery implies an "ego art," as it were, that is, an art which is in control of spontaneity [which often has a lot of compulsion to it] and conscience. We can regard the ideological art (politically correct art) that has prevailed in the last few decades as an example of the superego run riot—blind superegoism (which involves, among other

things, indifference to and ignorance of the complexities of human relationships and feelings). The superego is rather headstrong and limited, even when it is supportive rather than persecutory. I in fact think that many of the politically correct artists are projecting their own sense of being persecuted for being artists—as well as in general—onto society. (The old myth of being a persecuted artist remains naively alive and well.) They think that if they can "correct" society they will be cured. Similarly, we can regard the art involving the "disorder of the senses," as Rimbaud called it—I think David Wojnarowicz is the last Rimbaud, as it were, and shows the self-destructiveness and other-destructiveness such deliberate disordering leads to (whatever intriguing images it generates on the road to an endless season in hell)—as having run its course and become a popular cultural cliché. (If you want that kind of quasi-outlaw or pseudocriminal avant-gardism these days, you go to rap art and artists.) Both ideological art and disorder-of-the-senses [pseudospontaneous] art have run their courses, as indicated by the fact that they have both been integrated into our society of spectacle. However art-historically significant or insignificant it may be, the "new (old) master-ism" indicates the need for the ego to take control of the forces of the unconscious that have been unleashed by avant-gardism, out of inner necessity at the time, and as such legitimately. But now I think there is a new inner necessity: to put the crazy "Jacks" back in the box of the psyche, and to reach for hope and dignity, which no doubt no longer had credibility in the quasi-traditional art that appeared in the nineteenth century. Consciousness and self-control, rather than uncontrollable unconscious expression, seems to me the inner issue of art today, and the ego, among its other functions, is the center of consciousness and control.

This interview was conducted via e-mail on March 4, 1999.

An Interview with Donald Kuspit —a Biographical Remark

Mark Van Proyen

Mark Van Proyen: I was wondering if you could point to some particular aspects of your early experience that led you into an intellectual career?

Donald Kuspit: One of the factors that led me to an "intellectual career"—that it became that of a critic is secondary—is that my father was a businessman, and I didn't want to experience the difficulties he experienced. (Little did I know about the difficulties and businesslike character of academic life—the fact that the realm in which reason is supposed to rule is hardly that.) Like all businesses, his, while successful, was subject to seasonal and cyclic swings, and often demanded that he work all kinds of hours, beyond his control. Not for me, I thought. Also, I was extremely idealistic, as many young people are (or used to be), and thought that the life of the mind was a "higher life" (which probably meant that I didn't want to get my hands dirty), and rewarding in itself. It may well be, but as I quickly learned, there are so many "lower" factors that influence it, and, to reverse the biblical adage, one cannot live on mind alone. As for art criticism, I have always thought of it as critical consciousness brought to bear on a particular area of human endeavor, one that I idealized and enjoyed. That is, art criticism for me is critical consciousness—which must keep developing throughout life—in practice with respect to something that I experienced as genuinely pleasurable and enriching, and even ennobling. I still do, despite the fact that I am aware of the socioeconomic "impingements" that make art some-

what less "ideal" and "pure." I suspect that I thought I was trying to escape the "human condition" and the problems of human relationships (family included) by becoming a so-called intellectual, but of course there is no escape from them—which is partly why I have come to think that intellect and art are ways of articulating and managing them (for better and/or worse).

MVP: What kind of impact did the dramas of adolescence have on your high school years?

DK: I don't think the "dramas of adolescence" had much of an impact on my high school years, but they did on my undergraduate years. I was a kind of whiz kid, particularly in math and science (I went to Stuyvesant High School, an elite public school for such types), and spent only two years in high school (before that, in junior high school, I had skipped a semester), before I went to Columbia in 1951 (at age 16) with a Ford Foundation scholarship. In fact, I never graduated Stuyvesant—I have no high school diploma. But the teachers there—particularly one in chemistry, one in geometry, and one in biology—had enormous influence on me, and I still have vivid, happy memories of them. A rabbi was also an extremely important role model/surrogate father for me—in fact, I continued in Hebrew School, studying with him, beyond my Bar Mitzvah—until I went to college (I used to know Hebrew and Jewish fairly well, and can still find my way around the Old Testament). I wish I could remember the name of the rabbi, but unfortunately I can't. I just have a vivid sense of his presence and appearance. I do remember the name of the chemistry teacher—Lieberman—and biology teacher—Spenser—but not the geometry teacher. Again, I have a strong memory of their appearance and lively presence. It's people like that, knowledgeable and kindly, disciplined yet attuned, that make all the difference in one's life—much more than any theory.

It was in college that my emotional needs caught up with me. I was a science major my first two years, and then changed to a philosophy and humanities major. I experienced science as dry and mechanical—I still remember the dead, drill-it-into-them tone of several of my professors—and I needed something more alive and "creative." I began taking courses in literature and the humanities, ravenously consuming all kinds of materials, like a person suddenly finding an oasis in a desert. For example, I studied Oriental humanities for a

whole year (I was invited to go to graduate school in the area, on full scholarship), and plunged deeply into all kinds of literature. (I am still a ravenous reader, but now of psychoanalysis.) You must also recall that I was a serious poet at the time—I was published in the *Quarterly Review of Literature,* among other places. I still write poems, but I am no longer interested in the approval of the professional poetry world. Cleanth Brooks was quite encouraging of my poetry (at Yale, I not only studied philosophy, but attended all the courses of Brooks and Wimsatt that I could), as was Paul Celan a few years latter.

Incidentally, when I was an undergraduate at Columbia, I attended graduate lectures by D. T. Suzuki, who had a cult following. The room was full of all kinds of people, many not students, and many seemed to be in a kind of trancelike, somewhat detached state, if I recall correctly. Suzuki had a gentle, precise presence—very understated, low key. He read various Buddhist texts, then commented on them, in a "simple" expository manner. It was a wonderful otherworldly experience in the midst of the city's madness. The Buddhist temple on Riverside Drive, not far from Columbia—I'm not sure if it's still there—was also a wonderfully calm, meditative place.

MVP: What led you to settle on philosophy?

DK: I went into philosophy because it seemed to teach one how to analyze any text into its basic ideas, and it seemed to offer a comprehensive understanding of all phenomena. In other words, it satisfied both my intellectual side—indeed, it was an intellectually maturing activity (I still recommend it for that)—and my need for a kind of omnipotence. In other words, I went partly because it extended my scientific interests and understanding (progressive part), and partly for delusional reasons (regressive part). I think that is still why most young people go into philosophy. I fortunately came to realize that its sweeping claims to total understanding—very satisfying to the omnipotence in us all—were insane (that is, infantile), while its methodical questioning (and self-questioning) of whatever is the case was the core of sanity. Which is why what I now call a philosophical (skeptical) attitude is necessary, but the philosophical assumption (optimistic fantasy) that there are final "answers" or that philosophy has any of the "answers" is absurd, not to say foolish and simplistic. I continue to see philosophy as a curious, self-contradictory mixture of sophisticated tough-minded-

ness and naive tender-mindedness. Finally, I always had other options, because I always had a wide range of interests and enormous curiosity, and I think studying philosophy was a useful way of furthering those interests and developing that curiosity, but I am glad I gave up "professional" philosophy, for today, in my opinion, it leads nowhere human. I am not interested in the "play" and/or logic of ideas for their own sake.

MVP: Why did you choose to do your doctorate with Adorno at Frankfurt?

DK: I did my doctorate with Adorno because I was impressed with him as a mind and person (in that order), and because he was willing to work with me—which he did with very few students—which was a great honor (I became impressed with myself, which was what I needed at the time). I had gone to Frankfurt to teach at the University of Frankfurt. I wanted very much to get away from Yale and the USA, and a professor at Yale recommended me to the Director of the English Institute at Frankfurt. I taught English and American Literature, on a regular appointment. I sat in on Adorno's lectures, got to meet him socially, was taken into his circle. I was interested in his philosophical side—brilliant lectures on Hegelian dialectics (they became the basis for his "3 Essays on Hegel")—not particularly his sociological side. I lived in Frankfurt for three straight years from 1957–60, and was back for every summer thereafter until 1963 (if I recall correctly), and in 1964, I became a Fulbright professor at the University of Saarbrücken. I was invited to stay in Germany—Adorno was going to get me a job—and I probably should have—I felt much more at home there than I ever have here—but for personal reasons and because I had an offer at the American university I returned. My life certainly would have been different had I stayed. I go back to Germany yearly, sometimes for long, sometimes short periods, and maintain regular contact otherwise. During the sixties I spent a large amount of time in Germany and traveled widely in Europe in general.

MVP: How was your critical sensibility affected by Adorno?

DK: Adorno's critical sensibility, as it might be called, did influence my attitude to art, although, being Jewish, I was socially in a "critical" position as early as I

can remember. That is, I was always afraid of being deceived or taken in, so I never took anything for granted—never trusted appearances, so that Adorno's emphasis on the dialectic within appearances was something that I readily took to. In general, dialectical thinking, which I learned from him—and psychoanalysis (which heavily influenced him)—is inherently critical, that is, aware of contradictions and antinomies, and the ironies of the "truth."

MVP: And your interest in phenomenology evolved from this idea of "the dialectic within appearances"?

DK: For me, the core of phenomenology is the idea of phenomenological reduction or epoche. I viewed it as a deliberate intellectual process that emerged out of inner necessity—a (self-) saving grace within an overwhelming, confusing world of information and madness. My understanding of it is in part idiosyncratic, and in part grounded in Husserl's sense of the subject.

In any case, once the importance of the subject was acknowledged as the object of its own thought or reflection, the rest followed. I began to realize that art was essentially relational, and involved what my wife calls "the critical couple," that is, the artist and the seriously engaged receiver of the art, who is equally creative. Each needs the other to fulfill or complete his identity and destiny. Without this "dialectical couple," as I call it, no art, no identity, no meaning. I found major support for my idea in reception theory, but also in Duchamp's essay on the creative act, and his general emphasis on the importance of the spectator in creating the work of art as well as the importance of the artist. Again, this is a relational position. Psychoanalytic object-relational theory, which finds the core of selfhood in relationship (Rimbaud: "je suis un autre"), was a further support, which I have stuck with because it offers the clearest, most well-grounded understanding of relationality, far more subtle and precise than Hegelian dialectic, which for me is an idealized and overallegorized theory of object relationship. My problem these days is that I believe it is more important to have relationships with human beings than works of art—this is a personal triumph for me—however much more difficult the former are, and however much more likely they will not work out, for all kinds of subjective reasons. In other words, I value relationships with people more than I value relationships with works of art.

You may ask, why not both?, but I don't find much art worth relating to intimately these days—which doesn't mean it isn't good art by some abstract standard—although, being a good dialectical critic, I can always find some ground on which to relate to any art. If one were to summarize, in a single generalization, what I'm trying to do in criticism, one might say I am trying to restore everything that Greenberg eliminated from art with his notion of purity—that is, what he called "literature," by which he meant "life." Where Greenberg believed in the autonomy of art, premised on the modern tendency to the pure use of the material medium, I believe that the artist invariably invests the material medium with unconscious emotion, and that art is all too human, despite its pretension to be more than human.

This interview was conducted via e-mail on June 29, 1999.

Invisible Ink: Art Criticism and a Vanishing Public

I have been asked to address the question of "the evolution of the language of criticism in recent years," with particular attention to the question "to whom should critical language speak" and "what should it accomplish." Subsidiary to that is the influence of the academic study of art on its critical language, and the question of the relationship of academic criticism and journalistic criticism. The former often involves formal and poststructural analysis, while the latter may or may not involve one or the other. Also, the former tends to be addressed to a limited, specialized audience, while the latter tries to address a larger, less knowledgeable audience.

Let me begin by cutting through this wealth of questions with Baudelaire's remark that "there is never a moment when criticism is not in contact with metaphysics," and comment on Baudelaire with Whitehead's observation that "language . . . breaks down . . . at the task of expressing in explicit form the larger generalities—the very generalities which metaphysics seeks to express."

Now the tragedy and failure of academic criticism at its best is that it attempts to articulate the metaphysical truth about the art it addresses, and in the process "redesigns (ordinary) language"—to again use Whitehead's language—and thus loses contact with the ordinary public. In contrast, the tragedy

and failure of journalistic criticism at its best is that it loses contact with the metaphysics of art—that is, tends to be unconcerned with the larger generalities that are implicit in and sustain the art it addresses—in order to preserve access to the particulars of the art for the ordinary public that uses ordinary language. In other words, journalistic understanding sacrifices a deeper understanding of art to maintain the ordinary language which supposedly provides contact with art but in fact is inimical to art at its deepest (not to say the deepest art). In contrast, academic criticism sacrifices ordinary language for a language that supposedly engages and makes explicit this depth—but then that language is not easily readable by ordinary, that is, unmetaphysical people, only by the intellectual "happy few." These different attitudes to language imply different social attitudes: journalistic criticism serves the society of spectacle, that is, the society which reduces all to "mere appearance," as Guy Debord puts it, while academic criticism is self-serving, in that it is the activity of a pretentious, self-styled elite—metaphysical snobs—that claims to have the monopoly on the "reality" of art. One can join the elite if one lets oneself undergo an intellectual hazing at the hands of their language. Thus art language comes to serve a private, self-privileging cult, or else it becomes a public event, banalizing the art it touches.

Formalism in its way and poststructuralism in its way are academic attempts to articulate the larger generalities (of whatever kind) evident in art. Insofar as they "supply" the entity called the work of art with "a systematic universe" (general context)—to again use Whitehead's language—they help us understand its metaphysical significance. Journalistic criticism, insofar as it affords an adequate observation of the particulars of the work of art, helps us understand its sociocultural topicality. But observation of particulars, as Einstein said, is complicated by the fact that, to be sophisticated, it must be informed, however subliminally, by a systematic theory or a sense of generality; and systematic theory—metaphysical assumptions, as it were—is complicated by the fact that it must be informed by careful observation of particulars. Thus, the issue of criticism necessarily involves the old epistemological puzzle—double bind—stated by Kant in his first critique: "Intuitions without ideas are blind, and ideas without intuitions are empty." This can be restated for our purposes as: "Observation of art without a systematic awareness of issues of general significance is all too particular, while a systematic awareness of the general significance that informs art is empty without an observational prehension of its particulars."

In my own case, I have tried to strike a balance—establish a dialectic, as it were—between systematic theoretical academic criticism and journalistic awareness of prehended particulars. My main theoretical or "metaphysical" concern is the psychodynamics of art—the psychodynamic generalities that inform it. To me, the understanding of the psychodynamics of art is the key problem of postformalist criticism. In general, I think the most important intellectual task facing our society is to make explicit, in ordinary language, the psychodynamic generalities that inform life. I think our society's survival depends on our understanding of these generalities, which inform every aspect of life (and art).

I have tried to adapt my criticism to the venue in which it will appear, but one of the reasons I have not always succeeded—as I am aware—in integrating academic and journalistic approaches is because the writing venue itself does not always know which approach it wants to follow. Sometimes it wants to be a spectacle, sometimes it wants to be a club for the initiated—the self-appointed cognoscenti, full of the pathology of their superiority. The venue will often change the way it tilts to suit some desperately imagined—not to say mythic—public. But the larger reason I think the public is vanishing—for contemporary art as well as art criticism, of whatever kind—is because the neo–avant-garde art that is institutionally presented to the public as the most important contemporary art, does not psychodynamically appeal to it. That is, the art's "emotional transmission," to use Jessica Benjamin's term, does not convey anything of emotional consequence for the public, and thus does not satisfy it. Neo–avant-garde art is too busy being "advanced" art to be concerned about its emotional effect on its audience. Neo–avant-garde art is an industry that produces less emotionally satisfying products—except, no doubt, for the artists—than any other part of the culture industry, so why should anyone care what any art industry critic has to say about it?

This paper was originally presented at the Conference of the Association of Independent Critics of Art in New York on May 15, 1996.

Index

Books from Allworth Press

The Dialectic of Decadence
by Donald Kuspit (paper with flaps, 6 × 9, 128 pages, $18.95)

Beauty and the Contemporary Sublime
by Jeremy Gilbert-Rolfe (paper with flaps, 6 × 9, 176 pages, $18.95)

Out of the Box: The Reinvention of Art
by Carter Ratcliff (paper with flaps, 6 × 9, 224 pages, $19.95)

Sculpture in the Age of Doubt
by Thomas McEvilley (paper with flaps, 6 × 9, 448 pages, $24.95)

Uncontrollable Beauty: Toward a New Aesthetics
edited by Bill Beckley with David Shapiro (hardcover, 6 × 9, 448 pages, $24.95)

The End of the Art World
by Robert C. Morgan (paper with flaps, 6 × 9, 256 pages, $18.95)

Imaginary Portraits
by Walter Pater, Introduction by Bill Beckley (softcover, 6 × 9, 240 pages, $18.95)

Lectures on Art
by John Ruskin, Introduction by Bill Beckley (softcover, 6 × 9, 264 pages, $18.95)

The Laws of Fésole: Principles of Drawing and Painting from the Tuscan Masters
by John Ruskin, Introduction by Bill Beckley (softcover, 6 × 9224 pages, $18.95)

Looking Closer 3: Classic Writings on Graphic Design
by Steven Heller (softcover, 6³/₄ × 10, 256 pages, $18.95)

Sex Appeal: The Art of Allure in Graphic and Advertising Design
edited by Michael Bierut, Jessica Helfand, Steven Heller, and Rick Poyner
(softcover, 6³/₄ × 10, 288 pages, $18.95)

The Swastika: Symbol Beyond Redemption?
by Steven Heller (hardcover, 6 × 9, 176 pages, $21.95)

Please write to request our free catalog. To order by credit card, call 1-800-491-2808 or send a check or money order to Allworth Press, 10 East 23rd Street, Suite 510, New York, NY 10010. Include $5 for shipping and handling for the first book ordered and $1 for each additional book. Ten dollars plus $1 for each additional book if ordering from Canada. New York State residents must add sales tax.

To see our complete catalog on the World Wide Web, or to order online, you can find us at *www.allworth.com*.